149 Paintings You Really Need to See in Europe

149 Paintings You Really Need to See in Europe

(So You Can Ignore the Others)

———

JULIAN PORTER

DUNDURN
TORONTO

PROJECT EDITOR: Diane Young
EDITORS: Bob Chodos, Ginny Freeman MacOwan, Susan Joanis
DESIGN: Kim Monteforte, WeMakeBooks.ca
PRINTER: Imago
AUTHOR PHOTO: Michael Barrack

Conseil des Arts du Canada Canada Council for the Arts

Canada

ONTARIO ARTS COUNCIL
CONSEIL DES ARTS DE L'ONTARIO

We acknowledge the support of the **Canada Council for the Arts** and the **Ontario Arts Council** for our publishing program. We also acknowledge the financial support of the **Government of Canada** through the **Canada Book Fund** and **Livres Canada Books**, and the **Government of Ontario** through the **Ontario Book Publishing Tax Credit** and the **Ontario Media Development Corporation**.

Care has been taken to trace the ownership of copyright material used in this book. The author and the publisher welcome any information enabling them to rectify any references or credits in subsequent editions.

J. Kirk Howard, President

Library and Archives Canada Cataloguing in Publication

Porter, Julian, author

149 paintings you really need to see in Europe : (so you can ignore the others) / Julian Porter.

Issued in print and electronic formats.

ISBN 978-1-4597-0072-7 (pbk.).

1. Art museums—Europe—Guidebooks. 2. Painting, European—Guidebooks. I. Title. II. Title: One hundred forty-nine paintings you really need to see in Europe.

N1010.P67 201 708.94 C2013-902948-6 C2013-902949-4

1 2 3 4 5 17 16 15 14 13

Printed and bound in Malaysia for Imago

VISIT US AT

Dundurn.com | **Definingcanada.ca** | **@dundurnpress** | **Facebook.com/dundurnpress**

Dundurn
3 Church Street, Suite 500
Toronto, Ontario, Canada
M5E 1M2

Gazelle Book Services Limited
White Cross Mills
High Town, Lancaster, England
LA1 4XS

Dundurn
2250 Military Road
Tonawanda, NY
U.S.A. 14150

CONTENTS

ACKNOWLEDGEMENTS xvii

INTRODUCTION xix

Chapter 1 GREAT BRITAIN AND IRELAND 1

The Paintings

1 Anonymous, *The Wilton Diptych* 4

2 Bellini, Giovanni, *The Doge Leonardo Loredan* 7

3 Titian, *The Death of Actaeon* 9

4 Rembrandt, *Self-Portrait at the Age of 63* 11

5 Constable, *The Hay Wain* 13

6 Turner, *Rain, Steam, and Speed — The Great
 Western Railway* 15

7 Van Eyck, *Portrait of Giovanni Arnolfini and His Wife* 17

8 Stubbs, *Whistlejacket* 19

9 Uccello, *St. George and the Dragon* 21

10 Turner, *Snow Storm: Steam-Boat off a Harbour's
 Mouth Making Signals in Shallow Water, and Going
 by the Lead* 23

11 Millais, *Ophelia* 25

12 Waterhouse, *The Lady of Shalott* 27

13 Whistler, *Nocturne in Blue and Gold:*
 Old Battersea Bridge 29

14 Cézanne, *Lac d'Annecy* 33

15 Manet, *Bar at the Folies-Bergère* 35

16 Lawrence, *George IV* 36

17 Rembrandt, *Self-Portrait with Two Circles* 39

18 Rubens, *Adoration of the Magi* 41

19 Uccello, *Hunters in a Wood* 43

20 Caravaggio, *The Taking of Christ* 44

The Galleries

National Gallery, London 46

Tate Britain, London 49

Queen's Royal Gallery, London 53

Courtauld Gallery, London 53

Wallace Collection, London 54

Kenwood House, London 56

King's College, Cambridge 56

Ashmolean Museum, Oxford 57

National Gallery, Dublin 57

Chapter 2 FRANCE 59

The Paintings

21 Caravaggio, *Death of the Virgin* 61

22 Raphael, *Baldassare Castiglione* 63

23 David, Jacques-Louis, *Madame Récamier* 65

24 Delacroix, *Liberty Leading the People, July 28, 1830* 66

25 Géricault, *The Raft of the Medusa* 69

26 Quarton, *Pietà de Villeneuve-lès-Avignon* 72

27 Chardin, *Pipe and Drinking Cup* 74

28 Manet, *Déjeuner sur l'herbe (Luncheon on the Grass)* 76

29 Manet, *Olympia* 79

30 Degas, *In a Café* 82

31 Renoir, *Ball at the Moulin de la Galette, Montmartre* 84

32 Toulouse-Lautrec, *Le Lit* 86

33 Monet, *Water Lilies* 88

The Galleries

Musée du Louvre, Paris 91

Musée d'Orsay, Paris 97

Musée de l'Orangerie, Paris 100

Musée Jacquemart-André, Paris 100

Chapter 3 SPAIN 103

The Paintings

34 Bosch, *Garden of Earthly Delights* 104

35 Van der Weyden, *Deposition* 107

36 Fra Angelico, *The Annunciation* 108

37 Goya, *Third of May, 1808* 109

38 Goya, *Sabbath* 111

39 El Greco, *The Holy Trinity* 113

40 Velázquez, *The Surrender of Breda* 115

41 Velázquez, *Las Meniñas* 117

42 Caravaggio, *St. Catherine of Alexandria* 120

43 Cézanne, *Portrait of a Peasant* 122

44 Manet, *L'Amazone (Horse Woman)* 123

45 Dürer, *Jesus Among the Doctors* 124

46 Courbet, *The Water Stream (La Brême)* 125

47 Picasso, *Guernica* 126

48 El Greco, *Burial of Count Orgaz* 129

The Galleries

Museo Nacional del Prado, Madrid 131

Museo Thyssen–Bornemisza, Madrid 134

Museo Nacional Centro de Arte Reina Sofia, Madrid 136

Santo Tomé, Toledo 136

Chapter 4 ITALY (ROME AND VATICAN CITY) 137

The Paintings

49 Michelangelo, Ceiling of the Sistine Chapel 139

50 Michelangelo, *The Last Judgment* 143

51 Michelangelo, *The Last Judgment — Transporting
 the Dead* 147

52 Raphael, *Delivery of St. Peter in the Stanza d'Eliodoro* 149

53 Caravaggio, *Deposition* 151

54 Velázquez, *Pope Innocent X* 152

55 Gaulli, *Triumph of the Name of Jesus* 154

56 Caravaggio, *The Conversion of St. Paul* and
 The Crucifixion of St. Peter 157

The Galleries

Sistine Chapel, Vatican City 161

Vatican Museum, Vatican City 162

Vatican Art Gallery, Vatican City 162

Galleria Doria Pamphilj, Rome 162

Il Gesù, Rome 163

Borghese Gallery, Rome 164

Church of Santa Maria del Popolo, Rome 164

Chapter 5 ITALY (VENICE AND FLORENCE) 165

The Paintings

57 Tintoretto, *Crucifixion* 166

58 Tintoretto, *The Baptism of Christ* 169

59 Titian, *Pietà* 170

60 Veronese, *Feast in the House of Levi* 172

61 Lotto, *Portrait of a Young Man in His Study* 174

62 Canaletto, *Portico and Court in Venice* 175

63 Carpaccio, *Arrival of the Ambassadors,* from
 The Cycle of St. Ursula 177

64 Tintoretto, *St. Louis, St. George, and the Princess* 179

65 Titian, *Assumption of the Virgin* 181

66 Tintoretto, *Crucifixion* 183

67 Tintoretto, *The Last Judgment* 185

68 Tintoretto, *Presentation of the Virgin in the Temple* 187

69 Botticelli, *Primavera* 188

70 Gentile da Fabriano, *Adoration of the Magi* 190

71 Leonardo da Vinci, *Adoration of the Magi* 191

72 Botticelli, *Adoration of the Magi* 193

73 Verrocchio, *Baptism of Christ* 194

74 Titian, *Venus of Urbino* 196

75 Masaccio, *The Expulsion from Paradise* and
The Tribute Money 198

The Galleries

Scuola Grande di San Rocco, Sala dell'Arbergo, Venice 201

Accademia Art Gallery, Venice 202

Basilica of Santa Maria Gloriosa dei Frari, Venice 204

Church of San Cassiano, Venice 204

Madonna dell'Orto, Venice 205

Galleria degli Uffizi, Florence 205

Brancacci Chapel, Church of Santa Maria del
Carmine, Florence 209

Basilica di Santa Maria del Fiore, Duomo, Florence 209

Chapter 6 ITALY (OTHER REGIONS) 211

The Paintings

76 Veronese, *The Last Supper* 212

77 Titian, *St. Jerome* 213

78 Tintoretto, *The Finding of the Body of St. Mark* 215

79 Mantegna, *Dead Christ* 217

80 Bellini, Giovanni, *Pietà* 219

81 Bellini, Gentile, and Bellini, Giovanni, *The Sermon
of St. Mark in Alexandria* 220

82 Piero della Francesca, *The Legend of the True Cross* 222

83 Correggio, *Assumption of the Virgin* 225

84 Mantegna, *Family and Court of Ludovico III Gonzaga*
 and *The Meeting Scene: Grooms with Dogs and Horse* 228

85 Giulio Romano, *The Fall of the Giants* 231

86 Giotto, *St. Francis Catches the Devils of Arezzo* 233

87 Martini, *St. Martin Renounces the Roman Army*,
 from *Scenes of the Life of St. Martin* 235

88 Titian, *Pope Paul III with his Nephews Cardinal
 Ottavio and Alessandro Farnese* 236

89 Martini, *St. Louis of Toulouse* 238

90 Bruegel the Elder, *Parable of the Blind* 240

91 Signorelli, *The Damned in Hell* (part of *The
 Last Judgment*) 241

92 Giotto, *Devils Derobing a Man* (detail from
 The Last Judgment) 243

The Galleries

Brera Gallery, Milan 245

Basilica of San Francesco, Arezzo 247

Duomo of Parma 248

Ducal Palace, La Camera degli Sposi, Mantua 248

Palazzo Te, Mantua 249

Basilica of San Francesco d'Assisi, Assisi 249

National Museum of Capodimonte, Naples 251

Duomo, Orvieto 252

Scrovegni Chapel, Padua 253

The Paintings

93 Rembrandt, *Moses Destroying the Tablets of the Law* 257

94 Titian, *Self-Portrait* 259

95 Hals, *Malle Babbe* 260

96 Rembrandt, *Joseph and Potiphar's Wife* 262

97 Van Dyck, *Portrait of a Genoese Noblewoman* 263

98 Watteau, *The Shop Sign for the Art Dealer Gersaint* 265

99 Raphael, *The Sistine Madonna* 268

100 Van Eyck, *Altarpiece with the Madonna and Child,
 St. Michael, and St. Catherine* 270

101 Ruisdael, *The Jewish Cemetery* 272

102 Rubens, *The Fall of the Damned* 274

103 Boucher, *Reclining Girl* 276

104 Van Dyck, *Self-Portrait* 277

105 Titian, *The Crowning of Thorns* 279

106 Dürer, *Self-Portrait in a Fur-Trimmed Cloak* 281

107 Tiepolo, *America* and *Africa* 283

108 Bruegel the Elder, *Return of the Hunters* 287

109 Vermeer, *The Painter* 289

110 Titian, *Mars, Venus, and Amor* 291

111 Tintoretto, *Susannah Bathing* 292

112 Van Dyck, *Samson Made Prisoner* 294

113 Rembrandt, *Large Self-Portrait* 295

114 Bruegel the Elder, *Conversion of St. Paul* 296

The Galleries

Gemäldegalerie, Staatliche Museen, Berlin | 297

Schloss Charlottenburg Palace, Berlin | 300

Gemäldegalerie Alte Meister, Dresden | 300

Alte Pinakothek, Munich | 302

Würzburg Residenz, Würzburg | 304

Kunsthistorisches Museum, Vienna | 305

Chapter 8 EASTERN EUROPE 309

The Paintings

115 Rembrandt, *Return of the Prodigal Son* | 310

116 Matisse, *Dance* | 312

117 Veronese, *Conversion of Saul* | 313

118 Cézanne, *Great Pine and Red Earth* | 314

119 Rembrandt (School of), *Haman Recognizes His Fate* | 315

120 Picasso, *The Absinthe Drinker* | 317

121 Van Dyck, *Portrait of Henry Danvers, Earl of Danby* | 318

122 Leonardo da Vinci, *Lady with Ermine* | 320

123 Dürer, *The Feast of the Rosary* | 322

124 Titian, *The Flaying of Marsyas* | 325

125 Bruegel the Elder, *The Hay Harvest* | 328

The Galleries

Hermitage, St. Petersburg | 330

Czartoryski Museum, Krakow | 333

National Gallery, Prague | 333

Archbishop's Palace, Kromeriz 334

Lobkowicz Palace, Prague 334

Chapter 9 SCANDINAVIA AND THE LOW COUNTRIES 337

The Paintings

126 Rembrandt, *The Oath of the Batavians* 340

127 Rembrandt, *Simeon in the Temple* 343

128 Renoir, *La Grenouillère* 344

129 Rembrandt, *Self-Portrait* 345

130 Vermeer, *View of Delft* 348

131 Holbein the Younger, *Portrait of Robert Cheseman* 350

132 Ruisdael, *View of Haarlem* 352

133 Steen, *The Merry Company* 354

134 Vermeer, *Head of a Girl* 356

135 Rembrandt, *The Jewish Bride* 358

136 Rembrandt, *The Syndics of the Amsterdam Drapers' Guild* 359

137 Hals, *The Meagre Company* 361

138 Vermeer, *A Street in Delft* 363

139 Rembrandt, *Jeremiah Lamenting the Destruction of Jerusalem* 364

140 Vermeer, *The Milkmaid* 366

141 Rembrandt, *The Company of Captain Frans Banning Cocq and Willem van Ruytenburch* 367

142 Rembrandt, *Portrait of Jan Six* 368

143 Van Gogh, *Wheatfield with Crows* 370

144 Van Gogh, *Vase with Irises* 371

145 Van Eyck, *Madonna Adored by the Canonicus Van der Paele* 373

146 Memling, *St. Ursula Shrine* 375

147 Rubens, *Descent from the Cross* 377

148 David, Jacques-Louis, *Jean-Paul Marat, Politician and Publicist, Dead in His Bathtub, Assassinated by Charlotte Corday* 379

149 Van Eyck, *The Ghent Altar* 382

The Galleries

Nationalmuseum, Stockholm 385

Mauritshuis, The Hague 387

Rijksmuseum, Amsterdam 388

Jan Six Museum, Amsterdam 390

Van Gogh Museum, Amsterdam 390

Groeninge Museum, Bruges 391

Memling Museum, Bruges 392

Cathedral of Our Lady, Antwerp 392

Musées Royaux des Beaux Arts, Brussels 393

St. Bavo Cathedral, Ghent 394

NOTES 395

INDEX OF ARTISTS AND THEIR WORKS 397

INDEX OF PAINTINGS BY TITLE 405

INDEX OF PAINTINGS BY GALLERY 413

CHECKLIST OF THE 149 PAINTINGS 421

ACKNOWLEDGEMENTS

This book was long in the oven.

I owe thanks to many. My father, who was a fine painter and a gentle teacher. Professor Brieger, who taught me at university, for his love of Rembrandt. James Spence, who helped me focus in on the scope of this. Frans Donker, whose countless Book City sales created my art library. Kevin Sartorio for his help on copyright. Virginia Walker for her laborious photography of many of these paintings. Joey Slinger, who is the best possible viewer on an art tour. Jack Rabinovitch, who has painfully endured many lectures. Dirk and Ines Roosenberg, who explained the magic of Rembrandt in The Hague. Frank Iacobucci for unravelling access to King's College. Cliff Lax and Ian Roland, my cheery legal supporters, for their expression of confidence. Roy McMurtry, a sounding post for colour and the difficulties of painting. Margaret Atwood for her flow of innovative ideas about approaches to this. Michael Barrack for his pictures of me in Vienna. Baron Jan Six van Hillegrom, who provided me with the image of the portrait of Jan Six. Nancy Lockhart for her picture of Giverny. Dawn Mathews for pulling all this together. Anna for her guidance. And of course Rembrandt van Rijn, whom I have visited for some fifty-nine years.

INTRODUCTION

In 1955, during my last year of high school, I started work as a tour guide in Europe, and every summer after that, for seven years, I travelled to Europe with Canadian high school students, showing them the grand sites, the famous cities, and, of course, the galleries. While there, I fell in love with European art, and it has been my passion ever since. I have returned every year, either alone or with my growing family, with friends or small groups of lawyers, or with larger groups of acquaintances. Each time I have discovered something new, but my favourites remain those that most attracted me early in life, and though I have added to my list of "must-sees," I have rarely sacrificed an old favourite for a new discovery.

To really look at a painting takes time. The artist may have spent a month or more on the work, so it is only fair that you attempt to understand what it is about, to give it the time it deserves with your uninterrupted gaze. Knowing something of the story behind the painting helps in its appreciation, as does some familiarity with the customs of its times, and where it fits into the pantheon of great art. The more you know, the more you'll see, and the greater your enjoyment of the experience will be.

My purpose in writing this book is to introduce the gallery-going novice to the world of European painting. There are countless books on art and art history, and galleries and guidebook publishers have produced their own versions. I do not seek to replicate them. Rather, I want to talk to those viewers unencumbered by too much knowledge and say, look, here are 149 paintings or murals that I believe you must see before you die. In addition to the 149, I have recommended a few

additional paintings in the large galleries (in case you are keen to go on after the initial introductory must-sees). For example, I think you really should see about thirty paintings in each of the Louvre, the Prado, and the National Gallery in London. Most guidebooks will give you mind-bogglingly long lists for these galleries, but I do not think you can *really* look at more than thirty paintings in a day and remember what you have seen. After thirty of them, you have "blown your eyes." It's true. Just try it.

In order to effectively experience the works, I ask that you walk through successive rooms, glancing at paintings to get a feeling for where you are and where you must go next. You must learn not to stop in the rooms, not to be distracted, because the paintings I suggest you *must see* require your full attention. I have picked them because they are, in my opinion, representative of the best paintings by artists from Giotto to Picasso. I have selected this period, between 1298 and 1937, because Giotto's work profoundly influenced the development of Renaissance art, where figures stepped out of the gold backgrounds of iconography and acquired weight, force, and individuality. I stopped where Picasso launched into abstraction. With Picasso, the modern era of painting begins. It would, I think, require another book to explore this area. I don't pretend my choices are the only ones or the correct ones, but I offer a considered approach to the question, What are the great painting masterpieces I should see before I die? The list comes after more than forty years of gallery visits and reading all the major books of art history and criticism published over the past seventy-five years.

Others may look at my list and choice of galleries and say it is incomplete or blatantly wrong. But I believe that if you see everything on the list, you will learn quite a bit about art.

There are some things that art critics rave about and I don't like, so I've left them off my list. I agree with the writer Alan Bennett that some paintings should be avoided. When he became a trustee of the National Gallery in London in 2005, he received the privilege of a private tour. The head of the gallery was about to enter a room with Dutch flowers when Bennett said no. He just hated looking at flowers — apparently, they reminded him of the cookie tins of his youth.

On the whole, I agree with him. Bennett and I have the support of the American artist Georgia O'Keeffe, who once said, "I hate flowers — I paint them because they're cheaper than models and they don't move!"

I also dislike those gold early Renaissance enthroned virgins packed into large rooms in most of the galleries. Some artists, such as Poussin, have delighted scholars of French art, including Anthony Blunt, but I can't stand him. It may not be fair, and I may be missing some quality that Blunt found engrossing, but to me his work is wooden and staged. By all means, though, check out a few of his paintings and make up your own mind.

Some galleries have a great selection of certain artists, so when you visit you should concentrate on them. The Rijksmuseum in Amsterdam has a grand clutch of Rembrandts. It also has rooms of flowers, tables of cascading foods, cowscapes, and plump or lean burghers looking serious, straight ahead, all in black or brown with a stern Dutch air of smug righteousness. Don't look at them. Keep moving. Go to the Rembrandts. I have studied Rembrandt's self-portraits, which progress from his early cockiness and masterful superiority to a resigned, shadowy genius, and finally represent a pool of pain and memories of past triumphs.

There are a multitude of theories about what should be art's purpose, often reflecting the political or social view of the theorist or the prevailing world view of the time. I suppose that Sir Kenneth Clark in his *Looking at Pictures* said it safely: "Art must do something more than give pleasure: it should relate to our own life so as to increase our energy of spirit." A complicated definition of art from the artist's point of view is by the poet Rainer Maria Rilke (1875–1926): "Surely all art is the result of one's having been in danger of having gone through an experience all the way to the end, to where no one can go any further. The further one goes, the more private, the more personal, the more singular an experience becomes, and the thing one is making is, finally, the necessary, irrepressible, and, as nearly as possible, definitive utterance of this singularity."

But this book is about the paintings. We begin in London, at the National Gallery.

1

GREAT BRITAIN
AND IRELAND

British and Irish galleries are fun. Not only do they contain some of the world's greatest paintings, but these paintings are often housed in settings that make the overall experience of visiting the galleries a multilayered treat.

The **National Gallery** just may be the world's foremost art museum. It is literally in the very middle of London, on Trafalgar Square. The view from the gallery overlooking the Thames and the parliament buildings is stunning. There are two entrances — the Sainsbury entrance on the left as you face the gallery, and one in the centre. If you leave by the centre door you look down toward Westminster and the vast scene of a city in motion — the square before you is always full of people.

And get this — the gallery is free. Just imagine that, if you worked nearby, every day at noon you could step in and have a rendezvous with a different painting. What a glorious opportunity!

Then there's the recently renamed **Tate Britain**, which reminds me of why I wrote this book. It offers sumptuous and varied fare in the work of many important artists. In my list of favourites, I note paintings by Millais, Waterhouse, and Whistler as well as Turner. The gallery has so many Turners — from large to small, in several media — that it cannot display them all at once, so they are on rotating permanent exhibition.

Go to the back of the gallery and up a staircase to a study centre that has special exhibitions and many of Turner's sketchbooks (bequeathed by him to the nation) on view. Be sure to look at some of them.

The museum also has a marvellous video demonstration by Michael Chaplin, a contemporary painter, that shows how Turner prepared his medium and painted watercolours. It explains how he would have mixed colours, worked with wet paper, how he "scratched" watercolour surfaces, and how his drawings were done.

It conveys Turner's techniques for drawing, painting, using graphite, chalk, pencil, and a variety of brushes. It also explains the development of colours for artistic practice and when they were invented. It is the best demonstration I've seen on how art is created. Lasting a total of twenty minutes, it's a crash course on watercolour. The room has eight drawing tables with paper and pencils, and before you is a Turner sketch. Try to copy it, and keep your work. You will be amazed by what you have learned in such a short time and delighted by your new-found appreciation of the artistic process.

The **Queen's Gallery** on the left side of Buckingham Palace (facing it) is a superb gallery. In most galleries, the attendants are little pools of sloth calculating their next time off. Here the attendants, all proud to represent Her Majesty, are quick, courteous, and efficient. This gallery, with its rotating collection, offers the quintessential British experience of art.

The **Wallace Collection** offers, in my opinion, a mixed experience. Its luncheon under a glass-covered canopy over a courtyard is memorable. However, as pleasant as the site is, the collection of paintings is almost lost in the middle of the mumbo jumbo of china, armour, furniture, small sculptures, snuff boxes, swords, rifles, daggers, bowls, medals, plates, vases, bronzes, and Limoges enamels. Some of the glassed-in tiered paintings are stacked in dark rooms without clear identification. It can all be a hopeless mess unless you know what you seek.

You can, nonetheless, take advantage of the free guided tours of the collection that are given each weekday at 1:00 p.m. Admission to the museum, which is open seven days a week, is free — though you will be asked for a donation at the entrance.

Within this chapter, I also note some of Britain's smaller galleries — such as Cambridge's **King's College Chapel** with its ethereal entrance — all of which merit a visit. I then take you over to Ireland to introduce you to the **Irish National Gallery** in Dublin. Sitting close to the greenest of green parks, this gallery offers delights both within and around.

In the capital cities of England and Ireland, there is much to experience. Make the time to really *see* the twenty essential images I introduce below and, with whatever time you have left, be sure to embrace the fun that these collections have to offer.

THE PAINTINGS

1. The Wilton Diptych

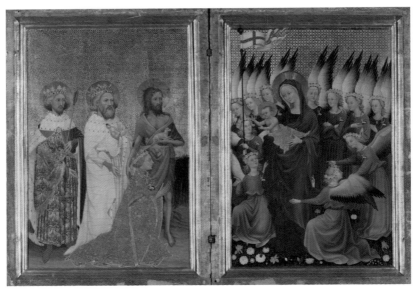

Anonymous, 1395–99
National Gallery, London, England
Photo: © National Gallery, London / Art Resource, NY

The Wilton Dipytch is a stylized painting on oak panels in the Sienese manner — thin alabaster figures, delicate but all having the same personality.

The little folding altarpiece shows Richard II kneeling, in the company of King Edmund, King Edward the Confessor, and John the Baptist. The angels surrounding the Virgin and Child wear garments emblazoned with the white hart, Richard's symbol, and crowns of roses.

The diptych's principal colour (aside from gold) is blue, a royal colour in Richard II's time. Until the middle of the thirteenth century

red dyed cloth, white undyed cloth, and black were European culture's dominant colours.

The bright blue pigment was made of lapis lazuli, which was very costly and contained speckles of iron pyrite — fool's gold. Marco Polo, in 1271, while in a mountain range to the north of Kabul, Afghanistan, wrote, "And you must also know that in another mountain of the same region is found the stone [lapis lazuli] of which azure is made — the finest and best azure in the world."

Blue slowly became an attribute of the Virgin in paintings.

The angels are all intent, all the same, intent, intent: the sameness creates a prevailing melody.

A tiny orb sits at the top of the flagpole bearing the red-and-white-cross banner, perhaps a symbol of the Resurrection and of St. George, patron saint of England. In the orb, if you peruse a blow-up of it, is a green island with a castle and a boat in a silver sea, representing England under the protection of the Virgin and Child.

The back of the altarpiece shows a white hart with a gold crown-shaped collar and chain hanging from its neck.

The king may have used this altarpiece for nightly prayers, perhaps as a source of comfort. He was deposed in 1399, held in captivity, and executed in 1400.

The artist has captured Richard II as a pompous little snippet of a know-it-all. Look at him! But he could be tough. In 1381 Wat Tyler from Kent and Jack Straw from Essex led the Peasants' Revolt. They burned Savoy House, home of John of Gaunt, the king's uncle and regent until he came of age. Richard II met Tyler in Smithfield, promising to treat for peace. There was a scuffle, Tyler was killed, and the peasant rabble's ringleaders were executed. Richard II had deceived them.

My view of Richard II is found in Shakespeare, who customarily rewrote history toward his plays' necessities. John of Gaunt, dying, comments bitterly on Richard's rule and his dictatorial taking of land (*Richard II*, act 2, scene 1):

> England, bound in with the triumphant sea
> Whose rocky shore beats back the envious siege

Of watery Neptune, is now bound in with shame
With inky blots and rotten parchment bonds:
That England, that was wont to conquer others,
Hath made a shameful conquest of itself.

2. The Doge Leonardo Loredan

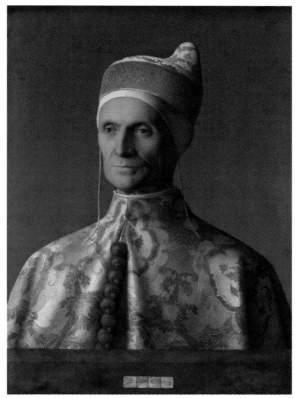

Bellini, Giovanni, 1501–4
National Gallery, London, England
Photo: © National Gallery, London / Art Resource, NY

Loredan led Venice as doge, the elected chief magistrate and military leader, for twenty years of constant warfare. It was a desperate struggle that he oversaw, and Loredan was brutally intent on advancing the interests of his republic. In the portrait he exudes calm inward majesty, focus, and unchallengeable authority — don't dare flout me!

Giovanni Bellini is the father of Venetian painting and lived a charmed life, producing a new kind of painting for sixty years. He was the Venetian Council's choice as the lead painter in Venice, a position of power ("painter extraordinary to the Lord"). Titian and Giorgione

graduated from his workshop. He gave comfort to Dürer when he visited. Unlike Titian and Tintoretto he had a gentle disposition. He conveyed figures with dignity and repose. He turned religious subjects into inhabitants of a serene and beautiful world.

The damask woven with golden thread is so palpable that you crave to touch it! The doge appears to have seen it all, without remorse, and the future doesn't hold fear. He's crafty, yes, but I would trust him, I thought on my first experiences of the painting. But when I visited again on September 17, 2011, I was not so sure about the trust: perhaps he'd do whatever was "necessary." He's a distant cold fish — no time for fools, and he might put me in that category.

I think this is one of the greatest portraits of all.

3. The Death of Actaeon

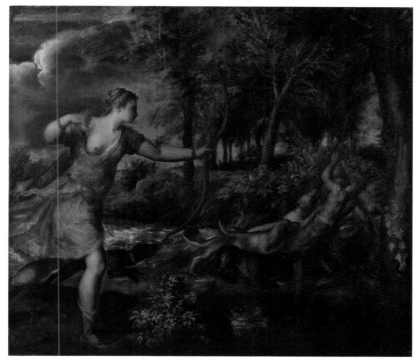

Titian (Tiziano Vecellio), c. 1565–76
National Gallery, London, England
Photo: © National Gallery, London / Art Resource, NY

Why is this considered to be one of the top two or three paintings in the world? The myth is gruesome and disturbing. Actaeon, a hunter, comes across Diana, a goddess, in the woods and sees her bathing. She is angry. Gods are not meant to be seen by mere mortals. She transforms Actaeon into a stag. Actaeon's five beloved dogs attack and devour him. It is a swift and terrible moment.

Diana is tall, in red, striding forth with a bow aimed toward the falling stag, the woods a furious sweeping brown, the sky a turbulent grey, everything thick with emotion, swarming with heavy, violent energy. The ground, river, and dogs just snaffle the poor stag up. The fluid terror of nature unleashed.

Look at Titian's splotchy style of applying paint: the rushing river with froths of white, Diana's Titian-red garment, canvas peaking through a scrabble of colours. I had not known there were so many variations of red.

4. Self-Portrait at the Age of 63

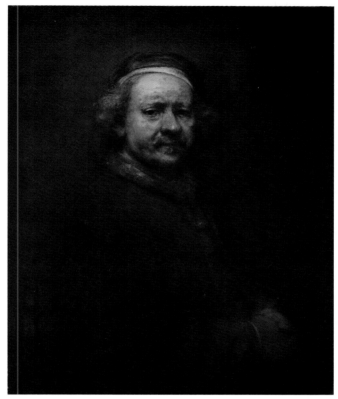

Rembrandt Harmensz van Rijn, 1669
National Gallery, London, England
Photo: © National Gallery, London / Art Resource, NY

Rembrandt was perhaps the greatest explorer of inner psychology. He painted at least eighty-three self-portraits from early to late in life. Here he is at sixty-three — his last year. In the middle of his career in Amsterdam he was a walloping success. But disaster struck. Bankruptcy, death, the passing of his beloved son, Titus, all crowd into his gaze in this painting.

Notice the brow wrinkled with concern, the hurt eyes, the bulbous nose, the scaly skin, the puffed semi-bloated face with its pouches, sags — a startlingly frank self-portrait, yet it has dignity. The eyes are

despondent but still have a determined gaze. They will hold your eyes and make you uncomfortable. I have visited this painting for more than fifty years, pretty well every other year. I know him well, flashing the grief of a painter straining for the unattainable.

The eyes. The eyes say, "I've seen it all, and it has not been pretty. I'm in a mental state of pure pain, but I'm a wise old bird with a lot more experience than you, the viewer."

The face peering out is impossible to translate into words, but it reflects this experience. You see it if you stand before this or another late Rembrandt self-portrait, one he produced in his last six years, say one at Kenwood House or in The Hague's Mauritshuis (see Chapter 9). Look at Rembrandt. Really look. The artist could not go any further or shed more light on his own life and the process of aging.

September 17, 2011, was my most recent visit. I found him sad, sad, with a dollop of hurt, more vulnerable than I had seen before, maybe because I am older. As someone said behind me as I wrote this, "There's a man who lived."

5. The Hay Wain

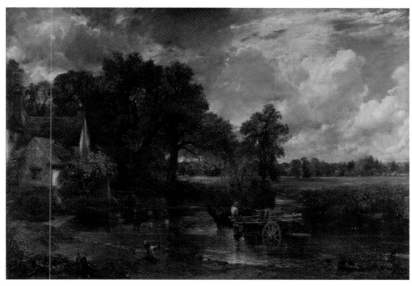

Constable, John, 1821
National Gallery, London, England
Photo: © National Gallery, London / Art Resource, NY

Constable is in good form here. In 1821 *The Hay Wain* was criticized for its heavy impasto and white patches on the water. When the painting was exhibited in Paris in 1824, however, people loved it. Delacroix was struck with its vivacity and freshness. Constable's motto was "light and shadow never stand still" and the skies "should always aim at brightness." The sky is so changeable here that you can sense a possible sprinkle an hour from now. The creaking wheel eases into the water — so clear that you can feel the cool. You are part of summer weather.

Constable said, "The sound of water escaping from mill dams, willows, old rotten planks, slimy posts and brickwork — I love such things. As long as I do paint, I shall never cease to paint such places."

In Constable's time painters portrayed landscapes as brown, always brown. His vibrant greens, blues — providing a real mirror of nature — were novel and disturbing. Constable said the sky was the "chief organ of sentiment" in a landscape.

His white flecks of paint used as highlights were slighted as "Constable's snow." Here there are smears of white on the river, varied greens for the trees, the scene topped off with clouds on the move, suggesting rain later. *The Hay Wain* became, as one critic said, "part of the landscape of every English mind."

6. Rain, Steam, and Speed — The Great Western Railway

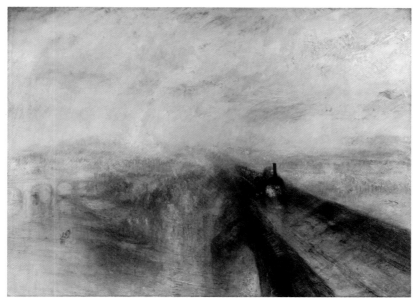

Turner, Joseph Mallord William, 1844
National Gallery, London, England
Photo: © National Gallery, London / Art Resource, NY

Turner was England's greatest artist. He could capture nature in all her moods, by paint, watercolour, or pastel. He painted "impressionist" pictures fifty years before the French impressionists did.

Turner was a star in his day, but controversial. He wasn't social and was a rather strange loner. He never married but he had a healthy sex drive. John Ruskin may have been titillated and pushed to extravagant praise, but others were hostile. When Turner died, Ruskin went through his papers and in a fit of prudery destroyed all his erotic drawings. Ouch!

A Cockney, raised behind Covent Garden, he kept the manners and accent of his youth throughout his life. Delacroix described him as having "the look of an English farmer, black coat of a rather coarse type, thick shoes — and a cold, hard face." Constable's impression was

that "he is uncouth, but has a wonderful range of mind." Aggressive and blessed with a photographic memory, he was a ceaseless worker forever drawing on his sketchpads.

Room 34 at the National Gallery contains some of his masterpieces, including this one. It is placed next to his *Calais Pier* of 1803 for comparison.

In 1844 he was approaching seventy and was chronically sick. This painting, so abstract, so thoroughly modern, is a vision of heavy sheets of wet thrown at your eye. It has the feeling of a car wash, the windshield wiper chasing soap suds away. To the future!

Turner was obsessed with how an artist portrayed light and its effect — light, its translucence, its various levels of mist, snow, fog, filtered sun, its power of creating abstract patterns — these were his signature. This was his lead-in to twentieth-century art. Abstract, heavy impasto, white, gold, a splatter of blue, a rush of pigment. This painting, bold, blue, brown, thick impasto — all a variation in colour. The only clear image is the black iron of the chimney of the train. Apparently (I can't really observe it) there is a small rabbit on the right of the oncoming train trying to outrun it, representing the modern chasing nature. I had never noticed it until I watched the most informative Internet show, *Smart History Video,* about this painting. You can see the thick yellow cream impasto. Welcome to modern abstract art!

Painted with a fury, with an excess, sometimes too much, but pointing the way to the future.

7. Portrait of Giovanni Arnolfini and His Wife

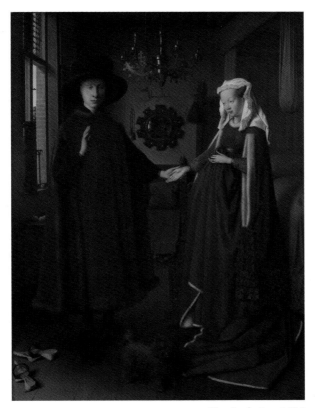

Van Eyck, Jan, 1434
National Gallery, London, England
Photo: © National Gallery, London / Art Resource, NY

Giovanni di Nicolao Arnolfini from Lucca was an adviser to Philip the Good, duke of Burgundy. Arnolfini dealt in money, and his bride here, Giovanna (or Johanna) Cenami, was an Italian banker's daughter. He was Philip's chamberlain and on occasion his envoy in secret matters.

This painting has provoked centuries of analysis. Is this their wedding? Is Johanna pregnant? No, apparently not, the full dress prow was a sign of beauty of the time.

If this is a wedding, where is the church official? You didn't need one then. In the fifteenth century a wedding could be performed

anywhere by the couple themselves. Only after the Council of Trent, a century later, were priests required.

Why are the clogs lying on the floor? Perhaps they were a symbol of fidelity? Or the Bible, Exodus 3:5: "Do not come any closer. Take off your sandals for you are standing on holy ground." So if it is a wedding, the couple to be wedded when administering the sacrament to each other are occupying holy ground. And what is the meaning of the candelabrum above the scene, one from Flanders, with only a single candle in place and lit? Does it signify an all-seeing Christ who is witness to the marriage vows? Perhaps.

The dog? A symbol of faithfulness? The oranges? A symbol of the purity and innocence that reigned in the Garden of Eden before the fall of man.

Jan van Eyck signed the work "Johannes de eyck fuit hic 1434" (Jan van Eyck was here 1434). So the signature, which appears above the convex mirror, transforms the panel into a document, as a witness to the marriage (with his image in the mirror).

The husband has always looked creepy to me, and I've never overcome this reaction.

I was finally able to track down his story. People sought his influence, as a powerful adviser to the duke of Burgundy. On one occasion the wife of an exiled husband implored him to revoke the exile. He didn't, but relying on the absence of the husband he seduced the wife and made her his "open" mistress. She got revenge — she exacted from him luxurious homes in Bruges and Brussels. Litigation followed. Eventually Arnolfini won, but he died a year later. The widow seen in the picture (Johanna) saw to it that he received a church funeral with pomp and ceremony.

What a piece of work Arnolfini was!

8. Whistlejacket

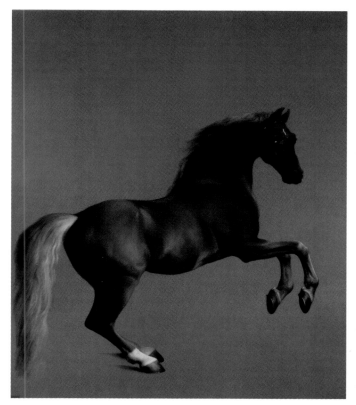

Stubbs, George, c. 1762
National Gallery, London, England
Photo: © National Gallery, London / Art Resource, NY

The absolute quintessential horse. Wow!

This is a stunning painting. Perhaps it is the glow of the horse's belly, the weave of his mane, or the startled look of his eyes, set off by a monochrome background that sets it up as if it is a sculpture.

Whistlejacket was not a great horse, but was famous for a victory in August 1759 at York in a four-mile race with a purse of 2,000 guineas. Whistlejacket was owned by the Second Marquess of Rockingham. In his career in the House of Lords, Rockingham was prime minister twice during the reign of George III — from July 1765 to July 1766

and from March 1782 to his death in July 1782.

There is some conjecture that originally the painting was to have had George III sitting astride the magnificent beast but Rockingham, moving into an era of conflict between Parliament and the king, changed the directions. There doesn't appear to be any direct support for this but it is a wonderful concept. Three years after the painting was done, Rockingham courageously attacked George III in a speech, declaring that the king "must give his genuine confidence to the responsible Minister otherwise it was delusory to expect that even new counsels or counsellors could succeed."

Rockingham was historically important because he revoked the Stamp Act, which taxed American newspapers, thus creating the frenzy of a free press that is so prominent today.

Stubbs was a lifelong student of anatomy and he dissected horses. He also published a book called *The Anatomy of the Horse*.

There is an anecdote that Stubbs painted this picture outdoors close to Whistlejacket's stable. The stable boy was leading Whistlejacket and Stubbs removed the painting from his easel and placed it against the stable wall, where Whistlejacket saw it. "Catching sight for the first time of his own image," the National Gallery guide suggests, "Whistlejacket supposedly began to stare and look wildly at the picture endeavouring to get at it, to fight and to kick it. Pummelling the horse with his pallet and Mahl stick Stubbs might nonetheless have relished this ultimate tribute to the realism of his art — its recognition by an animal." A Mahl stick (I looked up the definition) is a long wooden stick used by painters as a support to keep the hand that holds the brush from touching the painting surface. If this is so, it must have been a large pallet and a large Mahl stick!

I must say this is all a bit unlikely, but it's fun and it captures the spirit of the horse.

9. St. George and the Dragon

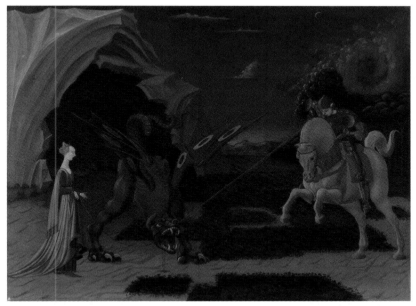

Uccello, Paolo, c. 1470
National Gallery, London, England
Photo: © National Gallery, London / Art Resource, NY

Paolo Uccello's eccentricity was an obsession with the rules of per-spective in painting. Vasari, a painter and art historian, wrote of this at the time:

> Paolo Uccello would have been the most gracious and
> fanciful genius that was ever devoted to the art of paint-
> ing, from Giotto's day to our own, if he had labored as
> much at figures and animals as he labored and lost time
> over the details of perspective; for although these are
> ingenious and beautiful, yet if a man pursues them
> beyond measure he does nothing but waste his time,
> exhausts his powers, fills his mind with difficulties, and
> often transforms its fertility and readiness into sterility
> and constraining, and renders his manner, by attending

more to these details than to figures, dry and angular,
which all comes from a wish to examine things too
minutely; not to mention that very often he becomes
solitary, eccentric, melancholy, and poor, as did Paolo
Uccello.

Uccello is most famous for his three battle scenes from the Battle
of San Romano, one of which is in the London National Gallery. They
are laboured but have a very magnetic design and some lovely colours
with figures all foreshortened on a shallow stage. Paul Johnson, the
eminent art critic, observed that the knights in these paintings are "like
toy soldiers riding rocking-horses" and "the armour and dead bodies
on the ground are waiting to be put back into the nursery box."[1]

I include this painting as one that must be seen because it is so
striking, so thoroughly modern that Salvador Dali could have done it.
Once you see this painting you can't push it out of your memory. You
return to it with a smile, observing the daring foreshortening of the
dragon, the markings of a fighter jet on the dragon's wings.

It is pure Dali; the cave and princess' robes could also have sprung
from Dali on his good days — perhaps. The drip of dragon's blood
melts the earth, next to the identically coloured shoe of the princess.
The slabs of the cave; the magnetic slither of the dragon; the check-
ered linoleum feel of the ground under a tornado swirl of bubbly
clouds — a modern video cartoon come to life in 1470.

At the end of his monograph on Uccello, Vasari says that in the
end he shut himself up in his house devoting himself to perspective,
which kept him ever poor and depressed up to his death. His wife
"was wont to say that Paolo would stay in his study all night seeking to
resolve the problems of perspective, and when she called him to come
to bed he would say, 'Oh what a sweet thing is this perspective!'"

10. Snow Storm: Steam-Boat off a Harbour's Mouth Making Signals in Shallow Water, and Going by the Lead

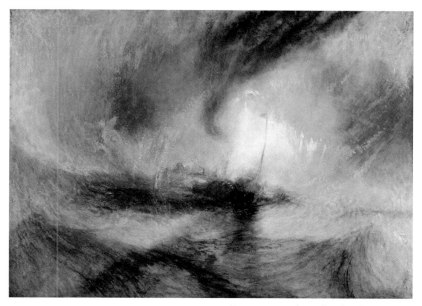

Turner, Joseph Mallord William, 1842
Tate Britain, London, England
Photo: Tate, London / Art Resource, NY

This painting was described by a critic as a mass of soapsuds and whitewash.

Turner asserted that he'd been lashed to the mast in order to experience the storm: "I was lashed for four hours, and I did not expect to escape, but I felt bound to record it if I did." This was just promo stuff. He was sixty-seven, suffering illness.

He was a visitor to the Royal Society dedicated to science, where he met Michael Faraday and Mary Somerville who created patterns of magnetic lines of force when they placed magnets under sheets of paper sprinkled with iron filings. This was the basis of the swirling black-brown fiery vortex in the painting.

"Going by the lead" in the title refers to navigation by plunking a

rope and lead ball into the sea to determine depth, although its utility in a storm would be pretty iffy.

The picture is of a distressed steamer, a product of industrial England, at the mercy of nature's violence. In the end all the great industry of England must go blind.

Turner anticipates Monet's dissolving colours of light and perhaps even Rothko with his total abstraction. His reputation declined after his death. Matthew Collings attributes the resurrection of his popularity to the rise of abstract expressionism in the 1960s and especially a show at the Museum of Modern Art in New York in 1966.[2] Collings argues that Rembrandt, in his *Jewish Bride* in the Rijksmuseum in Amsterdam (see Chapter 9), represents all of Turner's painterly qualities in the groom's sleeve alone, but also reveals a range beyond Turner in his study of psychology and personality. Interesting, perhaps true, as *The Jewish Bride* (Van Gogh's favourite painting) is a triumph. Yet, to stand before this sucks you into another alien region.

11. Ophelia

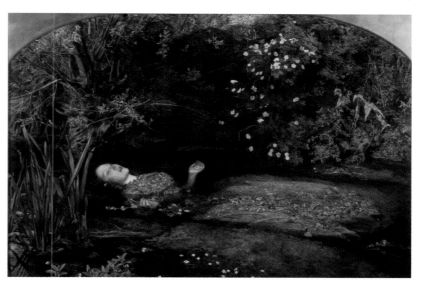

Millais, Sir John Everett, 1852
Tate Britain, London, England
Photo: Tate, London / Art Resource, NY

In 1848, an auspicious year of revolution, a group known as the Pre-Raphaelites began with the stated objective of returning to the purity of form, colour, and purpose of before Raphael's time. They loved the detail, intense colours, and complex composition of Quattrocento Italian and Flemish art. They had a strain of religion and ritual and turned to Catholic religious imagery.

The group used a technique of painting in thin glazes of pigment over a wet white ground — creating sparkling transparency and clarity.

The group was large and and included the painters John Everett Millais, John William Waterhouse, and Henry Wallis. The art critic John Ruskin and the poet Algernon Charles Swinburne were also associated with the group.

Millais's *Ophelia* is an arresting canvas. The water is spooky in its clarity; Ophelia's face both living and lifelike, with red blush of youth, parted lips, gossamer blond eyelashes (there drifts by the blond

teenager); the flowers a living encroaching force. In preparation Millais spent four months studying vegetation in Surrey. The flowers have a symbolic meaning — the poppy death, daisies innocence, pansies love in rain. The willow (symbol of forsaken love) and the nettle growing within it (symbol of pain) about Ophelia's head are painted with meticulous care over a wet white surface added for each day's work.

This was a huge hit in Paris in 1855.

The model, Elizabeth (Lizzie) Siddal, posed in bathwater for such a long time that she got sick. Although the tub was warmed by lamps, she got the chills when they went out. Lizzie's father threatened suit, compelling Millais to pay her medical bills. Dante Gabriel Rossetti, the leading Pre-Raphaelite, was smitten by her. He pursued her for ten years and married her. She died after a stillborn child and an overdose of laudanum in 1862.

Rossetti, a bad womanizer, was grief-stricken. He buried her with the manuscript of his poems. Seven years later he wanted the poems back, so he exhumed her. Rumour had it that Lizzie was in gorgeous shape, her hair as red and flaming as in life. Today there is a website devoted to Lizzie, a poet and artist in her own right (lizziesiddal.com).

Ruskin, the great critic, was high on Millais, as was Ruskin's wife, Effie, a model. While Ruskin may never have consummated his marriage with Effie, Millais certainly did and ran off with Effie. Ruskin supported many of the other Pre-Raphaelites but not Millais. Ruskin's disastrous marriage ended by annulment with a physician testifying in court as to nonconsummation. Shortly afterward, Effie married Millais and had eight children — eight!

12. The Lady of Shalott

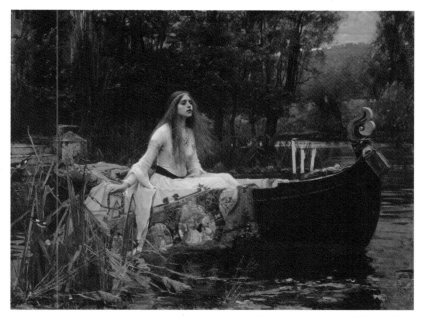

Waterhouse, John William, 1888
Tate Britain, London, England
Photo: Tate, London / Art Resource, NY

In 2009 I saw an exhibition of works by John William Waterhouse. At first the pictures were shocking in their dazzle and whiteness. White as pure white could be, Walt Disney Snow White, the paintings all drama and sparkle. The reproductions couldn't capture the tone or luminosity of the white or gold.

But while the paintings are at first arresting, the initial drama passes and a viewer sees talent but not genius.

His picture *The Lady of Shalott* has, over the years, been the most popular painting in the Tate. I'm not sure if most of the viewers have read Tennyson's poem on which it is based so the picture attracts because of its vamp luminosity, lush colours, and melodrama.

The Lady of Shalott is cursed by love and is only allowed to view the world in a mirror, but — you guessed it — she can't resist looking

at Sir Lancelot of Camelot. Whamo! The mirror breaks and she ends life floating down the river to Camelot singing her last song.

Here, in part, is how Tennyson tells the story:

The Lady of Shalott

> … She has heard a whisper say,
> A curse is on her if she stay
> > To look down to Camelot.
> She knows not what the curse may be,
> … She saw the helmet and the plume,
> > She look'd down to Camelot.
> Out flew the web and floated wide;
> The mirror crack'd from side to side;
> The curse is come and upon me!' cried
> > The Lady of Shalott
> … Lying, robed in snowy white
> That loosely flew to left and right –
> The leaves upon her falling light –
> Thro' the noises of the night
> > She floated down to Camelot:
> And as the boat-head wound along
> The willowy hills and fields among,
> They heard here singing her last song,
> > The Lady of Shalott.
> Heard a carol, mournful, holy,
> Chanted loudly, chanted lowly,
> Till her blood was frozen slowly,
> And her eyes were darken'd wholly,
> > Turn'd to tower'd Camelot;
> For ere she readh'd upon the tide
> The first house by the water-side,
> Singing in her song she died,
> > The Lady of Shalott.

13. Nocturne in Blue and Gold: Old Battersea Bridge

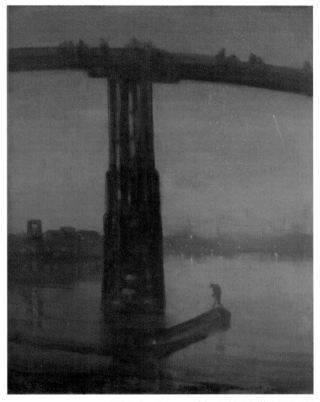

Whistler, James Abbott McNeill, 1872–75
Tate Britain, London, England
Photo: Tate, London / Art Resource, NY

Whistler thought artists should paint subjects just how they appeared to the artist. There was no need to have a dominant theme of religion or patriotism. Whistler described it as "Art for Art's Sake." He called his paintings "harmonies," "arrangements," "nocturnes," and "symphonies." This created consternation. Whistler diluted his oil paints and prepared the canvas by staining it, bringing the work closer to a watercolour. His *Cremorne Gardens* foretold modern drip painting and action painting.

The *Tate Britain Companion to British Art* by Richard Humphreys[3] says this of this faded green grey night silhouette over the Thames, the site of ceremonies and suicides, above a meteor:

> Mixing his paints with a runny mixture of copal, tur-
> pentine and linseed oil, he would brush and pour the
> "soup," kept in little pots, in layers onto an absorbent,
> rough-grained canvas, primed a dark rusty red, and often
> laid on the floor or a table. The paint was applied in
> such a way, frequently rubbed down, that this priming
> would show through the thin glazes, in the form, for
> instance, of the main structure of the bridge. The effect
> of bursting fireworks would be achieved by delicately
> flicking paint at the surface.

This painting became an issue in the libel lawsuit of Whistler v. Ruskin, which came to trial on November 15, 1878. The suit was precipitated by Ruskin's remarks about Whistler's works shown in an exhibition of contemporary artists organized by Sir Coutts Lindsay in Grosvenor Gallery in London in the summer of 1877. There is not an actual complete transcript of this one-day trial but Whistler created a rendition of the evidence in his *The Gentle Art of Making Enemies* (1890).[4] It makes riveting reading. Whistler was cross-examined about the *Nocturne in Blue and Gold* and aggressively criticized. Here's how the cross-examination proceeded:

> "What was the subject of the nocturne in blue and
> silver…?"
>
> "A moonlight effect on the river near old Battersea
> Bridge."
>
> The picture called the nocturne in blue and silver,
> was now produced in Court.
>
> "… It represents Battersea Bridge by moonlight."
>
> [Judge] Baron Huddleston: "Which part of the pic-
> ture is the bridge?" (Laughter.)
>
> His Lordship earnestly rebuked those who laughed.

And Whistler explained to his Lordship the composition of the picture.

"Do you say that this is a correct representation of Battersea Bridge?"

"I did not intend it to be a 'correct' portrait of the bridge. It is only a moonlight scene and the pier in the centre of the picture may not be like the piers at Battersea Bridge as you know them in broad daylight. As to what the picture represents that depends upon who looks at it. To some persons it may represent all that is intended; to others it may represent nothing."

"The prevailing colour is blue?"

"Perhaps."

"Are those figures on the top of the bridge intended for people?"

"They are just what you like."

"Is that a barge beneath?"

"Yes. I am very much encouraged at your perceiving that. My whole scheme was only to bring about a certain harmony of colour."

"What is that gold-coloured mark on the right of the picture like a cascade?"

"The 'cascade of gold' is a firework."

The case was ultimately decided in Whistler's favour, and he was awarded damages of one farthing.

The result was a disaster for both. Whistler had large legal bills (£500) and was forced to sell his beautiful house to a buyer whom he despised. He ended up in Paris where he was in demand for his portraits. When he died in 1903 his nocturnes were regarded with contempt. When the Battersea Bridge painting was sold at a Christie's auction in 1886 it was hissed. Ruskin resigned as Slade Professor of Art at Oxford because of the judgment.

It was hard for the public to understand that Whistler considered style and subject to be one and the same. For example, the actual view

of the piece he was painting did not matter — it was his "take" of the view that mattered. In the long run Whistler's approach became the central plank of twentieth-century painting.

The painting primarily at issue in the trial was another of Whistler's "nocturnes," generally referred to as *The Falling Rocket*. Oscar Wilde, cheeky as ever, once opined that that work was "worth looking at for about as long as one looks at a real rocket, that is, for somewhat less than a quarter of a minute." But Whistler could rival Wilde in quips. An admirer flattered him, saying that there were only two great painters, Velázquez and Whistler. He replied, "Why drag in Velázquez?"

14. Lac d'Annecy

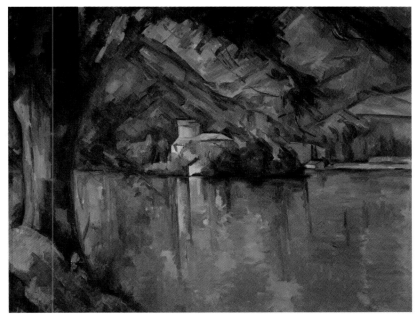

Cézanne, Paul, 1896
Courtauld Gallery, London, England
Photo: Erich Lessing / Art Resource, NY

Cézanne is work. It is somewhat akin to coming to terms with Wagner's music: it takes discipline and an ability to really observe. If you look at fifteen Cézannes in a row without careful preselection, you will literally blow your eyes.

He died in 1906, a reclusive master who had independent wealth. A year after his death there was a huge show of his work, later one in New York. Artists gravitated towards his paintings. Why?

Well, he led art from being a platform for the big idea to colour itself being the architecture of each painting.

In a letter Cézanne said, "Deal with nature as cylinders, spheres and cones, all placed in perspective so that each aspect of an object or plane goes towards a central point." Reds, yellows, and blues would produce "vibrations of light."

Cézanne was universally accepted as a valued artist. A Dutchman bought only Cézannes. His family thought this was so eccentric they persuaded a court to declare him insane because he was frittering away his fortune. He died in an asylum. The story of the art dealer Ambroise Vollard has a happier ending. He bought 250 paintings from Cézanne in the fifty-franc range. Later he sold them for ten to fifteen thousand francs each. Cézanne brought him vast wealth.

Cézanne inherited money when his father died in 1886. At all times he was quirky, eccentric, shy, and subject to moods. In the early days he was scorned and rejected. At the end he was immensely successful and artists such as Degas, Monet, Gauguin, Pissarro, Renoir, Matisse, and Signac had bought his paintings.

But in this process all was struggle. He was a loner, suspicious, driven — characteristics that made a bad brew of a personality. In 1866 he wrote to Camille Pissarro that he was in conflict with his family, "the most disgusting beings in the world, ... crappier than anybody." Thirty years later Pissarro noted that "this poor Cézanne is furious with all of us, even with Monet, who on balance has been quite kind to him." One time he refused to shake hands with Manet, saying, "I won't give you my hand, Monsieur Manet, I haven't washed for eight days."[5]

In a room full of Cézannes I stand quiet, alone, with landscapes, card players, pipe smokers, apples, peas, pictures of a cup with figurines. The room is a snapshot of Cézanne's scope and some of his darker works.

Lac d'Annecy is one of my early favourites. When I visited the Cézanne show in Philadelphia in 1996, the director of the exhibition said of this painting, "Ppphhhttt, just painting by numbers, but you must see his gorgeous red pine [in St. Petersburg]." The red pine (see Chapter 8) is striking but this is a triumph. Was ever a lake more blue yet not blue, icy cold yet merely refreshing? Were ever siding hills, slabs of red with black, blue, and green more a companion of water?

The tree on the left frames the vision.

In 1896 Cézanne wrote, "Life for me is beginning to be of sepulchre monotony ... to relieve my boredom I paint; it is not much fun."

15. Bar at the Folies-Bergère

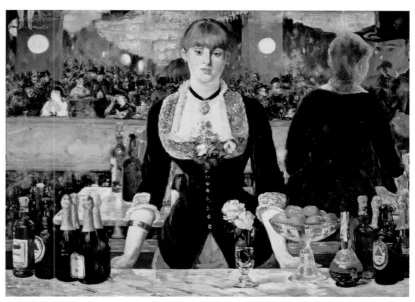

Manet, Édouard, 1882
Courtauld Gallery, London, England
Photo: bpk, Berlin / Cortauld Gallery, London / Lutz Braun / Art Resource, NY

Édouard Manet is the central artist in the Musée d'Orsay in Paris (see Chapter 2). His style, intimacy tempered with a sense of withdrawal, was very influential in the late nineteenth century.

This is Manet's last major painting. The waitress behind the bar in front of the mirror. Is she melancholic? Overwhelmed? Alluring? Dazed? Or simply bored and tired? The role of the mirror was criticized at the time, in 1882. The reflections did not correspond to bottles on the bar. So what?

All the glittering colours of a bar, the mirror, a reflection of noise, enjoyment, and a certain weary vacuity in the barmaid.

Neil McGregor, the editor of *Burlington Magazine*, wrote in 1985, "Loneliness, noise and light and abundance and emptiness."

16. George IV

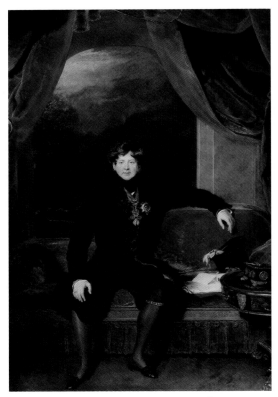

Lawrence, Thomas, 1822
Wallace Collection, London, England

At the end of the Wallace Collection's Great Gallery there is a vibrant perky portrait by Thomas Lawrence of George IV, who became king of England in 1820.

George IV, one of Mad King George III's fifteen children, lived from 1762 to 1830. He could speak French, German, and Italian fluently and was well versed in music and the arts. He was a good friend of the legendary parliamentarian Charles James Fox, the magnificent playwright Richard Sheridan, and Beau Brummell, the legendary arbiter of social customs and cravats.

George's tutor, according to the eleventh edition of the *Encyclopae-dia Britannica*, said when he was but fifteen, "Either he will be the most polished gentleman or the most accomplished blackguard in Europe." The *Encyclopaedia* concluded, "The latter prediction was only too fully justified."

George IV married Caroline, a German princess. Horrified at the mere sight of her he remained drunk for twenty-four hours after the service. He gave her a letter saying she didn't have any "conjugal duties." She was angry, went to the Continent, and vowed to return for her vengeance when he became king.

In 1820, after George III's death, Caroline returned and roused support from the Radicals. She wrote the London press recounting her soap opera woes. George insisted that a House of Lords commit-tee be set up to find she had been guilty of adultery. The attorney general produced dubious Italian witnesses with dramas of keyholes and sexual gestures.

Lord Brougham represented Queen Caroline and referred to George's obesity (this is in 1820, two years before the painting; contrary to the painting he was very, very fat). Brougham (now here's courage!) attacked the king himself, by paraphrasing *Paradise Lost:*

> The other shape —
> If shape it could be called — that shape had none
> Distinguishable in member, joint or limb;
> Or substance might be called that shadow seemed,
> For each seemed either …
> What seemed its head
> The likeness of a kingly crown had on.

All this inflammatory proceeding was dropped by the House of Com-mons. The London mob rioted in joy to support Caroline. Despite all the fuss, George IV was crowned in July 1821. Queen Caroline wanted to attend but didn't have a ticket to enter Westminster Abbey. The London public hissed as the unpopular George and his guests passed by.

Lawrence, a romantic painter, triumphed as a society portraitist.

His father was a broke tavern-keeper so Lawrence had little education, yet he was a child prodigy.

Well, this picture is the most captivating, bubbly portrait. Obviously Lawrence prettied up his paying subjects, as did Van Dyck.

Becky Sharp in Thackeray's *Vanity Fair* (1848) describes the portrait as "the famous one … in a frock coat with a fur collar, and breeches and silk stockings, simpering on a sofa from under his curly brown wig."

17. Self–Portrait with Two Circles

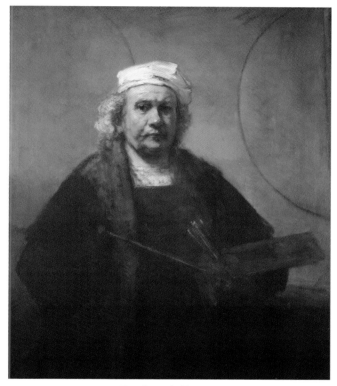

Rembrandt Harmensz van Rijn, c. 1665–69
Kenwood House, London, England
Photo: Album / English Heritage / Art Resource, NY

Done in the last four years of life, this self-portrait presents the artist with brushes and palette but no hands. His eyes show hurt, surprise: "Let's hurry on, if I must paint so be it." The jaw and mouth still have resolve, plenty of it. His third last self-portrait; all his struggles are in the past.

The telltale recurring theme, a dash of red on his drinker's nose, is here more than a dash, a splatter. He has gashed a deep facial wrinkle through his heavy paints with the handle of his brush.

Rembrandt was difficult, prickly, vain, and even abusive. Self-portraits of his old age, if accurate, didn't soften. They bring to mind

Michel de Montaigne's pensée, "I give my soul now one face, now another, according to which direction I turn it. If I speak of myself in different ways, that is because I look at myself in different ways. All contradictions may be found in me."

Rembrandt's genius is in persuading you that his self-portrait is a mirror to his soul, presented without guile or conceit.

18. Adoration of the Magi

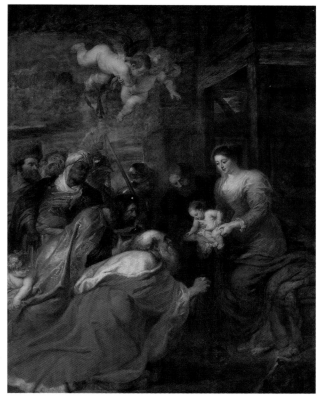

Rubens, Peter Paul, 1633–34
King's College, Cambridge, England
Photo: By kind permission of the Provost and Scholars of King's College, Cambridge

The ordinary gallery is uniform and it is rare that a painting is positioned with a dramatic separate focus. But some art is enhanced by its setting.

Rubens is one of the great masters, no matter how you count. No one should miss his two vast canvases at the end of the cathedral in Antwerp. In King's College Chapel, Cambridge, his *Adoration of the Magi* is the cherry on the sundae.

You must, you *must*, attend evensong at King's College. You line up for thirty minutes, then you're in. Proceed under a single vault of

custard cream colour of tracery fanning the ceiling. After you reach your chair, look up and see the eight fans of scallop shells on each side, a tracery with patterns of gossamer stone. This wavy magic was finished in 1515. Above is the Tudor rose joining the tracery web. (You can see this on a virtual tour at www.kings.cam.ac.uk.) Sit close to the choir. In they come, some so young that you groan at the wonder of it.

You sit in oak stalls carved in and around the time of Anne Boleyn's death in 1536. Her emblem, the falcon, is on the ceiling of the screen in the dark.

The choir sings. Evensong is a lark in the clear air. So delicate as to escape retention. As gossamer as the vault ceiling.

Stained glass windows, some as early as 1517, fill the bays.

The choir, with an extended breath in prayer, a solo ... the love of our Saayviourrr *Jesus Chrrrist*!

At the end is a tall, broad stained glass window of the Crucifixion (created between 1517 and 1547), and under it Rubens's *Adoration of the Magi,* painted in only eight days for a visit by a queen.

The painting, so lively, with a swirling energy, is not crushed by the window — it competes and blasts the Crucifixion scene from sight.

The black Magus, a Berber warrior with gold, a swashbuckler from a Delacroix action picture. The Christ child chubby, energy, a handful. The Magus at the base in a red robe, as red as Titian ever did red, is part of the swirl of force. Up, up, through the Christ child, through the beams of the barn, through the two floating putti, then down to the black Magus, down, down to the force of red, an electric circle. All the Magi and retainers are solicitous to the child. A concentrated solicitation to a bubbly infant, with Mother squeezing the little thigh.

As you watch this in awe the choir has slipped into a German hymn by Bach ("Komm, Jesu komm!" BWV 229). Oh, you have to be there.

19. Hunters in a Wood

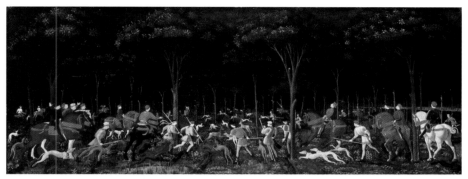

Uccello, Paolo, c. 1470
Ashmolean Museum, Oxford, England
Photo: Erich Lessing / Art Resource, NY

I have travelled to Oxford to see this painting. Was it worth it? Yes.

The guidebooks talk about Uccello being obsessed with rendering perspective by creating a focal point in the deep middle of the painting and vanishing point lines emanating as a straightened spiderweb. There is a stag far off, nearly invisible.

I see it as the perfect rendition of a dream which, although a dark one, is relaxing. There are vibrant colours of shocking red doublets at the edge of a dark, deep forest; the hunters on horses with bridles, saddle straps, with patterns of flags, bright red in the front, duller red in the bowels of the forest; a pageant charging into the night. The riders are hallooing, yet they are silent, a distant opera. This Uccello is smaller and more slender than his great *San Romano Battle* canvases in London, Paris, and Florence.

The visual delight is the panorama of trees (forty-five in all), umbrellas capturing the dark night, sheltering pools of black. Perhaps a forest is the most comforting of dream scenes, no sound, stillness, and fresh leaves. Little orange oak leaves plopped on top of the umbrella fan of branches create a dim twinkle. They lift the trees and lift your vision. Ah, the beginning trap of a dream.

20. The Taking of Christ

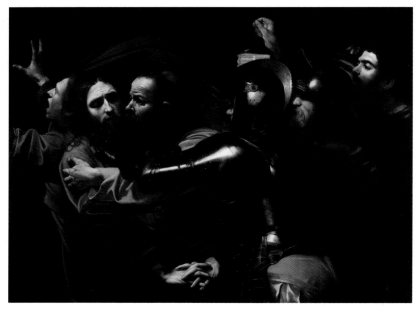

Caravaggio, Michelangelo Merisi da, 1602
National Gallery, Dublin, Ireland
Photo: © National Gallery of Ireland. Courtesy of the Jesuit Community, Leeson St. Dublin,
who acknowledge the kind generosity of the late Dr. Marie Lea-Wilson

This colourful Caravaggio of Judas kissing Jesus enveloped in the dark armour of the arresting soldier is a startling combination of glossy black, searing white, and coral red. At the back Caravaggio himself holds the lantern which creates the stage show. This is all theatre, and Caravaggio with his nearly acrylic sharp colours could produce a riveting show with the suspension of the moment.

Alan Bennett's observations on the role of Judas in art generally, and particularly in this picture, are, as ever, interesting. He says in *Untold Stories*:[6]

> In paintings [Judas is] generally presented as ... a stage villain ... Here Judas doesn't seem to me much of a villain at all; he seems genuinely puzzled and can't look Christ in the face. I certainly don't see much villainy

there, what's happening to him as terrible as what's happening to Christ, who's quite passive and, because he's looking down, almost abstracted from the scene.

Jonathan Harr's book *The Lost Painting* traces how the painting was identified in 1793 as the work of another artist, though at the time of its creation it was attributed to Caravaggio and owned by a Roman family of immense wealth. In 1802 the painting, attributed to a Dutch artist, was sold to a Scotsman. The Scottish family sold it at an Edinburgh auction in 1921 for perhaps eight guineas. The buyer gave it to the St. Ignatius Residence for Roman Catholic priests. In August 1990 the rector wished to have some of his paintings, which were known as "some dark copies of old masters," evaluated by the National Gallery of Dublin.

An Italian restorer of art saw a large painting in an ornate gilt frame. Harr describes his first viewing:

> It was dark, the entire surface obscured by a film of dust, grease, and soot. The varnish had turned a yellowish brown, giving the flesh tones in the faces and hands a tobacco-like hue. The robe worn by Christ had turned the colour of dead leaves, although Benadetti's [the restorer] eye told him that beneath the dirt and varnish it was probably coral red. He judged that it had not been cleaned or refined in more than a century.[7]

Benedetti and the gallery took the painting for cleaning. For months throughout the slow process of cleaning, other evidence of the painting's provenance and misattributions was carefully documented. The gallery officials concluded it was a Caravaggio but they had to be sure. A year passed.

Finally, in March 1992, the gallery was sure: the vanished Caravaggio had returned.

A discovery of a lost masterpiece in today's world is a rarity. Add to this the sheer electricity of the painting: attack, stealth, resignation, horror, duplicity, treachery, and a sparkling theatre stage.

National Gallery, London

Trafalgar Square, London, England, WC2N 5DN
Telephone: +44 (0)20 7747 2885
Web: www.nationalgallery.org.uk

Beyond the nine paintings I've introduced, the National Gallery has many more delights to discover. Go to the Sainsbury Wing entrance on the left as you face the gallery, and use the building's floor plan that is supplied at the desk. In addition to the ones included in my list of favourites, check out the following:

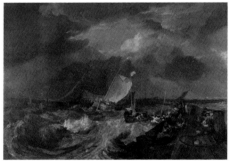

Calais Pier, with French Poissards Preparing for Sea: An English Packet Arriving
Turner, Joseph Mallord William, 1803
Photo: © National Gallery, London / Art Resource, NY

Turner was only thirty at the time of this work (also known as *The British Packet*), which shows water furiously battering the pier, with fishermen's families huddled under the wall, scrabbling for their catch. As the British packet steams uncertainly in, full of people looking wet and frightened, the French boats rush out with life-saving speed.

This is the best portrayal of the force of weather and the sea that I can imagine. Perhaps it is my favourite on my January 2005 visit — a big surprise to me.

Not everyone agreed with me. Some critics attacked the painting. One described its method as "brush broom with white wash."

Another said, "To speak of these as pictures would be an abuse of language."

Luca Giordano (1634–1705) — who was known as Luca Fa Presto because he painted so fast — painted this fine example of the grotesque in 1680. Why were such paintings so popular in the seventeenth century?

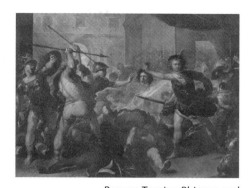

Perseus Turning Phineas and His Followers into Stone
Giordano, Luca, c. early 1680s
Photo: © National Gallery, London / Art Resource, NY

The myth is this. Andromeda was chained to a rock in the sea. Of course a sea monster was about to eat her in one big gulp. Perseus was flying about on Pegasus, his winged horse, and saw this "situation." He rescued her. She was engaged to be married to Phineas, but she switched to Perseus. Why not? Their wedding feast had begun, and Phineas, really pissed, burst in, intending to swipe Andromeda back and kill Perseus. Earlier on Perseus had slain Medusa, an evil winged creature with writhing snakes for hair, whose very look turned men to stone. Thinking quickly, Perseus grabbed Medusa's severed head from a bag he carried and flashed it at Phineas and his followers, turning them to stone.

It is a brawling canvas, tables upset, guests fleeing, bloody corpses just fallen, swords raised, and Medusa's open-mouthed head swinging like a lantern.

A wonderfully bloody opus, the good guys winning with comic-book bravado. And the colours are striking — warm flesh tones replaced by icy grey washing over the stricken and dying.

I loved it, laughed at it, revelled in it sitting down on a comfortable leather couch with no one else in the room.

Most reproductions of this painting seem sort of cardboard with cut-out figures to me. But the actual painting gobsmacks you. The gallery has on its audio guide a talk of the religious significance of the baptism of Jesus by John. The stillness conveyed in the scene is important, as

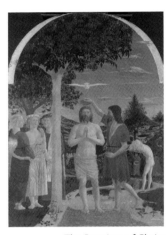

The Baptism of Christ
Piero della Francesca, c. 1450s
Photo: ©National Gallery, London /
Art Resource, NY

is the ambivalent substantiality of the three angels next to Christ — solid yet not solid. This painting, done in egg tempera on a poplar panel, seems to capture a millisecond, the time required for a camera shutter's click. A shaft is penetrating Christ — he in solitude, all reflection, with St. John tiptoeing by his side. In this stupendously significant moment you can see Christ recognizing the profundity and consequence of baptism as a direct communion with God. This sentiment is accentuated by Piero's peculiar ability to portray atmosphere — merely light, yet with him light becomes a medium.

Here is a central moment in the Christian religion, Christ stock-still, mind upward and elsewhere (how can an artist portray this, pray tell?) — the dove above. Yet the painting is all diversion. The pool at Christ's feet a river, to the side three rather suspicious angels squinting at the near-naked Christ, and in the background an unknown man stripping in mid-bend. What on earth is this about? All just a grand design, but certainly not conventional, even to this day. All in an "atmosphere" of eternity. No other artist, except Rembrandt, could capture such a moment.

Turner's seascape *Ulysses Deriding Polyphemus* (three masted ships midst setting sun and fiery elements) drew this from the *Morning Herald*:

> This is a picture in which truth, nature and feeling are sacrificed to melodramatic effect ... In fact, it may be taken as a specimen of colouring run mad — positive

vermilion — positive indigo; and all the most of glaring
tints of green, yellow and purple contend for mastery.

Perhaps the picture is an enigma. You search for Ulysses, and above
him in the traumatic sky perhaps a shape of the wounded Cyclops
nailed in the eye with a burning stake. Before Ulysses' ship, Nereids
preceded by flying fish, and off in the sun the horses of Aurora, the
Goddess of dawn.

Never mind the "plot." This, the
English version of Caravaggio high
theatre, trumpets a battle of molten
colours. The work with its fizz, spar-
kle, play of sharp edges where the
sails cut into darkness, man triumph-
ing over the power of the mytho-
logical forces. Mystery and bravura
combined.

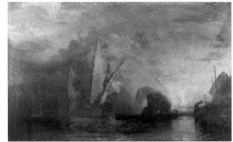

Ulysses Deriding Polyphemus —
Homer's Odyssey
Turner, Joseph Mallord William, 1829
Photo: © National Gallery, London / Art Resource, NY

Tate Britain, London

Millbank, London, England, SWIP 4RG
Telephone: +44 (0)20 7887 8888
Web: www.tate.org.uk

As noted earlier, Tate Britain has an extensive and varied collection,
especially of British art. All the English painters are here. Other than
Constable, Turner, and Hogarth, they are not my personal cup of tea.
Still, I have found much to admire at the Tate, including these two
paintings in addition to the ones featured:

O The Roast Beef of Old England
(The Gate of Calais)
Hogarth, William, 1748
Photo: Tate, London / Art Resource, NY

This appeals to my British roots. My mother, very English, daughter of a British Rear Admiral, loved roast beef and Yorkshire pudding. Like many Brits she had reservations about the French. This saucy painting sums up the British attitude to the French, happily hostile, much superior (although Lord knows if anyone could be *superior*, it is the French, *tant pis!*) — and it is a huge slab of beef.

Hogarth visited Calais in 1748 with his sketchbook. It was a rare time of peace between France and England. While waiting for the boat back to England he decided to sketch the post and drawbridge which still had the English arms as it was a captured port from 1346 until 1558. He was arrested by the French but persuaded his captors that he was but an artist. However, he was held in the Lion d'Or awaiting the change of wind and a boat to London. He was very angry at this, and it reinforced his dislike of the French.

So Hogarth's revenge was in the painting.

The servant barely carries a huge side of beef grained with tasty fat — my mouth waters at the mere look of it. The cloth bears the inscription "For Madam Grandsire at Calais." Grandsire was the landlord of Lion d'Argent, the inn at Calais frequented by the English. The succulent beef was to be eaten by the English.

The French soldiers, dressed in rags, slopping watery soup, look with disbelief at the succulent British beef. The fat French friar represents Hogarth's take on the prerevolutionary French church, which paid little tax and followed its own selfish agenda — this friar may get a bite of the beef.

In the far back through the archway people kneel before the host. The Holy Ghost is on a pub sign with a monk presiding.

The figure in the right foreground is a Highlander, an exile from the Jacobite uprising of 1745. Bonnie Prince Charlie led the Jacobites

who wished the restoration of the Stuarts and the Roman Catholic religion. Strange as it may seem, Bonnie Prince Charlie, a descendant of the man who would have been James III, was not a romantic figure, not at all. He was an out-of-control drunk, raised as an exile in Rome.

Hogarth didn't like the Jacobites, or the Highlanders who supported Bonnie Prince Charlie and followed him into England as far as Derby before retreating, ultimately to be slaughtered at Culloden. The Highlanders wore their clan tartans. Charlie escaped.

Here in the picture is a Highlander exile slumped against the wall, with a raw onion and a crust of bread. Hogarth wrote, "The melancholy and miserable Highlander, browsing on his scanty fare, consisting of a bit of bread and an onion, is intended for one of the many that fled this country after the rebellion in 1745." The food forms a snail shape, which the British thought was the same as frogs' legs, a regular part of French food.

Off to the left side is a portrait of Hogarth with his sketchbook. A soldier's hand is on his shoulder and the tip of the halberd is above him — the moment of arrest. A sort of Alfred Hitchcock intrusion.

Hogarth is most famous for his satires on morals and manners of the time. The Soane Museum at Lincoln's Inn Fields in London houses his original eight paintings of *The Rake's Progress* (1732–33). They portray the decline and fall of Tom Rakewell, spendthrift son of a rich man who comes to London, has a riotous time (drink, gambling, prostitution), and ends in the Fleet Prison, then Bedlam. This was a scathing commentary on the wicked ways of London. His *Marriage-à-la-mode* series, six paintings satirizing upper-class eighteenth-century society, is in the National Gallery.

The theme of resurrection is a medieval one, in terms of art presentation. Souls rising, being reclaimed. All of Christianity properly followed promised resurrection, a life everlasting. The spooky bodies of Signorelli in Orvieto express it, green shaded, slipping, nude from holes, standing in a trance, insects emerging from their chrysalides.

How would you show resurrection today? Strange, I hadn't thought of it. Well Stanley Spencer did. He was an odd duck, an eccentric Englishman who served in the First World War as a stretcher bearer. He saw his home town of Cookham as paradise. The local churchyard becomes the place of resurrection. Christ is enthroned on the church porch cradling three babies with God standing behind. Spencer introduces his friends and family, especially his fiancée, Hilda Carline.

The Resurrection at Cookham
Spencer, Stanley, 1924–27
Photo: © Estate of Stanley Spencer / SODRAC (2013).
Tate, London / Art Resource, NY

Spencer had recently enjoyed sex, apparently a novelty, and he was ecstatic. It became a revelation to him, orgasm maybe even a divine delight.

This was his view of resurrection: "In this life we experience a kind of resurrection when we arrive at a state of awareness, a state of being in 'love.'"

Stretched out along the side of the church are the prophets, Moses leading the lineup, the Africans close to Jesus maybe making whoopee. Spencer stands naked in a sort of Michelangelo David pose, his brother-in-law crouched in a Michelangelo ignudo form.

The girl rising amidst daisies is a take on Millais's *Ophelia*. Spencer's patron, a judge, rises in his robes before Spencer.

Hilda, the fiancée, lies sleeping, a princess in a nest of ivy waiting to be called to life with a kiss, recalling the sleeping beauty in Edward Burne-Jones's famous Pre-Raphaelite painting *The Rose Bower*). Hilda is also seen climbing over the stile to reach the boat so she can join the pleasure seekers going to heaven on the riverboat.

The painting has a weavy underwater magic.

You must see Spencer's *Resurrection of the Soldiers* and murals dedicated to the Great War in Sandham Memorial Chapel at Burghclere, near Newbury, Hampshire. See www.nationaltrust.org.uk/sandham-memorial-chapel for times of entry.

Queen's Royal Gallery, London

Buckingham Palace, London, England, SW1A 1AA
Telephone: +44 (0) 20 7766 7300
Web: www.royalcollection.org.uk

Her Majesty's collection is vast, and in my time I've seen Vermeers, Van Dycks, and Bruegels to weep for. But the collection rotates. So look up www.royalcollection.org.uk to see what's on.

Courtauld Gallery, London

Somerset House, Strand, London, England, WC2R 0RN
Telephone: +44 (0)20 7872 0220
Web: www.courtauld.ac.uk

The Courtauld is a small, intimate gallery. Cézanne's *Lac d'Annecy* and Manet's *Bar at the Folies-Bergère* have already been noted. Also worth seeing:

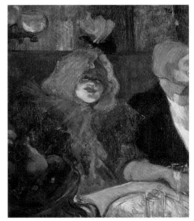

Toulouse-Lautrec was an aristocrat by birth and a bohemian artist who painted cafés and brothels, bringing a dignity to the scenes. Here is a picture of a blowsy, garish, painted prostitute, up close and wheezing cigarette smoke and sweet perfume.

This is Lucy Jourdain, giggling over her champagne with a companion partially in sight in a private room, which was a place of assignation after a masked ball. The smeared lips, flousied hair, the red banquette all symbolize Parisian theatrical sex.

Tête-à-Tête Supper
Toulouse-Lautrec, Henri de, 1899
Photo: © The Samuel Courtauld Trust,
The Courtauld Gallery, London

At the time Toulouse-Lautrec observed, "Everywhere and always ugliness has its beautiful aspects: it is thrilling to discover them where no one has noticed them before."

Whhooosh!

Wallace Collection, London

Hertford House, Manchester Square, London, England, W1U 3BN
Telephone: +44 (0)20 7563 9500
Web: www.wallacecollection.org

Start in the Great Gallery, which contains Lawrence's *George IV*, described earlier, and some other notable works. Years ago Conrad Black held a dinner in the Great Gallery. My table at one end faced Titian's *Perseus and Andromeda*. I was mesmerized by the painting and sat alone at my table during cocktails held elsewhere, to have the privilege of hobnobbing alone with Titian. But when I came again twelve years later, Andromeda seemed a huge, doughy, strapping teenager, Perseus fell dizzily, and the monster was a prickly form. At best a flawed painting, and not on my bucket list.

The Oval Drawing Room and East Galleries are also worth a visit. Each contains a painting of special interest.

The Swing
Fragonard, Jean-Honoré, 1767
Photo: By kind permission of the Trustees of the
Wallace Collection, London / Art Resource, NY

Fragonard's *The Swing*, in the Oval Drawing Room, is his most famous painting. If you ask what rococo painting was about — this is it.

The woman glides above her elderly husband and thirsting lover. The fanned trees hover over the erotic elusiveness of it all.

2

FRANCE

Exploring the museums of France requires a bit of a juggling act. You must exercise discipline and not get drawn into the seemingly endless collections of paintings so that you have the time and focus to really *see* the truly great ones. You also must plan carefully to avoid the punishing lineups and lengthy waits. And, at the same time, you must ensure that you make the time to take in the stunning interiors and exteriors of the galleries and their surroundings.

The **Louvre** is an architectural treasure. It was built in the twelfth century as a fortress to protect the western edge of Paris. It was transformed into a royal building in the fourteenth century; however, it took the reign of Louis XIV (1643–1715) to turn it into a sumptuous, treasure-filled royal residence. During the French Revolution, the Louvre was transformed once again — this time into a public museum that had, at its core, the deposed royal collection. Napoleon's military conquests then added to the collection.

In the courtyard of the Louvre, enclosed by traditional public architecture, there is a glass pyramid over the main entrance. This was created by I.M. Pei in 1988. The Pyramid creates a sense of vitality and livens up the elegant yet staid architecture around it.[1]

The **Musée d'Orsay**, which is across from the Jardin des Tuileries, is architecturally so remarkable that the paintings it holds almost pale when compared to the building itself. Built as a train station to accommodate traffic for the 1900 world's fair, it served as the terminus of the southwestern French railway network until 1939. After 1939, with

the arrival of newer, longer trains that needed longer platforms than the building could accommodate, the station began to serve only the suburbs. Transformed into a museum in 1968, this building — which was once filled with engines — now houses the world's largest collection of impressionist and post-impressionist masterpieces.

For a truly special viewing experience, the **Musée de l'Orangerie** cannot be beat. Soft benches and uniquely shaped rooms combine to give visitors a sense of sitting directly in the midst of Monet's *Water Lilies*.

Whether larger (such as the Louvre) or smaller (such as the **Jacquemart-André**), the museums of Paris are well worth the balancing act they require.

21. Death of the Virgin

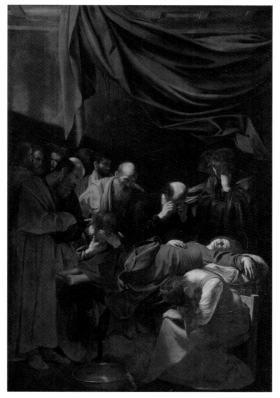

Caravaggio, Michelangelo Merisi da, 1605
Louvre, Paris
Photo: Erich Lessing / Art Resource, NY

This painting is just before a large marble urn in the middle of the long hall of the Grande Galerie in the Denon wing of the Louvre, on the right.

I deal with Caravaggio's life in Chapter 4. Caravaggio was the master

of shock. That was his trade. He used models from the street. The model for this Virgin was most probably a prostitute. The Carmelites, who commissioned this, were not happy and refused the painting because the Virgin's model was a courtesan and the picture was "compromised by its lasciviousness and lack of decorum."

Today you might think we are used to this. But maybe not so. According to a 2003 guide put out by the Louvre, Centre Pompidou, and Musée d'Orsay,[2]

> According to Catholic tradition, the Mother of God does not suffer death: she falls asleep and is borne to heaven to be crowned by her risen Son. The wretched model Caravaggio employed, her face bloated as if she'd drowned, has visibly experienced physical death; this time it is the tears of the apostles that are sacrilegious. Will the miracle take place? Is this a sacred scene at all?

Whew!

The hand of the Virgin on her distended belly, at rest at last. Her face is tired; it has seen much of a gritty life. The nape of the weeping woman's neck (in front) as she hunches over is a naked sight, almost erotic. The Virgin's feet are spread in an inelegant pose with swollen ankles.

The red curtain above seems to put a lid over the boiling pot of grief. This is a portrait of actual death and immediate shock.

22. Baldassare Castiglione

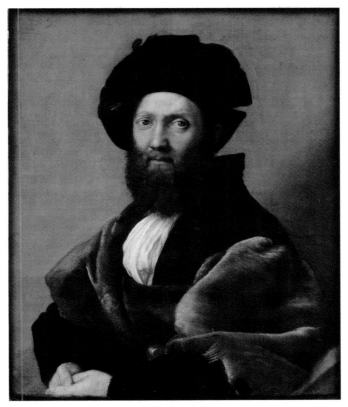

Raphael (Raffaello Sanzio), c. 1514–15
Louvre, Paris
Photo: © RMN-Grand Palais / Art Resource, NY

In *The Book of the Courtier*, his book on diplomacy, Castiglione says,

> When the courtier is at a skirmish, or an assault, or a
> land battle or engaged in other such undertakings, he
> ought to arrange wisely to separate himself from the
> multitude, and undertake the notable and bold feats
> that fall to him with as little company as he can, and in
> the sight of the most noble men in the camp, and espe-
> cially in the presence and (if possible) before the very

eyes of the King or the great man he serves: for it is right
that things well done should be shown.

I see Castiglione in this portrait as shifty-eyed. Sister Wendy Beckett,
the British contemplative and writer and presenter on art, differs with
my take on him, finding him dignified, detached, and just wonderful.

Well, who's right, Wendy or me?

Castiglione was a friend of Raphael. As a diplomat he gave rotten
advice to Pope Clement who had to face Emperor Charles V in 1527.
Castiglione told Clement that Charles V would obey the Pope.
Clement dithered, Florence fell, Rome was trampled.

In 2002 I visited this portrait three times. It is as good as any Titian
ever did.

Back I go in 2010. Am I right about his being "shifty eyed"?

The off grey/brown indeterminate background reinforces an aura
of subtlety. His grey fur cape is ready to touch. His eyes are not intro-
spective (as are Rembrandt's eyes) but aggressive and arresting. You
are stopped by them. They are not nasty or cold like Bellini's *Doge
Loredan* in the London National Gallery. The eyes say to me this mono-
logue: "Careful how you tread, my boy! I've seen all this before and
you better be very careful."

23. Madame Récamier

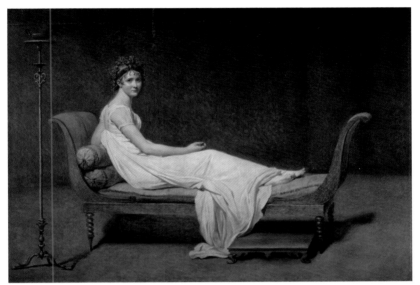

David, Jacques-Louis, 1800
Louvre, Paris
Photo: © RMN-Grand Palais / Art Resource, NY

David, an artistic leader of the Revolution, adapted with ease to the reign of Napoleon. He'd kiss anyone for work. His *Coronation of Napoleon* is an appalling example of sucking up.

But he could paint.

His *Madame Récamier* stops you cold. Commissioned by Madame Récamier in 1800, the picture remained unfinished. It is a precursor to the painting of impressionists. The background is blotchy and builds an atmosphere much like Raphael's grey background in the *Castiglione* portrait.

What kind of mind has she? One for the psychiatrist's couch? Or a mind to rival Jane Austen's? I hope the latter. Wikipedia tells me she was twenty-three when this was done. Her husband, older, was Napoleon's foremost banker. She held soirées for writers. A new society was emerging after the Revolution and she was a reigning queen of it.

24. Liberty Leading the People, July 28, 1830

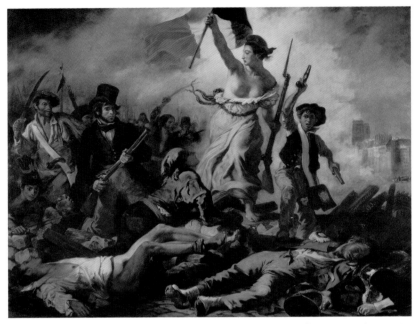

Delacroix, Eugène, 1830
Louvre, Paris
Photo: © RMN-Grand Palais / Art Resource, NY

Delacroix was a giant of French painting, the leader of the Romantic movement, sophisticated. His major rival, Ingres, was all classical with a touch of the erotic, whereas Delacroix was a Tchaikovsky of art, lush violins, blurred horns.

Rumour had it he was Talleyrand's illegitimate son.

Liberty Leading the People is different from Delacroix's other paintings, and to some critics it is a shallow, gaudy work. I love it. The Revolution of July 27 to 29, 1830 (the Three Glorious Days) in Paris rid France of its Bourbon kings who had resurfaced after Napoleon's fall.

The Bourbon King Charles X felt the elected government composed of his enemies was too radical. He believed he alone was obliged to create order and issued ordinances suspending the freedom of the press, dissolving the Chamber of Deputies and reducing its size, and

excluding the commercial bourgeoisie from future elections. This situation — a monarch supposedly restrained by a constitution but in fact pushing a coup d'état — brought about the revolt of the Three Glorious Days.

The people of Paris threw up barricades. Mercenaries deployed by the king advanced through narrow streets to be met with a barrage of furniture, wash tubs, roofing tiles, all hurled from above, culminating in cartons of melons raining on the royal troops. The people captured the city hall, raised the red–white-and-blue flag of the Revolution, and paraded in the boulevards. The royal troops were a bust. The Bourbon king abdicated and the victors picked a replacement king, the Duke of Orleans. Parliament imposed a charter on the new king.

I like this painting because it is the first war poster I've seen, the first pure propaganda clearly set out as propaganda. Oh the smell of the battle!

Liberty's breasts, brazen, power the picture.

The writer and critic Heinrich Heine reported on a conversation overheard when a father tried to explain it to his child:

> Father: "She is a goddess of liberty."
>
> Child: "But Daddy, she does not even wear a chemise!"
>
> Father: "A true goddess of freedom, my dear child, seldom has a chemise and is therefore angry at all the people who wear clean linen."

What Daddy didn't tell the child was that art critics were horrified at Liberty's exhibiting her underarm hair! Classical artists maintained such a goddess had smooth skin all over.

The state bought *Liberty* and bestowed a Legion of Honour on Delacroix, but the painting was not shown publicly until 1855. Perhaps it was considered an incitement to riot. It came to the Louvre in 1874.

Here is a description by Charles Baudelaire from his 1863 book on Delacroix. It reveals a workaholic:

He once said to a young man I know: "If you have not got the knack of making a sketch of a man who has thrown himself out of the window whilst he is falling from the fourth storey to the ground, you will never be able to go in for the big stuff."

25. The Raft of the Medusa

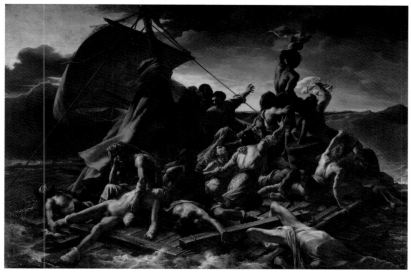

Géricault, Théodore, 1819
Louvre, Paris
Photo: © RMN-Grand Palais / Art Resource, NY

Here in *The Raft of the Medusa,* a colossal canvas five metres high and seven metres wide, the young artist Théodore Géricault portrayed the most shocking political scandal of his day.

A small squadron was ordered to go to Senegal in 1816 to occupy the colony. On June 17, 1816, the *Medusa* left its French port with 400 people aboard. The *Medusa* was considered a swift and modern vessel. It was under the command of an aristocratic former naval lieutenant who had not been to sea for twenty-five years.

July 2 was a clear day, with a calm sea. Through error, the *Medusa* struck shoals off the African coast between the Canaries and Cape Verde — a peril marked on nautical maps.

The captain and the governor of Senegal panicked and ordered the evacuation of the ship. The captain, governor, and officers got into six lifeboats. The remaining 147, including one woman, crowded onto a makeshift raft constructed of planks and rigging twenty metres long and

seven metres wide. It was tied to the lifeboats. Of course the promise was made that it would be towed to land. The castaways were given only a bag of sea-soaked biscuits, two casks of water, and six barrels of *vin ordinaire*. Four officers, one a surgeon, declined space on the lifeboats.

The lifeboats had trouble towing the raft. Soon the boats slipped the tow ropes. They left, reaching sight of Africa by sundown. The raft would have been but thirty-six hours away from shore if the lifeboats had still been towing. On the first night the drinking water went overboard and only wine was left. Fighting broke out over positions on the raft. The edge was submerged under heavy seas.

The men on the raft were the forgotten people of Restoration France: old Napoleonic soldiers parcelled out to the colonies; convicts, hospital attendants, labourers, a twelve-year-old cabin boy — all exposed to a fierce African sun and battering waves that threw people about. That night a pruning process began. Some were swept overboard, some crushed by the shifting timbers of the raft. On the second night there was a storm again, and this time a mutiny by the soldiers, who tried to kill the officers in the centre of the heaving platform. The soldiers guzzled the wine then attacked. The mutineers threw the water and wine into the sea. After this, sixty had been killed or washed out to sea. The survivors had some room, knee-deep in water.

After the first week there were only twenty-eight survivors, thirteen of whom had lost their reason and the ability to survive. They were thrown into the sea. The unfit, including the woman, were jettisoned. The dead bodies were cannibalized. Some instantly devoured parts of dead bodies while others cut the flesh into strips and let them dry in the sun. This was dressed with bits of flying fish. The survivors still had some wine, which lasted for six more days.

During this time they saw birds and butterflies flying overhead. On the morning of July 17 they sighted a sail on the horizon. It was this moment — the moment of deliverance — that Géricault painted. They waved little flags. The ship vanished but then two hours later it appeared again to save the fifteen survivors.

The wreck of the frigate *Medusa* created a great political scandal which the government of the day tried to suppress. Two of the officers

published a book. The captain was sentenced to jail for three years.

Géricault, who was born in 1791 to a wealthy family, met the two officers and found the ship's carpenters, who built him an exact scale model of the raft. He rented a huge studio and, except for trips to hospitals to observe models of pain and anguish, he became a recluse. He received cadavers in his studio, including a guillotined head. He locked himself in, shaved his head, and only left to occasionally study the sea and sky at Le Havre.

A great stage-lit opera of a painting, crashing waves, the grey white ivory of death, the tenors' exclamation of hope, the portrayal of reaching, physically, emotionally, all building to a tiny point off in the grim sea. God, what a rocky ride, set off against despondency and terror. The canvas is very big, with very, very ivory bodies. The black bitumen is blistering. The painting is a shocker.

Some critics attacked it — a slander of the Ministry of Marine. However, an art dealer in London took it to Piccadilly for a show where it was a huge success, earning Géricault 20,000 francs. The English enjoyed the predicament of the French and the cannibalism.

Ingres, an established portrayer of elegant alabaster nudes, said,

> I should like to see removed from the Louvre that picture of the *Medusa* and those two big dragoons ... I should like to have them placed in some corner of the Navy Department. Then they will no longer corrupt the public ... I resent pictures of the dissecting form; they show us man only as a cadaver.

26. Pietà de Villeneuve-lès-Avignon

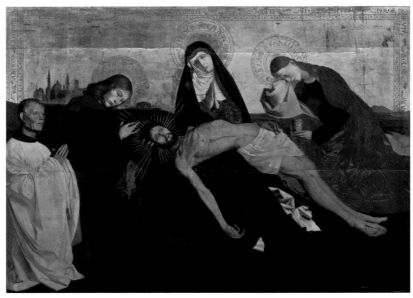

Quarton, Enguerrand, c. 1460
Louvre, Paris
Photo: © RMN-Grand Palais / Art Resource, NY

Why is this so special? It was painted in perhaps 1460, when contemporary art had moved beyond the gold of medieval painting with its halos. At this time Piero della Francesca was painting *The Baptism of Christ* (see Chapter 2), an example of photographic clarity. And it was twenty-five years after Van der Weyden's *Decent from the Cross* (see Chapter 3). The famous playwright Samuel Beckett, a distinguished art student who had applied to the London National Gallery for a job, noted on a visit to the Louvre, "I had forgotten how lovely the Pietà d'Avignon was."

As you look at this, the line of the cracked wood of the panel gives a sense of time and erosion. The old-fashioned gold sets off a cathedral in the far distance and heightens the visionary quality of the picture.

Every time I see it the arch of the back forces me to touch my spine in apprehension of some attack — ooohh it must have hurt!

Up close, Christ's face and collarbone are grey as bleached wood. Blood stripes his forehead, iodine red. The spikes of his halo are played by St. John as a harp. Jesus's collarbone pushes at the stucco grey of his very dead skin.

Mary Magdalene holds a Delft cup — now there's a time jiggle. The priest donor, vacant yet perhaps sensitive, has a drinker's nose, which brings me back to earth.

The incised inscription translates to "O all ye who pass by, look and see my sorrow."

27. Pipe and Drinking Cup

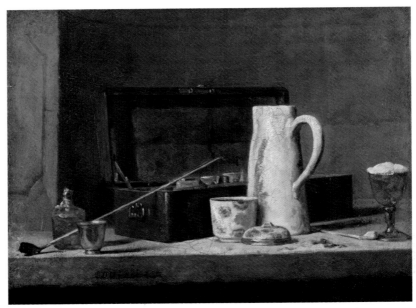

Chardin, Jean-Baptiste-Siméon, c. 1737
Louvre, Paris

Such elusively simple subjects: a small cabinet, a jug, a cup, a pipe, and copper containers.

Chardin was the French answer to Vermeer, particularly Vermeer's *Milkmaid*. There are no great themes or stories, just quiet glimpses of ordinary life. When I look at this I can smell the tobacco and feel the texture of the soft blue lining. All gentleness.

Matisse idolized Chardin. Of this painting he noted the "elusive blue on the padded lid of the box in the middle of the canvas, a blue which could look pink one day, green the next." Up close the paint is thicker than you would guess and it is grainy.

His paintings are of a restful intimacy. His family themes have a sense of solitude and the dignity of domestic labour. Proust said of Chardin, "For him, metals and earthenware will take on life and fruit will speak."

As you approach a Chardin you previously visited, you may emit a slight "Ooohhh," as you feel the smell, the yearning to touch this little memento of time past.

28. Déjeuner sur l'herbe (Luncheon on the Grass)

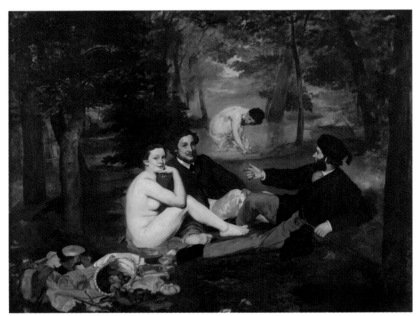

Manet, Édouard, 1863
Musée d'Orsay, Paris
Photo: © RMN-Grand Palais / Art Resource, NY

Manet was part of the impressionist movement.

Impressionism was a reaction to a staid, fixed academic clique that controlled the rules of art. If you disagreed you were out — there was nowhere to exhibit. One could only thrive within the establishment — what an establishment! Students learned little of colour and were not allowed to put raw paint to canvas. The drill was drawing, line, and form, and advanced lessons meant copying the masters in the Louvre. Copy, copy the High Renaissance — don't vary from perfection. The subject matter: classical mythology. The young artist could exhibit only if he was picked to be in a salon, chosen by jurors who were established academics. Rigid, firm opinions. You must have glossy finishes, a serious story to be told.

Pissarro, Monet, Renoir, Manet, and Degas caused havoc with unfinished canvases and everyday scenes — no moral, no reference to

the ancients. But they also made use of a profusion of new coloured paint produced by scientists. A lucky confluence of shocking colour, new colours, exploding on canvas. A variety of exciting paints for the first time readily available to the artist painting outdoors!

In 1863 Manet's *Le Déjeuner sur l'herbe* caused outrage. At the same time he produced *Olympia* to equal astonishment.

Le Déjeuner sur l'herbe shocked both because of its subject and because of the artist's technique. Two naked women (perhaps prostitutes?) with two men, without a moral or mythological pretext. The men appear out of place in their formal clothes sitting on roughly brushed grass. It may have been a play on Giorgione's *Concert Champêtre* (1508) in the Louvre, but the men are ridiculous — reclining, dressed to the nines, waiting for sure sexual trouble, yet pretending the girls are just passing through. The women, in almost theatre-white makeup, one frankly appraising the viewer with a "hello there" look, her robe scattered beneath her as if just slipped or pulled off. The man beside her displays a sense of bemusement. Sex is in the air with the frank naked woman appraising the viewer and planting her toe on the pant leg of the man opposite her.

One critic was disturbed by the naked presence with dressed men, one of whom "did not even have the presence of mind to take off his dreadful hat."

The British critics in the *Fine Arts Quarterly Review* said:

> I ought not to omit a remarkable picture of the realist school, a translation of the thought of Giorgione into modern French. Giorgione had conceived of the happy idea of a fête champêtre which although the gentlemen were dressed the ladies were not, but the doubtful morality of the picture is pardoned for the sake of its fine colour ... Now some wretched Frenchman has translated this into modern French realism, on a much larger scale and with horrible modern French costume, instead of the graceful Venetian one ... There are other pictures of the same class which lead to the inference that the nude when painted by vulgar men, is inevitably indecent.

In *L'œuvre*, Émile Zola's novel about the Parisian art world, the main character, Claude, is a composite of Monet, Cézanne, and Manet. This excerpt could well describe the reaction to *Le Déjeuner sur l'herbe*:

> A few carriages, unusual at that hour, were drawing up, while a tide of people, moving like an ant colony, forced its way under the enormous arcade of the Palais de l'Industrie … Claude raised his head and cocked his ear. A tremendous noise … rolled in the air with a steady din: it was the clamor of a storm pounding the shore …
>
> "What is that?" he murmured.
>
> 'That," said Bongrand, who moved ahead, "is the crowd upstairs, in the galleries." And the two young men … climbed up to the Salon des Refusés.…
>
> Subdued at the entrance, the laughter grew louder as he advanced. In the third hall, women were no longer stifling their laughs in their handkerchiefs. It was contagious hilarity of a crowd that has come to be amused … finding beautiful things as funny as detestable ones.…
>
> Claude, who had remained behind, heard the steady rise of laughter, a mounting uproar … And as he finally penetrated into the hall he saw an enormous wriggling mass … piled up in front of his painting. The laughter of the entire gallery swelled, bloomed, reached its apogee there. It was his painting they were laughing at.[3]

Manet had achieved notoriety.

29. Olympia

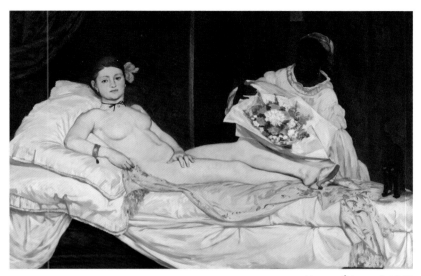

Manet, Édouard, 1863
Musée d'Orsay, Paris
Photo: © RMN-Grand Palais / Art Resource, NY

The same year he painted *Le Déjeuner sur l'herbe*, Manet painted *Olympia*, a prostitute reclining on a bed waiting for a client, looking at the viewer as if he was a potential customer. She is one tough tart, insecurity reflected in her razor mouth, awaiting the aging process when flowers would no longer be about. A black servant holds a bouquet of a suitor's flowers. Titian's *Venus of Urbino* (in the Uffizi, Florence) was supposed to have been a precursor to *Olympia*, but I think this painting stands by itself, without ties to historical works.

This modern Venus is not a sexual object, a plaything of man, but a self-possessed, assertive courtesan in complete control of her product: her body. The brazen look — that's what caused the fuss: "If you don't like it move on …, but I bet you want to untie my neck ribbon." At this time Paris was accommodating prostitution and the sophisticated courtesan had caught its attention.

The critic Amédée Canteloube wrote, "Nothing so cynical has ever been seen as this Olympia, a sort of female gorilla … Truly, young girls

and women about to become mothers would do well, if they were wise, to run away from this spectacle."

Margaret Atwood's tough eye and acerbic view of life perfectly captures it in her poem, "Manet's Olympia":[4]

Manet's Olympia

She reclines, more or less.
Try that posture, it's hardly languor.
Her right arm sharp angles.
With her left she conceals her ambush.
Shoes but not stockings,
how sinister. The flower
behind her ear is naturally
not real, of a piece
with the sofa's drapery.
The windows (if any) are shut.
This is indoor sin.
Above the head of the (clothed) maid
is an invisible voice balloon: *Slut*.

But. Consider the body,
unfragile, defiant, the pale nipples
staring you right in the bull's-eye.
Consider also the black ribbon
around the neck. What's under it?
A fine red threadline, where the head
was taken off and glued back on.
The body's on offer,
but the neck's as far as it goes.

This is no morsel.
Put clothes on her and you'd have a schoolteacher,
the kind with the brittle whiphand.

There's someone else in this room.
You, Monsieur Voyeur.

As for that object of yours
she's seen those before, and better.

I, the head, am the only subject
of this picture.
You, Sir, are furniture.
Get stuffed.

Manet was in a duel in 1870, perhaps with a disadvantage — he had syphilis. It slowly crept its course and did him in. His father, too, died of syphilis, as did Baudelaire.

Respectable married men of the time often played around in a demimonde. Manet had inherited money and Duran Ruch, the owner of a gallery, bought his pictures at a good price. He was a bit of a dandy. One of his dalliances may have been the model in his *Olympia* and *Déjeuner sur l'herbe*. We know her name was Victorine Meurent. She was born in 1844 in a poor Parisian neighbourhood and at some point became Manet's regular model. We don't know precisely how intimate their relationship was but she obviously excited his emotion. She seemed to change her personality for each painting. The black cord around her neck became her hallmark. Her level of society, distinct from prostitutes, was known as *grisette*. The name came from their tinted grey dresses of cheap cloth. They gave themselves to artists and students for long-term relationships and became the melodramatic heroines of fiction, abandoned and tubercular just like La Bohème.

Manet died in 1883 of syphilis with complications from the amputation of his leg. After his death Meurent wrote a letter to his widow plaintively requesting money as Manet had promised it to her if his paintings were sold.

I have no idea what the response was.

30. In a Café

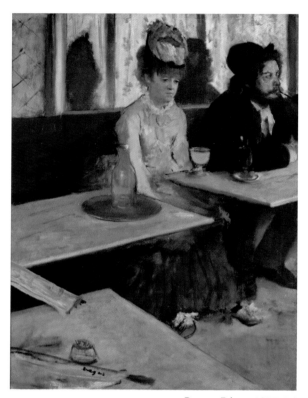

Degas, Edgar, 1875–76
Musée d'Orsay, Paris
Photo: © RMN-Grand Palais / Art Resource, NY

Degas occupies a place separate from the impressionist group. The son of a banker, he was raised in a prosperous household. He had no interest in the countryside — he was a product of the city, illustrating its modern life, horse races, ballet. "If I were the government," he said, "I would have a police force to investigate people who do landscapes after nature."

Degas was a misanthrope: "I don't know how to play piquet or billiards, how to be ingratiating, work from nature, or simply be pleasant in society. And if I weren't the way I am I wouldn't have a minute to myself for work."

His eyesight failed near the end but he had always disliked strong light. He needed soft light, so when he came for dinner candlelight was necessary, and he had aggressive peeves: nothing cooked in butter and no flowers on the table.

The lady (the model, an actress) immersed in solitude, isolation, wearing a vacant gaze, just sits, slumped, her feet splat on the floor. Her carriage gives a feeling of oompff, air leaking from an innertube, slowly.

The poor sodden lady sits next to a hungry man whose appetite is straying. She has dead brown eyes, all the more dead because of the tiny white pearl glistening in her ear. The mouth is strangely slack yet fixed. The genius is that in this moment of loneliness in a bar before the pale absinthe she has the look of vacuity, yet she reflects just enough awareness of the awful, solitary position that has become her milieu. This is accentuated by her bearded male partner who is sharp-eyed, looking to greener pastures. Marvellous.

31. Ball at the Moulin de la Galette, Montmartre

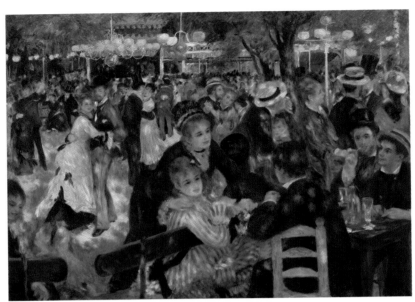

Renoir, Auguste, 1876
Musée d'Orsay, Paris
Photo: © RMN-Grand Palais / Art Resource, NY

Younger viewers love this painting. It is bathed in a mood, sunlight through the trees. Renoir's hues of blue and purple rippling through the canvas, long free brush strokes of warm colour serving up an age of affectionate innocence. You can hear the music, smell the tobacco, feel the straw boaters, and follow the eddy of the dancing.

Viewers at the time viewed it with derision. The picture is sketchy and figures lack detail. The lady in the foreground has a dress, all loose strokes of the brush, unfinished in effect. He captures the dissolving of forms in air and sunlight. He knew that with a hint the viewer would build up the whole form in the mind's eye. The sketchiness avoided too much detail which would have been lifeless.

Renoir became a very successful impressionist painter. Many of his paintings of pink fleshy nudes are boring. However, he did have the skill to capture olive trees in the sun. He said to René Gimpel, "The

olive tree, what a fiend! If you knew the trouble it gave me. A tree full of colours, not gray at all. Its little leaves, how they made me sweat! A gush of wind and my tree changes in tonality. The colour isn't on the leaves but in the empty spaces."[5]

Renoir said, "For me a picture should be a pleasant thing, joyful and pretty — yes, pretty! There are quite enough unpleasant things in life without the need for us to manufacture more."

This painting was purchased for $71 million in 1990.

32. Le Lit

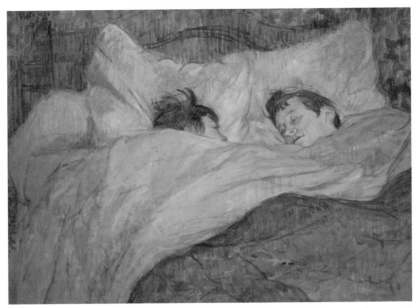

Toulouse-Lautrec, Henri de, c. 1892
Musée d'Orsay, Paris
Photo: Alfredo Dagli Orti / The Art Archive at Art Resource, NY

Toulouse-Lautrec's life was portrayed in John Huston's 1953 film *Moulin Rouge*, with José Ferrer in the lead role. For those who have seen that film, there is not much of interest that can be added.

Toulouse-Lautrec suffered a bone disease which stunted the growth of his legs. He was a little over four feet tall. He was afflicted by syphilis and alcoholism which led to his death at thirty-six.

He painted the cabarets and bordellos of Montmartre. He was the first master of poster art, celebrating the dancers of the Moulin Rouge. His posters had a bold simplicity, emphasizing line in a four-colour lithographic painting process. Simple, without emotion or moral messages.

He became friends with the prostitutes, who often were lesbians. He would sit in the bordellos and draw so often that they simply relaxed and went on with their daily routines.

This painting of two lesbians shows utter peace and near slumber. The slivers of white envelope the couple in a fluffy pastel cloud. He has captured a zone of comfort, the protection of a double bed. Life's trials forgotten.

This is as unusual for Toulouse-Lautrec as it is sentimental. His *La Toilette (Rosa La Rouge) Musée d'Orsay* is a study of a red-headed woman who has syphilis. Henri knew this, but it didn't stop him from love-making. He was ugly, with massive hands with runty fingers, puffed lips, and to boot an impediment of speech. His syphilis was treated with mercury, so his teeth became black.

He drew prostitutes without pity, rendering them with brutal stark realism. He captured their hard lives. The viewer often averts a gaze in the face of this directness.

33. Water Lilies

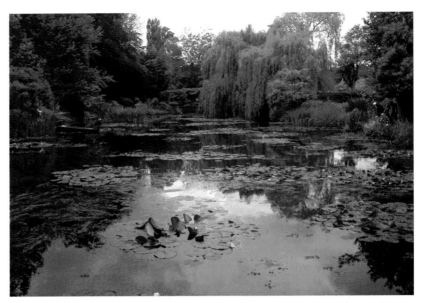

Photo of Monet's Gardens at Giverny
Nancy Lockhart, Toronto
Reproduced by permission
(in reference to *Water Lilies*, Monet, Claude, 1896–1923, Musée de l'Orangerie, Paris)

In his will, Claude Monet dedicated eight panels to France, with the stipulation that they were to be exhibited in two rooms in the Orangerie. Monet started working on these immense panels in 1893 and was still working on them at the time of his death in 1926. In 1923 he had three cataract operations which delayed the finishing of the works.

During the Franco-Prussian War of 1870–71, when Monet was thirty, he spent some time in England. He admired the works of Turner and Constable. His painting *Impression Sunrise* was in the first impressionist exhibition of 1874.

He became sufficiently successful that he bought two acres of land on the banks of the Seine outside of Paris at Giverny. At Giverny he created a water garden with lilies and needed permission from the authorities to divert the River Epté to provide the water. The authorities, after a struggle, reluctantly acceded. No water, no paintings. This

picture of the water garden was taken by Nancy Lockhart in 2009.

The eight panels are in two cylindrical egg-white rooms. The shape of the rooms, the embracing sweep of the panels running to the floor so you are at water's edge, creates a cocoon. As you sit on a bench you can swivel and be in the middle of the pond. They are broad canvases — a total of ninety-one metres placed end to end — and two metres high.

Words fail when describing abstract painting. Lilies, clouds, water, trees, hanging branches. Shimmer, shimmer, float, ripple, blue pink clouds, you are enclosed by water and solitude. The canvases encircle, forcing you to twist to see what is behind and to the side. I swear you can hear a frog croak, a mosquito buzz. The panels are flush with the ground which gives you the impression of walking around the pond.

Monet's "landscapes of water" became an obsession. He was going to reinvent landscape on canvases without horizons. He reached beyond a portrayal of reality and captured a sense of the passing of time. This broke with the Western approach to painting and set up abstract art.

He devoted his attention to the surface of the pond and the portrayal of perspective disappears. Monet said, "The water lilies are far from being the main attraction, and are actually more of an accessory. The essence of the motif is the reflecting water, which is shifting every moment as it mirrors the various swaths of sky, spreading movement and life. The cloud floating overhead, the cooling breeze, the dangling seed that finally drops off, the whistling wind that whips up, the light that wanes and then intensifies — so many elusive sources for the layman's eye, transforming the colour and distorting the pools of water."

In trying to capture colour that shifted in changing light, he was chasing the insubstantial. Monet described himself as wanting to "catch the moment." Chasing the wind — how does one capture it? Little speckles of colour glimmering then disappearing. This was hard, frustrating work.

On November 12, 1918, the day after the armistice was signed ending the First World War, Monet wrote to his friend, Prime Minister Georges Clemenceau, "I am about to complete two decorative panels that I wish to seal with the day of victory, and I write to ask if,

through you, I may offer them to the state. It is not much, but it is the only way I have of taking part in the victory. I wish these two panels to be placed in the Musée des Arts Décoratifs and I would be happy if you were to choose them."

Musée du Louvre, Paris

Rue Saint-Honoré, 75058 Paris
Telephone: +33 (0)1 40 20 5317
Web: www.louvre.fr

I have visited the Louvre at least every other year since 1955. It is huge and confusing. It may require you to make two visits, each about ninety minutes in length. Take one of the lecture earphones. They add information which is pertinent and interesting. Also take a map guide of the Louvre so you can follow the rooms.

The lineups at the Pyramid in the centre can be extremely long. If you have time to approach the Louvre by going across the Île de la Cité, you will discover a pearl of beauty. Otherwise, go off the Seine through the entrance at Porte des Lions, far to the left when you are facing the Louvre with the Seine at your back. No lineups! You can gain entry here every day (except Tuesday and Friday) from 9:00 a.m. onward. You enter the Arts of Africa section but you make your way up from there to the European Art section, clearly marked by pictures of *Mona Lisa*. You are now at the far end of the Grande Galerie in the Denon wing, which contains the paintings by Caravaggio, Raphael, David, Delacroix, and Géricault featured, as well as much else of interest. From the Grande Galerie you go under the Pyramid to reach the second half of the Louvre, the Richelieu and Sully wings. The Quarton and Chardin paintings featured earlier are here; Delacroix's *Jewish Wedding in Morocco* is another highlight.

Because the scale of the Louvre is so overwhelming, if you're looking for the paintings I've highlighted it will be helpful to have a guide to where to find them:

- Caravaggio, *Death of the Virgin*: Grande Galerie, near 12 Denon

- Raphael, *Baldassare Castiglione*: Grande Galerie, near 8 Denon

- David, *Madame Récamier*: Room 75, Denon

- Delacroix, *Liberty Leading the People*: Room 77, Denon

- Géricault, *The Raft of the Medusa*: Room 77, Denon

- Quarton, *Pietà de Villeneuve-lès-Avignon*: Room 4, Richelieu

- Chardin, *Pipe and Drinking Cup*: Room 39, Sully

It is also important to know what to skip in the Louvre. In that category, in my view, is the *Mona Lisa*.

It is rather cheeky to not line up before the *Mona Lisa*, in Room 29 of Denon. Just glance at it from a distance, over the heads of the crowd. It is muddy. Not a patch on da Vinci's glorious woman in Krakow (see Chapter 8). Still, it would be rather eccentric to say, "I was at the Louvre the other day and I gave the *Mona Lisa* a skip."

In 1550, Vasari, the contemporary artist who wrote about the lives of artists and covered all the masters of the time, wrote:

> Leonardo undertook to execute, for Francesco del Giocondo, the portrait of Monna Lisa, his wife; and after toiling over it for four years, he left it unfinished; and the work is now in the collection of King Francis of France, at Fontainebleau. In this head, whoever wished to see how closely art could imitate nature, was able to comprehend it with ease; for in it were counterfeited all the minutenesses that with subtlety are able to be painted, seeing that the eyes had that lustre and watery sheen which was always seen in life, and around them were all those rosy and pearly tints, as well as the lashes, which cannot be presented without the greatest subtlety. The eyebrows, through his having shown the

manner in which the hairs spring from the flesh, here more close and here more scanty, and curve according to the pores of the skin, could not be more natural. The nose, with its beautiful nostrils, rosy and tender, appeared to be alive. The mouth, with its opening, and with its ends united by the red of the lips to the flesh tints of the face, seemed, in truth, to be not colors but flesh. In the pit of the throat, if one gazed upon it intently, could be seen the beating of the pulse. And, indeed, it may be said that it was painted in such a manner as to make every valiant craftsman, be he who he may, tremble and lose heart.… And in this work of Leonardo's there was a smile so pleasing, that it was a thing more divine than human to behold; and it was held to be something marvellous, since the reality was not more alive.

It sure doesn't look like this today — all mud and a green tinge.

In the Richelieu and Sully wings I think the big French rooms are just awful. Endless huge Roman canvases, battles, all arms flailing and limbs astride, eye glazers. This means you miss Richelieu 11–19, and in Sully miss all of the top and both sides of the floor plan.

But be sure not to miss the following:

Ingres was the major rival to Delacroix. He adored Raphael and the Italian Renaissance. He believed paintings should have a high degree of finish. His paintings of jewellery and women's dresses can't be matched.

There are some silly paintings by Ingres in Room 75. *Homer Crowned* (also known as *The Apotheosis of Homer*) is a collection of the famous of the day, all posing as muses. Below it is *Oedipus Explaining the Enigma of the Sphinx*. Even sillier.

But next is his portrait of Louis-François Bertin.

He's not really looking at me. He will, I'm uncomfortably sure of that. This is one tough man. Is he imaginative? Surely stubborn.

Portrait of Louis-François Bertin

Ingres, Jean-Auguste-
Dominique, 1832

Photo: © RMN-Grand Palais / Art Resource, NY

Profound? Perhaps. Or is he a closed-minded middle-class shrewdie? He was a journalist and businessman. His newspaper was read by the liberal bourgeoisie. He supported the movement for a constitutional monarchy, an act that put him in jail. He opposed the reign of Charles X. He was obviously committed and brave.

Reaction to the painting at the time? Some critics found it ridiculous and vulgar. Bertin's daughter wrote, "My father looked like a great lord. Ingres turned him into a fat farmer." This work, which is the most famous male portrait Ingres painted, is often considered the embodiment of a social class. Indeed, Édouard Manet described Bertin as "the Buddha of the self-satisfied, well-to-do triumphant bourgeoisie."

Hans Holbein, known as the Younger (his father was a noted painter), met Desiderius Erasmus when he worked in Basel as a young painter. Erasmus (1466–1536) was the great Dutch humanist scholar. He spent time in England as Professor of Divinity at Cambridge. He disagreed with Luther. He advanced the revival of learning and tried to rescue theology from the pedants.

Erasmus's thoughts could be forceful. This is from *The Praise of Folly* (1509):

> The merchants are the biggest fools of all. They carry on the most sordid business and by the most corrupt methods. Whenever it is necessary, they will lie, perjure themselves, steal, cheat, and mislead the public. Nevertheless, they are highly respected because of their money. There is no lack of flattering friars to kowtow to them, and call them Right Honourable in public. The motive of the friars is clear: they are after some of the loot …

After the lawyers come the philosophers, who are reverenced for their beards and the fur on their gown. They announce that they alone are wise and that the rest of men are only passing shadows ... The fact that they can never explain why they constantly disagree with each other is sufficient proof that they do not know the truth about anything. They know nothing at all, yet profess to know everything. They are ignorant even of themselves, and are often too absent-minded or near-sighted to see the ditch or stone in front of them.

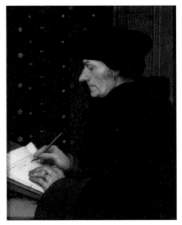

Erasmus of Rotterdam Writing
Hans Holbein the Younger, 1523
Photo: © RMN-Grand Palais / Art Resource, NY

As this portrait of Erasmus illustrates, Holbein made his reputation as one of the masters of portraiture. Here is Erasmus writing. You can just hear him murmuring to himself, "I must get this exactly right ... Ah ... There, that's it."

I like this painting because it captures intense concentration, revealing a completely focused mind. It takes a lifetime of practice to be able to concentrate with this resolution.

This simple Hieronymus Bosch is a treat!

An allegory of worldy folly. A ship flying the Turkish flag flounders on. The owl in the tree is heresy as is the Islamic crescent on the pink banner. The lute and cherries are fornication. The people in the water are victims of gluttony. The singing monk and nun are together against all the rules — they were to be separate and apart. The upside-down funnel in the water is a sign of madness.

The Ship of Fools
Bosch, Hieronymus,
1490–1500
Photo: © RMN-Grand Palais / Art
Resource, NY

Certainly the ship's direction is capricious as the long spoon is a poor rudder. When the rope gets cut and the roast bird falls, gluttony will win and the ship will at best go into irons.

This was part of a triptych (58 x 33 cm) and was one of the wings. The other wing, *The Death of a Miser,* is in Washington.

Jewish Wedding in Morocco
Delacroix, Eugène, 1837
Photo: © RMN-Grand Palais / Art Resource, NY

Delacroix went to North Africa and fell in love with the Berbers and the colours of their djellabas. He saw a new vision of light, of sun, of sparkle. I view this North African work as his foremost accomplishment. Here is *The Jewish Wedding,* with a cloistered feel of a family society tied in a ribbon of soft green upper balustrade with lemon stripes, framing a sparkle of lemon white wall. The guests are intimate, lively, yet some are reflective midst the sounds of music and dancing. You can imagine the tinkle of the tambourine. There is an exploding whitishness of the walls. The sloping sheet over the near upper balcony prevents the eye from being distracted and forces it down to the food, music, and rhythm of the society.

To conclude your visit try the Café Marly in the Louvre, where you can sit behind glass facing the Pyramid and look into the sun. Service is slow, the wine is good, the food is good, and you read while occasionally raising a glance to overlook the most famous courtyard on earth — the Louvre!

Musée d'Orsay, Paris

5 Quai Anatole, 75007 Paris
Telephone: +33 (0)1 40 49 4814
Web: www.musee-orsay.fr

You should stand on a balcony inside and marvel at the barrel vault of glass and finely cut stone, with rosettes. At the end there are six levels of walkways behind glass, but the huge railway clock is a piece of art in itself. Statues peep under the bottom of smooth arches. It is as if this building was specifically created to envelop and frame the art collection. From the balcony there are views of the Louvre, Montmartre, and Sacre-Cœur.

In the collection, in addition to the Manet, Degas, Renoir, and Toulouse-Lautrec paintings featured, two works in particular stand out:

The Angelus
Millet, Jean-François, 1857–59
Photo: © RMN-Grand Palais / Art Resource, NY

The son of a Normandy farmer, Millet painted the final scenes of a rural world and lifestyle at the very time of its change in the face of industrialization. He created a whole series of works showing labour in the fields. His paintings were of humble people, workers of the land. They strike you as a portrayal either of dignified work or of cruel, hard manual labour. After 1880 they attained great celebrity but horrified conservative critics and officials in the formal art world. His *Les Glaneuses* (*The Gleaners*), showing the hard labour of fieldwork, caused vehement reaction. Now it's hard to tell why.

L'Angélus, reproduced in farms all throughout France, was the most popular painting for religious families. This was a deeply nostalgic painting appearing in the middle of the Industrial Revolution. It was

frequently reproduced on petit point tapestries, chromolithographs, and chocolate tins. The *Angélus* was purchased in 1890 for 800,000 francs, an immense price at the time.

The purchaser took the painting to America for a tour. The American reaction was interesting:

> September 4, 1918
>
> I have seen Brandus, of whom Georges Petit was speaking the other month. It was he who toured that famous painting right across America. I remarked that he must have heard some odd comments, and he replied: "Oh, masses of them! Almost everyone wanted to know how much it cost per square inch, and also why a copy wouldn't be as good. A tailor said to me: "Your peasant's trousers don't fit him, they're much too short; so how can this picture be worth so much?" A visitor asked me: "Why is this painting called the *Angelus*?" and added, "It's probably the gentleman's name." I overheard a girl asking her mother why the man and woman were so sad; the mother replied that they'd just buried their child. A conversation between two labourers went: "Why are they looking at the ground in such an unhappy way?" "Because the insects have eaten the seeds and they won't have any harvest."[6]

Burial at Ornans
Courbet, Gustave, 1849–50
Photo: © RMN-Grand Palais / Art Resource, NY

Huge, very black, and a scandal at the time. A fine Caravaggio-like powerful painting of isolation, damp and bleak; on this cold raw day some of the figures resemble characters from Dickens. There are two groups, rather disparate, with only the cold damp herding them to the centre of the painting.

The Parisian public didn't know what to make of this painting because they couldn't identify the social or political strata of the mourners. The citizens of Ornans were pleased to pose — less so after they became aware of the Parisian disapproval.

Courbet was a talented showoff, ceaselessly promoting his own image and his views on life, sex, and drink. His paintings — some sexual scenes and pictures of ordinary working people, without more — caused a stir. Result: artistic condemnation. His *Origin of the World* (1866), a naked pudendum closeup at the D'Orsay, shows how much he liked to annoy critics back in 1866.

Courbet had a political history.

In the wake of France's defeat in the disastrous Franco-Prussian war of 1870–71, a commune led by disaffected French troops plunged Paris into a civil war. This was a workers' insurrection, with red banners. While the commune lasted, from March until May 28, 1871, priests, magistrates, and journalists were shot in batches. There was destruction by flame; cases of petroleum sloshed about; the Hôtel de Ville, the Palais de Justice, the Tuileries were torched. Barrels of gunpowder were placed in Notre-Dame and the Pantheon. Only the victory of the invading French government stopped the blowup.

During the civil war Courbet was in the forefront of commune politics. He was elected a delegate to the commune government and became head of the artists who wished to reorganize the Louvre and remove the old artistic barriers to new work. Courbet led the charge against the old Napoleonic heritage by demanding the toppling of the Colonne in the Place Vendôme installed by Napoleon I. This was done.

The commune fell to the French government troops who besieged the city. During the ensuing reprisals, perhaps 30,000 were killed and almost 50,000 were arrested — Courbet among them. On September 2, 1871, he was sentenced to six months in prison for his role in the Colonne Vendôme toppling in addition to the three months already served before trial, together with a fine of 300 francs and his share in the costs of the trial. He was the only accused who had any money.

When Marshal MacMahon, who had led the troops that suppressed the commune, became president of France, he amended a bill for the

rebuilding of the Colonne, declaring that the whole cost of 323,000 francs, payable in yearly instalments of 10,000 francs over thirty-three years, was to be met by Courbet. Courbet went to La Tour-de-Peilz, Switzerland, and died before payment of the first instalment was due.

There is a magnificent restaurant in the Musée d'Orsay called Le Restaurant.

Musée de l'Orangerie, Paris

Jardin des Tuileries, 75001 Paris
Telephone: +33 (0)1 44 77 80 07
Web: www.musee-orangerie.fr

The Musée de l'Orangerie, just at the end of the Tuileries gardens, beyond the Louvre, now houses Claude Monet's *Water Lilies*.

The museum is closed Tuesdays. Individuals are not admitted before 12:30 p.m. and it is open until 7:00 p.m. There are guided tours for individuals on Mondays and Thursdays at 2:30 p.m.

You can get a good preview of the panels on the virtual visit page of the website.

Musée Jacquemart-André, Paris

158, boulevard Haussmann, 75008 Paris
Telephone: +33 (0)1 45 62 11 59
Web: www.musee-jacquemart-andre.com/en/home
Email: message@musee-jacquemart-andre.com

The museum is open every day of the year.

Inside, each room is a distinct retreat. There is one dazzling prize, ironically not mentioned in the handout pamphlet on the museum's treasures: the frescoes by Tiepolo (1696–1770). One is at the top of an art nouveau marble circled staircase, the other above the tea room. Most frescoes are too far away to actually examine. Here they are near your fingertips.

You ascend the glorious white marble steps (under a glass ceiling spreading sky light) enclosed by curlicued metal scrolls, patterns of leaves, downward and around until you face Tiepolo, just an inch beyond touch. By my rough calculation the work is twelve metres across and five and a half metres high, with two side arches holding viewers and lovers who observe the scene.

This is a special treat because you can see how a fresco is actually painted, with its sense of sketch and urgency.

At the end of a fifteen-minute tour of the rooms you can have an exotic tea in the tea room under another Tiepolo fresco.

As noted, the brochure describing the considerable artistic assets of this museum does not mention Tiepolo by name. Weird! It's the reason to go there.

There are some other highlights, one of which is of special interest to lawyers — a sight to strike fear into even the most seasoned barrister. Van Dyck has done a "magistrate," which portrays unbridled judicial ferocity. A truculent, large old pink man with judicial hat, scowl, and black robes, glares at the viewer. You can almost hear him in full flight: "Uuummph ... Yeeessss?... You needn't repeat it, I have it!... Get to the point, counsel!... I've read the material. You needn't go on, I've read it!...Costs, what of costs?"

Whew! All in one painting — an accurate rendering of judicial terror in action.

3

SPAIN

Madrid can be cold in the winter, hot in the summer. Nonetheless, it is an essential stop on any art lover's tour of Europe.

The **Prado** is, of course, synonymous with Madrid. Once a grim gallery, it is now marvellously light and the pictures fairly sparkle against the coloured walls. It is a wonderful walk from the Prado to the Plaza Mayor — a lively, lovely square enclosed by uniform Hapsburg architecture with stores underneath the supporting arches.

Close to the Prado is the **Museo Thyssen-Bornemisza**, with its natural progression through immaculate spaces for displaying its impressive collection of paintings. Neither the Thyssen nor the **Museo Reina Sofia** — which is primarily known as the home of Picasso's celebrated *Guernica* — should be overlooked.

Before leaving Spain, the short train ride from Madrid to Toledo is a must. The trip offers stunning vistas over valleys as the train climbs the hills on which Toledo is perched. After a glorious entrance to the ancient town, the journey ends at **Santo Tomé**, the small church that houses El Greco's *Burial of Count Orgaz*.

34. Garden of Earthly Delights

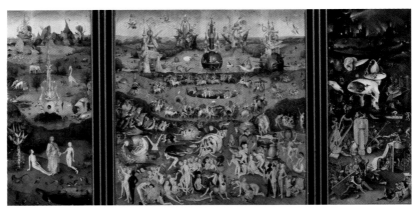

Bosch, Hieronymus, c. 1500
Museo del Prado, Madrid
Photo: Scala / Art Resource, NY

Hieronymous Bosch — a genius out of nowhere, without precedent or artistic roots. In about 1500 he created *The Garden of Earthly Delights*, a huge work depicting a world gone berserk — men in clam shells, men with flowers in their assholes, monster-coloured chickadees, sexual coupling in shells, bubbles, canisters, lobster claws. It requires time to assimilate, but it is worth it. Stand all alone before this genius while the occasional gusts of tourists blow by — one minute for the painting, then off.

The work begins with Adam and Eve in the left panel, in tranquillity with benign animals. God introduces Eve to Adam. He looks worried, which may wrestle with his required look of obedience. The owl in the pink structure foresees the end of the world. It is in the middle of the confluence of the four great rivers, the source of all. On the right is the tree of knowledge and good and evil. The snake represents evil

already present in the garden. The birds on the top are magnets for vices. The tree on the left is the tree of life.

The middle panel is a world gone topsy-turvy, symbolized by the extreme size of the animals. The strawberry is a symbol of luscious short-term pleasure. A strawberry in the hair of a woman denotes prostitution. The black women are also symbols of prostitutes. The horses running around the lake of prostitutes in the middle symbolize lust. The view was that horses are horny. Maybe they are.

As for the man carrying the clam with a leg peeping out: the clam is a vagina; the leg belongs to an adulterer; the deceived husband is carrying it. The mouse is a "negative" symbol. The men with fish are homosexual acts. The owl with the many legs under it is meant to be a hermaphrodite, a symbol of an unhappy marriage.

In the lower corner of adultery and lust, St. John the Baptist points at Eve in a glass prism. The apple is the originator of sin and the cause of human madness. Be careful with apples! The broken eggs portray an attempt to go back to childhood.

There has been speculation that Bosch was an adherent of an Adamite religious sect that was bent on purging sexual desires and did it by nude rituals. (Not such a bad idea, I suppose, but I can see that the rituals might lead to some backsliding.) This is most unlikely as the painting was done in 1500 and was placed in the Escorial, the royal monastery, to be viewed by King Philip II who was very pious. The work is a satirical comment on the shame and sinfulness of humanity.

The right panel depicts Hell — the consequences of the garden's "delights." At the top is a city on fire with flickering flames and explosions illuminating the dark night. Platoons of marching troops flee fire and damnation. Closer, horrible tortures are meted out on nude men and women by various monsters. A sow in a nun's habit attacks a man. Words can't capture it.

Lucifer, the blue bird perched on a stool, devours humans and defecates them down to a pit where gluttony and avarice reside. Some peer into this pool. Lucifer's cape hides his preferred sins, those of the senses. I am not sure what this means — imagination is more dangerous than action?

The central monster with a human face under a bagpipe and disc sits on two drifting boats, a symbol of the ship of fools. He is meant to be the image of lust and the devil. Funny, he looks quite like Laurence Olivier. The analysts say he is despairing and dying from a prolonged orgy. In his shell is a tavern, with priests ascending for a drink.

Music was often condemned as a sinful diversion. In this Hell it has a corner of its own where musical instruments play infernal, endless music to torment the inmates.

In the lower corner an abbess, shown as a pig, is trying to seduce a devout man to make false witness to authenticate a false relic. Her foot is on a metal object. In 1517 Luther nailed his challenge on the doors of Worms. Part of this challenge was about the church dealing in false relics to its own profit.

The idiosyncrasies of Hell are shown by the rabbit stalking the hunter. There are other hells for the monks, the knights, and the gamblers. As is to be expected.

All in all a subtle and intriguing work.

35. Deposition

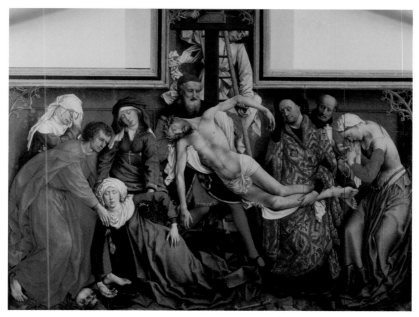

Van der Weyden, Rogier, c. 1436
Museo del Prado, Madrid
Photo: Scala / Art Resource, NY

Rogier van der Weyden's *Deposition* is a glory. The Mary at the top left sheds translucent tears that appear so real you can almost taste the one close to her mouth. The Virgin Mary's dress is aquamarine, smooth against the troubled white collar and headdress. Each participant wears precious shoes, all in a truly luminous setting — a setting of hushed, intense concentration. It is perhaps the egg white in the tempera, but it fairly glows.

Some major art critics take a dim view of this painting. Robert Payne thinks it is a painted wax work with the Virgin resembling a plump housewife who has fainted at the sight of some rats in her closet.[1] Others argue his pictures have a sense of people posing, static expressions, all unreal. Sister Wendy Beckett thinks it is one of the great masterpieces. Right on, Sister!

36. The Annunciation

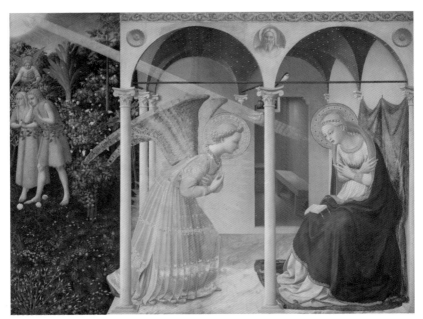

Fra Angelico, 1425–28
Museo del Prado, Madrid
Photo: Erich Lessing / Art Resource, NY

Fra Angelico was fighting a bit of a rearguard action by portraying religion in a non-naturalistic, old formal style. I love this painting for its innocence, the subtle realism of the angel's wings, and the Virgin's quizzical, careful, nearly suspicious look.

This is in its original frame. On the top left the angel Gabriel casts Adam and Eve out of Eden. Later Gabriel comes to the Virgin carrying God's message, to assist in humanity's redemption via Christ.

God's hands (it's rare that a painting shows God's hands) release the dove of the Holy Spirit, carried in the golden shaft. The face of God appears in the medallion above the middle support pillar. The swallow on the tie bar may be a symbol of the Near Eastern messenger swallow of antiquity. The robe of the angel Gabriel, pure pleated poetry, ironed especially for the mission, is of a deeper pink than the Virgin's. When God speaks by the golden shaft, the "paint" is burnished real gold.

37. Third of May, 1808

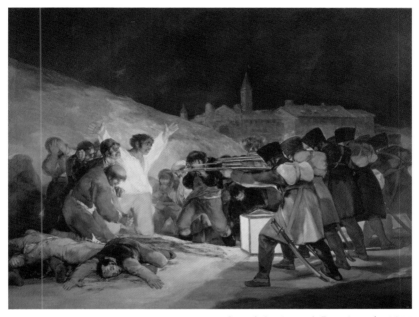

Goya (y Lucientes), Francisco de, 1814
Museo del Prado, Madrid
Photo: Scala / Art Resource, NY

Room 64 in the Prado contains Goya's great paintings.

Goya was born in Spain at a time when his country was in the artistic doldrums. He lived through the French Revolution, the Napoleonic wars, the Enlightenment — a time when Spain had lost its position as the world's greatest marine power to England. Napoleon installed his brother as king of Spain in June 1808. The church was attacked; it responded with a vengeance. Violence was the norm.

Goya became totally deaf at a young age, a byproduct of tapestry cartooning which carried with it a chemical hazard leading to deafness. From then on Goya was withdrawn, obsessed with his health, fearing blindness. He painted royalty and secretly did prints of the disasters of war — a bleak commentary on the horror of the French suppression of Spanish uprisings.

I will focus on *Third of May, 1808*, a picture portraying the brutality of modern warfare from the victims' perspective. There was a popular uprising in Madrid against the invading Napoleonic troops on May 2, 1808. Citizens attacked France's Moorish Cavalry (also a painting by Goya in the Prado). In response, France ordered execution by night.

The men to be shot have a horrified impotence in the face of the soldiers with rifles, an impersonal, godless, lethal force. The key figure in the painting has yellow pants and a blazing white shirt, his eye, the big black corner ringed in white, bulges with terror. He throws his arms up and out as though throwing his whole life in extremis in the face of his murderers. The arms portray crucifixion. Blood beneath, the red of an abattoir.

The central figure is not idealized, not a martyr sacrificing himself to an idea in the expectation of salvation, but a person who is no longer helped by faith, who has been denied human dignity, abandoned to brutality.

Most of the victims have faces. Their killers do not — killers who can't be identified. Welcome to the "modern" world.

38. Sabbath

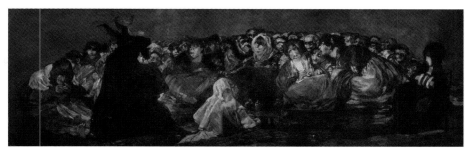

Goya (y Lucientes), Francisco de, c. 1821–23
Museo del Prado, Madrid
Photo: Scala / Art Resource, NY

Goya's black paintings in the Prado were originally in his farm outside Madrid, filling large rooms. They are images of black grief, without logic or apparent storyline.

At the end of his career, deaf, isolated, he surrounded himself in his house with a vista vision of horror and goblins. The Spanish, like the people in Shakespeare's time, must have believed in spirits, personified by ghosts. The black paintings are gobs of black, black hats, black faces with white cadmium slashes, all figures in an arch of huddled terror — terror at the past, terror at the present — suffused in the dark gloom. There is an occasional look of suspended belief — but they all *know* the horror that awaits them at bedtime. No real explanation is possible: it is living Hades.

Unlike Van Dyck, Goya relies on one shade of black, but it is set off by acid lemon yellows, russets, Meissen yellows — all done in a quick smear. Goya added printers' ink to the black, hence its lack of luminosity.

One of the panels, *Sabbath*, has the devil shaped as a goat (the Great He-Goat) with his back to the viewer, lecturing a group of witches. Their howling faces are images of shriek, venom, and full rant. The diatribe moulds the angry cauldron of witches into a collective howl.

A mother holds out her squirming baby as an offering to the devil.

Many a cutthroat here, the faces popping up, with no rhyme nor reason. It's crazy but the fear is *real*.

This prompts my impressions: "a huddle of black … spider, spider, spider joined together … squat toads, sitting, sliding, crouching, advancing … a phantasm of morbid … a dream could not be as dark."

In the final analysis the Prado is stamped by Goya's black paintings. They are so powerful that they surpass all of Bosch, Velázquez, and Titian in the gallery. There is a room of shimmering El Grecos, as tall as a canvas can be, fluted energy and light, but they can't trump Goya's sweep and swallow of black, more black, all blackness.

39. The Holy Trinity

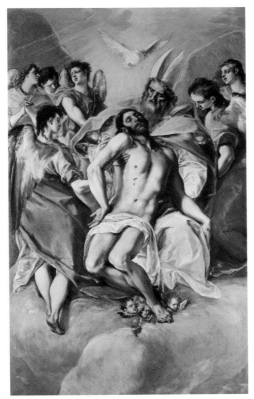

El Greco, c. 1577–79
Museo del Prado, Madrid
Photo: Scala / Art Resource, NY

I have always found El Greco somewhat precious, perhaps because what I have seen were small canvases (except *St. Jerome* in the Frick Collection in New York). Well, Room 10B in the Prado is a whole vast room of big canvases — and I mean big! They are not just flickering mannerist bits; they are giant flames.

A number of them stand out. *The Adoration of the Shepherds* has a variety of clashing colours with spiralling columns of blue and yellow searing the composition upwards towards a number of Spanish angels. *The Baptism* is a twisting marvel with an axe next to St. John, a symbol

taken from a sermon in which, according to the guide book, St. John "affirms the future destruction of the Jews, who are unworthy of being considered part of the chosen people." Everyone in all these canvases is a pure and distinct Spaniard.

This painting, *The Holy Trinity*, has angels, Christ, coloured pale black ivory set against the aquamarine of the angels' robes (with wings as feathery as Correggio). A sweep of violins.

El Greco enjoyed great success as an artist, living in a mansion of twenty-four rooms and dining accompanied by an orchestra. He was immensely well read. His estate at death had all the Greeks — Homer, Euripedes, Xenophon, Aristotle, Demosthenes, Isocrates, Aesop, Hippocrates — as well as sixty-seven volumes of Italian writers including Petrarch. He revered St. Francis of Assisi (he did fifty-six paintings in which St. Francis appeared). His figures are elongated, trapped in dark space, expressing emotion through the vibrating, shimmering robes — a complete contrast to the plastic stolidity of the down-to-earth figures of Andrea Mantegna. El Greco was a mystic, his sense of mysticism leading to ecstasy, and he was forgotten until the expressionists adopted him after the First World War.

40. The Surrender of Breda

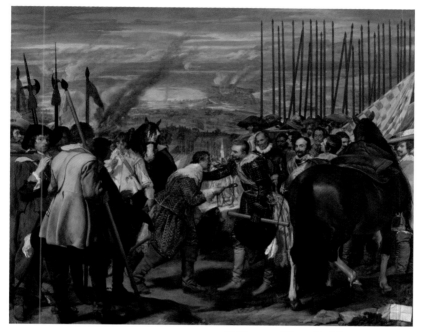

Velázquez, Diego Rodriguez, 1634–35
Museo del Prado, Madrid
Photo: Scala / Art Resource, NY

The Spanish defeated the Dutch at Breda on June 5, 1625. The taking of Breda was the only military victory of Philip IV while King of Spain. He sent Ambrogio Spinola, his general, a terse message: "*Marqués sumais Breda. Yo el Rey*" — Marquis take Breda. I, the King. That's pretty clear.

This scene is not the usual conqueror compelling a grovel. Rather, it portrays the conqueror's magnanimity, with the proud fatigue of the defeated. The victors on the right with a forest of upright lances are led by Spinola, who confers an arm embrace in slow-motion minuet prior to receiving the key to Breda from Justin of Nassau. Spinola was a mercenary and a friend of Velázquez. We know that the figure of the victor on the right is his portrait. The painting was done after Spinola's death in 1629 but before 1635.

The faces of the crowd are not posed, but caught in a moment, some watching, some turning, some gazing towards the viewer. The landscape way off, in a silvery light, a portrait of the Netherlands — blues, greens, yellow ochre (light brown) — is a haunting precursor of Cézanne. The horse, its back to us, smooth, shiny, in contrast to the smoky panorama, dominates the victors' side. The lances are reminiscent of Tintoretto's lances in his *Crucifixion* in Venice's San Cassiano (see Chapter 4). Velázquez saw this.

Spinola in elegant close-fitting armour, trim boots on shapely legs, a dazzling purple crimson scarf, the blue and white of the checkered flag, the sheeny rump of Spinola's horse — all this trumps the Dutch leader, Justin, in floppy breeches and plump doublet. It was said Spinola uttered these rather improbable words: "The courage of the vanquished is the only glory of the victor."

Two years later the Dutch recaptured Breda. This picture was intended to glorify Spain. The irony is that Spinola was of Italian birth and was a paid mercenary, as were all of his troops — a calculating bunch, most of them German. The "Spanish" troops don't appear too happy as they have been denied the plunder of Breda.

The weary resignation of the Dutch and the grace of the Spaniards constitute an absence of glory in the two principals. Civilization survives war.

41. Las Meniñas

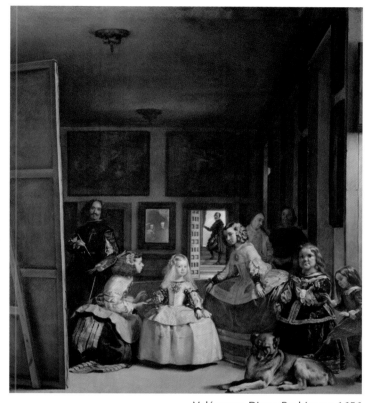

Velázquez, Diego Rodriguez, 1656
Museo del Prado, Madrid
Photo: Erich Lessing / Art Resource, NY

In 1985, forty-four experts commissioned by the *Illustrated London News* picked the top twenty paintings in the world. Number one was this painting. The dealer, Daniel Wildenstein, described it as "the greatest work of art by a human being. All others are far behind."

Well, reader, it's not my number one. Bully you say. Why? I'm not sure why. For years I agreed with the experts. Velázquez was as great a painter as Rembrandt. But in portraying court society and ceremony, he bleached out personality and eradicated emotion. I suppose royalty never show public emotion. A wizard with paint,

perspective, pools of light, yet he was annoyingly ambiguous in presenting human interaction.

Las Meniñas is fascinating, but its ultimate charm is the verbal explanation, not the glory of the painting itself. In other words, Velázquez is painting a picture and the mirror at the back portrays what he is painting amidst royalty and courtiers who play a certain role in the theatre positioning of the painting. What is striking is the amount of space occupied on the left hand side by the blank back of the immense canvas. This is risky. Does it add anything?

The plot: Velázquez on the left is at work before a huge canvas. The subject revealed by the mirror image on the back wall is of King Philip IV and Queen Mariana, who are sitting for the portrait. A crowd of people have come into the studio. Their little daughter, Infanta Margarite, is flanked by two maids of honour. We know their names as we know the names of the two dwarfs. The distant background people were obviously minders of the child.

Some of the personal circumstances are interesting. The king, a pompous one, with strict rules of hierarchy, loved theatre, the arts, and hunting, and even wrote plays. But on many levels he was a boob and he was broke. His fatal wars bankrupted the government. In winter there was no wood for fires and fish served on golden platters stank. He had many illegitimate children (thirty-two?) and married the queen in the picture when she was thirteen. She was intended for his son. But the son died so pop took his place. She had many stillborn babies; one boy survived as monarch but was mentally challenged. The infanta died shortly after her father.

The maids of honour on either side of the infanta were from noble families. One is kneeling, not from affection but for protection; the other is moving into a curtsy. There were strict lines of people in a chain supplying royalty. The dwarf on the right filled the function of a jester and had a fool's licence, which put him outside the strict social protocol.

Velázquez had a court job running part of the royal household. He wanted to be a member of the Order of Santiago. He had to apply and prove purity of blood (neither Jewish nor a Moor). He had no

aristocratic ancestry so he was stymied. Philip prevailed and myth has it that he painted the cross on Velázquez's vest after the painter's death.

Sir Kenneth Clark discussed the mystery of how the eye at a certain distance from the painting moulds the dabs, flecks, slashes, and smears of paint into an image. The eye makes it coalesce. "I would start from as far away as I could," Clark said, "when the illusion was complete, and come gradually nearer until suddenly what had been a hand, a ribbon and a piece of velvet, dissolved into a salad of beautiful brush strokes." Don't you love the phrase "salad of beautiful brush strokes"?

I'll grant that the painting is extraordinary, even a masterpiece. But *the best*? No, damn it, it's not.

These are my thoughts when confronted with *Las Meniñas* in the Prado. Now Velázquez is a favourite of mine. I purr with adulation over *The Surrender of Breda*; I praise Apollo setting Vulcan off in *Vulcan's Forge*; I give an unreserved tribute to his menacing portrait of *Innocent X* in the Doria-Pamphilj in Rome, which I may credit as the best portrait of all; and I revel over his lush *Rokeby Venus* in London. But it puzzles me that so many say this painting is the best. What do you do if you're met by a tidal wave of unfettered adulation over a painting and you just don't get it?

42. St. Catherine of Alexandria

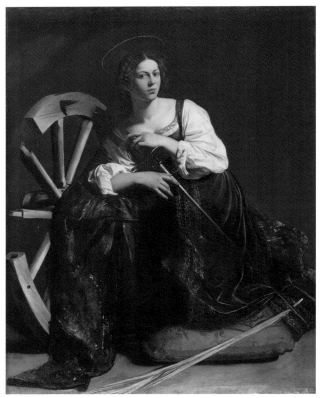

Caravaggio, Michelangelo Merisi da, 1599
Museo Thyssen-Bornemisza, Madrid
Photo: Museo Thyssen-Bornemisza / Scala / Art Resource, NY

A surprise here. A highly detailed blue-green cloak set as a sitting rug and a deep ripe cherry burgundy velvet skirt, all subtle, soft, and Van Eyck–like. Not Caravaggio's usual rough stuff.

The face, one of his regular models. She was a famous prostitute, Fillide Melandroni from Siena — not just a streetwalker but a courtesan at the top of her profession.

The hands are rough and pink, which is usual for Caravaggio as opposed to Van Dyck who always, but always, had elegant model hands.

Catherine, saint and virgin martyr of the fourth century, was so clever that she converted fifty pagan philosophers to Christianity in a debate in which they were supposed to have destroyed her faith. As a result they were burned at the stake in Egypt and she was beheaded by Emperor Maxentius (306–312). Maxentius tried to torture her by tying her to a wheel studded with iron spikes, but a thunderbolt from heaven destroyed the wheel before it was used.

43. Portrait of a Peasant

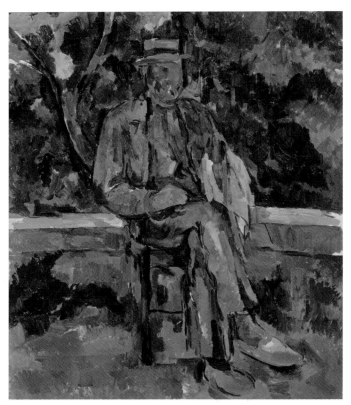

Cézanne, Paul, 1905
Museo Thyssen-Bornemisza, Madrid
Photo: Museo Thyssen-Bornemisza / Scala / Art Resource, NY

Here the body is but part of the landscape, warm, the feel of summer.

Cézanne did more than one of these. This one has an unfinished face that reveals how he worked colour, flowing into colour, form to frame colour. Done at the very end of his life, you can see his final theories and his varied paint slaps and rough colours bathed in the sun. It shows how he approached the structure of a painting. The magic of this is that it somehow manages to convey a sense of solidity in this ethereal mix and reflects noontime heat and lassitude.

44. L'Amazone (Horse Woman)

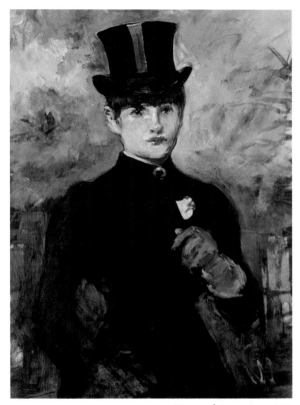

Manet, Édouard, c. 1882
Museo Thyssen-Bornemisza, Madrid
Photo: Museo Thyssen-Bornemisza / Scala / Art Resource, NY

Black silk top hat, tight curved riding jacket, hair black, curling down under the topper, squiggly eyebrows to match the slash of the blue sky. The lipstick red, a blur of a quick mouth. The hand in a falconer's glove, pale cheeks, all a moment of saucy speed, insecurity, and the possibility of sex.

This was painted a few months before Manet's death from syphilis.

45. Jesus Among the Doctors

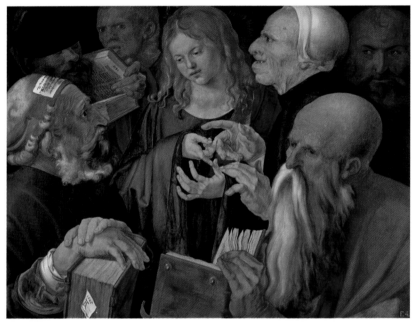

Dürer, Albrecht, 1506
Museo Thyssen-Bornemisza, Madrid
Photo: Museo Thyssen-Bornemisza / Scala / Art Resource, NY

On a white poplar panel, this is an extraordinary picture of the inter-play of hands. A very young Christ debates with six elderly doctors. Christ serene, pensive, one doctor with a Bosch rictus face yet not one of scorn. The doctors' intent, concentrating, reflecting eyes mirror thought.

But the reason this painting arrests is its highlights of hands, eight of them. Portrait painters say hands are the toughest bit. These hands have an element of a conductor's hands, delicate, mobile, and subtle. The hands are an extension of the learned doctors' minds, as they softly cradle the treasured texts.

Christ ticks off arguments, and the delicate hands suggest this is a polite and deferential debate. The learned hands love the feel of the parchment. The hands flicker, the spokesmen of wise men.

46. The Water Stream (La Brême)

Courbet, Gustave, 1866
Museo Thyssen-Bornemisza, Madrid
Photo: Museo Thyssen-Bornemisza / Scala / Art Resource, NY

Courbet often did brown water. Here it is a sparkling luminescent green. He has created a cave in the forest — water through it and the trees rising as if the nave of a church. A chapel of nature with light dappling down through the leaves onto the running water. So cool, so quiet, the ultimate spot of seclusion.

47. Guernica

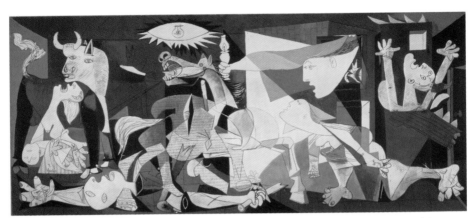

Picasso, Pablo, 1937
Museo Reina Sofia, Madrid
Photo: © Picasso Estate / SODRAC (2013). John Bigelow Taylor / Art Resource, NY

Spain endured a horrific civil war from July 1936 to April 1939. A radical Republican government tried to hold out against General Franco's fascist Falange. Franco eventually won. The war was brutal, pitting family against family, and the church was in the middle of it.

One region that annoyed Franco was the Basque area, with its different language and customs and constant demand for independence (which persists to this day). Franco formed an alliance with Hitler and Mussolini. Hitler wanted to try his air force out and experiment with a modern air blitz.

On April 26, 1937, the German von Richthofen used fifty aircraft, including Junkers and a Messerschmitt, to attack Gernika, a Basque town of 7,000 people, on its market day. Planes came in waves, dropping bomb after bomb, and then in another wave with incendiary bombs, creating a vast furnace. This was done so that they could advance the propaganda ploy that Basques had torched their own town. People who fled were strafed by low-flying planes.

Death, rubble, fire, indiscriminate murder of civilians — welcome to modern warfare.

The Republicans still controlled Madrid and Barcelona, and hence were still the government. There was to be a Spanish pavilion at the Paris world's fair, the International Exposition of Art and Technology in Modern Life, which opened on May 25, 1937.

The two dominant pavilions at the world's fair were those of Germany and Russia. Spain's very primitive exhibition only opened on July 12 and its major exhibit was Pablo Picasso's *Guernica*. It was done in four weeks, twenty-seven square metres of canvas, all black, white, and grey. He experimented with colour but in the final work eliminated it. It was Picasso's contribution to the Republican cause and paid for by the government.

The painting is a black and white image of torture, LSD dreams, and electric shock, your mental finger wetted up and jammed into the live socket while your feet are in water. The figures are unrealistic, part absurd. Is war anything but?

Today the work is an acknowledged legend. Le Corbusier, the famous French architect, didn't like it because it wasn't pretty. He said, "Guernica saw only the back of our visitors for they were repelled by it."[2] Robert Hughes wrote,

> *Guernica* was the last great history painting.... It was also the last modern painting of major importance that took its subject from politics with the intention of changing the way large numbers of people thought and felt about power.... Picasso could imagine more suffering in a horse's head than Rubens normally put into a whole Crucifixion. The spike tongues, the rolling eyes, the frantic splayed toes and fingers, the necks arched in spasm; these would be unendurable if their tension were not braced against the broken, but visible, order of the painting.[3]

Franco always denied that he was responsible for the bombing of Guernica. He was in control of Spain until his death in 1975 and he was always a dictator. He hated Picasso, whom he outlived by two

years. It was a jail offence to create a reproduction of *Guernica* while Franco lived. The police tore down copies in houses they searched. Picasso consented to let it be housed in New York's Museum of Modern Art until Franco had left, and vehemently insisted that the painting should not go back to Spain until democracy was established. Spain requested its return in 1975. MOMA stalled from 1975 until 1981. At last it went to its Spanish home — first at the Prado, then ten blocks away at the Museo Nacional Centro de Arte Reina Sofia.

I saw it years ago when it resided in New York, and again before the invasion of Iraq in 2001. The electric light bulb at the top sets the acid feel for the whole agonized howl of the grey, black, white, and off-white painting. In my last visit I really scrutinized the work, foot by foot. After the scrutiny I realized that, while with other works I am struck with my evolving perceptions, my impression of this work hasn't changed at all.

Across from this Spanish treasure there are six photographs of the evolution of the work. Picasso was constantly shifting focus and figures over the six weeks of its creation.

Compare it with Goya's *Third of May, 1808* in the Prado. Goya's *Third of May* portrays the French soldiers as an impersonal killing machine shooting the Spanish resisters who had murdered French troops in the Plaza del Sol the day before. The Spaniard in the white shirt, arms rigid in a V, eyes shimmering with terror, says it all about war and its consequences. The victims are either dead or desperately avoiding looking at the French rifles. Picasso expressed this slaughter in abstract harshness.

48. Burial of Count Orgaz

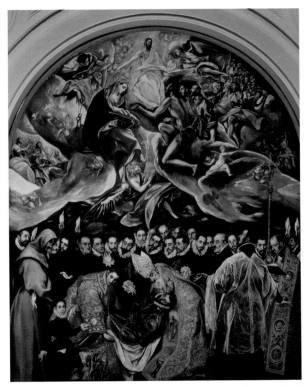

El Greco, 1586
Santo Tomé, Toledo
Photo: Scala / Art Resource, NY

It is in the apse of a small church, a separate area dedicated to the paint-
ing alone. There is no feeling of church, though, with a separate door,
money booth and charge of three euros. There is a distance of perhaps
nine feet between the viewer and picture. The dominant first impres-
sion is a black-robed line of men with white ruffs around their throats,
beneath serious black eyes. Count Orgaz in armour is being laid to rest
as in a deposition. Above, Mary riding clouds, an angel or two giving
it a touch of Correggio. One angel with immense wings is leading the
struggle up to Jesus.

I return to the men in line, most with pointy Vandyke beards. They

are all serious, cultured, mentally bright, mean. St. Augustin, the cardinal cradling Orgaz, is a picture of quiet reflection and solicitude. The large winged angel edging up the fissure through a chute in the clouds to reach Jesus is the only force of energy in the work.

This painting is wider than El Greco's usual thin, tall format. In the upper right there is a traffic jam of men aiming towards Jesus and, when there, bingo — heaven!

I note after a while that only men are going to heaven. Only the Virgin Mary and the angels are women. The hit of the painting is the row of men being the best Spanish society can produce, and the elaborate costumes of the front church officials.

One stunning trick is the translucent back of the priest's surplice in the front right. The swaying St. Augustin in a cardinal's peaked mitre bending, robed in gold across from the young priest, St. Stephen, in lighted gold vestments, creates a tapestry of dazzle, almost as if Vermeer had painted the patterns.

There is a self-portrait of El Greco in the piece: he is the only man looking directly at the viewer, with the face of a disciplined banker. El Greco's son in the front left, so serious — pop-up choirboy serious — is one of the few portraits in art that is not diminished by being described as "cute."

When I buy the detail postcards, they reveal a feathery perfection that is only apparent from a closeup viewing, which is denied you as there is a considerable space between viewer and Count Orgaz. So perhaps like St. Bavo's *Mystic Lamb* the actual viewing from too great a distance deprives you of the brilliance of the brush strokes; the feathery ruffs; the thin gauzed mantilla hood of the Virgin; the power of Christ distant; the golden embroidered collar of the young St. Stephen in the left forefront; the fan-like hand ensconced in a coral wrist cuff; the patterns on St. Augustin's cardinal's hat; the translucent black and white surplice of the priest.

Vermeer could do carpets: the patterns on the thick rugs or tapestries sing. Here El Greco has done it in gold vestments with patterns worthy of Van Eyck. Alas, the treasures can only be savoured by proximity. So my packet of pictures tells me what I missed.

THE GALLERIES

Museo Nacional del Prado, Madrid

Calle Ruiz de Alarcón 23, 28014 Madrid
Telephone: +34 (0)90 210 7077
Web: www.museodelprado.es

The Prado is one of the foremost galleries in the world. It is open every day but three in the year.

It is on the Paseo del Prado, an *avenida* with trees and a centre core of bushes, grass, and shade. The entrance for an individual is the Jerónimos entrance, closest to the Plaza Canovas del Castillo and across from the Thyssen-Bornemisza art museum.

We have already noted some of the great paintings by Goya, El Greco, and others in the Prado. Here are some other works worth seeing:

Pieter Bruegel the Elder's *Triumph of Death* is a great concentration camp of a work. Death the reaper, endless skeletons crushing the living, and all fall. Death with an extended empty howl.

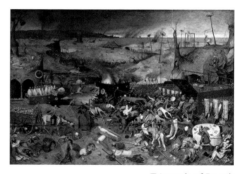

Triumph of Death
Bruegel, Pieter, the Elder, c. 1562
Photo: Scala / Art Resource, NY

In this time a dominant theme of thought was the inevitability of the Dance of Death. Here grey troops on the right march through all — including the sitting king on the left and the crouching jester on the right. The horse of death floats through with its skeleton rider scything all before it and in a second job pulling loads of skulls.

A gloomy vision of organized death.

131

Bloody Mary. The portrait is riveting for anyone who has studied the Tudors. For Queen Mary, who as a child in the tower was told she would have her head crushed "as a soft apple," life presented chal-

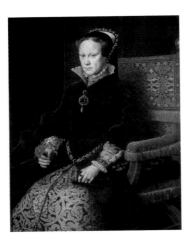

Mary I (Tudor), Queen of England
Mor, Anthonis, c. 1554
Photo: Scala / Art Resource, NY

lenges. She was the daughter of Henry VIII and Catherine of Aragon, Henry's first wife of huge European importance. Mary was not a looker and wanted to marry Emperor Charles V (also king of Spain), but that was not to be. In 1554 she did marry Charles's son, Philip II of Spain, her second nephew, eleven years younger. She became queen in 1553 and died in 1558. Repression was the sign of the times under both Henry VIII and Mary. There was many a head on a stake overseeing London bridges.

She holds in her hand a rose, symbol of the Tudors. The artist, Mor, was sent to London to portray her for Philip II.

Heaven knows what Philip must have thought when he saw this formidable fiancée. To me she is the old-fashioned schoolmarm catching a delinquent student whispering to a deskmate, her pale blue eyes all a river.

After she died, Charles V, a powerful force, decided he would retreat from kingly duties and he took this painting to his retreat. Odd. Hardly relaxing.

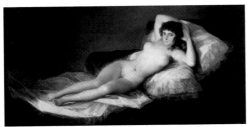

The Nude Maya
Goya (y Lucientes), Francisco de, c. 1789–1805
Photo: Scala / Art Resource, NY

The Inquisition forbade nudity. This isn't a portrayal of nudity with its sense of innocence — this is sheer naked.

Up to this time nudity was introduced by a mythological or religious context. Here the young woman leers at the viewer, no

props, no diversions, just sheer commercial lust. Goya was called up before the Inquisition, but there's no record of his explanation. Prime Minister Godoy had a clothed Maya by Goya on a pulley over the naked Maya. Whether or not Godoy would raise the pulley would depend on who his guest was.

The Nude Maya is awkward, stiff, with a head plunked on top. Not much eroticism here.

At the time there was some suspicion that the model was the Duchess of Alba, a leading member of the aristocracy. So long has the rumour persisted that in 1945 the then Duke of Alba had her disinterred to ascertain her height so that the allegation could be refuted. Paul Johnson indicates that the results of this review weren't made public.

I love the flow of this, the grasping, the crouching fervour, the swoosh of emotion. In an odd way this is my favourite here. Opera melds with religion and yet it doesn't lessen the message of it.

Imagine my irritation when I read in a note next to the painting, "The involvement of Titian's studio in the execution of the painting is evident in the unresolved foreshortening of the arm supported by the Virgin and the general simplification of the details."

NONSENSE!

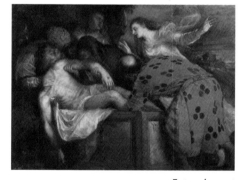

Entombment
Titian (Tiziano Vecellio), 1566
Photo: Scala / Art Resource, NY

Museo Thyssen-Bornemisza, Madrid

Palacio de Villahermosa, Paseo del Prado 8, 28014 Madrid
Telephone: +34 (0)90 276 0511
Web: www.museothyssen.org

The Museo Thyssen-Bornemisza has its own attractions, most notably Room 28, its room of rococo masters. Rococo was perhaps precious, frivolous, stressing silks, gowns, and gossip, but it could be delicate as perfume. In music, if baroque was the strident horn, rococo was a clarinet.

Room 28 has Jean Antoine Watteau's *Pierrot Content*, Nicolas Lancret's *The Swing*, Jean-Baptiste Pater's *Concerto Compestre*, Jean-Honoré Fragonard's *The See Saw*, and a painting by François Boucher, the perkiest of the bunch. Seeing them side by side gives you a lesson on one wall in the entire rococo métier.

Also in the Thyssen-Bornemisza, in addition to the Caravaggio, Cézanne, Manet, Durer, and Courbet noted earlier, are these paintings:

Mrs. Charles Russell
Sargent, John Singer, 1908
Photo: Museo Thyssen-Bornemisza /
Scala / Art Resource, NY

Sargent was a very successful American portrait painter of the grand manner. He was born in Florence and lived primarily in Europe. He was a friend of Monet's, an acolyte of the Frans Hals and Velázquez method. He revealed the nouveaux riches, a spoiled clientele. He has a magnificent portrait of two girls with a large urn in the Boston Museum.

Here, a sketch, a flirtatious pose of a difficult woman. But the dress, a stagey abstract sketch portrait, executed with assured fluid paint. A rippled water reflection of an impressionist pattern. As light as the touch of a moth. All so "other world," near jaded. One brush stroke, no reworking. Look at her — all shimmering and elusive. A tired nouveau riche.

Would you be happy if you were Mr. Russell? I think not, but it must have reminded him of the difficult nature of his partner. Anyway, the dress is lovely. But don't ask her to go out for the groceries.

De Hooch was a competitor of Vermeer and some of his works used to be attributed to Vermeer.

One summary of his life describes him as follows: "He died insane, but little is known of his life. After 1665 portrayed rich interiors with a bogus view of pseudo-aristocratic life. His very late work is feeble."[4]

Well, I don't know, Vermeer surely portrayed rich interiors too.

This one is the crème de la crème, a grand hall with a staged curtain, before a kind of Caravaggio painting next to a wall covering worthy of Rothko above irregular patterns of a marble floor.

An open stage set with the performers all standing on their marked cue spots. The ultimate presentation of theatre.

Interior of the Council Chamber of Amsterdam Town Hall
de Hooch, Pieter, c. 1663–65
Photo: Museo Thyssen-Bornemisza /
Scala / Art Resource, NY

So tiny, so perfect. How can a painting so small be so utterly entrancing? The tiny flowers on each side of the throne done 227 years before Vermeer in his prime in 1660! Imagine — 227 years before Vermeer and Rembrandt!

This tiny picture has many gems. The frieze on the top has figures depicting the Annunciation, the Visitation of the Magi, the Coronation, the Resurrection, and the Pentecost. See the sparkle of the crown!

Virgin and Child Enthroned
Van der Weyden, Rogier, 1433
Photo: Museo Thyssen-Bornemisza /
Scala / Art Resource, NY

Museo Nacional Centro de Arte Reina Sofia, Madrid

Calle Santa Isabel 52, 28012 Madrid
Telephone: +34 (0)91 774 1000
Web: www.museoreinasofia.es

Santo Tomé, Toledo

Plaza del Conde 4, 45002 Toledo, Castile–La Mancha
Telephone: +34 (0)92 525 6098
Web: www.santotome.org

4

ITALY
(Rome and Vatican City)

For anyone interested in experiencing the best in European art, a trip to Rome is a must. The Vatican and the surrounding chapels and galleries house one of the world's most extensive and impressive collections of Western religious art.

A visit to the Vatican requires courage and planning. You must be willing to face hordes of visitors — pious pilgrims, naive students, gawking shutterbugs, and self-important dilettantes — all crowding seemingly endless lineups. It is definitely worth the expense to join a tour or to have your hotel arrange a guide who can get you in and lead you to the **Sistine Chapel**.

The tourists stand in line for hours, proceeding through endless Vatican memorabilia of popes long past and incomprehensible maps. As they pass through the **Vatican Museum**, they reach the Raphael Room, which, though crowded and poorly lit, houses the superb *Delivery of St. Peter*. Eventually, they are shoved through to reach their ultimate goal, the *Capella Sistina* — the chapel of the pope — with its Michelangelo ceiling and *Last Judgment*.

The chapel is a hubbub, a sea of noise. Signs say no cameras, yet everyone is clicking, flashing, whirring, blazing away. The rumble of talk swings up towards a crescendo then, with the constant admonition of the Vatican Swiss Guards imploring *"silenzio,"* the sound falls off a bit — only to surge up again moments later. (I used to lecture in the

chapel. I know not how, but I did. The crowds would congregate, timid fish, listening then darting to another group. If I was in good form, with sonorous voice, I would get the outer fish for my whole tour. Rarely did the cheapies ever tip!)

Immediately adjacent to the entrance of the Sistine Vatican complex is the **Vatican Gallery**. Though renowned for its collection, I think that it holds only one truly remarkable painting — Caravaggio's *Deposition* (1604). The Vatican is extraordinary, but the hordes — and I do mean galloping, giggling hordes, all running up the escalators — do discourage.

Fortunately, the other Roman sites are easy and accessible. The **Galleria Doria Pamphilj** is an oasis of quiet in the bustle of the main street. A cloistered and cool delight, the gallery has been a family collection since 1651. It was established by Giovanni Battista Pamphili who, in 1644, became Pope Innocent X. The collection was assembled "under the encumbrance of entail" — which means that it cannot be broken up or sold.

Because Rome is a walking city, a visit by foot to the **Popolo** church or to **Il Gesù** may be the high point of your trip. Built between 1568 and 1584, Il Gesù — the first Jesuit church established in Rome — epitomizes both the Jesuit philosophy and Counter-Reformation baroque architecture. The church has a huge nave with side pulpits to preach to large crowds. The decoration of the nave, which is the stunner of the church, was added a century later. The *trompe l'oeil* message (a tricking of the eye that makes it look like something it's not) was a confident trumpet blast: Roman Catholic worshippers will be joyfully uplifted to heaven while Protestants and other heretics are flung to Hell's furnaces!

Visitors to Rome must also see the **Borghese Gallery**. Set in a lovely park overlooking Rome, it houses a varied collection of early Roman sculptures, sculptures of the Italian baroque, and a wide variety of paintings. It is worth a visit as it reveals the breadth and discipline necessary in a truly great collection of art. There is a particular joy that comes from viewing masterpieces thoughtfully arranged within elegantly furnished rooms.

THE PAINTINGS

49. Ceiling of the Sistine Chapel

The Libyan Sibyl, detail of the Sistine Chapel ceiling
Michelangelo Buonarroti, c. 1511
Sistine Chapel, Vatican Palace, Vatican City
Photo: Scala / Art Resource, NY

The Sistine ceiling is difficult to look at. The noise and crowd of the tourists prevent you from finding a private viewing spot. There is so much that the eye wanders and you get nervous, losing focus.

This ceiling was started in May 1508, was half done by August 1510 when Pope Julius ran out of money, started again in February 1511, and was finished in October 1512. Michelangelo was a sculptor at heart and viewed painting as women's work. No matter, he got the hang of

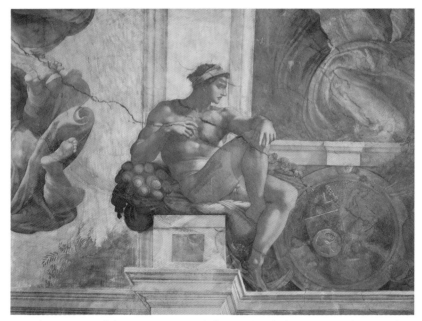

Ignudo (Creation of the Sun, Moon, and Plants), detail of the Sistine Chapel ceiling
Michelangelo Buonarroti, c. 1511
Sistine Chapel, Vatican Palace, Vatican City
Photo: Scala / Art Resource, NY

it and as he progressed through the stages of the ceiling his fresco abilities improved, figures became larger, simpler, scenes less crowded. At some point Julius ordered the scaffolding down so he could see the work from sixty feet away. This seemed to give Michelangelo a change of perspective. He painted freely, quickly, often ignoring the slow process of using the charcoal sprocket to outline shapes in the wet plaster — called pouncing — which created charcoal-dusted pinholes that mark the cartoon outline with charcoal.

Michelangelo rebelled at the sheer labour of it. His sonnet of 1510: "I've already grown a goiter … which sticks my stomach by force beneath my chin. With my beard toward heaven, I feel my memory-box atop my hump … my loins have entered my belly and I make my ass a crupper as a counterweight … In front of me my hide is stretching out and to wrinkle up behind, it forms a knot."

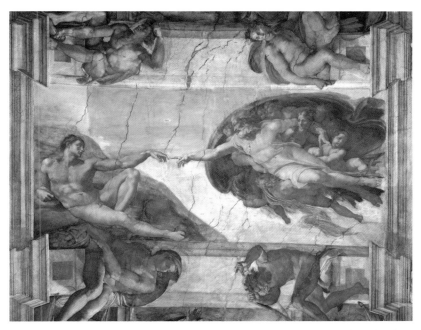

The Creation of Adam, detail of the Sistine Chapel ceiling
Michelangelo Buonarroti, c. 1510
Sistine Chapel, Vatican Palace, Vatican City
Photo: Scala / Art Resource, NY

Three of my favourite pictures in the ceiling are *The Libyan Sibyl*, one of the ignudi, and *The Creation of Adam*.

"Sibyl" is from the ancient Greek *sibylla* meaning "prophetess." In classical mythology as altered by medieval monks, the Libyan Sibyl spoke of the Final Day: "Behold the day shall come and the Lord shall lighten the thick darkness and the bonds of the synagogue shall part, and the lips of men shall be silent; and they shall see the king of the living."

On the side next to Jonah at the end is an immense torso in a lemon yellow garment, back turned to us, head side profile, reaching for the huge text prophesying the king of the living. She is next to the centre panel of the Creator separating light from dark, just as the prophecy says. I love the colour. I love the artificial arc of the body, one of the few times Michelangelo painted a sexy woman, not merely a man with

breasts. The side of the gown has a split to it, an entrance so to speak. In spite of the vast size, the feet arched render a dainty touch.

Then there are the ignudi — twenty of them, athletic nude men at the edges of each biblical main scene. With their fluidity and rhythm they create a chain of flesh binding the pictures. Lovely nudes whose presence created havoc. Pope Adrian VI saw the ceiling as a stew of naked bodies. My favourite is the demure coiled ignudo seated with knee up, toe laced under the other calf, atop a garland of acorns, hand regally resting on a naked knee. The acorns resemble the penis, in Tuscan slang *lesta da cazzo*. The acorn was the symbol of the della Rovere family, to which Julius belonged. This ignudo is located above Jeremiah in a deep funk of introspective gloom and near to God creating the sun and moon. Jeremiah sitting under this has a lot to worry about.

Then there is *The Creation of Adam* — Adam reclining in languor, utterly sated. As Sir Kenneth Clark says in *Civilization*, "A man with a body of unprecedented splendour is reclining." God reaching, finger close sending a *scintilla divinitatis*, a spark of life. God in his smooth shell of bodies — we can see his face. Moses, when he received the tablets, could only see God's backside. Here the ultimate Renaissance pride and conceit that only man is made in God's image.

50. The Last Judgment

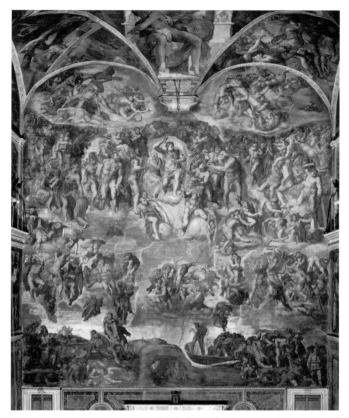

Michelangelo Buonarroti, c. 1537–41
Sistine Chapel, Vatican Palace, Vatican City
Photo: Scala / Art Resource, NY

Last judgments were a theme of many painters before Michelangelo did his fresco on the altar wall of the Sistine Chapel, where cardinals celebrated mass. After he finished, very few artists tried it.

The biblical setting for the last judgment can be found in the Gospel of Matthew (13:40–43):

> Just as the weeds are collected and burned up with fire,
> so will it be at the end of the age. The Son of Man will
> send his angels and they will collect out of his kingdom

all causes of sin and all evildoers, and they will throw them into the furnace of fire, where there will be weeping and gnashing of teeth. Then the righteous will shine like the sun in the Kingdom of their Father. Let anyone with ears listen.

Last judgments embody a number of themes. Uually there are three elements: in the centre, Christ in the act of judgment (portrayed either as dignified or as vengeful); on the left side of the work, the elect proceeding to heaven (either with a struggle or a gentle passage); and on the right, the artist's delight — the area or pit of the damned, usually with monsters dragging them to a cauldron of fire or to a satanic monster's jaws. Michelangelo has eliminated the weighing of the souls by Satan and St. Michael in order to decide who wins and who loses.

This work requires real attention — and binoculars.

The entire fresco is in motion with the dynamic Christ at its centre, all pulsing from the unrelenting Judge Jesus whose mighty extended arm pushes the fresco. His hands keep hundreds of figures circling. For the first time Christ is shown beardless and here with an aspect of a muscled Zeus showering thunderbolts below. St. John the Baptist on his left is huge and horrified. Mary cowers under Jesus. The blessed ascend, the damned fall. There is no Satan here, no hoofs nor tails nor pitchforks, no tortures of the damned, but the meaning of Hell is frightfully clear. The lost soul in the lower right with hand over one eye, his half-face in fear, horror, and hopelessness, is being pulled down by three demons. Here the anguish of the cast-off damned inspires horror.

It is a melée of fierce struggles between angels and demons for new souls. The result depends on the relative force of the contesting angel and demon rather than on the state of the blessed soul. Fierce fights abound. On the lower right angels fight to keep demons down. Michelangelo has introduced Charon from Dante's *Divine Comedy* who ferries the damned across the River Acheron, whacking with his oar any cringing body within reach. This part of *The Last Judgment* is so striking that it deserves to be considered separately.

Michelangelo glorified the nude male and female bodies. Needless to say, his novel approach caused a furor.

Aretino, a notorious writer, gossip, scandalizer — a man of murky reputation, raged, "I as one baptized am ashamed of the license, so harmful to the spirit, which you have adopted. How could you have shown impiety of religion in the foremost temple of God? Above the main altar of Jesus? What you have done would be appropriate in a voluptuous whorehouse, not in a supreme choir."

But on another occasion the slippery Aretino defended the naked parts, by insisting "excessive freedom in the portrayal of nudity [was] a source of particular vexation to the Protestants." Michelangelo portrayed Bartholomew (skinned alive) as Aretino in the fresco.

Daniele da Volterra, a painter, was called in to paint over nudes and add loincloths.

Michelangelo was a recluse of a sort, a composer of sonnets, a solitary, constantly unwashed stocky man, smelly, with a broken nose, his leggings virtually rotting. His self-portrait as the dangling skin (the most disquieting self-portrait ever) held by St. Bartholomew looking reproachfully at Christ, I suppose asking him whether he, Michelangelo, should be saved or fall. At this time Michelangelo was depressed, revealed in his sonnets. He felt hard done by:

> Here I am poor and alone
> enclosed like a pith in its rind
> or like a spirit holed up in a decanter
> and my dark tomb allows little flight ...
> About the exit are dung heaps of giants
>
> Melancholy is my joy
> I have a voice like a hornet in an oil jar
> coming from a leathern cask and
> a halter of bones
>
> My face has a shape which
> strikes terror
> Precious art, in which for a while

 I enjoyed such renown
has left me in this state
Poor, old and a slave in
 others' power
I am undone if I do not die soon.

Ouch! But he did die a rich man.

51. The Last Judgment — Transporting the Dead

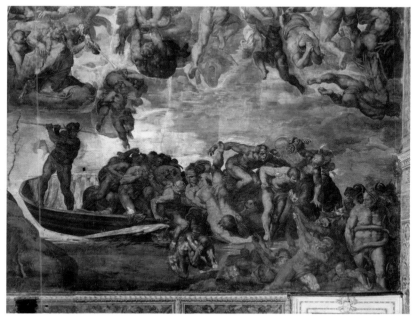

Detail of *The Last Judgment* (lower right)
Michelangelo Buonarroti, c. 1537–41
Sistine Chapel, Vatican Palace, Vatican City
Photo: Scala / Art Resource, NY

In the lower right of Michelangelo's *Last Judgment*, the ferryman Charon and the serpent-coiled Minos of the *Divine Comedy* are surrounded by cringing, shrieking individuals. Each has a distinct face, almost a personality. Strange, but there is no sense of mystical force, nor a portrayal of divinity. It is a dazzler of brutish bodies.

The mythological rivers Styx and Acheron formed the boundaries between Earth and Hades. They converged in the centre of the underworld. Gods swore oaths on the River Styx. If they broke the oaths they were compelled to drink from the river and lost their voice for nine years, followed by expulsion from the Council of Gods for nine years. Charon transported the newly dead (Dante placed him on the Acheron) over the river. He was paid an obolus, a Greek coin, a pittance.

Spenser in *The Faerie Queene*: "They pass the bitter waves of Acheron, where many souls sit wailing woefully."

Biagio de Cesena was the papal master of ceremonies. He had tried to persuade the pope to stop the painting of *The Last Judgment*, complaining that the nude figures were shamefully exposed, fit only for public bath or tavern. Michelangelo's revenge was depicting Cesena as Minos (the consummate emblem of evil), a judge in Hades in Greek mythology. A great serpent curls around his legs among a heap of devils in Hell. The snake serpent bites Cesena's penis.

His family pleaded with the pope to paint him out. The pope refused, saying that if Michelangelo had consigned him to Purgatory he could have helped, but over Hell he had no power.

52. Delivery of St. Peter in the Stanza d'Eliodoro

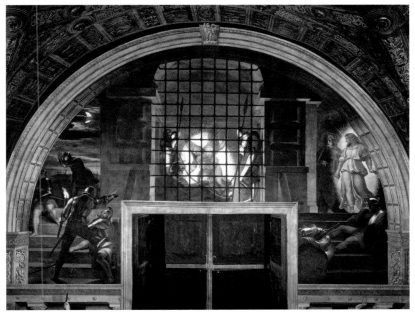

Raphael (Raffaello Sanzio), c. 1511–14
Stanze di Raffaello, Vatican Museum, Vatican Palace, Vatican City
Photo: Alinari / Art Resource, NY

The litany of the High Renaissance was always Michelangelo, Leonardo, and Raphael. Raphael, who died at thirty-seven, was talented, a superb draughtsman, a painter of virgin pulchritude, a master. No friend of Michelangelo though. He was a diligent, tactful painter who got along with his customers. I have picked his *Baldassare Castiglione* in the Louvre because of its subtlety.

In the Raphael Room, adjacent to the Sistine Chapel, he frescoed a number of stage sets. His *Delivery of St. Peter* is the ultimate expression of dramatic stage light and sense of the intervening saviour angel. If you ever dream of an angel plucking you from disaster, radiating a religious glow of support, this is, or should be, your dream.

St. Peter, facing execution on the morrow, is visited by an angel: "And the angel said to him, gird thyself, and bind on thy sandals. And

so he did. And he saith unto him, cast thy garment about thee and follow me." Peter is led out of prison, the doors spring open, and the guards are asleep.

Julius II, the militant pope of Michelangelo's Sistine ceiling, is portrayed as St. Peter. In 1511 the schismatic council of Pisa tried to depose Julius. The attempt failed and he survived in office. We see St. Peter behind bars, asleep, awakened by the angel, leaving with the angel slipping over sleeping guards and in the left scene, the guards noisily calling the alarm.

There is a remarkable variation of light. The angel's light in the centre is blinding, so much so it dissolves the forms of the prison and the guards. The juxtaposition with the prison bars magnifies the light. On the right, with the liberation of St. Peter, a softer light for the quiet slipping past the guards. On the left, flickering torchlight playing off the guards and architecture, the glow of the rising sun tingeing the far-off horizon with yellow, orange, and pink, and the silvery moonlight reflecting off the clouds.

Church militant, church triumphant — that is the message.

53. Deposition

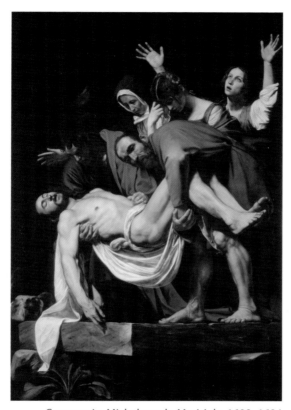

Caravaggio, Michelangelo Merisi da, 1600–1604
Pinacoteca, Vatican Museums, Vatican City
Photo: Scala / Art Resource, NY

Christ's feet caked with blood. Joseph, dirty feet, lowering Christ, clearly dead, neither of great weight nor light, with all about as tender as workmen could be. The white linen wrap forms the picture as it spirals down and around Christ.

Michelangelo's *Pietà* was the accepted model of dead Jesus, slender and graceful with a young mother. Caravaggio here was competitive. The Madonna is old. Christ's body is not delicate at all, heavy-veined, dirty feet, big hip bone. John's fingers press on Christ's wound. Christ is brusquely handled. All this was new.

54. Pope Innocent X

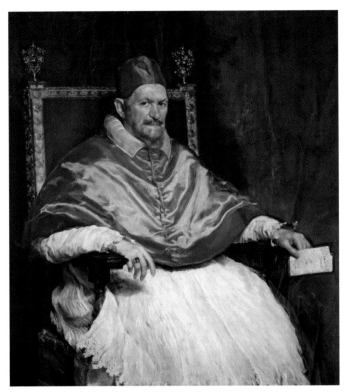

Velázquez, Diego Rodriguez, 1650
Galleria Doria Pamphilj, Rome

Photo: © ADP — licensed by Fratelli Alinari / Art Resource, NY. Alinari / Art Resource, NY

Pope Innocent X was extraordinarily ugly — so much so that it was considered to be a block to his papal ambitions. He was a seventy-six-year-old with the bearing, voice, and complexion of an adolescent, a man mistrustful of others. Tenacious, tireless, cunning as a rat.

The letter in his hand is a petition of Velázquez to enter the Order of the Knights of Santiago, the highest order of nobles in Spain. The committee in Spain receiving it refused to accept Velázquez's supposed noble ancestry, and demanded proof that he had neither Jewish nor Moorish blood. The pope intervened, and in 1659 the Order was at last conferred.

When Innocent first saw the painting he recoiled in horror, saying, "*Il troppo verro*" — it's too real. But he liked the portrait with its variety of reds, the muted maroon of the backdrop, the shiny crimson of the cloak, the rushing flow of the white dress, the pure steel of the eyes. The Pope's look: "Don't you even think about it," or "So you say — but I'm not that stupid," or "Stop, right where you are!"

When I saw *Innocent X* again in September 2008, maybe thirty years after I first saw it, I noticed that the white linen of his laced white gown sets off a ringed hand — at first blush effeminate; now, upon reflection, an iron grapple. The ruddy red, awash throughout the painting, the colour of blood, sets off the agate eyes, mean, quick — nothing, but nothing, escapes these eyes.

The finest portrait of all? Perhaps.

55. Triumph of the Name of Jesus

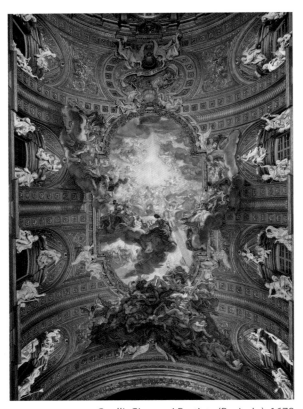

Gaulli, Giovanni Battista (Baciccio), 1679
Il Gesù, Rome
Photo: Scala / Art Resource, NY

I used to hold a prejudice that baroque church ceilings of floating figures, chariots, trumpets, and divine blazes were the candy floss of painting. Sweet, no substance, gone in a minute with only a vaguely annoying taste on the rim of the lip.

Yet in September 2008 I fell into the habit of visiting Il Gesù, close to my hotel. By the third time I was caught.

The huge nave is a barrel vault with golden rosettes ribbing the entire length. The nave decorations I wish to enthuse about were done between 1672 and 1685 by one Giovanni Battista Gaulli. I don't

have the faintest idea who he was, what he thought, or how difficult this thirteen-year nave creation/struggle was. No matter, it's boffo, a bell-tinkling triumph, all trumpet blast: *down* with the Protestants, *every last one of them*!

What all this ceiling, titled *Triumph of the Name of Jesus*, is about is perhaps beyond me. Angels and the blessed blast up through the heavens to reach IHS, the name of Jesus, in triumph. Near the end of the nave there is a tumble of the damned.

There is a tilted mirror on the floor which allows you to look up without craning your neck. It points at the portrayal of perhaps sixteen figures of huge size, fleeing a blast of revenge and damnation from above, hurtling down till they meet two stucco-white angels at the edge of the cupola. Their dashing slide stops as the angels force a seashell to stop their flow.

This is quintessential baroque, a grand mixture of sculpture, architecture, painting, and carved rosettes and ribs of vaulting. It is as if Bernini has popped up everywhere with glorious saints and martyrs in full operatic tenor mode. This is a symphony. All the good are floating up to heaven and the insignia IHS. They are surrounded by many angels, blond, wriggling, porky Rubenesque kids, all floating up, up, and away.

There is a grey, near-rain cloud with elegant figures perched atop, all dressed in elegant Veronese robes, turbulent, of ice cream Italian colour variety — pistachio, limone. I look up, their rich gaudy robes, breeches, fluttering dresses, up to heaven beyond. I am peeking up to their underwear. They straddle the cloud on the edge of the nave with ease, foot in leather boot hanging with a casual dangle.

The mirror at a tilt reflects the ceiling well enough but it appears to insert your own face and torso in the tumbling, scrabbling figures hurtling to Hell.

What brings me again and again is that the clouds are so real, so extended beyond the ceiling as if they were stucco, paper maché, grey turbulent forces spreading shadows over the gold rosettes!

There is light from the main window of the façade on this Roman afternoon. The shadow smears over the gold rosettes. Quite distinct.

So it must be a sculpted cloud throwing the shadow. But the shadow is in the same place on the rosette at 8:30 and 10:00 a.m., 4:30 and 6:30 p.m. What is going on? There would have to be a variance of shadow if the clouds were extended from the ceiling. What is going on is that the artist has painted the shadow on the rosettes. It is clearer on the large cast of shadow thrown from the figures hurtling to Hell.

All this gives me supreme joy and a grand giggle. Good for the Jesuits — albeit they could be tough and nasty.

56. The Conversion of St. Paul and The Crucifixion of St. Peter

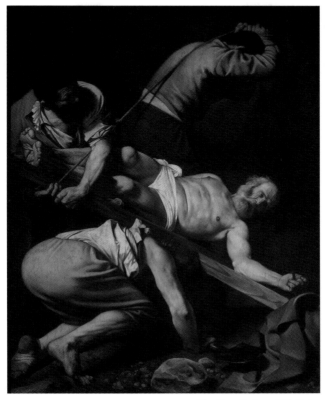

The Crucifixion of St. Peter
Caravaggio, Michelangelo Merisi da, 1600–1601
Church of Santa Maria del Popolo, Rome
Photo: Scala / Art Resource, NY

Michelangelo Merisi was born in Caravaggio in 1571. He was successful, and was courted by the church, but all through this stream of success he was embroiled in a litany of repeated violence. His life is well documented in police records. He fought a duel, killed a man, fled Rome, joined the Knights of Malta, insulted a superior, was jailed, escaped, received a papal pardon, and died of a malignant fever while returning to Rome in 1610.

The Conversion of St. Paul
Caravaggio, Michelangelo Merisi da, 1600–1601
Church of Santa Maria del Popolo, Rome
Photo: Scala / Art Resource, NY

Today he is considered one of the foremost baroque artists, argu-
ably the finest painter of his time, certainly a painter who communi-
cates with the modern viewer. But he was not embraced by the art
critics until the 1950s. His paintings were contentious. In the view of
John Ruskin, the great English art critic of the nineteenth century,
Caravaggio fed "upon horror and ugliness and filthiness of sin" and he
was "among the worshippers of the depraved." Bernard Berenson, the
legendary art critic of the 1940s and 1950s, wrote that "he was quick
tempered and bad tempered, intolerant, envious, jealous, spiteful,
quarrelsome, a street brawler, a homicide and perhaps a homosexual."

Why the furor?

In 1600 there were two conventions for artists. Art should represent ideal beauty, perfect proportion, and classical decorum. Also, a finished canvas should rely on many preparatory drawings. Caravaggio painted directly on canvas without elaborate planning and preparatory drawing. Not a single one of his drawings exists today.

However, he turned the art world upside down by placing at centre stage the poor, the labourer, and the servant as saints. This ran against the convention of the time. There are no cherubs, no delicate rendition of religious tranquillity.

The Conversion of St. Paul and *The Crucifixion of St. Peter* are in the Cerasi family chapel in the Church of Santa Maria del Popolo in Rome. They are opposite each other and hard to see unless you put money in a light box which illuminates the scene.

The Conversion of St. Paul was a popular theme for artists of the Renaissance.

Saul, a soldier on the way to Damascus to continue his persecution of Christians, was struck by a blinding light. He fell off his horse, hit the ground, had a vision of Jesus, and became the Apostle Paul.

Here Paul is frozen in a camera flash, with an ordinary horse methodically sidestepping to avoid him as he is whumped on his back, arms in a V, subject to the quizzical look of the horse's attendant. All very natural, yet there is a sense of electric shock in Paul. The Conversion is swarming in Paul's head, miles away.

Other renditions portray crowds, as Saul was part of a march, a blinding light, horses rearing, cowering soldiers, and perhaps an image of Christ. In short, chaos. (For instance Bruegel's *Conversion of St. Paul* in the Kunsthistorisches Museum, Vienna.)

Here the colour of the horse is difficult to capture in words, a subtle confluence of browns, greys, creams, and running black — a dappled dreamy off-brown, but the horse's silky shanks are etched in my memory.

Maybe I'm in love with the cocoa colour of the pinto horse's flank, the white of the horse's shank and shoulder setting off the creamy chocolate syrup of the sleek belly, as well as the sense of quiet stillness

with the attendant caring for the horse, a sensible thing, so it doesn't skitter and trample Paul. The details of the attendant's huge hand on the horse's bit, his veined legs, bigger than the horse's, his big dirty toenail, his knobbly toe, all real. No stamping, rearing horses here as a result of the focused purpose of a trainer doing his primary job.

The Crucifixion of St. Peter is a portrait of strain and awkward discomfort, three sinewy workmen methodically doing their job, unconcerned about Peter. One can feel the workmen spit in their callused hands while heaving to the menial task of nailing Peter's hands and feet.

St. Peter — dirty feet, a heavy power, straining up — is awkward, aggressive, yet looking to some far-off place where he can escape this excruciating torture. He is alone, at the end of his life, yet looking both past and forward. How can an artist capture such an elusive concept with mere paint?

There is a problem that begins to niggle. St. Peter has a huge rusty nail through his left hand and I assume beyond my vision a corresponding dirty spike through his right palm plus one through each foot. Yikes! I know he is a martyr, but surely he should be shrieking himself silly and his effort to roll up must be tearing his right hand. Where's the pain?

I see Peter saying, "Oh Lord, what have I got myself into?" A resignation surrounded by carpenters' hands and filthy feet.

Is this painting so improbable that it shouldn't be revered?

Other artists were shocked and stimulated by Caravaggio.

In addition to the Church of Santa Maria del' Popolo, you must also visit another church in Rome, S. Luigi dei Francesci near the Piazza Navona, where Caravaggio, in a cheery canvas entitled *The Calling of St. Matthew*, captures all light theatre and the moment of Matthew's conversion. The tax collector in a pub surrounded by men/boys purring over money. Matthew is surprised, "Who? Me?" Nearby is *The Martyrdom of St. Matthew*, all drama, all stage, so much so you are horrified at the murder. You're there, you should jump in, up, forward, stop it all, right now, get going!

THE GALLERIES

Sistine Chapel, Vatican City

Viale Vaticano, 00120 Città del Vaticano
Telephone: 0039 06 69884676
Web: www.vatican.va

Though there is much to see in the Sistine Chapel, Michelangelo's ceiling is, of course, the ultimate delight. In addition to the three frescoes which I've described above, one more is among my favourites.

God creating the sun, moon, and plants is a *force*. God's visage one of *terribilità*, an Italian word that catches the ferocity and primal thunder of the act of creation. Here on the fourth day of creation, "God made the two great lights, the greater light to rule the day and the lesser light to rule the night." The sun and moon but bowling balls caught in his hurricane of swoosh. God floating yet powering forth with humankind sheltering under the shadow of His wrath.

Creation of the Sun, Moon, and Plants, detail of the Sistine Chapel ceiling
Michelangelo Buonarroti, c. 1511
Sistine Chapel, Vatican Palace, Vatican City
Photo: Scala / Art Resource, NY

Vatican Museum, Vatican City

Viale Vaticano, 00165 Città del Vaticano
Telephone: 0039 06 69884676
Web: www.museivaticani.va

Vatican Art Gallery, Vatican City

Viale Vaticano, 00165 Città del Vaticano
Telephone: 0039 06 69884676
Web: www.museivaticani.va

Galleria Doria Pamphilj, Rome

Via del Corso, 305, 00186 Rome
Telephone: +39 06 6797323
Web: www.doriapamphilj.it

The Doria Pamphilj is still among the many land holdings of the immensely wealthy family whose ancestors created the gallery — and they remain active in its management. Indeed, the audio-taped gallery tour features the current son, a sophisticated English raconteur. He tells of his descent from Donna Olimpia Maidalchini (1594–1657), wife to Pamphilio Pamphilj and lover to his brother the pope. She pushed Innocent to be pope and then profited from it.

She persuaded the pope that it was immoral for the papacy to receive profits from numerous brothels in Rome. She had the profits assigned to the House of Pamphilj. To protect her "investment," she placed the family symbol over the door of each brothel, which alerted the police to buzz off. She was such a formidable power behind the papal throne that visitors to the pope took to stopping off first to see "La Papesse Donna Olimpia." Innocent X discovered this and their relationship cooled.

Velázquez's portrait of Pope Innocent X is next to a bust of Innocent by the famous Gian Lorenzo Bernini (1598–1680), a tireless worker who perhaps was the greatest consistent sculptor of them all. In fact there are two Bernini busts of Innocent. One has a split through the entire jawline. Bernini then created another in ten days! Ten days to do this subtle marble masterpiece of brooding arrogance.

If you have followed my basic admonition to look only at certain specified paintings while ignoring all others (here room upon room of landscapes by a cousin of Poussin), your eyes will be fresh. You will reach a lower hall near the exit that has two Caravaggios. His *Rest on the Flight to Egypt* (done when he was twenty-five) has an angel with a risqué backside playing a string instrument for Joseph. The Virgin, half reclining, is a picture of sweet innocence. Next to it the same model as Mary Magdalene in a luxurious prostitute dress of the time and in the same pose! A special added treat.

Il Gesù, Rome

Via degli Astalli, 16, 00186 Rome
Telephone: +39 06 69 70 01
Web: www.chiesadelgesu.org

At the apse of Il Gesù there is a sculpted figure by Bernini of San Roberto Bellarmino, the anti-Protestant Jesuit theologian who died in 1621. You must look at this. It is a marble portrait of a personality brimming with rectitude and moral certainty. Also a hint of sadness in his contemplation of souls, alas, gone astray — but not too much alas. No forgiveness in this pristine determination.

The other Jesuit church with a symphonic nave to see in Rome is Sant'Ignazio di Loyola with frescoes by Andrea Pozzo (1642–1709), celebrating St. Ignatius and the Jesuit order.

Its ceiling is all ablaze with illusionary pillars, columns, arches — a temple in the sky, but it also has an illusionary cupola under its huge dome. It is dark and appears to change when you view it from a

different vantage point. In fact it is a flat surface. The neighbours objected to a large domed cupola because it would create shadow and interfere with existing vistas. So the illusionary cupola, all dark and elusive, replaced it.

The church is in the Piazza di Sant'Ignazio, a subtle rococo square, a simple flute of architecture.

David with the Head of Goliath
Caravaggio, Michelangelo
Merisi da, c. 1606
Galleria Borghese, Rome
Photo: Scala / Ministero per i Beni e le
Attività culturali / Art Resource, NY

Borghese Gallery, Rome

Piazzale del Museo Borghese, 5, 00197 Rome
Telephone: +39 06 8413979
Web: www.galleriaborghese.it

This gallery houses a stunning display of Bernini sculptures. Also among my favourites here is a 1606 Caravaggio of David and Goliath:

Look at the glint of the thumbnail. Look at Goliath's shiny tooth. Perhaps a double portrait of Carvaggio, he as David and he as Goliath. For David, life will never be the same. One moment, one act, and youth has instantly passed.

Church of Santa Maria del Popolo, Rome

Piazza del Popolo, 12, 00187 Rome
Telephone: +39 06 361 0836

5

ITALY
(Venice and Florence)

The treasures of Rome and the Vatican, wonderful as they are, comprise only one small part of the riches of Italy. Indeed, I would go so far as to say that a visit to Venice and Florence is an essential experience for everyone hoping to experience Europe's art.

With water everywhere, Venice offers a unique experience. Navigating canals to reach each church or gallery turns every visit into an adventure. Venice is also the one European city in which you can easily get lost without worry. No matter which tiny, unnamed passageway you follow, you will end up at a canal and find your way back to St. Mark's Square.

Florence, Florence, you must visit Florence. It is a city of sculpture — Donatello, Michelangelo, Verrocchio, Ghiberti. It is a walking city, too touristy perhaps, but you must persevere. If you are careful to plan, and make reservations in advance, you will be able to avoid the horrendous lineups and spend your visit engrossed in your stunning surroundings.

57. Crucifixion

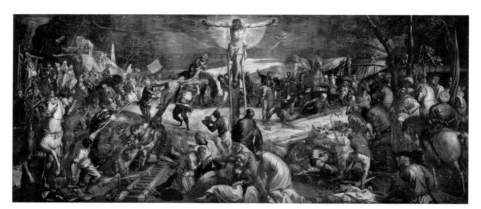

Tintoretto, Jacopo Robusti, 1565
Scuola Grande di S. Rocco, Venice
Photo: Scala / Art Resource, NY

Tintoretto's *Crucifixion* in Venice's Scuola Grande di S. Rocco is a circus of a painting with an evanescent Christ high up dominating workers, gawkers, potentates, hucksters, carpenters, crying women, and turbaned horsemen. Venetians in armour, Michelangeloesque workers are pulling, straining, and heaving, all in an eddy around Christ. Some viewers of wealth saddled on horses merely appraise, others gawk.

The Gospel of Matthew (27:33–50) sets the scene:

> And when they came to a place called Golgotha (which means place of a skull), they offered him wine to drink, mixed with gall; but when he tasted it, he would not drink it. And when they had crucified him, they divided his clothes among themselves by casting lots; then they sat down there and kept watch over him. Over his head

they put the charge against him, which read, "this is Jesus, the King of the Jews."

Then two bandits were crucified with him, one on his right and one on his left. Those who passed by derided him, shaking their heads and saying, "... If you are the son of God, come down from the cross." In the same way the chief priests also, along with the scribes and elders, were mocking him, saying, "He saved others; he cannot save himself. He is the King of Israel; let him come down from the cross now, and we will believe in him...."

From noon on, darkness came over the whole land until three in the afternoon. And about three o'clock Jesus cried with a loud voice, "Eli, Eli, lema sabachthani?" that is, "My God, my God, why have you forsaken me?" When some of the bystanders heard it, they said, "This man is calling for Elijah." At once one of them ran and got a sponge, filled it with sour wine, put it on a stick, and gave it to him to drink. But the others said, "Wait, let us see whether Elijah will come to save him." Then Jesus cried again with a loud voice and breathed his last.

The tumult of the crowd, the grief of the apostles, and the yearning of the penitent thief seem to come to a focus at Christ's head. There is a sense of excitement. We see Roman soldiers, skittish horses, and workmen heaving the thieves up on either side. Christ appears high above the throng, lit before a darkening sky. It is all part of an integrated scene — a disciplined swirl of energy inhabits this very large canvas. There is tense anticipation, horses in a still quiver, all in separate flows of energy, yet joined by a grey lateral sky.

The underlying dark (the priming) dominates the picture, which looks as if the action was in the middle of a thunderstorm illuminated by sudden flashes of lightning, creating a rich darkness.

Ruskin accused Tintoretto of painting with a broom because of his

brush strokes, known as *prestezza,* a series of rapid strokes that create an impression rather than detail. His contemporaries viewed this as deplorable hasty execution.

I suggest you take your binoculars and try to find the two men playing dice. Also find the ghostly silhouetted figures at the top right. See the anxious faces of the elderly in the left middle range. Who are the group in turbans on the left upper back? Note the workers, oblivious to all the opera about them, they are just concentrating on doing a heavy, sweaty job. The night, with its mixture of different groups, the sense of hustle, and the concentrated straining of the viewers make it a scene to remember.

By the fifteenth century it had become a convention to show the Virgin collapsed on the ground in a faint. The Council of Trent (1545–63) issued a directive to artists that St. John (19:25) wrote, "Near the cross stood his mother." Anyway, it suffered the fate of most civil servant directives — it was ignored.

When I wrestled with this painting, I searched elsewhere in Venice for a better or "easier" Tintoretto crucifixion. There is one in the Church of San Cassiano. On the left wall of the choir is a composition of the crucifixion turned to the side so the congregation can see it. It haunts my mind, all grey clouds above crossed lances, the insignia of Christ being carried on the ladder above his head. Although surrounded by the other two and the insignia bearer, he is utterly alone. Perhaps it offers a more effective message.

58. The Baptism of Christ

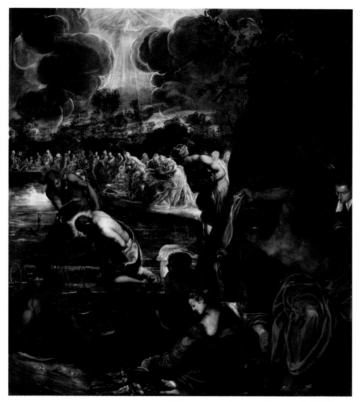

Tintoretto, Jacopo Robusti, 1579–81
Scuola Grande di S. Rocco, Venice
Photo: Scala / Art Resource, NY

The Baptism of Christ in a translucent pool is framed by a lateral parade of distant observers all on a level — a sort of chorus.

This work sends a shimmer of startling light piercing the crowds, rows of bending figures, ethereal compared to a muscular Christ bending under the water in the foreground. This special work mirrors a religious spirit.

59. Pietà

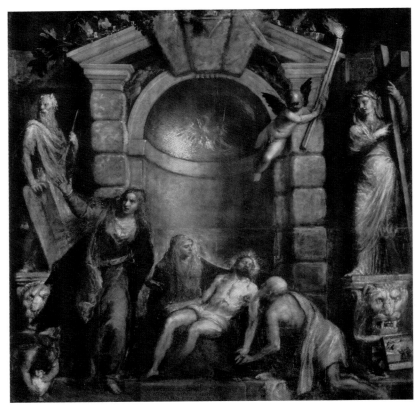

Titian (Tiziano Vecellio), 1576
Accademia Art Gallery, Venice
Photo: Scala / Art Resource, New York

What strikes one immediately about this painting is its size. The painting is huge (353 x 348 centimetres). It is generally dark, making the strong red, blue, and green robes stand out. Titian is immersed in the painting, having used his fingers as well as the ends of paint brushes to apply paint, all to extraordinary effect. As a whole, the *Pietà* is a viola chord of grief, pure, unadulterated, limitless grief.

Titian painted the *Pietà* as the plague was gathering strength. Indeed, he himself was a victim of the plague and died before he was able to finish the work; the final touches were completed by Jacopo Palma.

In the painting, Christ's chest is rent. One can see how Titian's fingers kneaded the grey-white paint. Exhaustion and illness are represented, the moment of transition suggested. One can detect a hint of resurrection, dead yet not dead.

And Mary Magdalene so angry! Hers is the haunting power, the resonating figure that lingers in one's memory. Maybe Mary Magdalene, with Moses and the Sibyl woman, holder of the cross, are all looking towards resurrection as predicted.

The square blocks made of hewn heavy stone that make up the huge niche where this drama unfolds give it a blunt gravitas, evoking permanence.

In the painting, the half-naked old man called variously Nicodemus, Joseph of Arimathea, St. Jerome, or even Job, lies prostrate asking for intercession by God for the next life. Nicodemeus approaching the *Pietà* is a self-portrait of Titian.

The painting contains some interesting symbols. Moses represents a prophecy of the Passion. The statue on the right is the Sibyl of the Hellespont, who prophesied both the Crucifixion and the Resurrection. We can see a pelican in the upper centre roundel. The pelican (it was thought) pecked at its breast to feed the young her blood, an allusion to Christ and his crucifixion.

On the lower right is a panel with two figures begging the Virgin for immunity from the plague. The figures are Titian and his son, Orazio. The plague struck them both down in Venice on August 27, 1576. Titian was buried the next day at the Frari basilica, in a state ceremony. Neither the plague nor this honour, however, prevented a mob from sacking his house.

60. Feast in the House of Levi

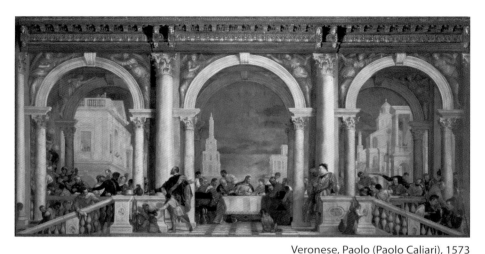

Veronese, Paolo (Paolo Caliari), 1573
Accademia Art Gallery, Venice
Photo: Alinari / Art Resource, NY

Veronese was all theatre, all show, all silk and satin, his paintings like a rich, creamy dessert. His scenes have the still-life feeling of an operatic aria, with all the costumed players having stopped for a breath. Oh, what elegance!

His *Feast in the House of Levi* depicts the last supper. It appears as a vast stage within a glorious architectural setting, including marble-streaked and pitted pillars. Christ and his companions sit at a long banquet table, surrounded on both sides by a variety of servants and jesters. Clothed in fantastic silks, they are frozen in their various actions.

The painting caused consternation and was prosecuted by a tribunal of the Inquisition. It riled the tribunal that such an array of additional characters was pictured at this solemn event. The judges questioned why a servant was depicted with a bleeding nose and demanded whether the painter thought it was "fitting at the Last Supper of the Lord to paint buffoons, drunkards, Germans, dwarfs, and similar vulgarities," noting that "in Germany and in other places infected with heresy [that is, the Reformation] it is customary with various pictures full of

scurrilousness and similar inventions to mock, vituperate, and scorn the things of the Holy Catholic Church in order to teach bad doctrines to foolish and ignorant people."[1]

The judges ordered Veronese to "improve and change his painting" at his own expense. Veronese refused to accept the tribunal's view and asserted he could decorate the picture as he saw fit and would paint what he wished. Because of the liberal religious atmosphere in Venice, he was never forced to make the changes demanded by the Inquisition tribunal. All parties seem to have been satisfied with a mere change of title, to *Supper in the House of Levi*. Veronese, however, never again painted Germans.

61. Portrait of a Young Man in His Study

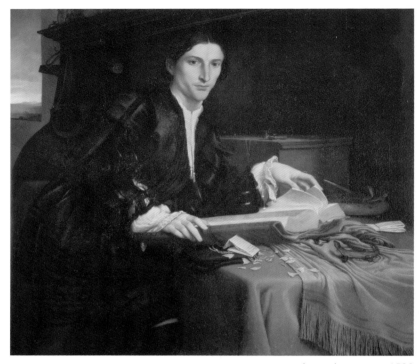

Lotto, Lorenzo, c. 1528
Accademia Art Gallery, Venice
Photo: Scala / Ministero per i Beni e le Attività culturali / Art Resource, NY

Lotto had the ability to paint portraits with a striking clarity. This one appears to be the ultimate portrait of a young introspective dandy.

The strewn rose petals, the broken-sealed letter, the ring on the table, all evoke a lost love. His pale face set off by the purple petals, his eyes insecure and worried.

Peter Humfrey, co-author of *Lorenzo Lotto*,[2] has summarized two possible interpretations of the sitter's personality. First, a playboy, with the lizard representing an insensitive failed lover; second, an introspective melancholic (rose petals in 1600 were thought to be a cure for melancholia).

62. Portico and Court in Venice

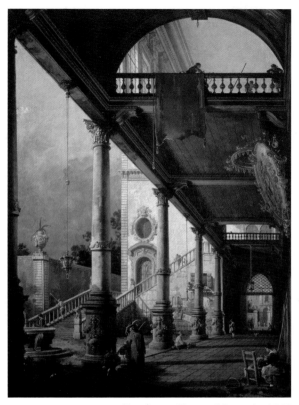

Canaletto, Giovanni Antonio, 1765
Accademia Art Gallery, Venice
Photo: Scala / Art Resource, NY

Canaletto did bright jewel-like points and sun-drenched perspectives. His *Portico and Court in Venice* brings out the best of his skill with detail.

The red curtain over the balustrade adds a magnificent touch of everyday living. We can almost feel the cool air in the shadows, the echo of the lower level, the coming rain, and hear the background sound of servants engaged in daily activities. We sense the great wealth represented in this residence, yet the artist hints at a lived-in familiarity.

Canaletto is a much-loved artist who captured the faded decline of Venice. He is immensely popular and recognizable to all. His ability to

capture detail in large settings is extraordinary. The eye lingers over the variety of people, things, architecture, hanging laundry, and dogs — life in a city.

Is this sort of painting really great? Well, one test is that you can revisit a Canaletto countless times and not be bored. You wonder how his hand could be so firm, as his thin lines are often plumb straight.

63. Arrival of the Ambassadors, from The Cycle of St. Ursula

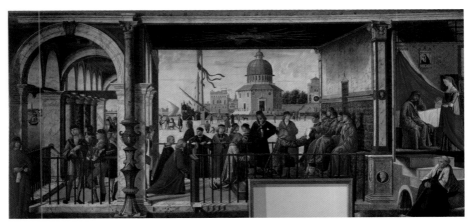

Carpaccio, Vittore, c. 1494
Accademia Art Gallery, Venice
Photo: Erich Lessing / Art Resource, New York

The Golden Legend by Jacobus de Voragino, published in 1475, told of Ursula, a Christian princess, daughter of the King of Brittany, who agrees to marry a pagan prince of England, Ereus, on condition he convert to Christianity. He must allow Ursula to remain a virgin for three years and accompany her on a pilgrimage to Rome with an entourage of ten virgins and another 1,000 virgins in tow.

Vittore Carpaccio painted nine panels that illustrated the story, *The Cycle of St. Ursula*. The panels are full of details of life in a lateral story-telling sequence. Ambassadors meet; Ursula and Ereus go to Rome, where they pay respects to the Pope. They end up near Cologne, where they meet the Hun who is equated with the Turk. It all ends badly, with the Turk/Hun killing everyone.

Carpaccio tames the violent killing scene by delicate patterns. His buildings, crowds of dressed-up courtiers, marble facades, and small dogs create a wonderful mirror of society. Each panel has an intimate level of detail. For example, when they first visit Cologne, we see a young soldier looking vacant and a bit weary next to a hunting dog

sniffing the harbour. Her visit with the pope is set before the huge Castel Sant'angelo. In the carnage of slaughter Ursula obdurately continues to pray, ignoring the danger — an arrow that is mere seconds away from doing her in. The archer appears casual, elegant even, in his good calf and silken jerkin. He may be Attila the Hun, who, according to the myth, slew all the virgins with his arrows.

My favourite is the first canvas, showing the arrival of the ambassadors. It has two sides. The first shows the courtiers and ambassadors, aloof dandies, intermingled with the marble pillars. The tiny sliver of three of them peeking past a pillar in profile shows Carpaccio's sense of humour.

The other end of the first canvas shows a vignette of someone soon to be married — St. Ursula, strong-willed, sure of herself, adamant in her wishes. Her father looks defeated, and the maid presents a study in grey, stoic resentment.

This room forces me to assess Carpaccio's greatness. He weaves a tapestry of what people actually did and how they really looked. While Titian painted vast emotion, pain, eroticism, pensiveness, and high drama; Rembrandt mirrored introspection or jealousy; Velázquez in *Las Meniñas* portrayed spatial relationship coupled with fleeting personal interrelationships; and Goya rendered horror, I don't sense these aspects in Carpaccio.

See his *St. George* in the Scuolo degli Schiavone, which shows St. George on his dragon-killing bout and St. Jerome on his adventures. Again and again one is drawn to marvel over his rendition of local detail. Venice is glamorized, courtiers are elegant, crowds are vast and well dressed. It's a moving picture that urges one to keep looking and see something new each time.

64. St. Louis, St. George, and the Princess

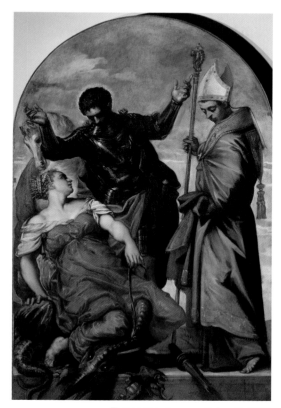

Tintoretto, Jacopo Robusti, 1555
Accademia Art Gallery, Venice
Photo: Cameraphoto Arte, Venice / Art Resource, NY

St. George has slain the dragon, and the princess is grateful that she has been rescued. Sitting astride the slithery dragon, she leans back and looks dreamily at the fetching saint, seeing her reflection in his armour. He in turn looks down at her with interest, as St. Louis blushingly looks aside. The dragon, meanwhile, lies there, glassy-eyed.

The guide book says of this painting, "In the iconoclastic and dramatic composition, the female figure sits boldly astride the dragon, in a pose of extreme virtuosity [*what does that mean?*] twisted backwards and outstretched towards her rescuer, reflected in his shiny armour.

The pensive St. Louis [*he's not pensive — he's embarrassed pink*] provides effective theatrical support [*huh?*]."

This one is fun.

65. Assumption of the Virgin

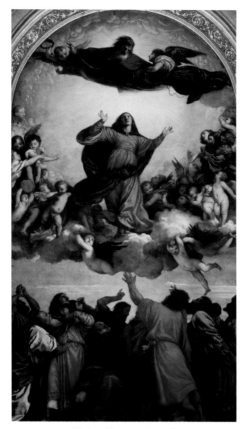

Titian (Tiziano Vecellio), 1516–18
Basilica of Santa Maria Gloriosa
Dei Frari, Venice
Photo: Scala / Art Resource, NY

Painted early in Titian's career, this was controversial from the start. The Frari monks questioned the painting so much that a pope offered to buy it, which chastened the monks. It was a maverick painting that set a new tone and style. It is staid and vertical, yet mixed with an element of startling energy.

The painting, cropped by the architecture of the apse, bursts upward. The apostle appearing on the lower right in Titian red, shoves,

yes, shoves the Virgin aloft. He is surrounded by the other apostles, suffused in shadow — together they form a symphony of force. Henry James compared it to the Wagnerian end of Parsifal.

66. Crucifixion

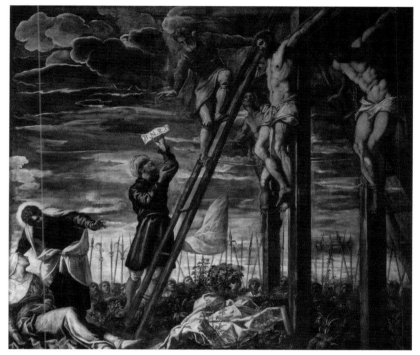

Tintoretto, Jacopo Robusti, 1568
Church of San Cassiano, Venice
Photo: Scala / Art Resources, NY

Somewhere someone has said that Velázquez borrowed from this painting in creating his *Surrender of Breda,* housed in the Prado (see Chapter 3). I can understand why. In *The Surrender of Breda,* the lances of conqueror and conquered alike mingle in a disorganized fashion before a misty panorama, the sky suggesting a distant smoky fire. Here we have a forest of pikes or halyards as a backdrop to the crucifixion before a sky of lateral clouds.

Christ's feet are held with one nail, the two others are roped. The perspective comes from below, in and under Christ's cross, which is an enormous solid timber. The second is equally huge, with the third standing behind Christ in sight line. The two compete with Christ for

visual attention, but Christ's bloody legs predominate with skin that is grey-white.

A man perched on a ladder leans down for the sign being handed up to him so that he might place it above Christ. The sign reads: "I•N•R•I" (Jesus of Nazareth, King of the Jews). The ladder looks precarious; it is on a slant running against and over the vertical Christ and crucifix.

The person hanging the sign is in Tintoretto red-pink, beneath him there is a red-pink banner amidst the pikes, the figure giving comfort to Mary is in pink, and a fluffy pink-red gown settles under Christ at the foot of the cross. All this is competition for the eye, yet it doesn't detract from the striking message of suspended grim meditation of Christ. Christ's look (towards Mary) is as if he were observing someone else's bad problem and was slowly deciding what action to take.

Christ is the only one with a distinct persona. Mary is in a swoon. The other two being crucified are either in screaming angst or sheer fatigued labour; both the man on the ladder reaching for the sign and the giver of the sign are in passive neutral, concentrating on the task at hand. The disciple tending to Mary is looking off in the distance. What a glorious piece of work!

When I went to San Cassiano and became mesmerized by this fantastic *Crucifixion*, I stayed for a long time. I gazed with a glaring determination, scribbled notes, drew sketches. I therefore missed two adjacent canvases that are meant to interrelate: The *Descent into Hell,* which is a dark bit of horror, and *The Resurrection,* stationed in the middle of the apse above the altar. Figures point or appear to flow from one to the other.

67. The Last Judgment

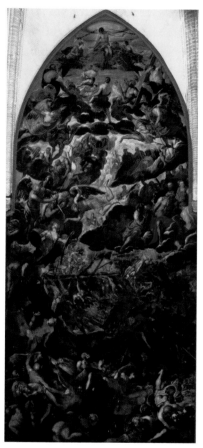

Tintoretto, Jacopo Robusti, 1562–64
S. Maria dell'Orto, Venice
Photo: Cameraphoto Arte, Venice / Art Resource, NY

This is my favourite *Last Judgment*. It is huge — 1,450 x 590 centimetres. You must put coins in a light box to illuminate this immense canvas.

The painting is a bravura floor-to-ceiling tumbling piece, impossible to detail. Doomed souls slither down a sluice on a slippery, watery route to Hell, with the occasional blue-robed angel trying to save a soul or two. There is no justice here, just a rush for the exit. It is all motion and divine justice, punishment, and virtuous escape.

The move upstream to heaven gives the feel of a salmon run — with the necessity of high leaps. Some on the left are ascending to the top haven of safety and grace, but it is all a whirling struggle. The right side is murky, dark.

In the lower part, a waterfall flowing over a concave half-tunnel serves as a catchment area for the damned, who slip and slide, inevitably sucked up by black shadowy creatures, and below that the beginning of a crematorium. The lower right is a mad retreat down to the body-choked hell — no fire, it's too wet.

Ruskin's note on Tintoretto's *Last Judgment*:

> Bat-like out of the holes and caverns and shadows of
> the earth, the bones gather, and the clay heaps, heave,
> rattling and adhering into half kneaded anatomies, that
> crawl and startle and struggle up among the putrid weeds,
> with clay clinging to their clotted hair ...

68. Presentation of the Virgin in the Temple

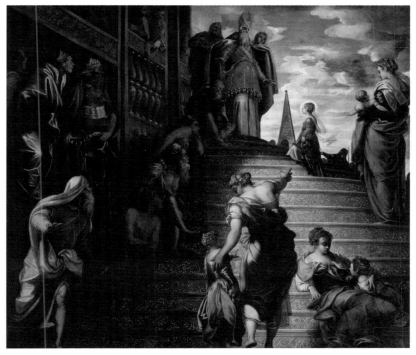

Tintoretto, Jacopo Robusti, 1552
S. Maria dell'Orto, Venice
Photo: Cameraphoto Arte, Venice / Art Resource, NY

The sense of upwardness in this painting, with steps rolling to the heavens, is so dramatic, the impression almost gives one vertigo. Large athletic figures exude a force shoving the tiny Mary towards the mitred bishop and the sky above. The gold patterned inlay of the steps creates a continuum of motion, an escalator to the sky.

It has a sense of force in the upward movement of the small child-like figure approaching the huge, remote cardinal figure. Also the observers appear enraptured, awaiting the outcome of the meeting.

69. Primavera

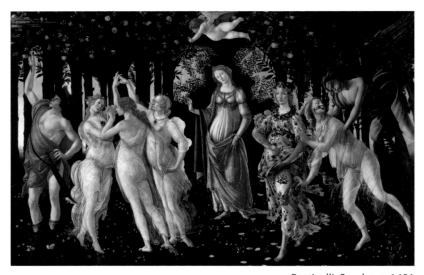

Botticelli, Sandro, c. 1481
Galleria degli Uffizi, Florence
Photo: Alinari / Art Resource, NY

This painting always provokes the question, "What is the green stuff coming out of the lady on the right?" It is Chloris, one of the Primavera nymphs, with a sprig of bindweed sprouting from her mouth. This was the symbol of the green tongue of alchemists who pursued eternal youth. The church persecuted such pagan thoughts. Indeed, the suspicion that this painting concealed heresies prevented it from ever being shown in a church.

The figures from left to right: Mercury, Grace, Beauty, Faith, Venus, Flora, Chloris, and Zephyr.

Zephyr was the god of the west wind, a wind said to be warm and gentle. Flora represented the herald of spring. Mercury on the left is touching clouds far away in order to reveal mysteries of the beyond, symbolized by the solid golden apples. Venus with child is in the midst of spring.

Botticelli is the star of the Uffizi. He became the painter of youth, spring, and flowers. Up until the time he created this work, religious

subjects had been his main focus. Then the pagan spirit, evoking Wagner's Siegfried, came to the fore. Here living images of human desire sway in a fragile dance.

The painting presents images of happiness that will leave you in a reverie as you absorb the scene. The flowers strewn on the ground coax the mind to create a perfume. For me, this painting represents the Renaissance: imagination, motion, myths, hurtling nature, the feel of change, the mystery of growth, the fragility of time.

70. Adoration of the Magi

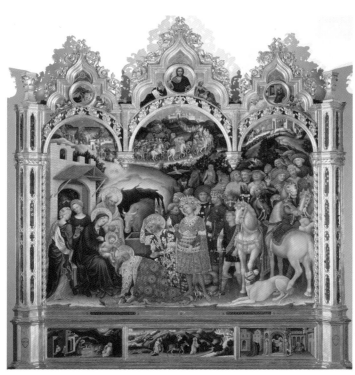

Gentile da Fabriano, 1423
Galleria degli Uffizi, Florence
Photo: Scala / Ministero per i Beni e le Attività culturali / Art Resource, NY

Gentile da Fabriano's *Adoration* is in the most ornate gold frame possible. This could be explained by the fact that Fabriano's apprenticeship started in a jewellery workshop.

The picture has an overwhelming halo for each king but not a representation of a black monarch. Borzoi hounds and proud horses jostle for attention.

The lighting is realistic, and while the procession's front rows are idealized, behind there is a rabble of the smug, the curious, and the devious. The meticulous details of nobles and horses off in the distance force one to wonder how he could carefully manage to fit all these figures into this depiction of a procession.

71. Adoration of the Magi

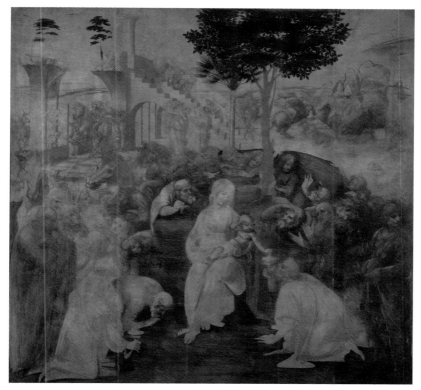

Leonardo da Vinci, 1481
Galleria degli Uffizi, Florence
Photo: Scala / Art Resource, NY

Leonardo's unfinished *Adoration* exudes trepidation. Frightened observers swallowed in a dark world. Will they be freed from the black shadows?

Leonardo was born in 1452 in Vinci. How many things could he do? Countless. His sketchbooks show he was an avid explorer of anatomy, botany, geology, and astronomy, and held an interest in hydraulic engines and architecture. He was also a poet. He wrote a treatise on painting. He embodied the spirit of the Renaissance, but his multiplicity of talents seemed to prevent him from finishing projects.

His astounding array of skills is highlighted in a letter he wrote in 1482 to Ludovico il Moro of Milan. In it, he describes the wide range

of "machines of war" that he has imagined and can produce, boasting that "I can invent an infinite variety of machines for both attack and defence." He adds, "In peacetime, I think I can give perfect satisfaction and be the equal of any man in architecture, in the design of buildings public and private, or to conduct water from one place to another. I can carry out sculpture in marble, bronze, and clay; and in painting can do any kind of work as well as any man, whoever he be."

72. Adoration of the Magi

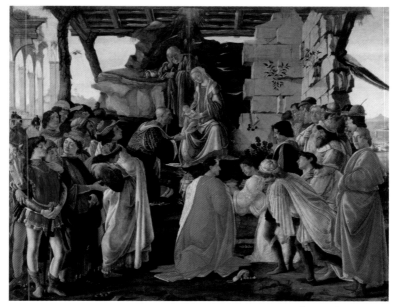

Botticelli, Sandro, c. 1475
Galleria degli Uffizi, Florence
Photo: Scala / Art Resource, NY

Botticelli has a startling *Adoration of the Magi*, which he completed when he was only twenty-seven years old. It is a Renaissance parade of gossip, show, and inattentiveness towards the supposed stars, the Virgin and child. Expensive attire, theatrical posing, whispered sarcasm — welcome to the Bourse.

It is surmised that the three submissive kings are the Medici — Cosimo the Elder, Piero the Gouty, and Cosimo's son, Giovanni. Their elegant attire sparkles. The work was commissioned by a stockbroker, Euasparre de Laura, he being the white-haired man in the middle right staring at the viewer.

The Medici were the bankers of Florence, the city that invented the florin, the precursor of the euro. Then, as now, the moneymen spun a web of commerce and credit far and wide, from Constantinople to London.

73. Baptism of Christ

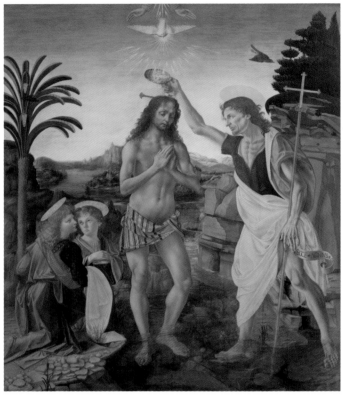

Verrocchio, Andrea del, 1470–75
Galleria degli Uffizi, Florence
Photo: Scala / Ministero per i Beni e le Attività culturali / Art Resource, NY

I love the work of Verrocchio, a teacher of Leonardo da Vinci, a fore-most artist, and, with Donatello and Michelangelo, a great sculptor. He ran a profitable, well-organized workshop, in competition with the Pollaiuolos and Ghirlandaio families, which produced a variety of artefacts in addition to paintings.

His *Baptism of Christ* is the perfect portrayal of Florentine Renais-sance painting, with an emphasis on line, "marble" bodies, theatrical gesture, and the beginning of a Leonardo sfumato-style landscape.

As a late-teenager, Leonardo helped with this painting. He painted

the angel on the left and probably the landscape behind this angel. The sculptured Christ, gaunt John, and the slightly pouty angel were all by Verrocchio. All this on top of exquisite, well-defined draughtsmanship. When Verrocchio saw Leonardo's work, he threw down his brushes and swore never to paint again "as a child could do better than [he] could."

Verrochio was a magnificent sculptor. His *Colleone* in front of the Church of SS Giovanni e Paolo in Venice is the ultimate image of ferocity of a soldier on a horse, the Condottiere Colleone. Horse and soldier are one smooth machine.

74. Venus of Urbino

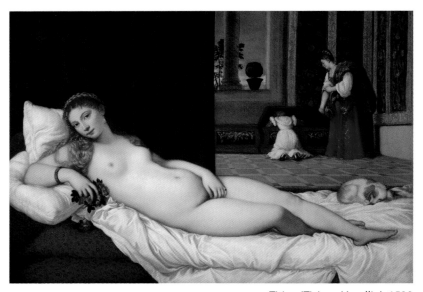

Titian (Tiziano Vecellio), 1538
Galleria degli Uffizi, Florence
Photo: Scala / Ministero per i Beni e le Attività culturali / Art Resource, NY

Theories of interpretation of this lush naked woman abound. Was she wanton? Was she a bride? Was she a courtesan? Venice had 11,000 of them. Was this just pornography for the elite, or was this a loving portrait commissioned by a husband? Certainly, most would agree that this is an erotic picture.

Certain elements suggest a marital circumstance. In the background we find a cassone, which is a marriage celebration box, containing the bridal clothes. The maid of the house is busy overseeing the cassone. If a man *has* entered the room, the dog's uninterrupted sleep by the woman's feet suggests it would have been the husband. The colour is a buttery bit of poetry highlighting the languor and the relaxed, contented expression of this naked woman luxuriating in the pillows of wealth.

Still, there are many out there who say, "Who are you trying to fool with this pointy-headed diversion? If this isn't an erotic picture, selling an overt hustle, I'm a monkey's uncle." Mark Twain expressed it best:

You enter [the Uffizi] and proceed to that most-visited little gallery that exists in the world — the Tribune — and there, against the wall, without obstructing rap or leaf, you may look your fill upon the foulest, the vilest, the obscenest picture the world possesses — Titian's Venus. It isn't that she is naked and stretched out on a bed — no, it is the attitude of one of her arms and hand. If I ventured to describe that attitude there would be a fine howl — but there the Venus lies for anybody to gloat over that wants to — and there she has a right to lie, for she is a work of art, and art has its privileges. I saw a young girl stealing furtive glances at her; I saw young men gazing long and absorbedly at her; I saw aged infirm men hang upon her charms with a pathetic interest. How I should like to describe her — just to see what a holy indignation I could stir up in the world … yet the world is willing to let its sons and its daughters and itself look at Titian's beast, but won't stand a description of it in words … There are pictures of nude women which suggest no impure thought — I am well aware of that. I am not railing at such. What I am trying to emphasize is the fact that Titian's Venus is very far from being one of that sort. Without any question it was painted for a bagnio and it was probably refused because it was a trifle too strong. In truth, it is a trifle too strong for any place but a public art gallery.

Michelangelo had said the Venetians couldn't draw, which he said was the real mark of an artist. Titian used colour, believing colour surpassed drawing. The male form was the norm for Michelangelo, while the female form in the hands of Titian was the focus of appreciation of beauty.

75. The Expulsion from Paradise and The Tribute Money

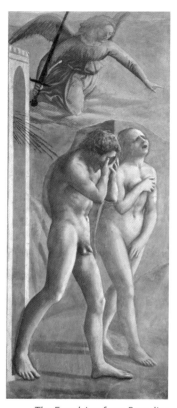

The Expulsion from Paradise
Masaccio (Maso di San
Giovanni), c. 1425
Santa Maria del Carmine, Florence
Photo: Scala / Art Resource, NY

We don't have a glimpse of the paradise Adam and Eve are leaving, that sweet place. Now they carry a load of shame and suffering. They are stark, tragic forms. Death awaits them after a life of toil. The angel ushers them out, in all their nakedness and howls of grief.

When Masaccio painted this he relied on the contemporary biblical source of the day. I don't know what it said, but the King James

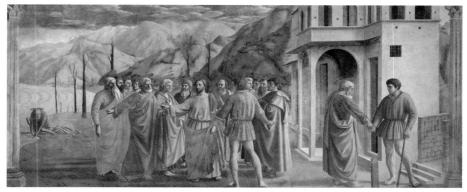

The Tribute Money
Masaccio (Maso di San Giovanni), c. 1427
Santa Maria del Carmine, Florence
Photo: Scala / Art Resource, NY

Bible of 1611 (Genesis 3:17–19) sets out Adam's punishment, with God declaring: "Cursed is the ground for thy sake; in sorrow shalt thou eat of it all the days of thy life; thorns also and thistles shall it bring forth to thee; and thou shalt eat the herb of the field; in the sweat of thy face shalt thou eat bread, till thou return unto the ground; for out of it wast thou taken: for dust thou art, and unto dust shalt thou return."

Adam not only survived, but lived a very long life — 930 years! Here Adam's physique appears supple and will be good for the long haul of his life. Eve embodies quintessential angst. The angel is a beauteous force. Life will be grim.

This is a huge advance in painters' portraits of nakedness and introspection. Directly across the way is Masolino's *Temptation of Adam and Eve*, all static in motion and thought.

The Tribute Money, in the same chapel, reveals the immense change wrought by Masaccio. Gold Byzantine forms have vanished. Now solid men stand squarely on earth with passion and a nervous discontent. The scenery behind is raw and rugged. In my university art courses, this Masaccio work was presented as the beginning of greatness, the vital touchstone of the Renaissance.

Situated on the upper left as one faces the chapel, in the form of a fresco, *The Tribute Money* depicts a story from the book of Matthew

(17:24). On the left side, we see Christ sending Peter to fish. The centre shows the exchange with the tax collector, and on the right at the foot of the building, the payment to the tax collector, who was raising the money for a local temple, is portrayed.

For the first time, we see a landscape that is real and imposing, so much so that you feel you could walk up this rough terrain. The sense of perspective comes from lines leading to Christ, then to Peter, the mountains, and the building, part of the perspective trick.

The people appear alive, powerful, yet portrayed with a poetry of spirit. There is a new aspect of personality, thought, and emotion. Almost a century earlier, Giotto was the first to give humanity a certain bulk and majesty, a dignity. Masaccio added a portrayal of thought, the beginning of subtlety. See the angst in Peter's eyes.

Masaccio's work reflects confrontation among the disciples mixed with a spirit of camaraderie. The apostles appear to be a tough, no-nonsense group. This I always find surprising, as much modern portrayal of the apostles emphasizes their kindness.

Scuola Grande di San Rocco, Sala dell'Arbergo, Venice

San Polo, 3052, Campo San Rocco, 30125 Venice
Telephone: +39 041 5234864
Web: www.scuolagrandesanrocco.it

This is an ornate building dedicated to the masterpieces of Tintoretto (1518–1594), who painted almost exclusively in Venice. These include *Crucifixion* and *The Baptism of Christ*, featured earlier, and *Way to Calvary*, shown here. His father was a dyer, a "*tintera*," so his son's nickname became Tintoretto. Titian was the great master of the Venetian school, followed by Tintoretto and Veronese. The Scuola was established by wealthy Venetian patrons dedicated to protecting Venice against the plague. There are two floors, all by Tintoretto and his son (1564–1587). Take your binoculars!

The journey of Christ carrying the cross up a tortuous route shoves three big crosses at the viewer. I mean big! The painting is all rope and wood, twisting, with angry turns up a rocky hill. Christ is led by a black man, a sort of advanceman with his back to us, with rope taut as it pulls Christ, and slack rope sliding from his hand on the far side of Christ. All pull, with a white flag of Cavalry in the midst of the three men struggling with the heavy wood.

Way to Calvary
Tintoretto, Jacopo Robusti,
1565–67
Photo: Scala / Art Resources, NY

Accademia Art Gallery, Venice

Campo della Carità, 1050, 30123 Venice
Telephone: +39 041 520 0345
Web: www.gallerieaccademia.org

This painting by Paolo Veronese really rivals Tintoretto's huge *Crucifixion*, found in the Scuola Grande di San Rocco in Venice, and refutes

the usual allegation that Veronese is only a fashion-plate painter.

This work is a dark swirl of emotion, anguished motion, and a pivot of horses. It is easier to look at than Tintoretto's, yet contains equivalent energy and tension. The sky, the city, the roiling of figures, and the predominance of horses all make it a challenge to Tintoretto.

Crucifixion
Veronese, Paolo (Paolo Caliari), c. 1582
Photo: Cameraphoto Arte, Venice / Art Resource, NY

The Pilgrims' Arrival in Cologne
From *The Cycle of St. Ursula*
Carpaccio, Vittore, 1490
Photo: Cameraphoto Arte, Venice / Art Resource, NY

This is another of the panels in Carpaccio's series depicting *The Cycle of St. Ursula*. *The Pilgrims' Arrival in Cologne* is a study of war preparation: people wait, gossip, and convey an odd pre-battle languor. The young sitting soldier, vacant, tired. The dog surveying his new kingdom. The churchman babbling to a young lad in a boat too small to carry them. An old warrior considering his instructions. Many disparate scenes crowd together, but this is a fine view of architecture and pre-battle pomp.

Carpaccio has captured bemused anticipation and a society of soldiers.

The famous *Tempest* by Giorgione is one of the paintings so treasured it is never, ever to leave the Accademia. Everyone frets over what this subtle work is about. It is lush, with great emphasis on landscape. There are many theories of the theme, but none is convincing.

Giorgione is a mystery, dead in his thirties of the plague, caught from his lover, whom he courted knowing of the illness.

The painting is a riddle. Is it a soldier coming to visit his gypsy lover with child? What's going on? No one knows. But this is by Giorgione, teacher of Titian, the great Venetian Master. There may be only five or ten paintings by his hand.

The Tempest
Giorgione da Castelfranco, c. 1507–10
Photo: Cameraphoto Arte, Venice / Art Resource, NY

Whatever the story is of this painting, it does, for the first time, blend nature and humanity, with nature being the predominant force. A storm is coming, lightning crackles, the atmosphere is dominant.

Tiepolo has four corner-curved frescoes transported from elsewhere — one showing two viewers of a scene perched over a balustrade as if in a theatre. Pure magic, it portrays the very spirit of opera with its saucy theatricality. The curve of the plaster gives this Tiepolo substance and a rare feeling of permanence. It shows he can be powerful on occasion, producing more than puffy clouds and winged chariots. But, of course, Tiepolo's ultimate triumph is his fresco in Würzburg (see Chapter 7).

Devotees Appearing Under a Loggia
Tiepolo, Giambattista, 1745
Photo: Cameraphoto Arte, Venice / Art Resource, NY

Basilica of Santa Maria Gloriosa dei Frari, Venice

San Polo, 30125 Venice
Telephone: +39 041 272 8611
Web: www.basilicadeifrari.it

Home of Titian's *Assumption of the Virgin*, this church also contains this notable Titian work:

Altarpiece of the Pesaro Family
Titian (Tiziano Vecellio),
1522–26

Titian's *Altarpiece of the Pesaro Family* is huge. I come to the conclusion that great painters work extra hard on large paintings (Velázquez's *Surrender at Breda*, Rubens's *Deposition*, Michelangelo's Sistine Chapel ceiling, Romano's *Palazzo del Te*, and others). This painting has two immense marble pillars in the middle and one eye-catching red flag of the Borgias, yet these domineering props dwarf neither St. Peter with his blue, blue gown slashed with a yellow shawl about his hips nor the Virgin, off centre. It is an amazing feat that the bodies can transcend the competition and in a mysterious way be strengthened by it.

Church of San Cassiano, Venice

Campo San Cassiano, Venice

Madonna dell'Orto, Venice

Cannareggio, 3512, 30121 Venice
Telephone: +39 (0)41 719 933
Web: www.madonnadellorto.org

The church is only open occasionally, so one must check the hours of admittance. It is close to Tintoretto's house in the northernmost area of Venice.

Galleria degli Uffizi, Florence

Piazzale degli Uffizi, 22, 50122 Florence
Telephone: +39 055 238 8651
Web: www.uffizi.org

This is a gloomy gallery with about forty-five rooms of paintings. To secure reservations in advance go to www.florence-tickets.com/index. php?ufizzi. The advantage of buying tickets in advance is no lineups. You go directly to the entrance for booked tickets. The gallery is closed on Mondays.

We have already noted some of Botticelli's great paintings and others in this gallery. Here are some others worth seeing:

Piero della Francesca, master of perspective and atmosphere, was a student of mathematics and geometry. Here we see the dual portrait of the Duke and Duchess of Federico Montefeltro, Lord of Urbino. Once seen, the Duke's face never leaves your memory. The profile in utter focus, a hawk in a red pillared cap, the one eye with gimlet gaze, the nose broken by a sword.

He was a mercenary, a highly paid condottiere hired by the City of Florence both to defend it and to attack other cities. The fifteenth-

century Italian wars had much blowing of trumpets, but they were pretty well bloodless and involved little real combat. Nevertheless, the hired condottieris made fortunes.

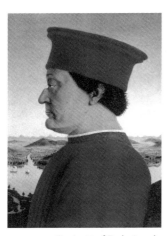

Portrait of Federico da Montefeltro
Piero della Francesca, c. 1465
Photo: Nicolo Orsi Battaglini /
Art Resource, NY

He lost his right eye in a tournament, and he received a nick on his nose as this portrait vividly illustrates. Some Renaissance sitters wished for paintings to be warts and all. Look at the back panels with their cardboard cut-out figures, clear eternal space, and pure colour. So simple, so direct.

Federico was wildly successful, rich beyond avarice. He was cultured and vowed to learn something new every day. We owe to his patronage many of the first translations from the Greek original. His reputation was one of being a learned man with a famous library.

Look at the reverse of the portrait which portrays a military triumph. Note that Federico's right eye, struck out years ago, is miraculously restored. The front has him in simple scarlet, relatively unadorned. The back shows him in shining armour with a crimson cloak and slots, with his right eye in place.

Adoration of the Magi
Mantegna, Andrea, c. 1464–66
Photo: Scala / Art Resource, NY

Mantegna's *Adoration* is part of a triptych that includes *The Ascension* and *The Circumcision*. It shows his strength of portraying ribbed rock and sculptured garments in shocking colours that overwhelm the act of devotion. The three, moving statues, appear to be reticent. The frame with its gold and blue arabesques is sheer glitter.

Hugo van der Goes, a follower of Rogier van der Weyden, painted the *Portinari Altarpiece* in Bruges. Tommaso Portinari was a Medici financial agent posted to Flanders.

This painting has attracted rave reviews, and I always wondered why. The theme is the adoration of the shepherds amidst mangers, hills, and refined women. A closer look has revealed why it's a gem.

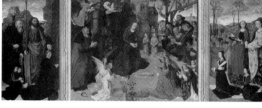

Portinari Altarpiece
Van der Goes, Hugo, c. 1475
Photo: Scala / Art Resource, NY

The left panel has a kneeling Tommaso with two young boys repressing their usual whir of energy and wearing an artificial stubborn piety. Above, in near life size, is a pink mottled Anthony Abbott with bell and cane, a wheezing encroacher. He is a precursor to Sydney Greenstreet of Maltese Falcon notoriety, shrewd and focussed as he peers at St. Thomas of doubting fame. Anthony supposedly lived in Egypt in 250 AD and retreated to the desert. He was the founder of monasticism, which started in the eleventh century in his name for sufferers of a skin disease known as Sir Anthony's fire.

The middle panel has three rough, exuberant shepherds. In the background there's a stamping shepherd with sheep and the Christ child bathed in gold rays. In the foreground, irises to match Van Gogh's.

The right panel, Mrs. Portinari (Maria Maddalene Baroncelli), elegant in black and white, is a simple, almost stark showstopper. Above her, St. Margaret from the Golden Legend, was a third century shepherdess in Antioch, Syria. Raised pagan, she converted to Christianity and vowed to remain a virgin. A Roman governor took after her, she refused, and was thrown in prison. She then was swallowed by the devil — dressed as a dragon — but not to worry, she escaped from the dragon's insides. This escape made her a medieval poster girl for painless childbirth. Here she is on top of a bear rug with glassy eyes and ten big fangs.

Mary Magdalene is the other life-sized figure with her ointment of fame and her gown a match for the most subtle of Vermeer's carpets

(Art in the Allegory of Painting, Vienna nearly 200 years later!)
In the background, winter trees and country life. Welcome to 1475!

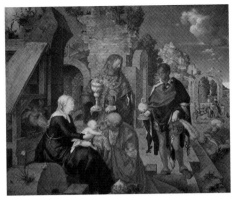

The Adoration of the Magi
Dürer, Albrecht, 1504

Photo: Scala / Art Resource, NY

Dürer's *Adoration* emphasizes the black magi, a teenager before a fantastic backdrop of a perchéd palace-glutted mountain and Romanesque arches. A cow intrudes behind a plump Virgin. She is gleaming in her blue gown, which competes with the ornate gold gifts. A stag beetle crawls along the step at the bottom right.

Lucrezia Panciatichi
Bronzino, Agnolo, 1540

Photo: Scala / Art Resource, NY

The lady, oh the lady — drop dead gorgeous, a marbled beauty. In real life perhaps opaque and narrowly self-centred or a romantic rollercoaster. Pucci's necklace inscribed *"amore lure sans fin"* — love lasts forever. The husband, whose portrait is nearby — ugh! Suspicious but quick, oh so quick! Jealousy ready to run.

Brancacci Chapel, Church of Santa Maria del Carmine, Florence

Piazza del Carmine, 50124 Florence
Telephone: +39 055 212331

You must book the Brancacci Chapel in the Church of Santa Maria del Carmine as reservations are required. Reserve on the Internet. The tickets take at least two business days to confirm. You must arrive ten minutes before your scheduled entrance time to redeem your tickets. A forty-minute film, *The Eye of Masaccio,* precedes your viewing of the chapel. So you'll be well briefed by the time you actually see it. You will then see the works for a restricted time of fifteen minutes.

Basilica di Santa Maria del Fiore, Duomo, Florence

Piazza del Duomo, 17, 50122 Florence
Telephone: +39 055 215380
Web: www.duomo.firenze.it

You climb up to the dome to reach the apex of all of Florence. The climb is a relatively claustrophobic ascent, round, round, round, round, up, up, looking at the intricate lattice brickwork in the interior walls, the occasional view of Florence. At the end you are at the base of Giorgio Vasari and Federico Zuccari's vast *Last Judgment* (1572–79), breathtaking in its audacity.

Your head is adjacent to the bottom part of the fresco, all in a quick sketch form, with a cartoon slash quality. The lower circle of Hell around your head is a wonderful frolic with pokers placed in every sinner's orifice. There is a leering beast, seven-headed serpents, chewing at sinners and spitting out skeletons. Other reprobates are pitchforked to Hell.

It's worth the exhausting climb because it illustrates precisely what fresco painting is about, far far above the distant nave. The top two circles of the saints and angels are bores, except for the cherubs peeking out from under the robe of the enthroned Christ.

This is a crude rendering of Hell, much of it in the vein of Signorelli's frescoes in Orvieto with his gleeful devils (see Chapter 6). Vasari died early in the work and Zuccari finished it in a much sketchier, more slapdash manner. Violent gestures and blood red seeping.

6

ITALY
(Other Regions)

If you want to truly experience the artistic riches of Italy, you must be willing to explore some of the smaller cities, towns, and regions. There are so many gems that you simply must experience.

In Milan you'll find the **Brera** — a small, workable gallery. This is, in my opinion, one of the three finest small galleries in the world (the other two being The Hague's Mauritshuis and the Frick in New York).

Mantua may just be the most beautiful town in Italy. Surrounded by water, it is reached by crossing a water-level bridge to the ancient walls of the town. With limited access due to its small size, an advanced ticket to the **Ducal Palace** is a must.

Other places are equally enticing. Parma is a delight of a manageable town, with a grass square near the cathedral. Orvieto's cathedral façade is on a square, and directly opposite it you can drink a Campari and watch the birds flutter to its multicoloured marble façade. And, despite its mayhem, Naples offers an extraordinary experience: when you reach the idyllic park that houses **Capodimonte**, you can ascend until, suddenly, you are in fresh, sparkling air.

The charm of the varied environments, along with the stunning masterpieces, make visiting these other regions of Italy an absolute must.

76. The Last Supper

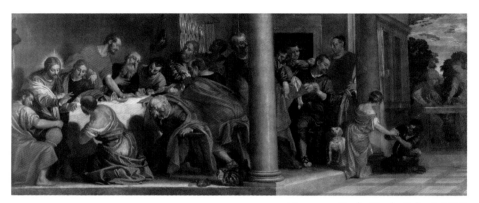

Veronese, Paolo (Paolo Caliari), 1585
Brera Gallery, Milan
Photo: Scala / Art Resource, NY

Veronese painted this *Last Supper* after 1581, close to the time of his death. It is darker than usual for him and has a more serpentine feeling, all broken up with counter-motions, a pillar in the centre, disciples diving hither and thither, creating a subtle fugue of near impending violence. One has the feeling that a storm is coming. Peter appears very theatrical. Two disciples seem to be falling under the table from the shock of Jesus' words.

This version of the Last Supper contains a lot of movement in contrast to the fixed poses in others.

77. St. Jerome

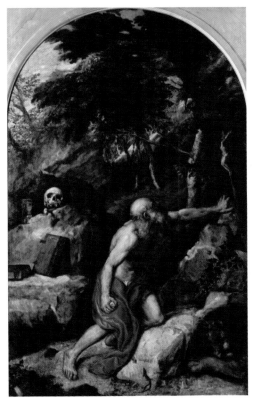

Titian (Tiziano Vecellio), c. 1555
Brera Gallery, Milan
Photo: Scala / Ministero per i Beni e le Attività culturali /
Art Resource, NY

This painting is all rhythm, top to bottom, a landscape of such power that when I first saw it I called it "a gorging landscape." St. Jerome is a Michelangelo figure, huge and full of motion, an older athlete painted with a sharp mannerist elongated line, his shoulder and arm an axis of power. So big, so focused, the towering landscape cannot suffocate him.

St. Jerome initially retired into the Syrian desert to be a hermit. He used a stone to beat himself so he could expunge sexual fantasies — wow! He came back to Rome in 362 AD and translated the Bible into

Latin. It was known as the Vulgate, Latin being the common (*vulgus*) language. According to thirteenth-century fables, he had removed a thorn from a lion's paw.

78. The Finding of the Body of St. Mark

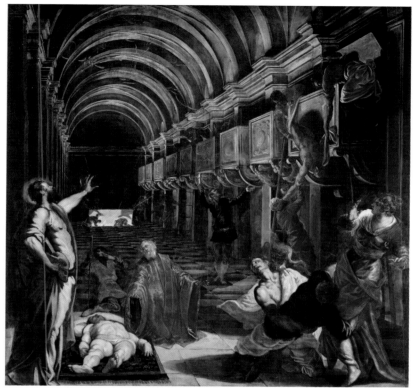

Tintoretto, Jacopo Robusti, 1562–66
Brera Gallery, Milan
Photo: Erich Lessing / Art Resource, NY

This dark painting has a kind of jerky energy. I love it for its tubular mystery, its perspective of vaulted arches leading to a fiery furnace, its feeling of ghosts and bats.

Why is St. Mark the Apostle the patron of Venice? Venice didn't exist when Mark lived. He was born and raised in Jerusalem. He was said to be the first bishop of Alexandria in Egypt. He was seized at an altar, dragged through the streets by a rope, then beaten to death. A thunderstorm raged during his burial, scattering his foes and allowing Christians to bury him.

At some point the spin doctors elevating Venice had Mark hearing from a whispering angel on the way through a mosquito-laden lagoon en route to Rome, the (naturally) Roman words *Hic requiescet corpus tuum* — here shall your body rest.

In 828 two Venetians, Buono Tribuno da Malamocco and Rustico de Torcello, stole Mark's body from Alexandria, smuggled it past Muslim guards in a shipment of pork, and gave it to the Doge. Presto! Venice now had St. Mark.

The Venetian party that broke into Alexandria didn't know which body was St. Mark's so they rooted through the elevated tombs, as we see depicted in the painting.

The painting portrays St. Mark pointing to his own foreshortened body being exhumed from a wall tomb. St. Mark is performing miracles; the man at the right with the mark of the plague on his forehead is being freed of a demon that had possessed him and is escaping, a wisp of smoke. The receding vault is a structured flitter leading to a torch illuminating an escape route.

79. Dead Christ

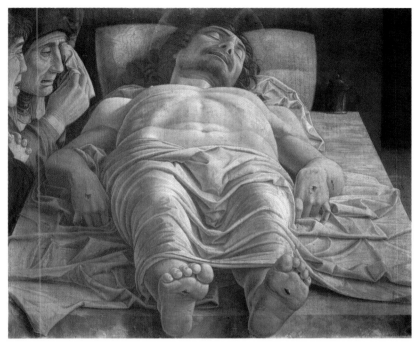

Mantegna, Andrea, c. 1480
Brera Gallery, Milan
Photo: Scala / Art Resource, NY

Andrea Mantegna's *Dead Christ* is the signature work of this small gallery. The very ticket to the Brera portrays the foreshortened cadaver. When you are looking at the painting, Christ's toes come straight at you. The cadaver shoved at you as if on a gurney moving out to your hips. Mary and John are edged to the side, secondary observers.

The colours lack brightness because Mantegna used unvarnished tempera (emulsion made of powder pigments with egg yolk and thinned with water) — very quick drying, tough, and permanent.

I have always been fascinated by this cadaver. I marvel in it and in a perverse way find a beauty in it. Imagine my surprise when I discovered that the famous eleventh edition of the *Encyclopaedia Britannica* says,

… in the Brera, Milan, the *Dead Christ with the two Maries Weeping*, a remarkable tour de force in the way of fore-shortening, which, though it has a stunted appearance, is in correct technical perspective, as seen from all points of view. With all its exceptional merit, this is an eminently ugly picture. It remained in Mantegna's studio unsold at his death and was disposed of to liquidate debt.

80. Pietà

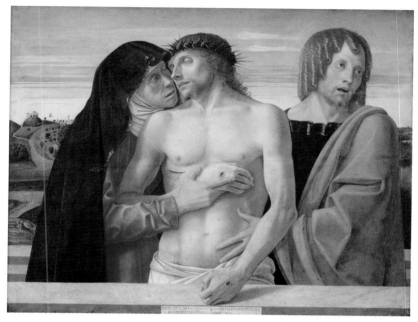

Bellini, Giovanni, c. 1465–70
Brera Gallery, Milan
Photo: Erich Lessing / Art Resource, NY

In Room VI with Mantegna's *Dead Christ* is Giovanni Bellini's *Pietà*.

Here grief is echoed by the dull tones of the landscape. The gashed hand of Christ, the livid cut of flesh under his chest, all create an excruciating intensity. The mother's face, nestled into Christ's, a grey mouth and eye shadow of a morphined grief face. The pale blue of St. John's robe sets up the white-grey pallor of Christ's skin.

81. The Sermon of St. Mark in Alexandria

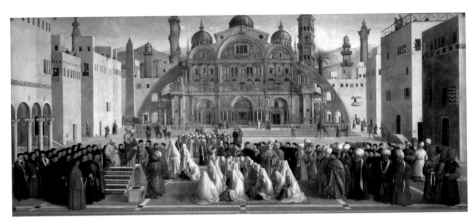

Bellini, Gentile, and Bellini, Giovanni, 1504–07
Brera Gallery, Milan
Photo: Scala / Art Resource, NY

Now I write of a picture that at first did not interest me as it was a sprawling Italian "city square" painting, all about buildings and standing dignitaries, very formal and very static.

But Gentile Bellini and Giovanni Bellini's *Sermon of St. Mark in Alexandria* grew on me, primarily because of the twenty-six nuns sitting near the front of the crowd. They are all in white with conical headdresses, a small army of angels in lampshade cowls with silk veils over their mouths. They form a phalanx of unified white virtue, a block in a painting of blocks of people. Behind the nuns, we find six business-minded Italians, then come Turkish turbans and the look of a different culture.

This is the story of Mark giving his last sermon. His words are taken down by a scribe sitting behind him on the left dais, while a Turkish executioner with a large scimitar stands by.

The architecture to the right and left suggests disciplined Venetian, but in the middle, welcome to Constantinople! A round gothic type of Hagia Sophia rises and weaves over the entire scene of turbaned Ottomans, nuns, and a squad of Italian-looking clerics.

Gentile, who died in 1507, had been to Constantinople on a diplomatic mission as a representative of Venice in 1497. He worked in the court of Mehmet II and was knighted and given a gold chain from the sultan (he is portrayed on the left in red foreground with the chain). He had helped seal a peace with the Turks in 1478. Gentile gave Mehmet II one of his father Jacopo Bellini's drawing books. Today this resides in the Louvre.

82. The Legend of the True Cross

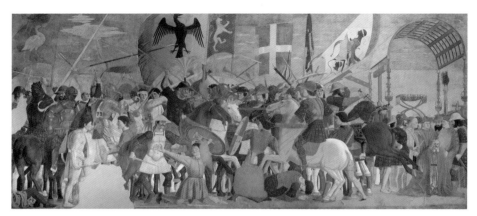

Legend of the True Cross: Battle of Heraclius and Khosrow
Piero della Francesca, c. 1450–65
Basilica of San Francesco, Arezzo
Photo: Scala / Ministero per i Beni e le Attività culturali / Art Resource, NY

The Legend of the True Cross is the name of a series of eleven frescoes. This is the greatest of Piero's works.

The plot of *The Legend of the True Cross* is so convoluted that it's nearly incomprehensible — a hodgepodge of stories setting out a fantastic history of the cross. At one point the Queen of Sheba observes the wood of the cross (then a bridge) and foresees it will become the cross on which Jesus will hang. The cross later becomes the emblem of renewal of the Roman Empire. Emperor Constantine also has a dream on the eve of a great battle against barbarians. Later, a Persian king, Chosroes, steals the cross. Heraclius, a Christian opponent, goes to war and gets the cross back.

I especially recommend two of the eleven frescoes: *Constantine's Dream* and *Battle of Heraclius and Khosrow*.

Battle of Heraclius and Khosrow couples patterns of conflict in pale fresco tones with a stylistic portrait of the horrors of war — blood, swords, grim faces, the anguish of death, the resigned disgrace of defeat. We also see the banners of war: the imperial eagle, an ahinga, an African woman, a white stork, a triumphant lion, and the white cross on red,

Legend of the True Cross:
Constantine's Dream
Piero della Francesca, c. 1450–65
Basilica of San Francesco, Arezzo
Photo: Scala / Ministero per i Beni e le
Attività culturali / Art Resource, NY

waving against the palest of blue skies with mere dashes of cloud, a crescent moon falling to earth. There are Moorish figures in tatters, broken lances, and fractious horses. We can practically hear the cacophony of a battle, the rattle of armour, the grunts and screams. The faces are engrossed in killing or in dying. There is also an immense variety of eccentric headgear. The victor, Heraclius, Christian Emperor of the East, is surrounded by men wearing Grecian-style helmets, with sorrowful, knowing eyes.

To the right is the shocking pink throne of the vanquished king of

Persia, Khosrow, who had placed the cross on the throne topped with a rooster as a sacrilegious representation of the Holy Spirit of the Trinity, the king being the father and the cross the son. The king awaits execution, surrounded by the Italian faces who look appropriately unforgiving. The banners on the right, representing the losers, appear in disarray.

One panel of this fresco reveals the anti-Jewish passion of the time. A Jew who knows the whereabouts of the buried cross has been shoved down a well until he reveals the secret to the empress, Helena, and her fellow Christians.

Piero's patterns haunt — cityscapes modern in shape, clashing war banners, perpendicular jewels. Abstract art is just a step beyond this. Piero della Francesca painted atmosphere, which reflected subtle thought and imaginings. He was a student of Euclid and wrote at least three treatises on mathematics and perspective.

Piero's *Constantine's Dream* in this chapel burns in my memory. Perhaps it is the pink in the coned tent or the flash of evening light on the curtains in its V shape, which provides a dark area of atmosphere around Constantine's pure sleep. Here the creation of atmosphere, the depth of night, the deep hold of a state of reverie, all on the eve of battle. The emperor sleeps. All colours are muted, figures are reduced to cylindrical shapes.

Jerusalem has been destroyed. The Hebrews have been scattered. Christianity is spreading throughout the Roman Empire. Constantine and Massenzio are about to do battle. The night before, the angel, bathed in cold lunar light with extended arm, announces victory in the sign of the cross: "IN HOC SIGNO VINCES."

The sign illuminates the quiet night scene, turning it into a stage. Perspective foreshortens the angel. The soldier in front is a dark silhouette before the bright light. Piero's treatment of light is novel. Before him, medieval artists ignored light as a way to model figures and to create the illusion of depth. These experiments of Piero della Francesco leapt centuries forward in twenty-five years.

83. Assumption of the Virgin

Assumption of the Virgin
Correggio, Antonio Allegri da, 1526–30
Duomo of Parma
Photo: Scala/Art Resource, NY

In the cathedral of Parma, Italy, the home of Verdi and Parma ham, there is an eye-popping golden yellow fresco. It is a conventional cathedral with a long nave covered in frescoes depicting all of Christ's life, including the crucifixion, last supper, and expulsion of the money changers from the temple. Painted prophets perch on clouds under the corner of each mural. The multiple scenes create a confusion of images. It is distracting, busy, and ordinary. As you proceed up the nave, you mount steps to stand under the central dome. There you'll find a golden explosion, fireworks!

Your neck cracks as you look up, up, up, to see the eight-sided base of the cupola illuminated by eight clear glass rose windows, flooded by sunlight on a bright day. Although the dome is octagonal at the base, the fresco creates a seamless twister, whisking the viewer up to paradise. The theme is the Virgin Mary's ascension to heaven, the spot way up

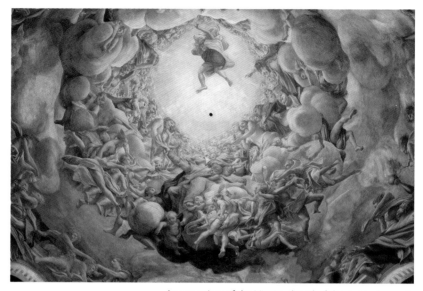

Assumption of the Virgin, detail of the central cupola
Correggio, Antonio Allegri da, 1526–30
Duomo of Parma
Photo: Scala/Art Resource, NY

on the very top of the dome. The Virgin ascending with frolicking angels is next to Adam and Eve, symbolizing the Redemption.

The dominant view is that hundreds of nude girls and women are gliding above you with their legs dangling, floating — a symphony of legs. The apostles stand at the base, their robes fluttering as they encourage the Virgin on upwards to heaven. As you proceed up the base of the dome, there are prophets on clouds. There are grey cotton fluffs of clouds, clouds that effortlessly support observers watching the Virgin shoot up to paradise. Your eyes move up through a layer of clouds laced with girlish figures, in a swirl of wind. There are rings of faces all watching the upward motion of it all.

Christ, remote, caught at the very top of the work by a gust of wind, then thrown askew, appears as a gliding, roiling figure. Only with binoculars can you see his face looking down surrounded by rings and rings of angels all watching the Virgin's ascension to a ball of yellow with nothing above except Christ at the top of the Meissen-yellow cupola.

In times past Correggio was viewed as the fourth master, together with Leonardo, Michelangelo, and Raphael. In the middle of the nineteenth century he fell out of favour. But this work is magic!

84. Family and Court of Ludovico III Gonzaga and The Meeting Scene: Grooms with Dogs and Horse

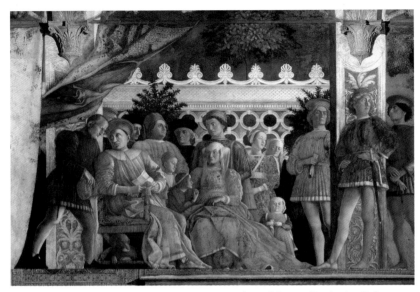

Family and Court of Ludovico III Gonzaga
Mantegna, Andrea, c. 1470–74
Ducal Palace, Mantua
Photo: Scala / Art Resource, NY

There are other good things to see in this complex, but this is the "must see" jewel.

Mantegna took at least four years to fresco the waiting room of the Gonzagas on two walls, along with a ceiling of angels and others peering down from a circular balustrade. The frescoes are magic.

One wall is a group portrait of the family Gonzaga flanked by attendants. The other is the father greeting his Cardinal son on a road surrounded by family. An adjacent panel depicts servants, horses, dogs, and a background of hills with towns. Above is an oculus, or an eye to the sky, a well of light falling from a pagan heaven with naked angels, smiling women, a Berber, a peacock under a blue sky with cloud — some looking down at the viewer, others across at the figure opposite.

Ludovico Gonzaga was a remarkable Condottiere (a military leader

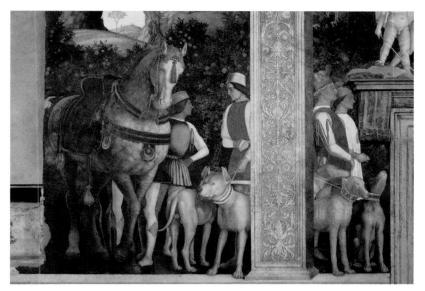

The Meeting Scene: Grooms with Dogs and Horse
Mantegna, Andrea, 1465–74
Ducal Palace, Mantua
Photo: Scala / Art Resource, NY

on hire to defend Milan) who was trusted and who actually sought peace. By his clever diplomacy he built the duchy of Mantua between Milan and Venice and, through diplomacy, secured it. His retinue could extend to as many as 800. He made money from his military jobs. He negotiated for his son to be a cardinal and one panel of the room shows Ludovico meeting his son with the papal announcement.

Ludovico Gonzaga married Barbara of Brandenburg, a Hohenzollern related to Emperor Sigismund, a bright woman but not a beauty as the portrait reveals. The family suffered rickets and humped backs inherited from her. The elder son, Federico, was described as an "amiable, engaging man with a hump." Mantegna camouflaged this.

Federico loved the arts, architecture, war, and commerce. He succeeded his father and ruled Mantua from 1475 to 1484, but was lacklustre in comparison. He was obsessed with music and would summon musicians in the middle of the night. He wearied of things quickly.

In the family portrait is the family teacher, Vittorino da Feltre, dressed in black with white hair. He was an inspired intellect who taught with kindness and civility and passed on a love of learning, music, art, poetry, Latin, and Greek.

I love the smell of intrigue, of power, the quiet dominance of the father amid a cold gaggle of slippery opportunists. Most of the men are on the make while servants gossip amid dappled grey horses and hunting mastiffs. The servants with red and white stockings, emblematic of the Gonzaga entourage, seem to strut while standing still. The well-preserved fresco whispers power, erudition, and a measured, enforced calm.

The father, Ludovico, combines a purblind stare with an aspect of a piercing gaze. It is a difficult concept to comprehend, let alone to paint.

85. The Fall of the Giants

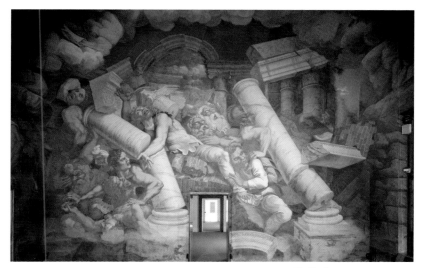

Giulio Romano, 1526–35
Palazzo Te, Mantua, Italy
Photo: Scala / Art Resource, NY

This painting is the great destination within the Palazzo Te. One's first impression upon entering the Chamber of the Giants is the crack, crunch of lightning, followed soon by the whap of thunder. A fresco covering the entire room without separation or distance, it engulfs you — an avalanche of boulders, clattering marble pillars, shattering as they fall.

The mythological tale depicted is of the fall of the giants, whom we see fighting and tumbling to the ground around us, drawing us wholly into the scene. The myth tells how the giants, wicked inhabitants of the earth, tried to scale Mount Olympus and take the place of the gods. Unable to gain direct access to the holy mountain, they piled Mount Ossa on top of Mount Pelion to climb to the summit. But Jupiter, assisted by the other inhabitants of Olympus, hurled his thunderbolts and unleashed the elements against the huge mountain of the giants. The moment depicted is that of divine revenge, with the mountains collapsing and the giants either crushed by the rocks or attempting a last-ditch effort to save themselves.

There is an almost comic-book effect to this portrayal of Jupiter hurling lightning bolts on rival giants who tumble down, descending under walls of crushing stone. Huge grimacing giants, some cross-eyed, all in full operatic aria warding off tumbling stones and corinthian columns.

Romano, a student of Raphael, does not imitate his master's stately anatomical perfection. Here bodies are huge, some faces as big as a moon, hands gargantuan, maybe four feet wide, but they are right next to you, not far off on a ceiling fresco. The arms, contorted faces, are "ungainly." Faces are crushed, so grimaces to end all grimaces abound. Only Jupiter on an ethereal throne above manifests calmness — the rest is an expression of profanity before the deathly accident. What profanity can you hurl before sure death? What helps as you eye the end of life?

Charles Dickens just hated this:

> There are dozens of Giants (Titans warring with Jove) so inconceivably ugly and grotesque, that it is marvellous how any man can have imagined such creatures. In the chamber in which they abound, these monsters, with swollen faces and cracked cheeks, and every kind of distortion of look and limb, are depicted as staggering under the weight of falling buildings, and being overwhelmed in the ruins; upheaving masses of rock, and burying themselves beneath; vainly striving to sustain the pillars of heavy roofs that topple down upon their heads; and, in a word, undergoing and doing every kind of mad and demoniacal destruction. The figures are immensely large, and exaggerated to the utmost pitch of uncouthness; the colouring is harsh and disagreeable; and the whole effect more like (I should imagine) a violent rush of blood to the head of the spectator, than any real picture set before him by the hand of an artist.

86. St. Francis Catches the Devils of Arezzo

Giotto di Bondone, 1298
Upper Church, San Francesco, Assisi, Italy
Photo: Erich Lessing / Art Resource, NY

Giotto (1267–1337) represents the beginning of the Renaissance. The Scrovegni Chapel in Padua was the starting point, yet the work there is somewhat dour, solid, and heavy. Giotto's frescoes in Assisi are lighter and have some surprises. The building has lyrical architecture, tower upon tower, and bat demons floating above the pistachio, orange, and white towers.

Giotto painted twenty-eight frescoes in the basilica about St. Francis. To the Catholic faithful, St. Francis's life mirrored that of Jesus as a journey of faith. There is a large panel fresco at ground level

in the second bay of the north wall of the upper church — the nave — called *St. Francis Catches the Devils of Arezzo.*

This represents the legend of St. Francis. During a civil war in Arezzo, St. Francis prays, and his brother, Sylvester, orders the demons out. All this piffle is ensconced in a glorious dream of wedding cake architecture. A most perfect, serene church (Cathedral of San Donato) and tower frames the kneeling St. Francis.

87. St. Martin Renounces the Roman Army, from Scenes of the Life of St. Martin

Martini, Simone, c. 1320–23
Basilica of San Francesco d'Assisi, Assisi, Italy
Photo: Scala / Art Resource, NY

St. Martin Renounces the Roman Army, close to the entrance of the chapel on the right side next to the archway, shows a figure seated under a tent with horses and men passing gold coins. Off in the hills are banners, helmets, crossed halliards, emblazoned war shields, and peaked, patterned tents. It's stylized war at the ready.

88. Pope Paul III with his Nephews Cardinal Ottavio and Alessandro Farnese

Titian (Tiziano Vecellio), c. 1545

Museo Nazionale di Capodimonte, Naples, Italy

Photo: Scala / Ministero per i Beni e le Attività culturali / Art Resource, NY

This is the devastating picture of an uneasy pope with advisers bent on conspiracy. No wonder Luther had such an easy target.

Here in a faded, washed–out red, a frail pope peeps warily at his nephew. Paul III, bent with age yet oh so cunning, gives his nephew (most probably his son) Ottavio, a shrewd look. His nephew Alessandro appears indifferent while Ottavio is unctuous, able, on the make. This is a portrait of court intrigue emphasized by the sketchy red paint in the pope's robes. Titian must have known the pope wouldn't buy this mirror of foxiness, so he left it unfinished.

It is nevertheless a masterpiece. Titian said a painter needed to master three colours: white, red, and black. It's all here.

Titian influenced Rubens, Velázquez, and Rembrandt in the seventeenth century; Courbet, Degas, and Manet in the nineteenth.

89. St. Louis of Toulouse

Martini, Simone, c. 1317
Museo Nazionale di Capodimonte, Naples, Italy
Photo: Scala / Ministero per i Beni e le Attività culturali / Art Resource, NY

Simone Martini is one of the Trecento early Italian masters, and I knew he would have to be in the final cut of this book. Yet his famous *Virgin Annunciations* (in the Uffizi, Florence) were too precious, stilted even.

In Naples I came across his 1317 painting *San Ludovico di Tolosa*, made for the elder brother of the King of Naples. Set in a darkened alcove with a fleur-de-lis blue and gold frame with five predella panels underneath with stories of the Franciscan saint and pauper, it shocks because of its brightness set against the dark of the alcove.

We see the gentle, almost shy, look of Ludovico, who had given

the throne to his brother so he could take Franciscan vows of poverty. San Ludovico has a fey knowing alabaster face with a sappy, yet vaguely sly look. He wears a sumptuous robe. His brother, Robert of Anjou, is smaller, kneeling. Ludovico seems a touch disgruntled as he crowns his brother. His boysenberry red robe patterned against his grey habit is pure subtle. The painting stopped me in my tracks. Bam! It was the only painting here I really wanted to possess!

90. Parable of the Blind

Bruegel, Pieter, the Elder, c. 1568
Museo Nazionale di Capodimonte, Naples, Italy
Photo: Scala / Ministero per i Beni e le Attività culturali / Art Resource, NY

We see six blind men, holding each other as they walk, stumbling and falling in a field before a church. This painting expresses a moral viewpoint on the spiritual blindness of all men. Christ told the parable of the blind to describe the spiritual blindness of the Pharisees.

Here there is horror, scarring, awful hideousness. The painting frightens because it is not part of a mass Hell scene, only a detail in a larger story, six wretched souls beyond hope or redemption. Here the particular charges at you, and you can't escape.

From Matthew 15:14: "And if the blind lead the blind, both shall fall into the ditch," this painting stands as the clearest possible portrayal of a living Hell. The vacant look, the gasp, the sheer scariness of blindness is here, the faces vacant with fear.

91. The Damned in Hell (part of The Last Judgment)

Signorelli, Luca, c. 1500–03
Duomo, Orvieto, Italy
Photo: Scala / Art Resource, NY

Michelangelo saw Luca Signorelli's 1503 *The Last Judgment* in Capella della Madonna di S. Brizio, Orvieto Cathedral. He poached Signorelli's concept of the chosen bodies rising from death's graves in full blossom and health in *The Resurrection of the Flesh*.

The most mesmerising part is where the dead rise through the earth to the call of judgment to receive a new spiritual body to replace the physical bodies worn out by earthly life. These spooky, solitary figures gingerly emerge. They have vigorous, perfect bodies, possibly reflecting Christ's age at the time of his execution, a sign of the perfection of the resurrected and transfigured body.

The *Damned in Hell* mural is fresh, complex, colourful, full of unbridled energy and of such quality you can understand why Michelangelo cribbed from it. Signorelli has produced a startling fresco of wrestling

nudes enmeshed in a torrent of athletic lust and gymnastics. The damned in Hell are caught in a cacophony of feverish angst, pushed by purple and green devils, gleefully shoving, yanking, twisting, strangling the wicked down. A dense riot.

Critics are not kind to this work, but I am enthralled by it. All the torturing devils are strong and powerful, the victims in the prime of life, the women beautiful and sexually attractive without any of the sense of sin that medieval works attributed to "wicked" women, such as a downcast look, a cringing — not here.

92. Devils Derobing a Man (detail from The Last Judgment)

Giotto di Bondone, c. 1305
Scrovegni Chapel, Padua, Italy
Photo: Alinari / Art Resource, NY

The first painter to move beyond medieval stylization and general images was Giotto. He banished lifelessness from art.

In 1303 Giotto painted the Arena Chapel in Padua, the Cappella degli Scrovegni, a chapel donated by a money lender, Enrico Scrovegni. Scrovegni privately commissioned Giotto, perhaps the first time a private citizen was a patron. Visitors to Giotto's Scrovegni chapel were promised a reduction of one year and forty days off their stay in purgatory.

Giotto's *Last Judgment* in the chapel is an important fresco in the evolution of this topic. Christ is a serious, kindly, almost patient man. This is not a portrait of threat.

The part that interests is Hell and Satan eating the damned and defecating the sinners, shown here. Satan is a potbellied ape with horns,

wild whiskers sprouting around the partially eaten bum of a nude sinner being gobbled. Out the bottom of this Satan plops a blond-headed sinner clean as a whistle surrounded by a furry-taloned flesh-swallowing serpent.

Giotto's figures have moral power and exist in the atmosphere of a real world. The Arena Chapel is in bad repair and there is a wooden quality to his work, but it constitutes a huge leap towards a realistic representation of people interacting with others. Gone is the Byzantine perpendicular single-dimension semi-gold figure with halo.

Often last judgments condemned usurers to terrible tortures. Here not so. The Virgin Mary accepts the usurer's vast gifts in the very centre of the piece.

In the seventh circle of Hell, Dante encounters the Usurers (*Inferno* 17.49), one of them being Enrico Scrovegni's father Rinaldo. Squatting on the ground and subjected to a constant rain of fire, those who had never earned their wealth by the work of their own hands are forced to use their hands unceasingly to shield themselves from fiery torment:

> When I came among them looking about
> I saw the head and shape of a lion
> in azure on a yellow purse;
>
> Then as I kept looking I spotted
> Another purse, red as blood
> Displaying a goose whiter than butter,
> And one, on whose white money bag
> was an azure, pregnant sow,
> asked me, "what are you doing in this pit?"

The questioner was Rinaldo Scrovegni, one of the richest usurers in Padua. The most important *Last Judgment* of the fourteenth century could not exist without the son of the man who questioned Dante in Hell.

THE GALLERIES

Brera Gallery, Milan

Via Brera, 28, 20011 Milan
Telephone: +39 02 7226 3264
Web: www.brera.beniculturali.it

Napoleon decreed after he conquered Italy that paintings from other parts of the country would come to the Brera Gallery in Milan. In the classical courtyard there is a large statue of Napoleon as Mars the Peacemaker by Antonio Canova.

The gallery is all on one floor. Mostly the paintings are Italian. One of the world's great small galleries, the Brera has at least one remarkable room, Room IX, where the best of Venetian painting resides.

It is hard not to hurry through the early parts of a gallery housing early religious European paintings, all gold, halos, toes pointing down, beards, fingers pointing up, everyone frozen in gold. The medieval painter didn't think proportion was important. Piety and devotion were the prime subjects.

It became desirable to display the most costly and wonderful pigments in flat, unbroken fields of colour: vermilion, ultramarine, and gold. These colours had merely to be laid out on the panel to inspire admiration and awe in onlookers.

Gold in these paintings was very real. Craftsmen known as gold beaters took a gold ducat and hammered it into thin sheets which were then applied to the wood.

In the Brera (Room IV), there is a *Valle Romita* by Gentile da Fabriano (1385–1427), which combines the art of a goldsmith with delicate details of furs, flowers, and soft wool robes. Midst all this gold is an elusive subtlety and intimate delicacy. Not at all what you would

expect from one of the "gold" early painters.

In addition to the paintings noted above, here are some of the highlights of the Brera:

Supper at Emmaus
Caravaggio, Michelangelo Merisi da, c. 1606
Photo: Scala / Ministero per i Beni e le Attività culturali /
Art Resource, NY

Caravaggio is difficult, but his *Supper at Emmaus,* all dark and hardly protruding, is a true masterwork. He uses darkness as a revelation. The Caravaggio is hard to come to terms with, as you need time to incorporate the dirty fingers, the sceptical waiter.

This may well be the king of the litter in the Brera. His *Supper at Emmaus* in London (1602) is not as subtle as this.

Portrait of Admiral Andrea Doria as Neptune
Bronzino, Agnolo, c. 1530
Photo: Erich Lessing / Art Resource, NY

Bronzino is controversial. He was a court painter to the Grand Duke of Tuscany. Most of his portraits are icy cool, skin smooth as porcelain, elongated bodies, an aloof elegance. The beautiful women are perhaps vacant, perhaps calculating and shrewd.

Here Bronzini portrays a mostly naked Andrea Doria, the famous Genoese admiral, as Neptune, the God of the Sea. It resembles Michelangelo's Moses, in tilt of head, ferocity, and his left hand. This is a startling, imaginative eye-stopper. Half-naked, thuggish, King of the Sea.

Tintoretto adds to the feast in Room IX. This smaller *Pietà* is a gobsmacking show-stopper. Without a huge expanse of canvas, he gets down to real work with a grisly body of Christ slumped, blood trickling, amidst grief-stricken attendants. Grey, ivory death so pale as to shock. The feeling of old cadaver.

Pietà
Tintoretto, Jacopo Robusti, c. 1560–65
Photo: Scala / Art Resource, NY

This is interesting because Rubens is always interesting, and it is essentially a different style from the Italian style. Here Judas appears in the forefront, eyeing the viewer. All the rest is a baroque show-stopper, high Broadway. All strain to listen; they are not yet at the point of Veronese's *Last Supper* (Room IX), where the disciples have gone one step further and reacted. Here a concern of deep thought as the idea of betrayal begins to take hold.

Last Supper
Rubens, Peter Paul, 1630–32
Photo: Erich Lessing / Art Resource, NY

Basilica of San Francesco, Arezzo

Via di San Francesco, 52100 Arezzo
Telephone: +39 0575 352727
Web: www.pierodellafrancesca.it

Arezzo (east of Siena) is a small town with a sloped central square surrounded by restaurants, stores, and a medieval church — an atmosphere of quiet. Piero della Francesca, a painter of startling clarity, a

conveyer of atmosphere, a student of perspective and design, did frescoes in the Bacci Chapel, Church of San Francesco, Arezzo, circa 1452–66.

You will have to buy tickets for a prescribed time as the church limits the number of visitors at any one time.

Duomo of Parma

Piazza Duomo, 43121 Parma, Province of Parma
Telephone: +39 0521 235886
Web: www.cattedrale.parma.it

Look for Correggio's extraordinary fresco in the dome.

Ducal Palace, La Camera degli Sposi, Mantua

Piazza Sordello, 40, 46100 Mantua
Telephone: +39 0376 352 100
Web: www.mantovaducale.beniculturali.it

Mantua is the most beautiful of towns, with many piazzas and some exquisite restaurants. It is a walled town surrounded by water. You cross a low water level bridge and reach the wall of the town.

The rooms of the Ducal Palace of the Gonzaga family constitute the best preserved frescoes as they were done slowly with care using the best lime and lapis lazuli. Only twenty people at a time are allowed in the rooms, so one must sign up separately for entry. Often by noon an announcement is posted saying it is full for the day, so take care to get the ticket for this early.

Palazzo Te, Mantua

Viale Te, 13, 46100 Mantua
Telephone: +39 0376 323266
Web: www.palazzote.it

At one edge of Mantua is the Palazzo Te, a separate quarter of regal splendour with a "must see" of Giulio Romano's Chamber of the Giants. It is a summer palace of the Gonzagas in Mantua. Giulio Romano was hired by the family to convert a villa into a palace for Federico Gonzaga's mistress. It is a grand mannerist palace, with gardens, vast façades, and decorated rooms. In addition to the Chamber of the Giants, there is a Sala dei Cavelli with horses painted on the wall, some peeking at you. There is also a Camera di Amore e Psiche, which is thoroughly raunchy.

Basilica of San Francesco d'Assisi, Assisi

Piazza San Francesco, 2, 06081 Assisi, Province of Perugia
Telephone: +39 075 819001
Web: www.sanfrancescoassisi.org

If you arrive by car, the approach to the Basilica of San Francesco is dramatic. It is perched with its tall square tower, with wide supporting walls descending into a valley. The arcades cradle a square, and you ascend steps next to the fluted arcades to reach the basilica.

Along the way on the north wall is *The Dream of Innocent III*. St. Francis sought authorization from the pope for his fledgling monastic order. Innocent was the ultimate powerful pope. The pope interpreted a dream to mean that St. Francis would save and reform the church. St. Francis, the son of a wealthy merchant, renounced his life of privilege and embarked on a faith journey, in abject poverty. He indeed

attracted pious followers who strengthened the church. I just love the inherent wackiness of this fresco. The whole church tower is falling, Francis is holding it up and the pope dozes. St. Francis must have been as strong as Clark Kent!

In the St. Martin Chapel in the lower church of the Basilica of San Francesco d'Assisi, Simone Martini (1320–23) has done frescoes of St. Martin, a tale of a soldier who turns to religion, including *St. Martin Renounces the Roman Army*, featured earlier.

The Last Supper
Lorenzetti, Pietro, c. 1310–29
Photo: Scala / Art Resource, NY

Pietro Lorenzetti (1280–1348) was born and died in Siena. He did tempera frescoes in the lower church of the Basilica of San Francesco d'Assisi in and around 1310–29. He worked in Assisi alongside Simone Martini.

Judas sits at the Last Supper. He has sort of slick mod hair. Christ passes him the broken bread. *The Last Supper* is different and memorable because of the two servants on the left side cleaning the dinner plates and leaving the scraps for the dogs. Ah, the domesticity of it all. Above them, pantry tools, next a burning fire, a cat watching or dozing. The woman servant pointing with her thumb as she talks, "Hey, something special is going on in there." The man servant listening and reflecting.

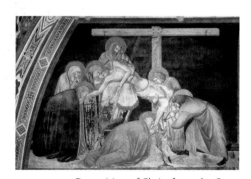

Deposition of Christ from the Cross
Lorenzetti, Pietro, c. 1310–29
Photo: Alfredo Dagli Orti / The Art Archive at Art Resource, NY

Lorenzetti's *The Deposition of Christ,* with Christ's grey plastic tubular body, foretells the *Pietà de Villeneuve-lès-Avignon* in the Louvre, painted about 130 years later. Squints of grief

smother Christ's body, his gold-red hair combed by one of the Mary's fingers.

National Museum of Capodimonte, Naples

Via Miano, 2, Porta Piccola, Via Capodimonte, 80137 Naples
Telephone: +39 081 749 9111

The reason I endured the hideous traffic and went to Naples was to reach this beautiful gallery. It was once the home of Charles of Bourbon, King of Naples, the son of Philip V of Spain and Elisabetta Farnese. The royal palace is entirely devoted to art and sits in a stunning setting of pines, grass, and fresh wind on a hill far above the madding jostle of Naples. In addition to the paintings by Titian, Simone Martini, and Bruegel featured earlier, there is an interesting mannerist portrait and another Titian study of Pope Paul III.

A young woman in luxurious dress, elegant, threaded silk hanging heavy and straight over a patterned damask blouse over white petalled breast. She has an almond-shaped face and big teenage eyes. A marten stole hangs down her shoulder to her gloved forefinger. She is the artist's lover.

Parmigianino, a mannerist, often sketched fluid drawings. In contrast, this is done with the finished care and sheen of a Veronese.

The pope, hunkered down, still foxy, still alert, looking for your weakness.

Sir Kenneth Clark, the magnificent English art critic, viewed this as perhaps the greatest portrait of

Antea
Parmigianino (Francesco Mazzola), 1530–35
Photo: Scala / Ministero per i Beni e le Attività culturali / Art Resource, NY

Pope Paul III Farnese (r. 1534–49)
Titian (Tiziano Vecellio), c. 1543
Photo: Scala / Ministero per i Beni e le Attività
culturali / Art Resource, NY

all time. From the legendary author of *Civilization* and the doyen of British culture this is special praise.

Pope Paul had what could be considered a speckled family history. Although this crafty dodger was a man of subtlety and sensitivity, his provenance proved to be suspect. Sir Kenneth wrote, "In many ways he was the last of the humanist Popes. He was cradled in corruption. He was made a cardinal because his sister, known as La Bella, had been the mistress of Alexander Borgia. In culture and in sympathy he was a man of the Renaissance."[1]

While in Naples, try to see Caravaggio's *Seven Acts of Mercy* in a local church, Pio Monte della Misericordia. Art critic Ingrid Rowland considers it one of his best. I missed it to my regret.

Duomo, Orvieto

Piazza del Duomo, 26, 05018 Orvieto
Telephone: +39 0763 342477
Web: www.opsm.it

The town of Orvieto sits propped on a hill over valleys north of Rome. The square before the cathedral is ideal for sitting and watching the setting sun reflect on the pink façade. This Italian cathedral is enlivened by dark green strips of marble and a galaxy of carvings, representing annunciations, judgments, seasons of the year, gargoyles — the whole medieval works.

Scrovegni Chapel, Padua

Piazza Eremitani, 8, 35121 Padua, Province of Padua
Telephone: +39 (0)49 201 0020
Web: www.cappelladegliscrovegni.it

This is another part of Giotto's *Last Judgment* featured above. There are four caverns of Hell, passages surrounded by fire. Here disembowelled men hang from a tree; a man hangs by his penis. There are actual portraits of existing machines of torture such as the spine roller. It hurts just to look at it. Countless hairy devils grab, torture, beat, rape, and spear hapless victims. Hell is not for sissies.

*Hanging People on Trees
(Last Judgment, detail of Hell)*
Giotto di Bondone, 1303
Photo: Cameraphoto Arte, Venice /
Art Resource, NY

7

GERMANY AND AUSTRIA

There is an extra dimension to viewing art in Germany and Austria. Many of the galleries you will visit, and the cities in which they are located, were devastated in the Second World War. In some places, you will find buildings that have been lovingly restored; in others, survivors from the past; in still others, completely new creations — in all, a unique combination of old and new.

Contemporary Berlin is a city of stunning modern architecture, and its **Gemäldegalerie** a beautiful gallery, newly built. It may be the most logical gallery of any, with a striking long hall that forms the spine of the building. It has the effect of a mosque, the Alhambra without colour and stripes. It is a long oasis of tranquillity with quiet water in the middle, pillars throughout, and circles of light from cupolas. **Schloss Charlottenburg**, also in Berlin, is a palace amidst a beautiful park of trees and water. Bombed in the war and now restored, it contains a wing that comprises the most marvellous example of rococo.

The **Gemäldegalerie Alte Meister** in Dresden is in the Zwinger, an area that houses the palace of 1710–30, entirely rebuilt after the Allied bombing and obliteration of Dresden in February 1945. The exact rebuilding of the gallery to its prior state is eerie. As you view the palace surroundings of the art gallery, you hear the music of Handel.

In Munich — city of beer halls, a spring asparagus festival, and lederhosen, all surrounded by ice cold lakes and frosted mountains — the **Alte Pinakothek** is a gallery of great space and multicoloured, disciplined rooms. In Vienna, the Ringstrasse in the centre of the city

is a streetcar on a dedicated track, and the **Kunsthistorisches Museum** is en route. Built by the Hapsburgs in 1891, it is palatial in appearance and scope.

Finally, take a train trip to Würzburg through a storybook countryside of rolling hills, wheat fields, great copses of trees, and the occasional church spire — an idyllic path on the Bavarian romantic road. At your destination you will find — in addition to Tiepolo's amazing ceiling — a city that has been entirely resurrected after being bombed flat in the Second World War, all the old edifaces rebuilt faithfully or with interesting modern variations. It is a lesson on how, with architecture and spirit, a city can be recreated.

93. Moses Destroying the Tablets of the Law

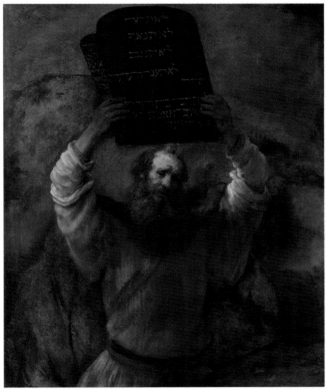

Rembrandt Harmensz van Rijn, 1659

Gemäldegalerie, Staatliche Museen, Berlin, Germany

Photo: bpk, Berlin / Staatliche / Anders / Art Resource, NY

Using a technique of thick and heavy paint application, Rembrandt has created a picture of wrath. In white and grey-brown, Moses is large, a study of force and majesty as the tablets come down overhead — YEEESSS! This is what strong painting is about. Not too much

detail, so as not to divert the terrible timeless majesty of the fact, the forever moment.

Moses about to smash the stone tablets, which he just received from God, in rage over the golden calf his people made when he was away. The Hebrew transcription shown is accurate. Was ever such power and grief mingled?

In the 1650s, the Dutch Republic identified with the children of Israel. Preserved by dikes, the Dutch saw themselves as the chosen people, and saw their destiny in terms of the Old Testament, Exodus, prophecy, the celebration of the founding and perpetuation of the Dutch Republic.

94. Self-Portrait

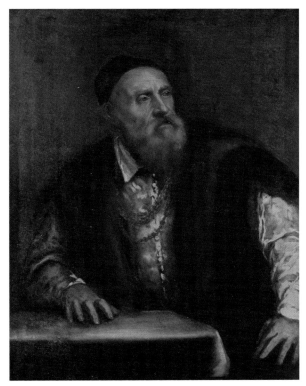

Titian (Tiziano Vecellio), c. 1560
Gemäldegalerie, Staatliche Museen, Berlin, Germany
Photo: bpk, Berlin / Staatliche / Anders / Art Resource, NY

This self-portrait was painted when Titian was seventy and still had twenty more productive years ahead of him. We see white paint gobs on his silk blouse and the four-strand gold chain he received as a gift from Emperor Charles V. The arm of white silk is rough in pattern and shape. He doesn't hold a palette; his hands are a picture of power.

The unfinished hands give a sense of a work in progress. He is ready for action. He is hearing distant voices and far-off sights beckon. This man is not going into the night gently; he's not going at all.

I looked at it from the faraway door, and he is a power leaning into the wind. This is from across a big room!

95. Malle Babbe

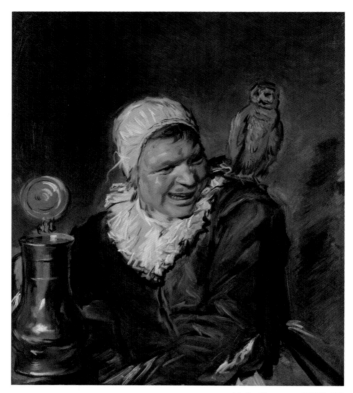

Hals, Frans, c. 1633–35
Gemäldegalerie, Staatliche Museen, Berlin, Germany
Photo: bpk, Berlin / Staatliche / Anders / Art Resource, NY

Courbet and Manet were followers of Hals, who, we are told, brought new insight into the painting of likenesses. Certainly, mad Babette of Haarlem displays the quickest brush strokes I have ever seen. A mad woman driven by drink engaged in a harangue. Hals invented a new portraiture — spontaneous, unfinished, slash painted, giving the viewer the visual job of putting all the elements together. The suggestions are there but barely so. The face, patches of brown, the bonnet, slashes of white, some extending off and beyond. The painting is a snapshot catching Babette turning — action, spittle, all a blur. It looks like impressionism, but 200 years early.

The folklore of this is the owl on her shoulder. The owl was a symbol of wisdom, but it also mirrored a darker side, alcoholism, which is here suggested by the beer stein. There was a Dutch saying, "As drunk as an owl."

I am sure Hals was remarkable. He did part of a group painting in the Amsterdam Rijksmuseum with one Peter Codde, which is as elegant as can be (see Chapter 9). I don't think the *Laughing Cavalier* in the Wallace Collection is sufficiently revealing as a portrait to be special. But *Malle Babbe* is the ultimate in revelation.

96. Joseph and Potiphar's Wife

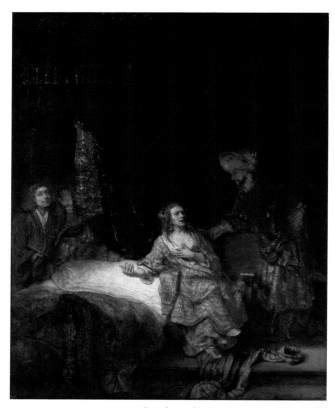

Rembrandt, Harmensz van Rijn, 1655
Gemäldegalerie, Staatliche Museen, Berlin, Germany

Photo: bpk, Berlin / Staatliche / Anders / Art Resource, NY

I was struck by this painting partly because it captures the precise moment of a bald-faced lie. Potiphar's wife falsely accuses Joseph of sexually assaulting her. Potiphar listens, his eyes calculating, edging toward scepticism. She in a sketchy reddish carpet-like robe, with theatrically white breast, eyes averted, dramatic hand pointing to Joseph in full symphony as she makes her spiel. She's a breezy bit of luxury. There's a gold bed, gold pillars, Potiphar also in gold — an oriental splendour. Somehow, at a glance Rembrandt has conveyed that she's lying.

97. Portrait of a Genoese Noblewoman

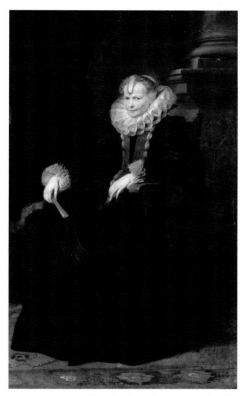

Van Dyck, Anthony, c. 1621–23
Gemäldegalerie, Staatliche Museen,
Berlin, Germany
Photo: bpk, Berlin / Staatliche / Anders / Art Resource, NY

This is part of a set, with this painting forming a pair with *Portrait of a Genoese Gentleman* by the same artist.

I studied reproductions of this couple before I visited them. Of the wealthy, powerful man I decided the issue was: is this man a fount of wisdom or a wealthy curmudgeon lording it over those with less money? I hedge towards the curmudgeon view.

What of the woman? Is she as bright as she appears or is this a wealthy pose of brittle superiority? One way or the other, not much gets past her. I lean to the brittle conclusion.

When I see them large, with black predominant, it's strikingly clear that I have misdiagnosed them. He clearly holds a powerful intelligence, capable of profundity. She is clever, her mind searching, curious and probing, not engaged with the trivial.

The guidebook notes some variations in the technique of the paintings. For example, the gentleman fills more of the canvas with landscape in the background. The brush strokes are broader, applied with thicker paint. In fact, because it's black, I couldn't see this when I squinted before it. The woman apparently has smoother surfaces, more delicately handled and finely drawn details of nose and mouth. I couldn't tell. But the carpet below the woman is a subtle pattern of quiet wealth.

Two fine minds. I would have loved to listen to them. I think of what I would have asked them: Have you heard of Rembrandt? Does Genoa care what the pope thinks? Have you heard of Galileo and his telescope and his funny views?

98. The Shop Sign for the Art Dealer Gersaint

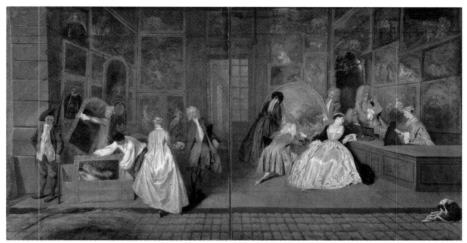

Watteau, Jean-Antoine, 1720
Charlottenburg Castle, Preussische Schlösser und Gärten, Berlin, Germany
Photo: bpk, Berlin / Charlottenburg / Anders / Art Resource, NY

Many critics consider Watteau's *Shop Sign for the Art Dealer Gersaint* one of the world's great paintings. Watteau, who died of consumption at thirty-six, painted it in his last year of life. André Derain, the famous 1920s French painter, said that he fainted when he came upon it.

Gersaint was an art dealer with a shop on a bridge close to Notre Dame, Paris. The story can best be told in Gersaint's own words:

> In 1721, on his return to Paris, in the first years of my business, he came to me and asked if I would allow him to paint an over door to be exhibited outside my premises, in order (these were his words) to take the numbness from his fingers ... It was the work of eight days, and even so he worked only in the mornings, his delicate health, or rather his weakness, not allowing him to paint any longer. It is the only one of his works which slightly sharpened his self esteem: he admitted this to me unhesitatingly.

It was the first advertising done in art. It was a big wooden sign hung outdoors to attract patrons. Was ever a capitalist sign so subtle? Come, peer, get curious, satisfy yourself, buy.

The picture: on the left a clerk is putting a monarch's portrait into a wooden case. The painting was done in 1720 shortly after the death of the Sun King, Louis XIV, so this cheekily suggests the passing of an era. The lady on the left, seen from the back, goes into the shop with her lover; she enters a chamber which purveys the joys of love. There are faint reproductions of pictures — many nudes on the wall in the background. Some perhaps can be identified but they really serve to enrich the tone of the background with a play of muted colour. The back of this young lady's gown is pink lilac (or perhaps lavender) with smudges of near purple, a cloud of colour feathering down. She has a grey shoe with an emerald green stocking peeking out of her gown.

In the middle an old man is kneeling to squint at nude women in a painting. He has a cold grey frock coat, with gold buttons on the back. Next to him, standing, is an older lady peering at the trees in the top of the painting with the nudes her husband is sniffing at.

On the right Gersaint himself and his wife are sitting at the counter holding a mirror so the sitting customer can look. She is in a lilac, light blue silk dress that has a sheen which glistens and sticks in your memory. Sir Kenneth Clark describes this silk dress as "an indescribable combination of spring colours." His theory of the colours is that there is a rhythm of tones, white, cool, warm, cool, black, cool, warm, black: it is a design as strict as a fugue. If you struggle before the actual painting (reproductions don't capture it) you can follow the warm/cool alternating theme. When the sun flashes on it through the rococo windows, the dresses shine. In light the painting just pops.

Why is this so special? What words can capture it? Unlike other rococo paintings, these figures are larger and not part of a dance or a chorus; they are individuals in circles of activity. The atmosphere in the back with its vague outlines of actual paintings do not interfere, they create an atmosphere.

Jean Cocteau once said the role of dresses in rococo was to provide armour for women: "The frills and flounces are their armour. They

are mailed in satin." It is not so here. The dresses are so delicate that they invite; they are tranquil pools of femininity.

Rococo was the era of the minuet, of elegance for the sake of elegance, of flutters and whispers and mysteries of the heart. If you see *The Shop Sign for the Art Dealer Gersaint* you will never be able to discount rococo painting.

99. The Sistine Madonna

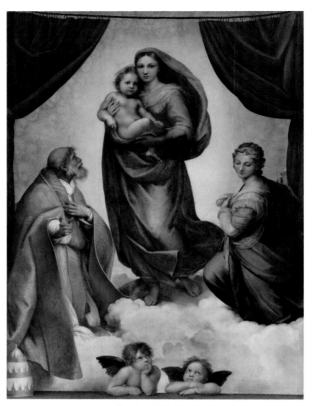

Raphael (Raffaello Sanzio), c. 1512–13
Gemäldegalerie Alte Meister, Staatliche Kunstsammlungen,
Dresden, Germany
Photo: bpk, Berlin / Gemäldegalerie Dresden / Klut / Art Resource, NY

Raphael was a stupendous artist; his drawings are without equal. He painted countless Madonnas that are beloved in Italian homes, but I have always felt they were saccharine. This painting, however, is considered to be the great prize in Dresden, together with a Van Eyck and a Giorgione.

The painting is very large. It fills an arch and is positioned at the end of a long corridor, so you are marching to this big blue figure way off in the distance. When you arrive, it doesn't disappoint.

The two figures on the side are irrelevant; they merely fill a space. The Virgin in blue is a force needing no support from anyone. She is not Raphael's usual demure, sweet-cheeked blushing girl. There is no little flower or emblem to sidetrack us here. Her visage is motherly, possessive, and defensive-aggressive. The baby Christ is more important, but still a baby.

Julius II called Raphael to Rome in 1508. This painting was for Piacenza in 1512 when it became a papal state. The papal tiara on the side has an acorn and oak leaves which adorn the coat of arms of Julius's family. So although the male figure is a St. Sixtus of the third century, Julius has his fingerprints on it. He wasn't a war pope for nothing!

100. Altarpiece with the Madonna and Child, St. Michael, and St. Catherine

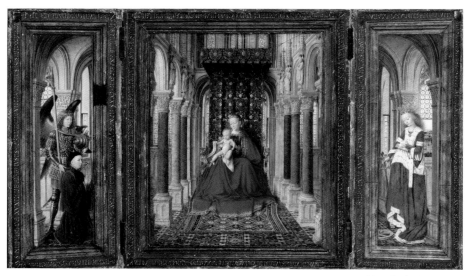

Van Eyck, Jan, 1437
Gemäldegalerie Alte Meister, Staatliche Kunstsammlungen, Dresden, Germany
Photo: bpk, Berlin / Gemäldegalerie Dresden / Klut / Art Resource, NY

Tucked away in the basement of the gallery in Dresden is this tiny Van Eyck. A little triptych eased into a delicate slim wooden frame meant for a bedside devotional, which could be folded and carried. To my mind, this is perhaps his best small work, and that's saying something.

Here the Virgin and Child are enthroned in a Romanesque church. The focus in this painting is the architecture. There is a perfect presentation of Romanesque solidity livened by the patterns of carpets and tapestries behind the Virgin — elegant, yet much different from soaring Gothic. The colour lifts up the apse, and varied patterns on the supporting columns create harmony. Behind, the translucent pearled windows give vibrancy.

The donor in the left panel is most likely an Italian with archangel Michael behind. The right panel has St. Catherine of Alexandria with her wheel a symbol of her torture (see Tiepolo's St. Catherine in

Berlin). In the background sits a populated landscape, with tiny blue-gabled castles.

But it is the centre of this piece that is the magic. The circular beaded glass runs against the different patterns of the carpet before the Virgin. Each marble pillar has a different array of veins. The golden circled buttons on the carpet behind Mary are God's whispers. The little triptych centre panel, perhaps fifteen by twenty-five centimetres, captures the grand effect of this subtle architecture, whose poetry and purpose glorifies religion. This extraordinary quiet atmosphere of carpet, gown, and church came a full 223 years before Vermeer's prime in 1660. Incredible!

101. The Jewish Cemetery

Ruisdael, Jacob van, 1655–60

Gemäldegalerie Alte Meister, Staatliche Kunstsammlungen, Dresden, Germany

Photo: bpk, Berlin / Gemäldegalerie Dresden / Klut / Art Resource, NY

There is another Jewish cemetery painting in the Detroit Institute of Fine Arts, but it is not quite as clear as this.

This painting is displayed behind glass, and it gives an impression of gloom, appropriate for a graveyard. Here we see a Jewish cemetery, white tombs, a dead tree, the ruins of a castle, a dark and stormy night. The running stream gives it energy. I view it as a magnificent portrayal of gloom, decay, and permanence of religion. When standing before the painting, I couldn't see the rainbow in the back; the glass and reflection obscured it. If there really is a rainbow, gloom might turn to hope, which counters the air of decay.

Goethe in 1813 praised the symbolic power and poetry in *Ruisdael*

as Dichter (Ruisdael as poet): "A pure, sympathetic, clearly thinking art-
ist, proving himself to be a poet, has achieved a perfect symbolism."
He was also a medical doctor when he painted this.

102. The Fall of the Damned

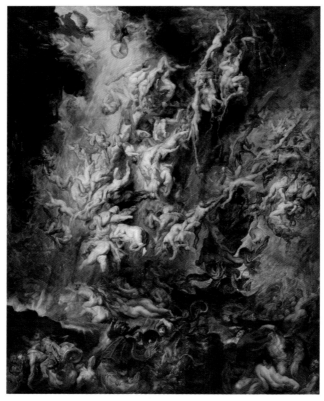

Rubens, Peter Paul, 1620
Alte Pinakothek, Bayerische Staatsgemäldesammlungen,
Munich, Germany
Photo: Erich Lessing / Art Resource, NY

The words of the Judge of the World according to Matthew (25:41): "Depart from me ye curse into everlasting fire, which is prepared for the devil and his angels." Here we have a graphic depiction of monstrous figures, lapsed angels from the dawn of time, attacking the damned.

How can I explain Rubens's *The Fall of the Damned*? It resembles an unfinished underpainting in browns and russets, but perhaps it is the dull red of the "fading embers of Hell" that gives it a live feel of torment.

The scene is a blur of descending bodies, some struggling against the tide. It is a vast tumble, a spiral down. If you concentrate, you will see corpulent bodies, pink, piggish, writhing before their time on the fiery spit beneath; pythons swallowing men; winged furies catching torsos by the feet; dead grey devils pulling golden tresses of fleshy sensual women — down, down. All these are descending to monsters; octopus, lions, tigers, giant ferrets, and bat dragons. These gorge on the damned flesh. A few tortured faces peer out, a warning to all.

103. Reclining Girl

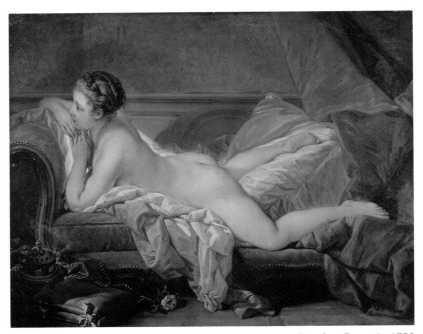

Boucher, François, 1750
Alte Pinakothek, Bayerische Staatsgemäldesammlungen, Munich, Germany
Photo: bpk, Berlin / Art Resource, NY

The reclining girl in this painting, Louise O'Murphy, is only fifteen. When Louis XV saw a miniature of her a year later, he made her his mistress. She had a child with him before losing favour in the court and being married out three years later.

Her skin is buttery pink. She is languorous. I imagine her waiting for a nibble of chocolate. Louise's smile is benign. Up close Boucher has captured a pink innocence.

This erotic portrait is hung adjacent to Boucher's *Madame Pompadour* (1756), another mistress to Louis XV. She was very grand, very bright, and a confidant of the king. She was made Lady in Waiting. The official portrait is perhaps glamorous but is stilted and faintly ridiculous and provides a startling contrast to Louise O'Murphy.

104. Self-Portrait

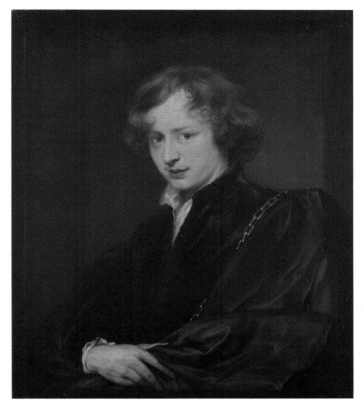

Van Dyck, Anthony, 1621–22
Alte Pinakothek, Bayerische Staatsgemäldesammlungen,
Munich, Germany
Photo: bpk, Berlin / Art Resource, NY

He looks a tad dandyish, but *what* an artist! Sheer genius.

There are three self-portraits of Van Dyck from around 1621–22. One is in the Hermitage, one in the New York Metropolitan, and one in Munich's Alte Pinakothek. They are similar yet different. All were painted while as a twenty-one-year-old he'd been hired by James I, king of England.

It is important to remember that Van Dyck was a child prodigy. In musical terms he was a Mozart. Trained by Rubens, he was a tireless

producer, always a success, dining with his court subjects. He produced a thousand paintings — in contrast, Velázquez, who lived twenty years longer, produced a hundred.

But here in this first visit to England (he returned when Charles I became monarch), perhaps things were not so rosy. It was a time of violent views and partisan hatreds. Our painter was a young Catholic from Antwerp, then a part of the hated Spanish Empire. Van Dyck's flashy works were too Italian, and Italy was a Babylon. Plays of the time served up horror, murder, and sex, all in the trappings of evil Italy. To add to this, he was a papist at a time when James's efforts to have his son Charles marry the sister of the Catholic king of Spain were highly unpopular. This was trouble in the streets.

This is a picture of a confident, elegant impresario. If there is insecurity in the eyes, it is that of the artistic genius who is never exactly sure. And the eyes penetrate. Some call this nervousness. Others argue that it is a portrait of melancholia, which was a rage of the day.

105. The Crowning of Thorns

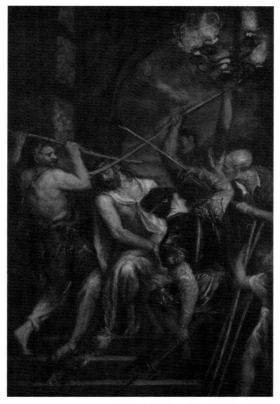

Titian (Tiziano Vecellio), c. 1570
Alte Pinakothek, Bayerische Staatsgemäldesammlungen,
Munich, Germany
Photo: bpk, Berlin / Art Resource, NY

Interestingly, Titian's picture of this scene that hangs in the Louvre
and was completed almost thirty years earlier bears the identical phys-
ical poses in terms of stance, arms, even lances — identical. The earlier
one clearly shows Christ groaning in pain. Yet this one must be by a
different painter. Here all clarity is gone, and brush strokes, shimmer,
and daubs of gold prevail. The bodies dissolve in colour, which gen-
eralizes the brutality. Here the tormentors dance around Christ, mock-
ing. They are intent muggers, and Christ is a picture of resignation,

with a resistance to pain, while engulfed in a swarm of pummelling energy. The painting cannot be looked at closely — only at a distance do the thick impasto and highlighted forms create an atmospheric space.

This painting, with its surface network of brush strokes and broken touches of colour, transfers the theme into another mode — a middle distance, a pool of atmosphere, only seen when you are the right distance away, where the eye joins the patches and the bold strokes.

106. Self-Portrait in a Fur-Trimmed Cloak

Dürer, Albrecht, c. 1500
Alte Pinakothek, Bayerische Staatsgemäldesammlungen,
Munich, Germany
Photo: bpk, Berlin / Art Resource, NY

This is of interest because Dürer was a magnificent technician. The inscription in gold print says, "Thus I, Albrecht Dürer of Nuremberg made an image of myself in appropriate colours in my 28th year." This is the first self-portrait in European art, full front pose, unaccompanied by any private or personal emblems — just a reflection of dignity and marked individuality. Rembrandt painted self-portraits without any emblems from 1630 on, but that was 130 years later.

In *A Face to the World: On Self-Portraits*,[1] Laura Cumming finds the painting to be distant, eerily clinical, and flirting with the concept of

an icon (is it meant to say I, Dürer, am Christ?). Yet it is obviously a self-portrait, described in the inscription as such.

Paul Johnson aggressively argues that this is the greatest self-portrait. What of Rembrandt? Van Gogh?

107. America and Africa

America
Tiepolo, Giambattista, 1753
Residenz, Würzburg, Germany
Photo: Erich Lessing / Art Resource, NY

The Tiepolo frescoes are a triumph of paint and architecture, so vast that the viewing must be done in a variety of access points on ascending steps with angled turns, the total space over 1,800 square metres, a labour of four years (1750–53). You can't see it from one single viewpoint and hence there are a series of new vistas as you ascend the stairs. The architecture is a fluffy white meringue wedding-cake style which enhances the murals. The staircase is a staircase to heaven, the banister posts rising, leading the eye to the ceiling.

These magnificent ceiling frescoes in this mansion fashioned after the Versailles Palace represent the continents of the earth. At 677 square metres, Tiepolo and two of his sons, Giondomenico and Lorenzo, created the largest continuous picture that has ever been painted as a fresco. And they managed to paint it all from the summer of 1752 to

the autumn of 1753! Tiepolo and sons worked fast!

How did they do it? The ceiling and sides have to be well stuccoed long in advance, and here it was done over ten years, where many layers of stucco seal the ceiling and wall. Then many portable scaffolds had to be built. The Tiepolos did not work in a reclining position but were always standing no matter what the height. The paintbrushes were made of hog bristles, pine marten, and squirrel hair. There would have been at least three groups, each consisting of a painter, a plasterer, and an assistant. Each day they would have a certain area that would be covered with wet plaster just as far as the drawing of the day's proposed work extended. The cartoon was drawn by Tiepolo with great detail on paper. The sheet of paper was placed over the wet plaster. Then someone drew lines through the paper, marking a precise engraving on the wet plaster. Then the paper came off and the artist would fill out the lines.

The artist had to paint on the entire wet plaster and do this in the day before it dried. The speed of his painting on the plaster created a unity of style, colour, and feel. Fresco work is not for the fainthearted or the cautious. You can't go back and redo something or just add a bit more of this colour or that colour a week later. They started at the centre top and worked down. It has been calculated that a large portion of sky with clouds could be done in one day during the time of drying whereas a large individual figure may have taken a day in itself.

How could they see way up in the top of the ceiling? How could they judge the colours? There were some windows at the top but more light would have been needed. Torches or candles were very expensive. Most probably a combination of mirrors and "shoemaker's globes," round glass balls open at the top which concentrated and intensified the light generated from the burning wick inside them, did the job.

The ceiling portion is not much higher than the top of the wall and in fact is quite flat. Tiepolo creates an illusion of great upper space. It is the ultimate trompe l'oeil foreshortening of figures and a variation of cloud colour that creates multiple depths.

What an *America*! A naked full-breasted wonder woman figure — hair streaming with coloured feathers, astride a crocodile to end all

Africa
Tiepolo, Giambattista, 1753
Residenz, Würzburg, Germany
Photo: Erich Lessing / Art Resource, NY

crocodiles: its immense jaws slavering over four severed heads, victims of cannibalism. Chunks of human flesh are being roasted, observed by an artist straddling the actual marble/plaster edge of the fresco, who almost tips over into the fire. One leg straddles the edge, his brown coat floating over the "lip" of the fresco.

This is the first huge cartoon poster art. Tiepolo painted figures to amuse and entertain. He used a vast range of colours: ochre, vermilion, dark cobalt, but always with a magnificent gap of white space, so that all is bathed in sunlight. In contrast to the darker colours, he adds his signature pale colours: greens, roses, lavenders, pale ultramarines, silver greys, all so light in density, so fresh to lighten the work. He avoids the trap of most ceiling painters, who create a too-busy jumble.

His style can be summed up in the word *pittoresco*, which stresses imagination and fantasy. Others use the word *sprezzatura* or "using in all things a certain nonchalance that what one does and says is done

without effort and almost without thinking" — an expression of facility and fluidity of movement.

In the section devoted to *Africa*, a bearded monkey falls over the edge of the canvas, grasping an ostrich tail, a goofy camel holds up Lady Africa, and a fantastical pair of huge robed traders appear, focused on profit. A Western merchant buys jewels from a turbaned vendor. Pearls sit in a green casket. Not just any green, but malachite, a most expensive, startling green. This had to be used sparingly, as was vermilion, a deep red.

Born into a family of ten in which his father died early, the struggle of life was daunting for Tiepolo. He was a feverish worker and painted furiously until his death at seventy-four. He married the sister of Francisco Guardi, the painter of lush Venetian scenes. He painted more ceilings in fresco and canvas than any other artist. He was the last of the Italian fresco giants. Yet for some reason, he is viewed as a lightweight by many critics.

108. Return of the Hunters

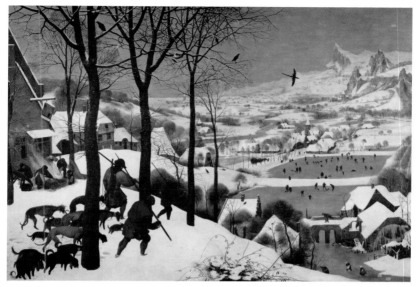

Bruegel, Pieter, the Elder, 1565
Kunsthistorisches Museum, Vienna, Austria
Photo: Erich Lessing / Art Resource, NY

Vienna has more fine Bruegels than any other city.

Not much is known about Bruegel, who lived from 1525 to 1569 in Breda, then part of Brussels. Some critics have opined that his works are serious moral commentaries on the evils of the day. Intellectual theories abound that he was portraying moral corruption and that he was exposing "sin and folly."

This is pointy-headed erudition. There are some which evidently point this way, but most are otherwise. The paintings are not judgmental; they portray a vibrant working-class society — warts, beery breath, and all.

The Italian painter and writer Giorgio Vasari commented on Bruegel because he had seen his prints. He would not have seen Bruegel's paintings as they didn't travel and were limited in number. He only painted in the last ten years of his life. He was famous at death, then his name vanished. It was suddenly revived in the twentieth

century because Belgian historians, tired of Italian Renaissance artsy stuff, turned to Bruegel as a portrayer of real history and local colour which had a saleable truth.

Return of the Hunters is a white, slate green tableau of frozen fields, skating rinks, and snow-capped mountains — a picture reminiscent of a cold February day in northern Canada. It was the first time landscape was the dominant part of a painting, and maybe the first rendition of winter. Previously, painters had created an arbitrary juxtaposition of landscape and figures, but in this work people are a part of nature.

Return of the Hunters portrays eye-watering cold, the hunters with heads scrunched down, closed mouths, grim, ducking the blasts of wind. The details are so true, the straggly summer weed bush in the foreground still sprigging above ground. The dark olive green patterns of ice bounded by snow frames. The broken hanging sign, the solitary crows, the huddled houses, all part of a design. Are the houses warm inside? Perhaps. Kids are skating, so it is not a time of disaster. But one hare for three hunters — is this enough? Will this be met by glee or a quiet sigh?

The clutch of dogs is a veritable dog pound on the loose — Irish wolfhound, borzoi, many others of indeterminate parentage.

109. The Painter

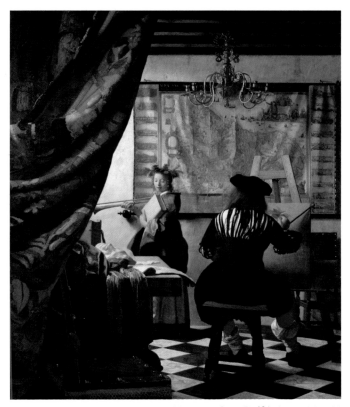

Vermeer (van Delft), Jan, 1665–66
Kunsthistorisches Museum, Vienna, Austria
Photo: Erich Lessing / Art Resource, NY

Vermeer's *The Painter* is a stunner. The curtain on the left is so damn *heavy* you can feel the rough deep weave, your fingers mentally pushing the carpet bristle. The marble floor is cool, you feel your shoe soles on it. The gold of the lamp speaks of wealth. The abstract patterns on the carpet are a precursor of Cézanne. The artist's red socks are a shocker. Lovely.

The layers of meaning in the allegory are overlaid on one another in a complicated way. Clio, the Muse of History, poses as the painter's model. The objects spread out on the table — a treatise on painting,

a mask or sculptor's model, a sketchbook, and the map of the seventeen provinces of the Netherlands before their separation in 1581 — should also be woven into the interpretation. Thus the Muse of History inspires the painter while at the same time proclaiming the fame of the art of painting in the old Netherlands, which she is entering into the book of history.

Following his death, as he had vanished from public acclaim, few Vermeer pictures surfaced — thirty-six or so. Pieter de Hooch, a contemporary in time and in subject matter (interiors, light through windows), was the more famous. This painting was purchased in 1803 for a pittance as a de Hooch. There was a forged de Hooch signature but everyone overlooked the signed "I VERMEER" on the map close by the girl's head. But in 1886 an art critic began to resuscitate Vermeer's reputation, which has only grown since.

110. Mars, Venus, and Amor

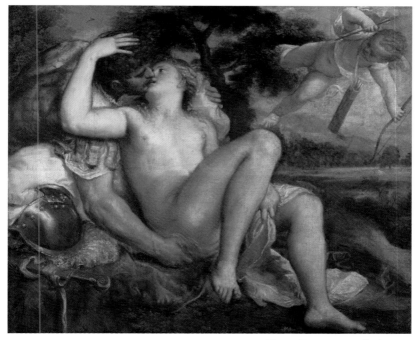

Titian (Tiziano Vecellio), 1560
Kunsthistorisches Museum, Vienna, Austria
Photo: Erich Lessing / Art Resource, NY

Titian's naked women exult in nature. This is placed near the same artist's *Danae*. Take a seat between two of the most erotic paintings of the Western world.

The Duke of Ferrara's Ambassador to Venice indicates the possible cause of a health problem from which Titian had been suffering: "I have been to see Titian, who has no fever at all: he looks well, if somewhat exhausted; and I suspect that the girls whom he often paints in different poses arouse his desires, which he then satisfies more than his limited strength permits; but he denies it."[2]

111. Susannah Bathing

Tintoretto, Jacopo Robusti, after 1560
Kunsthistorisches Museum, Vienna, Austria
Photo: Erich Lessing / Art Resource, NY

A regular subject of artists in Renaissance times, based on a biblical story. The biblical setting was the deuterocanonical or apocryphal additions to the book of Daniel. The wife of rich Joachim was approached by two lecherous magistrates who threatened, "Lie with us or be charged with adultery." She replied, "I choose not to … I will fall into your hands rather than sin in the sight of the Lord." They accused her of adultery. At trial the lechers were found to be liars and sentenced to be stoned to death.

This large painting (146 x 93 centimetres) poses an immense bejewelled nude, a uniform green–gold light, all in buttery white, surrounded by tools of beauty: combs, silver cups for powders, rings, a snake of pearls. All this before a hedge. At the very front of the hedge in the viewer's front line of vision, the bald pate of a bearded fogey crouching, trying to sneak a peak at Susannah's nether regions.

The tension palpable — a glorious, clear, yet tension-ridden painting.

It is a voluptuous delight!

Tintoretto has created an erotic piece where Susannah may well be a Venetian courtesan; symbolic of Venus, she is transformed from virtuous wife to sensuous beauty. There is a mirror before Susannah. The mirror was a classic symbol of lust and also used by prostitutes. Venetian ladies were famed for their bleached blonde hair, created by sun and salt water. In 1543 prostitutes were prohibited from wearing pearls, goldsmith's work, costume jewellery, or silk dresses, as they aroused the envy of chaste ladies. Look at it — is she chaste? In 1509 there were 11,654 courtesans registered in Venice.

When I revisit, as with all great paintings, I see something I missed — his use of white on the skin and yellow in the light. It is a glorious bath of light, over her skin of a faint custard ivory, yet not the sharpness of ivory. Perhaps twelve shades of white? Is this possible? Walt Disney's brother, who controlled the colour aspects, said white was the most expressive, varied, and difficult colour.

Tintorettos are meant to be seen in Venice, his town. He filled buildings and churches with massive works of flickering energy.

112. Samson Made Prisoner

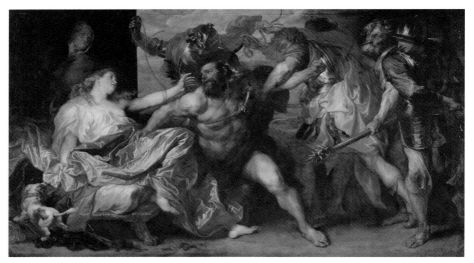

Van Dyck, Anthony, c. 1628–30
Kunsthistorisches Museum, Vienna, Austria
Photo: Erich Lessing / Art Resource, NY

The look of Samson, with shorn hair, what is it? Confusion? Fear? Lust? Distress? Surprise? A rotating fullback, swivelling to a languorous Delilah, a deceptive pose as she's in on the arrest.

The painting is a swoosh of power, prison paraphernalia, four strong men on Samson, yet they are barely a match; only the cords, which will tighten because of Samson driving forward, will stop him. The man at the end will need his ugly spiked club. Samson's locks of hair litter the floor next to a pair of near garden shears large enough to cut the mighty rope of hair.

Such poetry! The treacherous Delilah reclining, inviting Samson, he a bewildered lover dragged away still harkening to past love. *Samson Made Prisoner* is the most romantic painting I can ever remember, and it is the hit of the show.

Beside *Samson Made Prisoner* is Van Dyck's *Jacomo de Cachiopin*. Together they illustrate his immense scope.

113. Large Self-Portrait

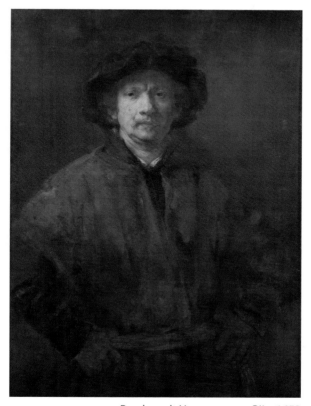

Rembrandt Harmensz van Rijn, 1652
Kunsthistorisches Museum, Vienna, Austria
Photo: Erich Lessing / Art Resource, NY

This is Rembrandt in his prime.

Rembrandt's 1652 self-portrait is all discipline, a touch of arrogance, bristling power. It reminds us that in his prime he was *formidable*.

Financial troubles are gathering, yet here is the ultimate portrait of the chief executive, ready to work, ready to perform, no trouble at all — I'll do it, just let me do it.

114. Conversion of St. Paul

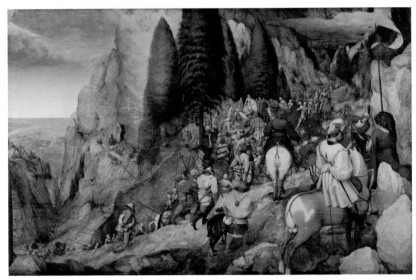

Bruegel, Pieter, the Elder, 1567
Kunsthistorisches Museum, Vienna, Austria
Photo: Erich Lessing / Art Resource, NY

Saul was on the way to Damascus to arrest more victims (early Christians) when he was, according to the book of Acts (9:3–4), "suddenly struck to the ground and blinded by a supernatural light, and heard the voice of the Lord saying 'Saul, Saul, why persecutes thou my children?'"

On close examination, you can just see Saul and the fallen horse. The lances throughout resemble vertical porcupine quills. A sense of a lightning strike — how could it possibly find Saul in this crowd? It must be the work of God.

This is a multi-peopled landscape of pleasing yellows, golds, and oranges, the soldiers lonely foragers in the woods on the edge of alpine resistance. The army comes to a halt.

THE GALLERIES

Gemäldegalerie, Staatliche Museen, Berlin

Matthäikirchplatz, 10785 Berlin, Germany
Telephone: +49 (0)30 266 42 4242
Web: www.smb.museum

It is wise to take a taxi to the Gemäldegalerie as it is a long way from a subway stop.

There is no art in the striking long hall that forms the spine of the building. There is a running bench around the edge. From this space you can enter the various areas of the gallery. Buy the gallery handbook and you have a map of access. If at any time you're confused as to what's next, you slip out to the centre hall, sit and regroup — and sure enough there is an entrance but fifty feet away to wherever you wish.

We've already highlighted a number of paintings in the Gemäldegalerie. Here are a few more to look for:

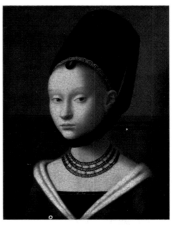

This young lady is an upper-class Burgundian Netherlander whom some revered critics have found to be mysterious. Her headdress of black velvet and trim with ermine was the dress of the day. She has an ever so slightly cross-eyed look. She is womanly yet clearly a child with her delicate eyebrows.

Portrait of a Young Lady
Christus, Petrus, c. 1470
Photo: bpk, Berlin / Staatliche / Anders /
Art Resource, NY

The Netherlandish Proverbs
Bruegel, Pieter, the Elder, 1559
Photo: bpk, Berlin / Staatliche / Anders / Art Resource, NY

The Netherlandish Proverbs (1559) by Pieter Bruegel is a feast of at least a hundred proverbs. It was originally called *The Blue Cloak* or *The Topsy Turvy World*. *The Blue Cloak* refers to the centre of the painting, where a woman places a blue cloak over a man, the top of the cloak over his forehead, like an extended duck's beak. This was a sign she was cuckolding him.

If you go to the Wikipedia site for this painting,[3] you will see an explanation of the multitude of happenings in it. Each represents a saying.

The man in the lower right spreading his arms over the table so he can barely reach one loaf means "he has difficulty living within budget." Behind a white pillar a man kneels before a devil figure. Confessing to the devil means "revealing secrets to one's enemy." Of course the simple one at the left forefront, a man butting his head into a brick wall, means "to try to achieve the impossible."

The painting is fun. Take your time with it.

The Paternal Admonition
Terborch, Gerard, c. 1654–55
Photo: bpk, Berlin / Staatliche / Art Resource, NY

The Paternal Admonition by Gerard Terborch (pronounced *Terrabach*) illustrates the importance of a title. Goethe apparently referred to this fatherly admonition in a novel. It appears that a handsome father is counselling a standing daughter, her back to the viewer as her mother observes the exchange. You can almost hear him saying, "Well, my dear, that may not be such a wise course of action and of course you are not old enough yet to …"

Some researchers, burrowing through

various bric-a-brac in the painting, say, oh no, this man is really visiting a brothel, with curtains drawn, and the sitting "wife" is really the procuress, and a price is being negotiated, with the tall young lady being the subject of barter.

The subject of this painting was the mayor of Nuremberg, a friend of Dürer. Wow, is he ever delivering a look! Sceptical yet friendly, the eyes have the added quality of reflecting the window and its panels. Pretty difficult.

Dürer was the Leonardo da Vinci of his era, with a fascination for science, perspective, human physiognomy — an all-round curious man who found it difficult to adhere to Catholic dogma.

He was a prodigious worker from a prosperous family. His godfather was the wealthiest publisher of the day. His material grandfather was the Medici agent in Nuremberg, his father the goldsmith to the Holy Roman Emperor.

Hieronymus Holzschuher
Dürer, Albrecht, 1526
Photo: bpk, Berlin / Staatliche / Anders / Art Resource, NY

The beheading of St. John is all a spurt of blood and protruding neck bone, with the chopper looking much like a fidgety, shifty accountant (with a pate, encircled by a fringe). In the background, way back, Herod and Herodionus at dinner stab at the heart of John on a plate presented by Salome.

St. John the Baptist Altar
Van der Weyden, Rogier, 1455
Photo: Volker-H. Schneider

The myth of St. John and Herod proves you shouldn't criticize powerful monarchs. John the Baptist was jailed for criticizing Herod marrying his brother's wife, Herodias. Salome, daughter of Herodias

by her first marriage, was a looker. She did a turn before Herod, who got all hot and bothered. He blurted out, "I'll give you anything you want." Salome's mom said, "Ask for John's head on a platter." She did.

Schloss Charlottenburg Palace, Berlin

Spandauer Damm 20-24, 14059 Berlin, Germany
Telephone: +49 (0)33 196 94 200
Web: www.spsg.de

Take the underground to Richard Wagner Platz and then walk to Schloss Charlottenburg. If you have time, take a guided tour of its history.

Go to the Neuer Fleugel, the entrance on the far right edge of the castle, which houses Frederick the Great's apartments. You needn't have a guide — you go upstairs, turn left, and proceed through the Golden Gallerie, which is a long gold, green, and white rococo hall with large windows. The hall is flooded in light, opening out to trees, which seem to flow inside and mingle with the green painted vines on the white walls. You proceed through this endless elegant dance hall, and suddenly you reach a room of art. Turn around, and it's there.

Gemäldegalerie Alte Meister, Dresden

Semperbau am Zwinger, Theaterplatz 1, D-01067 Dresden, Germany
Telephone: +49 (0)35 149 14 2000
Web: www.skd.museum

Take a cab from the train station to the Zwinger. Look out the gallery windows, and you'll see the splendid architecture of the resurrected

palace, baroque, theatrical, and oddly delicate. The delicacy may be a result of the postwar restoration. The pity of it is that the rebuilding — an accomplishment of extraordinary effort and skill — has pieced together past glory, yet a sense of frailty remains. The rebuilding has recaptured past beauty and re-established the architectural lines, but there is a sense of architecture alone — without the feel of milling courtiers, servants, and the attendant royal hustle and bustle.

Look out and see the balustrades, gold turrets, sweeping staircases, putti, baroque pediments, bulbous gold-leaved diadems of crowns, arches, and mythological Gods in chariots pulled by lions. Have lunch in the museum café, outside if possible, in the middle of the garden.

In addition to the works by Raphael, Van Eyck, and Ruisdael featured above, the gallery contains a number of other paintings of special interest:

Giorgione was a victim of the plague in 1510–11. Hence there are only about eleven or twelve Giorgiones, making this is a rarity. Here is Venus for the first time on a large scale, and remarkably naked for 1510. Venus is utterly relaxed, at peace with her nakedness.

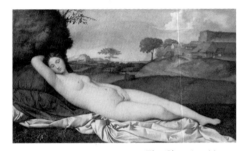

The Sleeping Venus
Giorgione de Castelfranco, 1508–10
Photo: bpk, Berlin / Gemaeldegalerie Alte Meister, Staatliche
Kunstsammlungen, Dresden / Hans-Peter Klut / Art Resource, NY

It is thought Titian finished it — perhaps the white sheet and wide landscape. After this, the floodgates of painters — especially Titian — portraying naked women were opened.

Cranach painted Duke Henry the Pious in 1514, maybe a first full-length figure outside of religious topics. Henry is a dandy, sword and all. Cranach painted Henry the Pious again in 1537 — a much different, very sombre work.

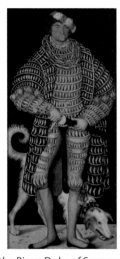

Henry the Pious Duke of Saxony
Cranach, Lucas, the Elder, 1514

Photo: bpk, Berlin / Gemaeldegalerie
Alte Meister, Staatliche Kunstsammlungen,
Dresden / Hans-Peter Klut / Art Resource, NY

Henry the Pious secretly protected Martin Luther. Cranach was a close friend of Luther and painted him often. At seventy-five, Cranach went to prison with his friend John Frederick the Magnificent, the Elector of Saxony. Cranach died a year after being released.

The French communist poet and surrealist Louis Aragon argued that Cranach was the only painter Picasso would not have dared to paint over. He had a theory that Cranach begot Dürer, who proceeded to Holbein, and that German painting was the bridge between the Flemish Van Eyck and the Italian Raphael. Holbein was the quintessential Renaissance figure of international stature.

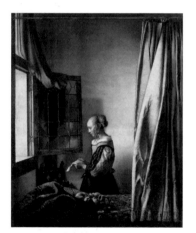

*Girl Reading a Letter by an
Open Window*
Vermeer (van Delft), Jan, c. 1659

Photo: bpk, Berlin / Gemaeldegalerie Alte
Meister, Staatliche Kunstsammlungen,
Dresden / Hans-Peter Klut / Art Resource, NY

There is the sense of aloneness, contemplation, and softness in this painting. The girl's reflection caught in the window, the pale green sheen of the silk curtain, slightly dominating the window light.

I wonder what the letter says? "Dear Girte… this is a difficult letter for me to write…."

Alte Pinakothek, Munich

Barer Strasse 27, 80333 Munich, Germany
Telephone: +49 (0)89 238 05 216
Web: www.pinakothek.de

There are two more paintings of note in the Alte Pinakothek, in addition to the ones featured:

Sileni are beings that are quite similar to satyrs; in fact, they are almost indistinguishable from each other. The true Silenus, however, is the one who appears at Bacchus's side. Legend has it that Silenus raised and educated the god of wine. Ovid tells how one day, wandering drunk among the hills of Thrace, Silenus is captured by some farmers and brought before their king, the famous King Midas. The king immediately recognizes Silenus and returns him to Bacchus.

Silenus is also famous for his wisdom and certain divine abilities. It is said that while he lies drunkenly asleep, people can get him to predict the future by circling him with garlands of flowers.

In the painting, there are grapes under his arm, vines covering his genitals, a blurred yet fixed gaze with vine leaves riffled through his pate, big awkward feet. He lurches on huge veined legs, a sixty-five-year-old Falstaff yet with a brown

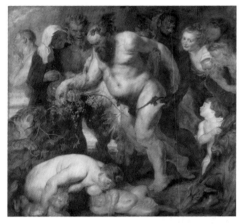

The Drunken Silenus
Rubens, Peter Paul, c. 1616
Photo: bpk, Berlin / Art Resource, NY

beard. The drunken revellers provide a chorus of approving tipplers as he lurches towards a fallen drunken mother, with two big kids lying on the ground milking away on mother's breasts. Silenus's blue-grey flesh repeats the blue of the background sky. Wow, will there be a hangover all around tomorrow!

Kenneth Clark in *Civilization* found the "protestant" mentality odious. To him, the Germans were relic destroyers — any church art, no matter how innocent or endearing, was smashed, all in a senseless rubble-making rage. He quotes

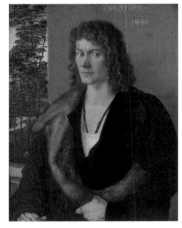

Oswald Krel
Dürer, Albrecht, 1499
Photo: bpk, Berlin / Art Resource, NY

from Erasmus, who viewed these German "protestants" as being congenitally irritable and of a bilious disposition. Clark points to this portrait by Dürer in 1499 of Oswald Krel as being the perfect portrait of a nasty bit of aggressive religious rage.

My, he looks angry, doesn't he? Quick-tempered, asking for a row. The Germans had plenty to be angry about with a Catholic Church corpulent from tithing and the selling of indulgences to avoid purgatory. The money spent on golden heathen angels and marbled popes made the Germans mad. Who needed the priests anyway? And Roman priests to boot!

Würzburg Residenz, Würzburg

Residenzplatz 2, Tor B, 97070 Würzburg, Germany
Telephone: +49 (0)93 135 5170
Web: www.residenz-wuerzburg.de

The Prince Bishop of Würzburg, Carl Philipp von Greiffenclau, wanted a palace to rival Versailles. The Residenz, high on a hill, which houses the Tiepolo frescoes, is huge and broad.

The Residenz was a mess after British bombing in 1945. Windows had been blown out and the building was a shell, but cultural preservation was important to a young American officer, John D. Skilton, who spent from May to October 1945 here and saved the Tiepolo ceiling. There is a watercolour of Skilton in washed brown khakis, hand on Wedgwood chair, all the picture of a British academic, yet he was American. Without his vigilance, this masterpiece would have fallen to some accident. The Rathaüs (city hall) has an exhibition about the British bombing led by Bomber Harris in retaliation for the German attack on Coventry.

Kunsthistorisches Museum, Vienna

Maria-Theresien-Platz, Burgring 5, 1010 Vienna, Austria
Telephone: +43 (0)1 525 240
Web: www.khm.at

In addition to the paintings featured, these are worth seeing:

Henry VIII famously married many times. As a painter of these passing subjects, Holbein had something of a risky job. If the portrait was too flattering and the actual object an annoyance to Henry, problems could arise.

Here we have his portrait of the careful Jane Seymour, shortly after her marriage. From an established family, she was a lady-in-waiting to Queen Catherine of Aragon and Queen Anne Boleyn (whose head was sworded off to make way for her). She died in childbirth after delivering King Edward VI, Henry's wish of a son at last fulfilled.

Jane Seymour, Queen of England
Holbein, Hans, the Younger, 1536
Photo: Erich Lessing / Art Resource, NY

In 1515 Giovanni Bellini, at eighty years of age, revolutionized painting by showing a young woman, all alabaster, nude, and looking into her mirror, before a dreamy landscape suffused in soft lyrical colour. An ordinary woman, not part of a mythological or religious theme, sitting in the nude, without a story? What is this? This opened a novel avenue for Titian and Giorgione. It was as if the impressionists had arrived.

Woman at the Mirror
Bellini, Giovanni, 1515
Photo: Nimatallah / Art Resource, NY

The gorgeous pale carpet, all intricate geometric patterns and yet lush, is a precursor of Vermeer — a full 150 years earlier! See his *Artist in His Studio* (1665) in this museum.

The Head of Medusa
Rubens, Peter Paul, c. 1618
Photo: Erich Lessing / Art Resource, NY

Medusa is often called the Gorgon, yet she is actually one of three famous Gorgons, daughters of Phorcys and Ceto, and the only mortal among them. The ancients describe them as monsters with hissing snakes on their heads, bronze hands, and golden wings. Their terrifying gaze is so powerful that whoever looks on them immediately turns to stone.

Regarding her symbolic representation, artists — especially those from the Baroque period — primarily depicted Medusa's head, at times by itself, at times being held by Perseus as a sign of victory. The snakes hiss and the gashed neck startles.

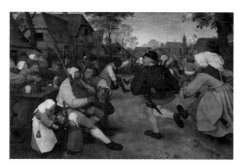

Peasants' Dance
Bruegel, Pieter, the Elder, 1568
Photo: Erich Lessing / Art Resource, NY

The citizens of Antwerp often travelled to the nearby town of Hoboken, famous for its cheap beer. An imperial decree of 1546 limited to twenty the number of guests at country wedding feasts. This may be one of the first truly unenforceable civil service bylaws ever enacted.

Here, one beggar and four others either blind or drunk sit at a table groping for beer, behind a drunken man with an off-tilted red cap, who plants a blubbery smack on a lady's lips. Around them the jogging and jigging of dance to a bagpiper.

I now find this jolly and enervating. When I first saw it some years

ago, I made a profoundly different and rather pompous note on the painting, "Rather dour, anti-social, celebrating the building of a church, yet all are social outcasts without many social skills, they can only get drunk. Bruegel was interested in the common people and didn't prettify it, no gloss."

8

EASTERN EUROPE

In the vast area that constitutes eastern Europe, there are three essential stops in our quest for the must-see masterpieces of European art: St. Petersburg, Krakow, and Prague.

The **Hermitage** in St. Petersburg, known also as the Winter Palace, sits on the edge of the Neva River, at night all aglow in golden light, which reflects in the water, a site of magic. The interior façade over the Palace Square, green, white, and gold, a fairy-tale cake.

Krakow presents a schizophrenic feast. Medieval, untouched by war, a square that can match the best in Europe. And its **Czartoryski Museum** has Leonardo da Vinci's glorious *Lady with Ermine*, unquestionably a must-see. Yet twenty minutes away — Auschwitz. They don't mesh, and my pleasure in my surroundings is mitigated by my awareness of that grim history.

Prague may be awkward to reach, but architecturally it is rivalled by few other cities in Europe. Prague's architecture exploits colour and turrets. Again and again you reach for the camera, for a view of a façade, in a narrow street, or a row of buildings next to an elegant river.

115. Return of the Prodigal Son

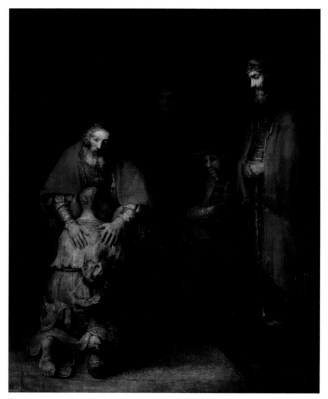

Rembrandt Harmensz van Rijn, 1668–69
The State Hermitage Museum, St. Petersburg, Russia
Photo: Scala / Art Resource, NY

The Bible story of the prodigal son is every wastrel's heaven. The father gives him money early, he leaves the house, travels to a faraway country, and "there [wastes] his substance with riotous living." When hard times come, he returns and says, "Father, I have sinned against heaven

and before thee." All is forgiven and father gives him rings, shoes, and a fatted calf to eat. The brother who has toiled these many years is furious (Luke 15:30–32): "But as soon as this thy son was come, which hath devoured thy living with harlots, thou has killed for him the fatted calf. And he said unto him, Son, thou art ever with me, and all that I have is thine. It was meet that we should make merry, and be glad: for this thy brother was dead, and is alive again; and was lost, and is found."

The Bible's parable is a hard lesson, the wastrel being celebrated, the righteous and dutiful ignored in this reunion. The father is not meditating on the past; he is caught up in a recognition of love, now. Is Rembrandt siding with the prodigal son? As a viewer one doesn't side with the just son, envious in the light of the father's generosity.

The returning son, with dirty feet, stubbled lice-filled hair, and defeated shoulders, crouches in the enveloping gentle strength of the father's welcoming hands — the sinner son meets a resurrection of forgiveness. The two figures meld into one emotional musical note of compassion. The son nestles into the embrace.

Critics have remarked on the father's hands — one so much lighter and more feminine than the other. Is it saying he is both father and mother?

As you approach the painting, it is almost framed by the arched corridor, and its reds are glorious. I am struck by the bare foot, the dirt, the tear in the back of the prodigal's gown, the shiny, shiny paint, the enveloping brown atmosphere.

In a PBS television show about Hermitage employees, a young man is interviewed. Bead, rings, tattoos, no more than twenty-five years of age, he has been to Afghanistan as a soldier, now he's a mover of paintings. He says of this painting, "It represents us all returning to home, it has a sense of family."

116. Dance

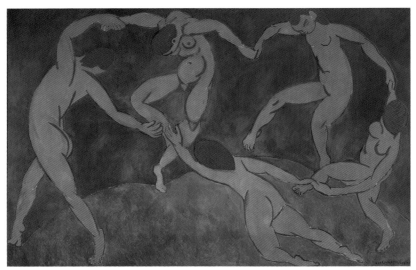

Matisse, Henri, 1910
The State Hermitage Museum, St. Petersburg, Russia
Photo: © The State Hermitage Museum / photo by Vladimire Terebenin, Leonard Kheifets, Yuri Molodkovets

This painting offers the ultimate presentation of pattern, curve, and interlocked motion, rhythm, and contrary colours venting an unexpected harmony.

Compare this with the painting in the Museum of Modern Art in New York. Done in 1909, it was the preliminary version of this work.

Matisse could be imperious. One had to be if one was a contemporary of the arrogant Picasso. Once a dealer asked if Matisse could explain why a colour was used. He retorted to the effect, "I don't explain."

117. Conversion of Saul

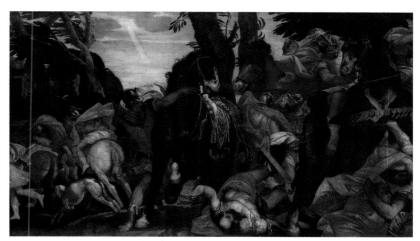

Veronese, Paolo (Paolo Caliari), 1570
The State Hermitage Museum, St. Petersburg, Russia
Photo: © The State Hermitage Museum / photo by Vladimire Terebenin, Leonard Kheifets, Yuri Molodkovets

Veronese catches the turmoil of God's intervention and Saul's fainting and blinding on a large canvas. Five horses bolt, chomp at the bit, and rear, the scene an uncontrollable flash of panic. Saul in his robin's-egg delicate blue is crashing to earth. All the rest is in shades of red, orange, and yellow, set off by two black horses.

Veronese was skilled at creating a ballet of interlocking shapes, yet with a high voltage of rebellion against the rhythm. The trees and soldiers are buffeted by a hot wind. It's all action and cries — whoa, steady now, what is *happening*?!

I love Vernonese's ability to lock the figures in a rhythm, all encased in enchanting robes, vests, breastplates, and helmets. An interlaced rhythm of limb and horse.

My favourite conversions of Saul with flashes of light are Caravaggio's first (see Chapter 4), Bruegel's second (see Chapter 7), and this one third.

118. Great Pine and Red Earth

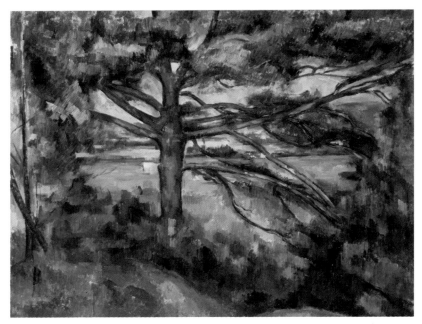

Cézanne, Paul, c. 1895
The State Hermitage Museum, St. Petersburg, Russia
Photo: Scala / Art Resource, NY

To quote from Signac's 1898 *Cézanne Show Guide:*[1] "In front of a tree trunk, Cézanne discovers elements of beauty that escape so many others. All these lines that intertwine, that caress and envelop one another, all these colored elements that overlap, that diminish or oppose one another, he takes hold of them and disposes of them."

The pine was part of Cézanne's childhood. In 1858 he wrote to his childhood friend, Émile Zola, "Do you remember the pine tree planted on the banks of the Arc with its hirsute head projecting above the abyss at its foot? That pine whose foliage protected our bodies from the intense sun?"

Cézanne's friend Monet's painting of pine trees danced in brilliant seaside light. In contrast, this pine tree is a power, a massive presence dominating the valley.

119. Haman Recognizes His Fate

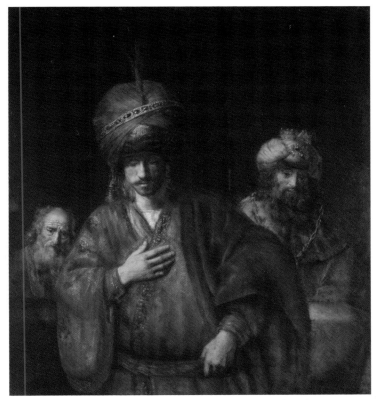

Rembrandt (School of), c. 1665
The State Hermitage Museum, St. Petersburg, Russia
Photo: © The State Hermitage Museum / photo by Vladimire Terebenin,
Leonard Kheifets, Yuri Molodkovets

This story, told in the biblical book of Esther, is interesting. In the fifth century BC, King Ahasuerus (generally identified with Xerxes I) of Persia fell in love with Esther. Esther's foster father, Mordecai, was a Jewish official at the royal palace. He told Esther not to disclose her Jewish roots to the king.

Meanwhile, Mordecai refused to bow to Haman, the king's chief minister. Haman plotted revenge on Mordecai and his people by persuading Ahasuerus to issue an order of death to all Jews. Esther appeared

unannounced before the king and invited him and Haman to a banquet, where she sprung a trap on Haman. The king loved Esther, and when she revealed that it was she and her kin who were targeted by the order of death, he made sure Haman got his due. In anticipation of the slaughter, Haman had erected a gallows for the proud Mordecai. Tah dah! Guess who hung on the gallows?

Haman is thunderstruck; Mordecai in the back all squint and worry. Haman's face in deep shadow, grim mouth, shadowed hurt, checked anger, the conflict so subtle yet there. The hand on chest — a badge of formal denial.

Haman's strawberry boysenberry robe with scrimples of gold; his nose a smear of white; the turban shows crazy opulence; the feel of the robe is close to the *Jewish Groom and Bride* in the Rijksmuseum — even Mordecai's despair, typical of Rembrandt's old men.

Haman Recognizes His Fate is one of the controversial paintings in the museum. Some time in the late 1970s a committee started to review the authenticity of all Rembrandts. It reassigned almost 25 per cent of all Rembrandts to "followers of Rembrandt." Imagine the horror of the galleries — a current star Rembrandt could be knocked for a loop. Thousands and thousands of dollars gone by a mere change from "by Rembrandt" to "by the school of Rembrandt."

120. The Absinthe Drinker

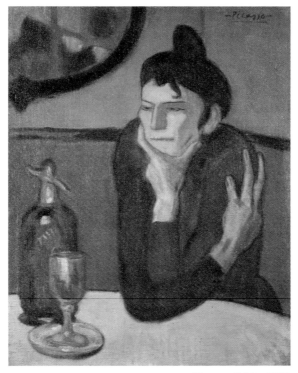

Picasso, Pablo, 1901
The State Hermitage Museum, St. Petersburg, Russia
Photo: Scala / Art Resource, NY

Picasso was only twenty-two when he painted this severe portrait. It is interesting to compare this to Edgar Degas's portrayal of absinthe drinkers in his *In a Café* in the Musée d'Orsay in Paris, which conveys a mood of blotto, an alcohol torpor.

Here a sense of discomfort, a woman wearing the badges of a very tough life. This is heightened by Picasso's sketchy application of paint, which allows the pebbled canvas to jump out, creating ribs and divots of bleakness. The impossibly huge working hand trying to enclose her own shoulder is a cry from the grave to be. The hand clamping her chin is an attempt to regain discipline. The eyes, heightened by mascara, a rage.

Alone, fatigued, nothing is going to get better.

121. Portrait of Henry Danvers, Earl of Danby

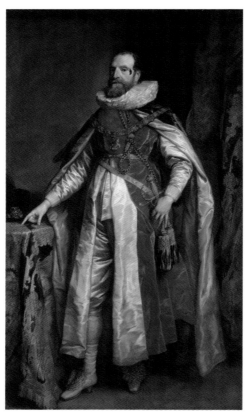

Van Dyck, Anthony, late 1630s
The State Hermitage Museum, St. Petersburg,
Russia

Photo: © The State Hermitage Museum / photo by Vladimire
Terebenin, Leonard Kheifets, Yuri Molodkovets

The Hermitage has several Van Dycks of interest, including a self-portrait similar to the one in Munich noted in Chapter 7, and yet different.

Van Dyck painted this portrait of Henry Danvers, Earl of Danby, in the late 1630s. Henry Danvers was exiled in 1594 for murdering Henry Long. In the course of a feud between the Danvers and Long families, Henry Danvers and his brother did Henry Long in.

The odd crescent half-moon scar below his left eye was incurred while he was a mercenary in Europe. He came back to England under James I, served in Ireland, and was Governor of Guernsey. In addition, he founded the Oxford Botanic Garden and was a connoisseur of art. As an art patron he could be picky. He once ordered a Rubens, but when Rubens's *Lion Hunt* arrived, Danvers found it not finished enough:

> In every paynter's opinion he hath sent hether a peece scarce touched by his owne hand, and the postures so forced, as the Prince will not admit the Picture into his gallerye I could wishe thearfor that the famous man would doe soum on thing to register or redeem his reputation in this howse and to stand amongst the many excellent workes wch are hear of all the best masters in Christendoum, for from him we have yet only Judeth and Holifernes, of littell credit to his great skill ... and theas Lions shall be safely sent him back for tamer beastes better made.[2]

122. Lady with Ermine

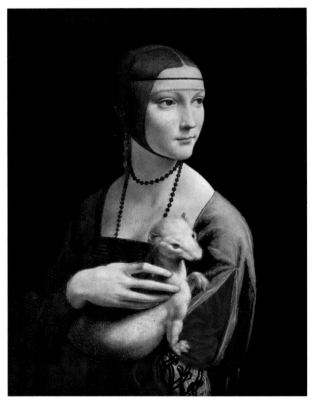

Leonardo da Vinci, c. 1490
Czartoryski Museum, National Museum, Krakow, Poland
Photo: Scala / Art Resource, NY

Leonardo's painting of 1490 depicts a girl, sixteen perhaps. It is a portrait of Cecilia Gallerani (1473–1536), the mistress of Duke Lodovico Sforza el Moro (a tough, fleshy man). Cecilia was from a noble Milanese family and cultured — acquainted with philosophy, fluent in Latin, a musician and a poet in her own right. Lodovico may have been a bit of a sloth, but he was wise enough to take her counsel on all affairs. She was his mistress and had one child by him.

The lady is in profile, with blue off her shoulder and a red trim protruding under the blue. Her hand, cradling the ermine, is a hand of

divinity. The ermine is alive, wild, with remorseless eyes; the hands mirror the feline quality of the ermine. Yet the portrait has an element of lethargy. Magic.

The band encircling the girl's high forehead has a lace effect enclosing quintessential youth, young and alive. The eyes, the clear eyes of certain, judgmental youth. The background, at least today, is merely an impenetrable colour. The painting has suffered from restoration. The hair was originally a transparent veil where it looks like it's tied under the chin.

Few of Leonardo's paintings survive. This *Lady with Ermine* shows what he was about when he was in top form.

The German-appointed governor of Poland throughout the war years was Hans Frank, a cultured man who tried to charm the locals with his gentle erudition. In 1945 he fled Poland with this painting in his suitcase. Not so fast, the Poles said. But his unsuccessful theft did show good taste!

123. The Feast of the Rosary

Dürer, Albrecht, c. 1506
National Gallery, Prague, Czech Republic
Photo: Scala / Art Resource, NY

In *Art and New History*, Paul Johnson gives this accolade: "If ever a work deserved the title of masterpiece, it is this one."[3]

When very young, Dürer became famous as a creator of woodcut illustrations for books, then just becoming widely available as a result of the recent invention of printing. Dürer's woodcuts made him the best-known artist in northern Europe. His Apocalypse series in book form created a large flow of income over an extended time. Already famous at his death in 1528, Dürer's fame only increased with the romanticism of the eighteenth and nineteenth centuries. Goethe idolized him, and Bismarck, pushing German nationalism, did too.

Dürer was known as the Leonardo da Vinci of the north. When he visited Venice, he was adopted by Giovanni Bellini, the lead painter of

the time, who exposed him to Italian art theory and the influence of the ancients. Dürer was thrilled to flee the cold of his home town of Nuremberg. He wrote, "Here I live like a prince, in Germany like a beggar in rags shivering."

Emperor Maximilian was something of a Renaissance man beyond the Alps. It was he who befriended Dürer and ennobled him, after a German noble refused to hold the ladder for this "commoner" when Dürer was painting the ceiling of a banquet hall for the meeting of German princes. "I can make a noble of a peasant," Emperor Maximilian barked at this prince, "but I can never turn a noble into an artist such as he."

The Feast of the Rosary took Dürer perhaps eight months to complete. Paul Johnson again:

> This amazing work, in which the Virgin and Child are
> enthroned amid a vast collection of saints, monarchs,
> angels, musicians, and spectators — including Dürer
> himself— is a summation of all that he had so far learned
> about art, a tour de force of form and color, simple
> delight, and exquisite virtuosity. It is also a striking blend
> of everything Dürer had learned in Italy (especially
> from Bellini) and the German mystic soulfulness so
> alien to the Italian vision.[4]

This work includes images of Pope Julius II and Emperor Maximilian I and a self-portrait among the nineteen figures portrayed.

The first time I saw it I was disappointed. I couldn't fathom what Johnson saw in this rather awkward bit of work. I do see that the gowns of the men surrounding the Virgin and child are subtle. The faces appear obdurate and perhaps just plain thick. When I returned three days later, I relented a bit. There is a young girl angel with wings, playing a lyre. The wings have three colours and are "real" wings protruding from the shoulders. Julius II (the great warrior pope and employer of Michelangelo) kneeling at the left is in a surplice of the faintest pink, near lavender, with gold brocade patterns. The robe's

subtlety has a touch of a fourteenth-century stained glass window with fine etching marks in the pattern.

Behind Julius II is a priest in kneeling position, he too with a silk surplice, such a light medley of butterfly colours in this cascading robe. Maximilian I also has a gown of royal swoop with fur running down his arm. Maximilian's big hands reaching towards a chubby long Christ child are set against the Madonna's blue robes.

124. The Flaying of Marsyas

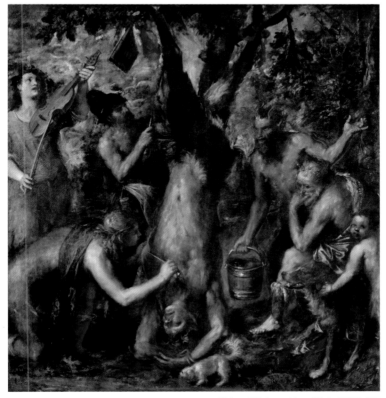

Titian (Tiziano Vecellio), 1570–75
Archbishop's Palace, Kromeriz, Czech Republic
Photo: Erich Lessing / Art Resource, NY

Sister Wendy Beckett thinks Titian is the greatest painter in the world in his later works, and this she picks as the greatest Titian ever painted. She sees in it a spiritual meaning. At first blush, this is difficult to comprehend. How can it be so? This is an impressionistic picture of pagan mythical savagery. She says in *1,000 Masterpieces of Western Art*,

> Apollo golden and beautiful, with exquisite care, cuts
> away at the satyr's skin. Marsyas hangs in agony, and
> yet if we look at his face, his lips are curled in a beatific

smile. The true artist, as Marsyas was, aims at godlike status and will give his life if that is what art demands. Marsyas knows that he has had this privilege.[5]

Interesting, if she hadn't written it, this would never have occurred to me. She also sees the lady violinist on the left as the young artist embarking on a career, unaware that she might challenge the greatest as Marsyas did.

This painting may have been inspired by an actual flaying. Here is the historical base: In 1571, the Turks were fighting the Venetians and winning. A Venetian-controlled city fell and surrendered. There were terms. The Turks reneged and actually flayed the Venetian representative. He was alive watching the flaying until it reached his chest. Then he popped. The Turks presented the skin to the Sultan. In October 1571, thanks to the Doge Venier, the Turkish fleet was defeated at Lepanto. Later the Venetians raided and snatched the skin back. It was placed in an urn in the Venetian church. This sets the scene for Titian. It is not just one of savagery but of self-sacrifice just before the great victory at Lepanto in 1571.

The mythical base is this: Apollo, the god of music, was offended by the arrogance of Marsyas, a satyr (part human, part animal, who lives in the forest and loves wine and sensual pleasures) who boasted of his excellence as a reed (oboe or flute) player. According to fable, Minerva invented the flute and played upon it to the delight of the celestial auditors, but the mischievous urchin, Cupid, having dared to laugh at the queer face which the goddess made while playing, caused Minerva to throw the instrument indignantly away. It fell down to earth and was found by Marsyas. He blew upon it and drew from it such ravishing sounds that he was tempted to challenge Apollo himself to a musical contest. Apollo of course triumphed and punished Marsyas by flaying him alive.[6]

Dante used the myth of Marsyas as a symbol of purification. So Titian's work was an expression of what one is willing to suffer for one's goals. Maybe Sister Wendy was right after all.

The victory of Apollo represents an artistic allegory — the triumph of divine art, being the stringed instrument, over natural art, the wind instrument.

There are perhaps two Apollos in the picture, one back left with violin (an x-ray shows there was under it a fully developed figure with a lyre) and one on the lower left with a scraping knife — its laurel crown is an emblem of Apollo. The reed instrument of Marsyas is replaced by a pan pipe.

The sitting gowned man on the right is a representation of Midas (and also perhaps a self-portrait as it is similar to Titian's self-portrait in the Prado), who was a judge of a music contest between Pan, who invented the syrinx, a wind instrument made by joining reeds together side by side, and Apollo. He favoured Pan, a big mistake. In revenge, Apollo makes King Midas grow donkey ears.

As I stand before this very large painting, all the intellectual theories vanish. The flaying of the Venetian envoy created public revulsion and hatred. The work captures brutal savagery.

The blood spatters down on Marsayas's bicep, a little dog is nearby to lick up the drippings. In Marsayas's eye, there is one tiny dot of white in the pupil, a label of horror.

125. The Hay Harvest

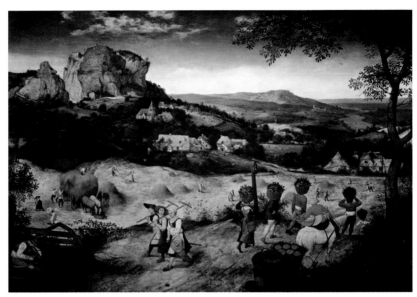

Bruegel, Pieter, the Elder, 1565
Lobkowicz Palace, Prague, Czech Republic
Photo: Erich Lessing / Art Resource, NY

Bruegel painted six paintings of the seasons, but only five still exist. The audio guide says this is the best preserved. You must see all five of Bruegel's seasons — in New York, Vienna, and Prague. Formerly in the Prague National Gallery, *The Hay Harvest* is now in a separate gallery owned by a private family named Lobkowicz.

The Hay Harvest was painted in 1565 to hang in the dining room of an Antwerp merchant. The whole series of six was then given to the governor of the Netherlands, and later transferred to the imperial collection. In 1870 it was listed as part of the Lobkowicz family's collection. The family's properties and art were confiscated by the Nazis and later the Communists, and not recovered until 2007.

This season emphasizes the farm labourers in the forefront of the picture. It is a study of men and women working. One thing strikes me at once — it does not have the feeling of the heat and sweat of hard

labour. I remember as a seventeen-year-old pitching first-cut hay, which was very heavy and loose, distributing many thistles on hair and face as I flipped it up on the cart. The curator, John Somerville, says in his audio:

> For the first time landscape is the subject of a painting in its own right, not just a backdrop for biblical subjects. The place in which the common man or woman go about their ordinary lives following the natural cycle of the seasons that determine their everyday existence. The peasantry in this totally rural world is in a preordained and inescapable communion with nature. As such, Bruegel elevates their hard and mundane lives to something heroic yet idyllic.

As he says this there is music in the background, perhaps Brahms, to catch the air of early summer. I am not sure Bruegel was a moralist or a painter of philosophy as the curator's comments suggest.

Here there aren't any patterns of landscape. Work dominates here, the sway of the bodies carrying produce on their heads tells you the workers must find a rhythm to survive this work. The hayers in the field at a distance appear to be part of a simple dance. Three ladies walk to work with hay rakes. A young girl in the middle turns to the viewer with a beatific smile. They have just passed eight poppies in arresting red. They approach the man sharpening the scythe. You can hear the sound of the whet stone on the blade.

There is no doubt this is a portrait of work in action amidst an idyllic safe countryside with thatched-roof houses, friendly copses of trees all under the protection of a castle, and a monastery perched on a colossal rock reaching to the sky. The houses in the middle ground represent security and hearth evidenced by the thatched roofs. The skyscape, a distant blue of faraway river, town, and mountain, started a trend other northern painters followed.

THE GALLERIES

Hermitage, St. Petersburg

2, Dvortsovaya Ploshchad, St. Petersburg, Russia 190000
Telephone: (812) 710-90-79
Web: www.hermitagemuseum.org

The rooms in the Hermitage are a jumble, with paintings piled high indiscriminately and subject to the affliction of glaring light and dirty glass. The corridors are chock full with white marble bust sculptures of mythological figures. You must struggle to come to terms with the paintings as they scramble to great heights beyond a proper view.

The contrast between this and the Berlin Gemäldegalerie could not be greater. In Berlin, paintings hang side-by-side with great breathing space between them and a perfect modulated light. Despite this, the Hermitage is an experience you mustn't miss.

Entrance to the Hermitage is complicated. If you go as an individual, you must book in advance for a specific time of entry. My theory is, stand in line and sure enough someone will be running a tour, which will enter shortly. Join the tour, pay the money, and after a little, step away from the tour and explore. The guides appear to be too regimented, and certainly they have a different purpose — which won't be yours.

In addition to the paintings in the Hermitage featured earlier, there are several more worth seeing.

Although not as acclaimed as the others, Pissarro was a leader of the impressionists. Usually he painted rural scenes. This one is extraordinary, as he captures the life of an immense city street. You are there,

next to horses, under awnings, waiting for the trees to bloom. There is a palpable sense of the jostling crowd all out for a promenade. This is as good a sense of city impressionism as you will find anywhere.

Boulevard Montmartre in Paris
Pissarro, Camille, 1897
Photo: Scala / Art Resource, NY

Pissarro was a Jewish anarchist who drew up an impressionist charter based on the charter of the baker's union in Pontoise. The bakers were loud, angry, and anti-government. His father married his uncle's widow in the West Indies. At the time the Jews were not to engage in art. Pissarro was admired by the other impressionists, and he exhibited in all the shows.

The Sermon of St. John the Baptist
Brueghel, Pieter, the Younger, c. 1604
Photo: bpk, Berlin / Hermitage / Beniaminson / Art Resource, NY

A picture of an enthralled crowd. This effect seems to be accomplished by a combination of the intruding tree and the set of the listeners' backs. Strange, but that tree really is the dominant force in the painting. What does it add? Gravitas? Weight? The word?

Danae
Titian (Tiziano Vecellio), 1553–54
Photo: Scala / Art Resource, NY

Titian produced five *Danae*s. This Hermitage one has the ugliest Krone catching Zeus' gold coins and crushed red enclosing curtains.

Danae's glimpse of the impending intercourse produces a faint fey look, already under the anaesthetic. In all four, Danae has nearly the same look — not exactly, but close.

Stranded Ships (or Boats) near the Shore of Normandy
Bonington, Richard Parkes, c. 1823–24
Photo: Scala / Art Resource, NY

In 1818, Bonington's family moved to Paris to open a lace store. There he met Eugène Delacroix, the great artist of the time, and became a pupil of Antoine-Jean Baron Gros. Gros was an ardent admirer of Napoleon and painted military scenes of violence and death, with molten brushwork and a sense of spectacle.

Young Bonington became a noted watercolourist and at the age of twenty-two received a gold medal at the Paris Salon of 1824, along with John Constable. He lived with Delacroix. In 1828, he collapsed during a sketching tour of the Seine. Tuberculosis took him quickly; he was only twenty-five.

Bonington had a romantic approach to painting, and here the paint is smeared on as if fingered or trowelled on, leaving gobbets of paint, blurbed here and there, a parallel to Constable. Your hand wants to touch the nobbly parts of the paint to reassure yourself that such a blob can create the flotsam of the shore. The water has Constable's streaks of snow, which caused such a howl in British art critics. The horses are drenched in paint, simply drenched, so much so that they move cautiously in the shallow white-smeared water.

The painting, with its Van Gogh blurbs of paint, is so tactile that it has a look and feel of a stucco-bumpy surface covered with quick swipes of hasty paint. If you look closely, the paint is smeared on in toothpick globs, yet at a distance it all magically meshes.

Delacroix loved Bonington:

> To my mind, some other modern artists show qualities of strength, or of accuracy in representation, which are superior to Bonington's, but nobody in his modern school, or possibly even before him, has had the lightness of touch which, particularly in water-colour, makes

his pictures as it were like diamonds that delight the eye, quite independently of their subject or of any represen- tational qualities....

We all loved him. I used to say to him sometimes, 'You are king in your own realm and Raphael could not have done what you do.'[7]

Czartoryski Museum, Krakow

Swietego Jana 19, 31-000 Krakow, Poland
Telephone: 12 422 55 66
Web: www.czartoryski.org

This museum is notable primarily as the home of Leonardo da Vinci's *Lady with Ermine*, featured above. It is off a side street, up stairs, in a large house with mostly bad paintings. Turn a corner in the hallway and there's Leonardo's work.

The Princes Czartoryski Museum is closed for remodelling until 2014. Parts of its collection have been moved to the Niepolomice Castle for an exhibition there. Leonardo da Vinci's *Lady with Ermine* is temporarily displayed in the western wing of the Krakow Royal Castle of Wawel.

National Gallery, Prague

Sternberg Palace, Hradcany Square 15, Prague 1 – Hradcany, Czech Republic
Telephone: +42 (0)2 33 090 570
Web: www.ngprague.cz

Archbishop's Palace, Kromeriz

Kromeriz, Czech Republic
Telephone: +42 (0)573 331 186
Web: www.zamek-kromeriz.cz

Kromeriz is three hours from Prague and two and a half hours from Vienna by car. Titian's *The Flaying of Marsyas* and the other paintings in the collection are in the Château Picture Gallery, which is part of the Archdiocesan Museum. Sometimes the painting is on loan elsewhere so you should check before you go. It may be difficult to nail this down as the website isn't terribly helpful.

Lobkowicz Palace, Prague

Prague Castle, Jirska 3, 119 00 Prague 1, Czech Republic
Telephone: +42 (0)2 33 312 925
Web: www.lobkowicz.cz

This gallery, in a beautiful setting in the Prague Castle complex, is owned by a private family named Lobkowicz. The family of nobles had immense political and social influence over the centuries and possessed palaces and art. In the twentieth century it was sympathetic to Czech nationalism, which was unusual for the rich landed gentry.

Max Lobkowicz supported the new Czechoslovak state created in 1918. In the 1930s he sought diplomatic support against German annexation of the Sudetenland. During the Second World War, the Nazis confiscated all his properties because he represented the Czechoslovak government in exile in England.

In 1948 the Communists took the property again. Then in 1989, Václav Havel led the Velvet Revolution. In 1991, he introduced legislation that allowed repatriation of confiscated property. After twelve

years of struggle, the Lobkowicz family regained their castle and art. In 2007, they reopened their castle with an art gallery that exhibits, among other paintings, Bruegel's *The Hay Harvest*, featured in this chapter.

9

SCANDINAVIA AND THE LOW COUNTRIES

As we've explored the galleries of Europe, the works of Dutch and Flemish painters have provided many of the highlights of collections from London to St. Petersburg. But there is no substitute for meeting these masters on their home territory. What better way to conclude our exploration than by visiting the galleries of Holland and Belgium? We will also take a side trip to Stockholm, a city of the sea, much like Halifax with changeable, threatening weather. Around the edge of the harbour, there is a whiz of cyclists everywhere, and in the centre, Sweden's **Nationalmuseum**.

In Holland, as you drive from place to place, the light is extraordinary, a different sparkle, and the sky is everywhere. The land is at sea level or even below in some places.

The approach to the **Mauritshuis** in The Hague, one of the world's great small galleries, is through an idyllic park with neat rows of trees surrounded by regal houses, one hotel, and one museum, similar to London's wealthy Belgravia. Before the park is a chic shopping street. Here is a manageable town. Go along the Dennewelt, a street of antiques and an 1898 art nouveau building, and on to the square of Lange Voorhout just before the Mauritshuis. Here, as in London, in a tree-adorned park around a divine square of seventeenth-century Regency architecture, all is as William and Mary would have had it.

The Mauritshuis itself is a small square building with scrolls of

garlands over a pond circled with lampposts, lights, and flowers. The setting could not be more romantic. The small tower adjacent to the gallery is the prime minister's office, next to it the small turreted parliament building. When you enter the gallery, you have a view of the pond.

In Amsterdam I recommend going to see the four great canals — the Singel, Herengracht, Keizersgracht, and Prinsengracht. There is a dazzling feast of little bridges and small boats, with the best continuous lateral architecture in the world, perhaps rivalled only by Venice and Prague.

First all the narrow frontages — so narrow, some tilting, all part of a harmonious continuum. These separate jewels blend together in your head. Various colours — black, maroon, cream, ochre brown — each building quite separate with its clear vertical shafts yet joined in a lateral harmony along the canal. There is not a site in the world that has side by side by side so many similar yet distinct façades running on and on. You search each one, marvel over it, yet when your eye eases to the next façade, off you go again. Every building insignia and ornamental curve is a feast. The pity and wonder of it is that you can't retain it in your memory bank, yet you know this pattern of narrow, disciplined, laced architecture is special beyond imitation.

Crossing the border into Belgium, the art in Bruges is worth a visit, but Bruges itself is glorious: tranquil canals, horses clopping, corridors of scalloped architecture, cobblestone streets, the smell of flowers. The buildings are intricate with their red brick, the launches on the canals sleek and trim. The ambiance of Bruges is special, a town of chocolates (pralines), tapestries, laces, and early Flemish art. In the eighteenth century Bruges was the centre of international banking, the creator of the Bourse, the first stock market. All trade gravitated to Bruges, especially because of its ability to weave tapestries. But the entrance route for boats silted up (or the water went down), and Bruges became stranded, leading to its sudden decline.

In nearby Antwerp, the main cathedral, with its Rubens triptychs, is in the glove and shoe market area (Handschoenmarkt). Along the way is the egg market and the milk market, with cobbled side streets

and a grand variety of small stores. You feel you are in a livable historic square — an experience of human scale combined with historical continuity that is a large part of what gives this whole area of Europe its charm.

126. The Oath of the Batavians

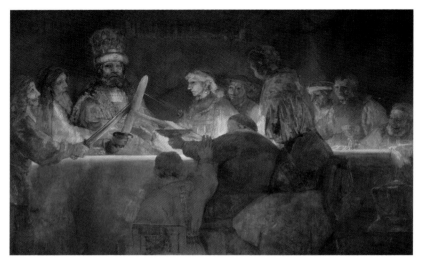

Rembrandt Harmensz van Rijn, 1662
Nationalmuseum, Stockholm, Sweden
Photo: Erich Lessing / Art Resource, NY

Here I am before *The Oath of the Batavians*. I suffer some trepidation. What if this quixotic trip to Stockholm solely to see this particular painting proves to be a flop?

According to Tacitus, the Roman writer, Claudius Civilis was a leader of the Batavians, and he led a revolt against the Romans. Civilis had lost an eye while a prisoner of the Romans. According to Tacitus, Civilis came upon a number of imbibing Batavians in a grove who were somewhat the worse for wear. He saw they were drunk, so he issued a harangue expounding a ghastly rendition of past cruel treatment, present slights, and dishonour to the tribe, highlighting the urgency of revenge. All present pledged an oath to kill.

Holland viewed this history with longing as its seven united provinces in the north were aching to escape brutal Spanish rule. So the burghers of Amsterdam wanted a symbolic hoopla.

Rembrandt originally painted it four times this size (six metres by six metres). We know not exactly how it looked, although there is a sketch in Munich.

The aldermen of Amsterdam preferred clean historical heroics, precise, with whitened calf and glistening bare arm. They were not pleased with this — it was too muddy, too fearsome. Perhaps they expected a portrait of a refined group of idealists reclaiming liberty for the public good. In any event, the painting was returned to Rembrandt in 1663 after having been shown in the town hall for a short time. Rembrandt cut it down, and this piece of about three metres by four and a half metres was in his estate at his death.

Claudius appears as powerful as Stalin — with only one eye. The closed eye flickers, brushing back terrible memories. The open eye is wary, agitated, looking for an enemy. Nastiness tries to break out through the thick paint on his face. The mouth a gash caught in his beard. Yet his robe is luminous, with dabs of gold, next to the white and Copenhagen blue-grey silk of his shirt. His crown has a top hat profile with blue-grey background and huge acorn shapes.

Five swords touch at the moment of oath taking. The upper background is brown with drips of paint. The supernatural candlelight in the middle joins the conspirators, all acutely aware that this is an undertaking that cannot be entered into lightly. There will be consequences from opponents, or if they falter in purpose, Claudius's revenge will be worse.

Up close the paint on the two left conspirators' sleeves is poured on by palette knife, a rough margarine, as in the old days when one had to mix the colour into margarine, creating lumpy orange brown, near yellow.

On Claudius's shoulder sits a rough cascade of uncombed, matted hair, above patches of brown on his sleeves, not defined, so the eye is drawn to the chunky gold chain dripping down his right front.

This illustrates Rembrandt's method at the end of his career. In

opposition to the then current popularity of classical, clean, detailed bright works, he turned to applying paint, layers upon layers of paint, to create a new world, the paint in itself, a lump, a mashed lump, not fine or silky, but a power and end in itself.

The swearing of the oath of rebellion shows a massively uncouth Civilis, a rough-cast hero sworn to bloody insurrection bonded in a pagan ceremony with a motley, repellent crew. The paint trowelled, running, a work of sculpture.

At the far right before a sitting older man and a young worried man is a gold glass goblet caught in the candlelight. In this large work, the crystal goblet makes an effort to match the heavy sword of Claudius. Surrounded by slabs of painted jerkins, slathered on by palette knife used as a near trowel, puffed sleeves, faces painted as sketches struggling through heavy impasto, the goblet, with its Venetian glass, is a kind of Tinker Bell at a very serious party.

Rembrandt has done a trick here. Art is full of Last Supper paintings, all twelve in a row, or Judas on the near side alone. Here the sense of table is portrayed by a river of light and is stopped by three figures on this side, one sitting, one leaning over the table, one standing. Together they make the conspiracy a circle.

Just as I'm ready to leave, I notice the delicate nature of the figure in the light next to Claudius, prominent in the centre. Is it possible the figure is a she, with white hair, pretty gown, with a heavy gold necklace — Claudius's wife? Yes, she has an earring! Her eye is a muffled black, her face pale, but her vestment is very costly.

Paintings are meant to be invitations to the viewer. Not so here. I feel as if I am a surreptitious interloper who has quite by fluke stumbled over this conspiracy. I shouldn't be here, and if I let anyone know about it, I'll be in danger. I visit the painting three times before I leave. When I returned, I swear I was frightened! Yes, it is this powerful. Yes, it was worth the trip to Stockholm.

127. Simeon in the Temple

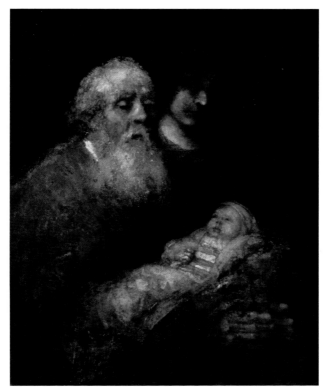

Rembrandt Harmensz van Rijn, 1669
Nationalmuseum, Stockholm, Sweden
Photo: Kavaler / Art Resource, NY

Simeon in the Temple was perhaps Rembrandt's very last painting. It is interesting to examine because it shows how abstract Rembrandt had become and how his bulky applications of layers of paint became an object and force in itself.

The heavy patches and abstract patterns all flow together, and from a distance they meld to make a mood. Up close it is the genesis of modern nonrepresentational art.

The tired dark eyes, the grey scrabbled beard, the sense of communion from abstract layers of paint: the effect is genius.

128. La Grenouillère

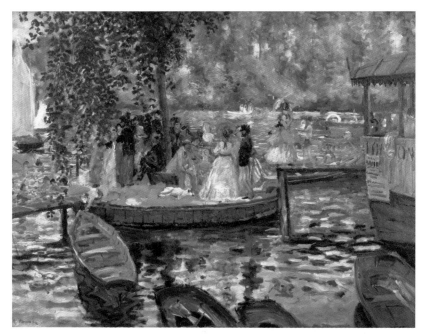

Renoir, Auguste, 1869
Nationalmuseum, Stockholm, Sweden
Photo: Visual Arts Library / Art Resource, NY

Renoir and Monet both went to La Grenouillère (the frog pond) out-side of Paris. There they competed, painting quickly to capture the moment, applying paint directly out of the tube.

I would choose Monet's *La Grenouillère* in the Metropolitan Museum of Art in New York — a depiction of the identical scene — over the one here done by Renoir. This version nevertheless captures the point; the lecture on the headset about the newness of impressionism and the role of men and women in it is most informative.

Interestingly, the romance attached to this little retreat of working Parisians is perhaps arguable. In a short story, Guy de Maupassant wrote the following about this very venue: "The whole place stinks of stu-pidity of the rabble of love for sale."

129. Self-Portrait

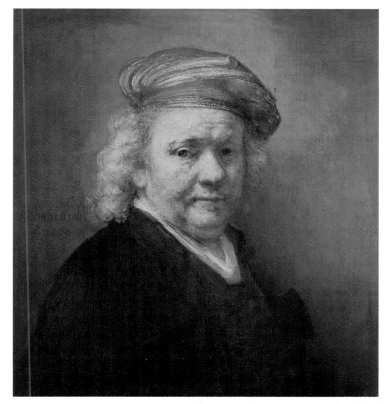

Rembrandt Harmensz van Rijn, 1669
Mauritshuis, The Hague, Netherlands
Photo: Scala / Art Resource, NY

This is Rembrandt's eighty-fifth and last self-portrait, painted in 1669 — the year of his death.

The left eye has a gleam, the right is murky. The thick paint scraped on, smeared on, as if plaster over a rough wall. Look at the hair, the sick hair of a dying man. Contrast it with the vibrant hair of Frans Hals's *Laughing Boy*. Above the upper lip a smear of white. When you are near death, who cares?

A friend who lives in The Hague and visits the painting often says,

Rembrandt is not number uno among a great company of painters for nothing. Somehow one spends more time with his paintings than anyone else's. It catches your eye and then you start wondering why, because there is nothing directly spectacular about it, until you start looking and get sucked in. The self-portrait is a super example, an old man who has had enough but somehow goes on anyway. The ambivalence jumps at you!

For this I need to go to my teacher at university, Professor Peter Brieger, a lovely man, born in Germany, adorned with European manners. He wrote of this painting in the Canadian Expo 1967 Catalogue:

Rembrandt saw himself here, as always, with uncompromising honesty. He never lets us forget his physical handicaps; nor does he let us forget his enormous inner strength. The flesh of his face is sagging, his skin is wrinkled, his bulbous nose juts over pendulous cheeks, the contours of a once firm jaw are lost in a double chin, and his eyes are sunk deep into their sockets. Although the dark robe is relieved only by the white neck cloth, there is an indomitable swagger in the shape and folds of the shining cap.

The simple mass of his body is but a support for the massive, leonine head with its dominating brow contracted throughout. Life and soul seem to triumph in the large luminous eyes and a hint of a smile around the mouth, a smile not of self-pity, but of compassion and resignation. As in all of Rembrandt's paintings it is the light which overcomes the darkness which threatens to engulf man; and it is a light which pulsates with life. Glowing upon the upper left half of the painter's face it seems to come, not from without, but from within this ruin of a man, as a symbol of his inner strength.

I once thought that what Professor Brieger said was spot on and that I could not improve on his reflections. But I go again in April 2009, and what I see surprises me.

Up close there are vast smudges of black on the eye, a smear of black soot on the tip of his pink nose and in the curve of his cheek. From a distance this black messy blur turns to shadow. I find I do quarrel with Professor Brieger's reflections. I see a trite phrase, sadness or is it pain? His beloved son Titus had died the year before. I see none of the triumph or great inner strength that Professor Brieger observes.

130. View of Delft

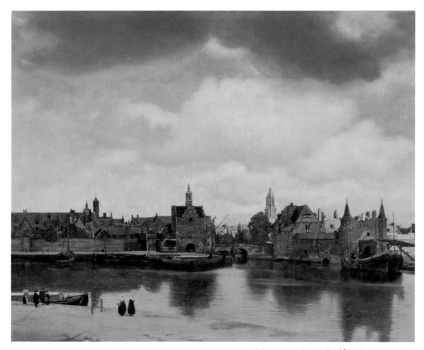

Vermeer (van Delft), Jan, c. 1658
Mauritshuis, The Hague, Netherlands
Photo: Scala / Art Resource, NY

In 1985, a panel of noted art experts commissioned by the *London Illustrated News* named this painting as the number two picture in the world, after Velázquez's *Las Meniñas* (see Chapter 3).

It portrays a morning view of the harbourfront of Delft in late spring or early summer. To the left is the brewery de Papagaal, then the Kettel Gate, the Schiedam Gate, the Tower of the New Church (in the sun), and the Rotterdam Gate (behind the herring boat on the right). Vermeer made the gates taller and narrower than in real life.

It is a study of subtle colour. Look at the reds on the roofs of the brewery on the left. How many reds? Two or three? At the far left, a soft ripe strawberry water colour, then a little farther to the right a dark pink, and then a rosy terra cotta.

The artist Josef Albers (1888–1976) observed, "If one says 'red' and there are fifty people listening, it can be expected that there will be fifty reds in their minds. And one can be sure those reds will be very different."

How do you create a grey-purple slate roof that dances to the eye? To the left of the Rotterdam Gate behind the big herring boat, the roof is grey, purple, with flickers of off-white and pearly dots. The architecture and red brick make this a picture to last and last. Looking at the boat, its studs appear gold in the morning light, and the dabs of paint on the hull suggest a reflection of water.

The water sports a white dance, yet it is slate, thinly painted in brown-grey and grey-blue, everything opaque. It is vital in that it reflects the town and joins the front viewing beach with the building. Vermeer extended the shadow on the right (X-rays reveal it was done later) so as to anchor the townscape with the tip of the beach.

Notice the warm, heavy clothes of the burghers on the beach. This should be a warm day. The sky suggests a possible sprinkle. Try to find the one tiny bird in the clouds.

Van Gogh observed it was executed with different colours than you see from a distance. Up close there is far less detail than you expect. There is a "skitter" on the water, as if tiny breezettes feather the surface.

The painting is placid. I mean this as a compliment. It nudges the viewer to a state of repose.

131. Portrait of Robert Cheseman

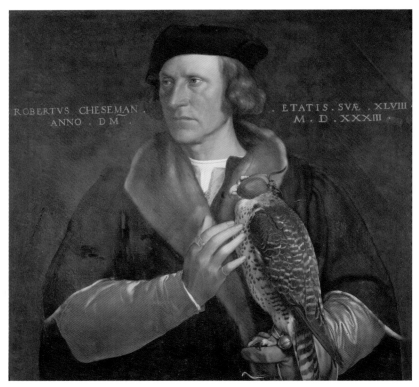

Holbein, Hans, the Younger, c. 1533
Mauritshuis, The Hague, Netherlands
Photo: Scala / Art Resource, NY

Holbein, son of the painter Hans Holbein the Elder, began his career in Basel, Switzerland. He was a friend of Erasmus, whom he met in Basel (see Chapter 2), and Thomas More. (Imagine that! What dinner conversations!) When the Reformation arrived in Basel it discouraged painting of any religious subjects. Holbein moved to England and, with Erasmus's recommendation, became part of More's circle. Later he worked for Thomas Cromwell and Anne Boleyn. Then he became Henry VIII's artist.

This portrait of Henry VIII's falconer once belonged to the English Royals. Around 1700, William of Orange, king of both England and

the Netherlands, brought this painting to his hunting lodge in Apple-doorn. After William died, the new English monarch, Queen Anne, demanded its return to England. As you might expect, the Dutch gruffly refused.

All of Holbein's work contains exquisite psychological detail. Look at the beady eyes of this falconer, as focused as a falcon itself. The mouth, that of a tough taskmaster. He would have to be to survive the impetuosity of good King Harry. And yet there is a delicate gold ring on his forefinger.

The falcon has a tapestry of dappled plumage, grey, pearly oyster, mottled white — oh to touch. But remember, the falcon is wild. The mink collar, soft against the hard mouth. Finally, there is a little gold bell on the falcon's claw to alert the hunters as to the bird's where-abouts, before it devours its prey.

132. View of Haarlem

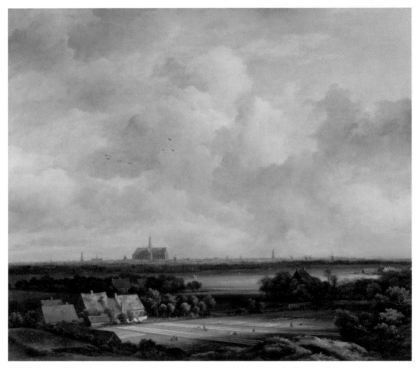

Ruisdael, Jacob van, c. 1670–75
Mauritshuis, The Hague, Netherlands
Photo: Scala / Art Resource, NY

I dream of this painting — a happy dream. I dream of the strips of yel-
low — almost a Meissen yellow, nestled with the white, ribbons of
coloured land nurtured by surrounding green — alternating dark and
light strips under great banks of cumulus clouds, the quintessential
full-blown storm brewing.

Long strips of white linen lie bleaching in the sun — the pure water
from the dunes used to help the process. This is at the edge of the
coastal dunes towards Haarlem, where you can see the St. Bavo church.

Look closely at the roofs of the moss-ridden farm buildings, the
swan curl from the bleaching linen on a laundry line, the sails of wind-
mills (ten in all?), the olive green trees, and three gulls in the changing

sky. River of sunlight set under the pearly grey clouds, clouds and more clouds.

Ruisdael was also a doctor, but as a painter who invented northern romantic landscape he was not successful in his lifetime. He belonged to a sect of Mennonites who applied for him to be accepted into an almshouse at the end of his life.

133. The Merry Company

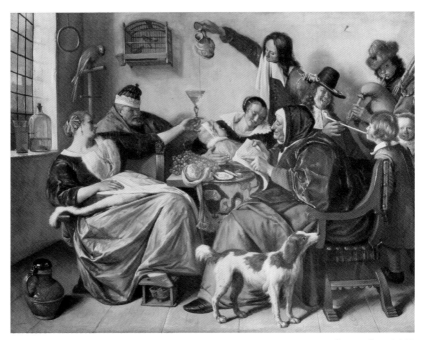

Steen, Jan, 1665
Mauritshuis, The Hague, Netherlands
Photo: Scala / Art Resource, NY

Steen portrays the Dutch proverb, "As the old sing, so pipe the young."
Here he is the laughing man with the pipe, and the voluptuous woman
on the left is his wife, Grietje van Goyen, daughter of the painter Jan
van Goyen.

Apparently another proverb stated, "He who sins before a child
sins double." Here, father smokes, one child smokes, the other plays
the bagpipes.

The parrot is a symbol of children saying things, not knowing what
they say. A bit of a stretch perhaps, but that's what the analysts say.

What I see in this painting is exquisite, jewelled detail. Look at the
wine from the carafe splashing into the glass. Is it rosé or a light bur-
gundy? What a steady hand and good eye. Look at the wife's rosette in

her hair. Five off-pink shards of what may be enamel above a dangling earring. Look at the pale, pale liquid in the jar on the window shelf. What is it? My, isn't this a noisy party? But Granny can still read the paper amid the brouhaha.

134. Head of a Girl

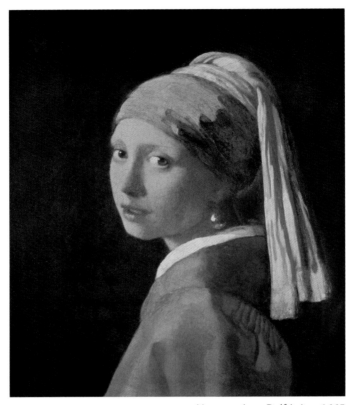

Vermeer (van Delft), Jan, 1665
Mauritshuis, The Hague, Netherlands
Photo: Scala / Art Resource, NY

People know little of Vermeer, other than he was the dean of the Painters' Guild and was active as an art dealer and appraiser. When he died, he had produced maybe thirty-six paintings, eleven children, and huge debts. There were difficult economic times following the French invasion of the Netherlands in the 1670s.

This painting, better known as *Girl with a Pearl Earring* (the subject of Tracy Chevalier's 1999 novel and the subsequent film), is the signature piece of the Mauritshuis. It was bought in 1881 by the grandfather of my mother-in-law's husband, one A.A. des Tombe. The purchase

price at auction was two guilders plus a 30 percent markup. The painting was cleaned up, and Vermeer's signature was discovered, which made it more valuable. In 1902, A.A. des Tombe left eleven paintings to the Mauritshuis in his will, including the *Head of a Girl*.

The subject is known as a troonie, which is a study of a head. Women didn't wear turbans — this is Vermeer's invention. I consider *View of Delft*, also in the Mauritshuis, Vermeer's greatest work, and his *The Painter* in Vienna (see Chapter 7) trumps all in its rich sense of touch. Still, this painting is a jewel.

When I see it again in 2009, I am struck by how inadequate the reproductions are. Up close the alabaster forehead is striking. Her turning glance has a spark; is it of recognition or hope? There is more personality than I expected.

The pearl, the pearl. A blob of white enamel at the top left, a smear across the bottom of the pearl reflecting the white above. Two brush strokes, and that's it.

135. The Jewish Bride

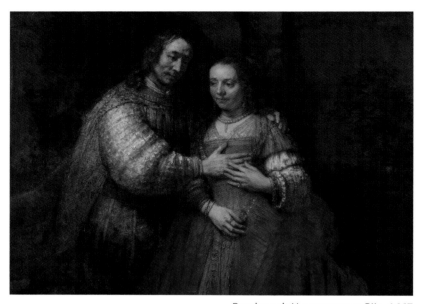

Rembrandt Harmensz van Rijn, 1667
Rijksmuseum, Amsterdam, Netherlands
Photo: Rijksmuseum Amsterdam. On Loan from the City of Amsterdam

When he saw this painting in 1885, Van Gogh said, "What an intimate, what an infinitely sympathetic painting. Believe me, and I mean this sincerely, I would have given ten years of my life if I could sit for a fortnight before this painting with just a dry crust of bread to eat."

Van Gogh must have been attracted to the thick yellow gold impasto of the groom's doublet sleeve. It is gold upon gold, laced, ribboned, thick, representing quintessential heavy luxury — sugary in effect, almost a caramel croissant. The bride's red, pomegranate gown begs touching. Her pensive contemplation of the bond of marriage is both dreamy and aware. She looks forward, her anticipatory look one of prudence, weighing the serious nature of her pledge. His hand on her breast is not a shock but an affirmation.

136. The Syndics of the Amsterdam Drapers' Guild

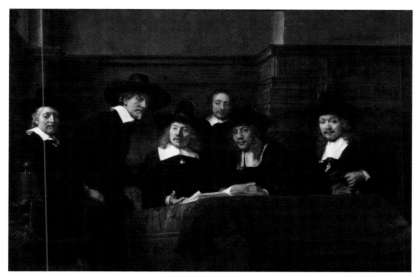

Rembrandt Harmensz van Rijn, 1662
Rijksmuseum, Amsterdam, Netherlands
Photo: bpk, Berlin / Rijksmuseum / Buresch / Art Resource, NY

The sitters are the sampling officials of the Amsterdam Drapers' Guild in 1661–62. They monitored the quality of laken, a felt-like woollen cloth, using test pieces or samples for comparison — hence the name "sampling officials."

The typical views of a syndicate, many of which exist in the Amsterdam museum, usually have people set out in a row with uniform gloomy, severe visages, all dour and no heart, each one paying equal so each rewarded with a precise similarity. That was the rude fate of equal pay for equal representation.

Here, five of them with one servant are all in different mental and disjunctive physical states. But the one second from the left, looking directly at the viewer, offers a clear psychological portrait: tough, an inch of humour, but not a forgiver — knowledgeable. How can one divine this with one glance? How can a white impasto on a scarred cheek tell me all of this?

The others I imagine to be stubborn, judgmental, pompous, and one even sagacious. When I look at the sagacious one (second from the right, sitting), I imagine after a friendship developed he could be witty, wise, and droll. It is ever thus with Rembrandt: the personalities are subtle.

The red tapestry rug sets off the black costumes and prevents them from glooming the picture.

137. The Meagre Company

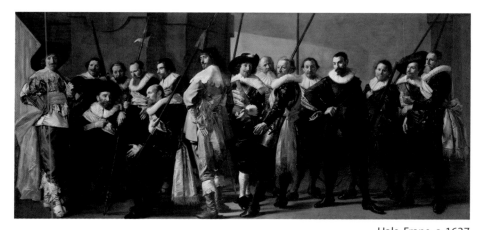

Hals, Frans, c. 1637
Rijksmuseum, Amsterdam, Netherlands
Photo: Rijksmuseum Amsterdam. On loan from the City of Amsterdam (A. van der Hoop Bequest)

Frans Hals had a sort of Rembrandt life with bankruptcy woes partly due to having eight children. Successful yet broke. He had at least nine commissions for group portraits and perhaps 200 portraits but was rarely well paid. When seventy-two he owed money to the baker who forced him into bankruptcy. He lived to eighty-four. The municipality of Haarlem, his town, paid for lodgings and clothes.

Like Tintoretto, he had a slashing brush stroke and the ribbons of thick colour created life, the work of an early impressionist. He doesn't throw off the sense of profundity or introspection of Rembrandt and he's often viewed as a lightweight. But he painted show-stoppers, dazzling vivid affronts to the eye. There is a sense of theatre taking place under the lights before the proscenium arch.

Captain Reael's Amsterdam civic guards must have been admirers of Hals. In 1633 they asked him to paint their portrait. That was unusual, because a portrait commission normally went to a fellow townsman. They did make it a condition, however, that Hals should paint the portrait in Amsterdam. Hals found travelling back and forth difficult. Three years later, with the work still not finished, the civic

guards became impatient: the portrait had to be completed within fourteen days or Hals would not be paid. Hals refused and did not receive his fee of 1,056 guilders.

The guidebook says:

> The painting was finished by Pieter Codde, who lived in the civic guards' neighbourhood. It was not an easy task for a painter used to working with great accuracy in a small format. He tried to imitate Hals's style as best he could. Yet there is a difference: Hals's figures are alive, Codde's are rather stiffer.

I can't tell which figures are by Codde. It is fun to surmise whom Hals painted and whom Codde did but it is a grand expression of unified elegance.

The colour is arresting. Copenhagen blue silk, orange curtains — it is a refined dazzler. Van Gogh said, "It's worth the journey to Amsterdam for that painting alone." It's so slick in an attractive sense, so smooth, united, with such a sheen that it flows laterally from figure to figure as if a minuet.

There is fluttering silk, velvety blacks, and many, many hands, all conducting or posing. It is a rarity, this, such a jolly group of good-natured men buoyed by the extraordinarily vivid, almost acrylic colour.

138. A Street in Delft

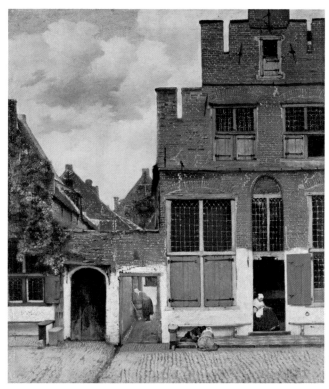

Vermeer (van Delft), Jan, 1658–60
Rijksmuseum, Amsterdam, Netherlands
Photo: Erich Lessing / Art Resource, NY

This was my mother's favourite. Olive green shutters forcing the eye to a narrow alleyway with bended maid in red with a blue skirt. The precise jewels of dapples on the red bricks energize the painting. A pattern of bricks over the bottom make a tactile smear of whitewash down to street level. Someone recently discovered where the actual house and street is in Delft. How do you make bricks lovely? I don't know, but Vermeer certainly did.

It only becomes apparent after revelling in the pattern of bricks and olive green shutters that this is a panorama of chimneys, steep roofs, and Dutch façade architecture.

139. Jeremiah Lamenting the Destruction of Jerusalem

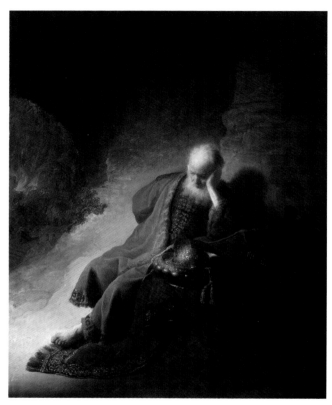

Rembrandt Harmensz van Rijn, 1630
Rijksmuseum, Amsterdam, Netherlands
Photo: bpk, Berlin / Rijksmuseum / Buresch / Art Resource, NY

Rembrandt was only twenty-four when he painted this. Ordinarily I move past this stage of Rembrandt because I know of the glories of his 1655–69 stage, but this stops you. If this was the end of Rembrandt's production, it would be a glorious climax. The gold is so thick and rounded that it strikes the viewer as real gold.

Jeremiah is despondent. He had predicted the destruction of Jerusalem, but King Zedekiah ignored the prediction. The conquering enemy, Nebuchadnezzar, torched Jerusalem. On the left there is a very

sketchy tiny picture of Zedekiah standing in a cloak before the fire.

Here is Jeremiah in a near purple robe. You can touch it, feel it. His hand holds his frail head nearly upright in a slow sigh. Age, reflection, gloom, the realization of his own prediction coming true is all there. The eyes reflect backwards in thought. A weary pain. Imagine being able to capture that! With paint!

140. The Milkmaid

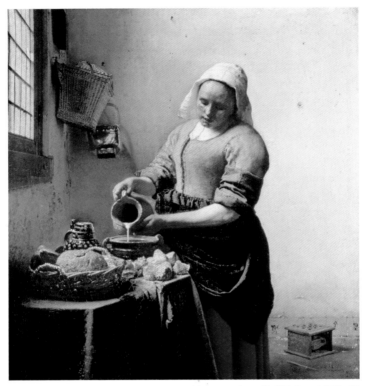

Vermeer (van Delft), Jan, 1658–60
Rijksmuseum, Amsterdam, Netherlands
Photo: Erich Lessing / Art Resource, NY

It is advertised as the hit of the museum. This is questionable considering that it is competing with the mighty Rembrandt in full flight. It is, however, a striking picture of a maid pouring milk from an earthenware jar. The tour guide dribbled on about the fantastical catching of the pouring milk.

The jumping blue of the balloon skirt against the flaxen yellow of the cloth blouse set under a gold pot against an ivory spotted wall flooded in light is a drawing room bravura act. There is a broken pane of glass in the light-passing window.

The bread, the bread — you can almost feel the crust.

141. The Company of Captain Frans Banning Cocq and Willem van Ruytenburch

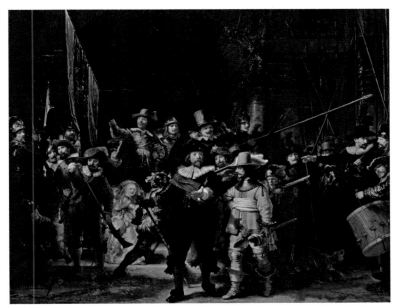

Rembrandt Harmensz van Rijn, 1642
Rijksmuseum, Amsterdam, Netherlands
Photo: Erich Lessing / Art Resource, NY

This painting with its dazzling colour shouts *booooommm* to you. *Boom, boom, boom.* As if John Philip Sousa has struck up the band right behind your left ear. Rembrandt has broken every rule in the book — hence the beginning of his decline. He placed art over patrons' conceit. Remember, everyone paid equally and therefore got equal frontal square footage. Not here. It's a bounce and a joyful hustle and bustle. In the background, lances, arches, a large mirror — a huge cavern.

A captain gives a command and the whole company is set in motion. The ensign raises the standard, the drummer beats the drum, the guards grasp their weapons. A small girl walks between them. Rembrandt did not paint a neatly arranged portrait of civic guards in a line, but created an exciting spectacle of men in action. It is a civic guard portrait the like of which had never been seen. It became world famous.

142. Portrait of Jan Six

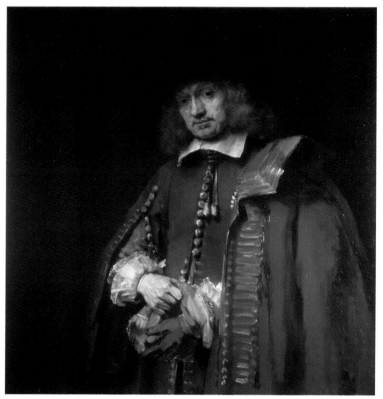

Rembrandt Harmensz van Rijn, 1654
Jan Six Museum, Amsterdam, Netherlands
Photo: Six Collection, Amsterdam

Part of the Six Collection, this painting is in Jan Six's house in Amsterdam, which will be open to the public in 2013. Some say it may be the greatest portrait of all.

In 1647, Rembrandt had made an etching of this young, wealthy aristocrat, Jan Six, who was also a playwright. The etching portrayed a prim, precise man of letters. It has little to do with this later rendering.

Rembrandt had a bohemian lifestyle that included his collecting a considerable amount of art. Just prior to 1654 (the year he painted this portrait), money problems began to press Rembrandt, along with

society's scorn for his living with Hendrickje Stoffels. The Calvinist church council called her to appear before them and accused her of "living in whoredom with the painter Rembrandt." She was severely admonished and banished from communion.

Rembrandt's house became a fiscal burden, leading him to borrow 5,000 guilders. Six provided 1,000 guilder (roughly a shopkeeper's annual income) in an interest-free loan. In 1654 Rembrandt was forty-eight, Six thirty-six — both in their prime.

The scarlet cloak with slashes of gold epaulettes, the bottom ones quick smears of molten yellow, the odd "pigeon" grey (that's what at least two critics call it) vest with its innumerable buttons. The flash of the hand and glove, all patrician. The hands are the hardest part of a portrait, and they are the most telling trait of personality. We see the wide white collar, not effeminate or fussy, smack against the scarlet and gold lapel of the cloak. The spontaneity of dashing off the gloves, epaulettes, the hurried scarlet — impressionism is born.

I love the flash of the picture — scarlet, gold, ruff, buttons, glove — all elegant and superior. I love the dry brush ladder of yellow (for gold) epaulettes running from the buttons. The person I see embodies the ultimate imperiousness of intellectual conceit coupled with money's rant — in a word, unfettered arrogance, his eyes miles away, staring at some vague semi-distant danger. We don't matter to him. Others have divined an inward reflectiveness bordering on modesty. I don't agree.

143. Wheatfield with Crows

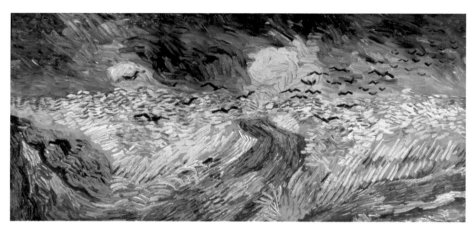

Van Gogh, Vincent, 1890
Van Gogh Museum, Amsterdam, Netherlands
Photo: Art Resource, NY

What is show-stopping in this angry work is the shock of startling blue. The reproductions don't catch the blue's intensity. The blue of the sky flirts with black. The ravens, true black, fly into the near black.

The wheat flows in an angry pattern, a rough sea divided by a green and ochre-red furrow. The dead wheat somehow alive. It rushes up and to the side with thick pasta strips of parallel paint. Above the blues, slashes of angry paint rain down in meaty ribbons. The ravens try to break the tide.

Power, heat, a dry wind. The ravens soldiering off to elsewhere. This was painted perhaps only two weeks before his suicide. Is it a premonition? He ordered new paints days before his death.

144. Vase with Irises

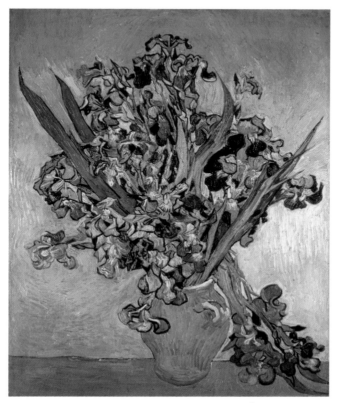

Van Gogh, Vincent, 1890
Van Gogh Museum, Amsterdam, Netherlands
Photo: Art Resource, NY

Vase with Irises was painted in April 1890. Van Gogh died on July 29, 1890, of a self-inflicted gunshot wound.

Flowers and especially paintings of flowers are usually just that — tulips, orchids, whatever. Van Gogh's irises, however, have a purple iris hue, sharp forms, surging up and fallen, early droop around the greenest sharp spears of the stems. It's as if a colourful army marches, wearing an armour of many splendoured blue with streaks of white. The blue inherits power from the yellow (nudging orange) backdrop and energy against the green swords.

They form a tower of blue jumble. Are they in their prime or past it? Probably past. It matters not. The nocturne of varied blue has a musical sweep. Is it a trombone? A violin?

145. Madonna Adored by the Canonicus Van der Paele

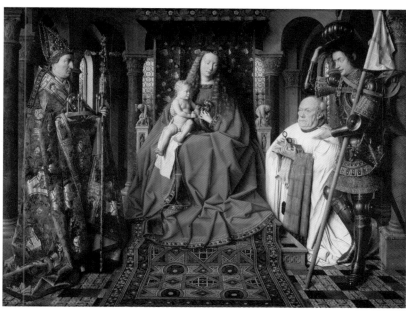

Van Eyck, Jan, 1436
Groeningemuseum, Bruges, Belgium
Photo: Erich Lessing / Art Resource, NY

In a small, well-paced gallery we find Jan van Eyck's *Madonna Adored by the Canonicus Van der Paele*. The canon is a fat man, sclerotic, near the end of his sedentary life, kneeling under St. George, paying homage to the Virgin Mary with the Christ child and a parrot. He holds a pair of large horn spectacles in his right hand. Spectacles could not be worn in Flanders except by special warrant. This tells us how special is the status of the canon.

One is meant to linger over this painting. The message is neither here nor there. The textures are what make it special. On the left, a bishop stands in a blue surplice over marble floor tiles. This blue, beaten gold robe, so tactile you can almost feel it. You dream of the pageantry of the church with its tapestry, clerical costumes, and sculptured dress.

The eye and the hand wish to touch this fabric of a time past. The painting is all patterned and jewelled magic. Watch out, the canon is going to suffer a stroke soon!

146. St. Ursula Shrine

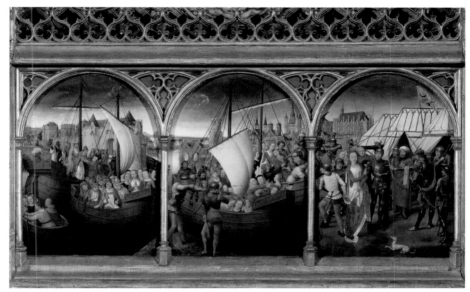

Memling, Hans, c. 1489
Memling Museum, Bruges, Belgium
Photo: Erich Lessing / Art Resource, NY

The *St. Ursula Shrine* portrays the rather bizarre legend of St. Ursula. In this myth, a pagan prince from England wished to marry Ursula. She said okay, but — and it was a huge *but*. He would have to convert. He agreed. She must also be allowed to make a pilgrimage to Rome accompanied by 11,000 virgins (11,000!).

Memling has captured this improbable theme on an eight-sided mini-chapel box, the panels housed in a metre-high gothic gold build-ing box (length 91 x 41 centimetres). This shrine resembles a mini-church with a saddle roof, spires with paintings enclosing the walls as glass windows and atop the roof.

Well, Ursula's trip proceeds with all the virgins. Reader, I am com-pelled to tell you it did not end well, not at all. Ursula and the virgins went to Cologne and on to Rome where the pope received her and the entourage. The first side of the mini-church is a study of ships

and medieval architecture around wholesome, prim girls. Dare I say it? Virgins?

The pope accompanies the travelling group back to Cologne, portrayed in architectural detail, where a shock awaits. Guam, king of the Huns, murders Ursula, her betrothed (the silly pagan had been cajoled to join the circus), the 11,000 virgins, and the pope. This is all a myth of course.

Why is this so special? First, because it is a combination of the architecture of the box chapel and art, each complementing the other. Second, in front of a rendering of medieval Cologne, the faces have such variety while being assaulted by the Hun crossbow and sword. The pagan boyfriend dies in Ursula's arms.

The last scene is saved for the death of Ursula. (She is always shown in saint pictures as the woman holding the arrow.) There are two peculiarly indifferent figures in the scene — the man and woman behind Ursula. Some say this is a self-portrait of Memling and his wife, Tanne, but there is no verified self-portrait of Memling.

147. Descent from the Cross

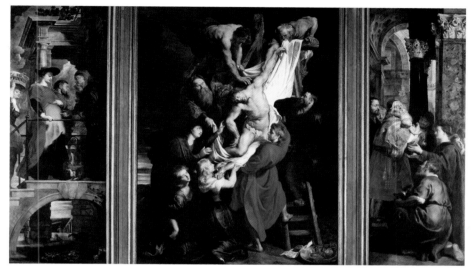

Rubens, Peter Paul, c. 1612
Cathedral, Antwerp, Belgium
Photo: Scala / Art Resource, NY

Because of the stories of impressionist painters' hard times, it is often thought that all painters were poor. Not so. Rubens was born in 1577. His father converted from Catholicism to Calvinism, was charged with heresy punishable by death, and so he ran away to Germany with his family. He had an affair with the wife of a Protestant prince and was jailed and death awaited. He slipped out of it. Rubens watched this and in all his fame was moderate, pious, and a prodigious disciplined worker who became a diplomat. No drunkenness, no affairs. Highly educated, he travelled the world as an honoured and revered guest everywhere he visited.

Rubens was a devout Catholic in Southern Netherlands which was ruled by Spain. The north was Protestant, aided by England. A war of propaganda erupted between Protestants and Catholics — who mounted a Counter-Reformation to curb the heresies of the Protestant Reformation and seduce lost Catholics back to the "real religion."

This was the role of much art and certainly was the role of the two huge triptychs in this cathedral, *Elevation of the Cross* and *Descent from the Cross*.

When you enter the front of the church, go to the side aisle and look down the tunnel. At the end is the striking grey-white Christ being lowered. From that point you can see across the nave to the left aisle and at the end Christ being lifted, which gives the impression of motion up on the left flowing across to the right aisle where Christ is coming down.

In *Descent from the Cross*, Christ's grey arm stretched out forever surpasses Michelangelo's arm of Adam in the Sistine Chapel. The arm, a grey power streaked with blood — up and on to meet a labourer gripping the dazzling white shroud in his teeth (a novelty). The electric white of the sheet sets off the greenish marbled grey of Christ and the blast of red in St. John's cloak, all soft and scalloped, as he sways, yields and cradles Christ. Although subdued in colour next to the winding sheet, Christ's body is the source of the energy of the work. This is the best of baroque, power without show-off.

Christ's foot, bloodied, a dead grey-green, is planted with force on Mary Magdalene's shoulder. The force and tactile feeling aroused is shuddering as her blond tresses mingle amidst his toes. Of course Mary had, as a token of her repentance of sin, washed and dried Christ's feet with her hair.

All descend to St. John, tensing to his task of carrying the burden of death, faith, and belief. The Virgin Mary is in blue, black hair, deathly pale, black eyes, trying to touch Jesus. The grief of it.

Rubens created this power and drama and yet imbued it with delicacy and near-serenity. He finished paintings with speed, using a special brush, laying out lines of brush strokes up to three feet long, all with sureness.

The surrounding architecture of this relatively newly made Gothic church sets the ambience.

Rubens, freshly back from Italy, was very young (thirty-three) when he painted this.

148. Jean–Paul Marat, Politician and Publicist, Dead in His Bathtub, Assassinated by Charlotte Corday

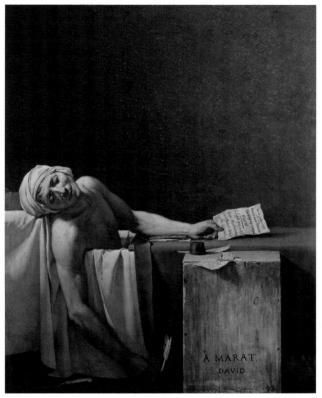

David, Jacques-Louis, 1792
Musée d'Art Ancien, Musées Royaux des Beaux-Arts,
Brussels, Belgium
Photo: Erich Lessing / Art Resource, NY

I've never actually seen this painting, but I plan to before I die. I am most curious to see the green of the blanket and the pale ivory of the skin on the dead body — angled over the bathtub. Marat was a leader of the French Revolution. He was murdered, and the nation went into a tizzy, fomenting more violence than even Marat regularly meted out.

Marat, a journalist, had a power base of radical and committed small property owners and artisans known as the *sans culottes* (without knee

breeches). He became known as "The Friend of the People," which was the name of his newspaper. His extremism was expressed thus: "Liberty must be established by violence." He had 860 gallows erected to deal with his political enemies and sent more than 200,000 of them to the guillotine.

Marat was ugly and was afflicted by a painful skin disease. On July 13, 1793, twenty-four-year-old Charlotte Corday from Normandy murdered Marat, whom she viewed as a madman who had pushed the Revolution to limitless murder. She knew she would be caught and guillotined. She intended to do it on July 14, but Marat couldn't go to the Assembly. Corday slipped into his house, into the bathroom, pulled a five-inch butcher knife from her dress and plunged it through Marat's right collarbone side. Marat died quickly. Corday made no attempt to escape. She remained calm as she was guillotined on July 17 — the day after Marat's funeral.

David suffered from a bad stutter made worse by an injury to the inside of the left cheek from a fencing match (see his self-portrait in the Louvre). He was damn near incomprehensible. His impassioned speeches were only understood when reading the subsequent official record.

He was, however, a greatly admired painter when he was elected deputy for Paris at the National Revolutionary Convention in September 1792. He allied himself with Robespierre, Marat, and Danton, a tough triumvirate. He and Marat were close.

David's *Death of Marat* became a Republican altarpiece. He finished the painting on October 14, 1793, and gave it to the Deputies of the National Convention on November 14, 1793. He said at the convention,

> Citizens, the people ask for their friend again, their sorrowful voice wished itself heard — my talent is roused, they want to see again the features of their faithful friend: David! they cry; seize your brushes, avenge our friend, avenge Marat; let his vanquished enemies grow pale again at the sight of those disfigured features, reduce

them to such a state that they could envy the fate of him whom they were cowardly enough to have killed when they could not succeed in corrupting him. I heard the voice of the people; I have obeyed....

It is to you my colleagues, that I offer the tribute of my brushes; when gazing at his livid and blood-soaked features you will recall his virtues, which must never cease to be your own.[1]

Marat, although withered in life, is given graceful strong arms — one dangling, reminiscent of a Christ deposition scene. His pitted skin is clear. Usually Marat made lists of candidates for execution, but David put in his hand a note saying, "You will give this assignat [Revolutionary currency] to the poor mother of five children whose husband has departed to defend the homeland."

The picture is serene and a new religion is born, not to last for long though. The painting was a huge success, but Marat fell out of favour two years later and it was returned to David.

Later David, a bit of a political dancer, became an apologist for Napoleon, doing grand propaganda pieces for him. After Napoleon's fall, David went into exile in Belgium, taking his *Marat* with him. That is why the painting is at the Musées Royaux in Brussels.

149. The Ghent Altar

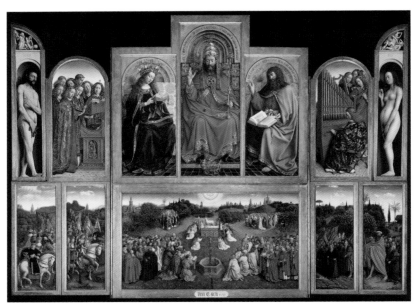

Van Eyck, Jan, 1432
Cathedral of St. Bavo, Ghent, Belgium
Photo: Erich Lessing / Art Resource, NY

Acknowledged by art lovers as a "must-see," this Ghent altarpiece in the Cathedral of St. Bavo, Ghent, Belgium, is known as *Adoration of the Mystic Lamb*. When the side panels close over the main panels it is a little under four metres high and two and a half metres wide. When open it is five metres wide. It is supposedly by both Hubert van Eyck (an older brother) and Jan van Eyck. There used to be an inscription on the frame stating that Hubert van Eyck, *maior quo nemo repertus* (greater than anyone) started the altarpiece but that Jan van Eyck, calling himself *arte secundus* (second best in the art), finished it in 1432. Hubert is a bit of a mystery and some argue he did the top three figures in the open panel.

I wish to concentrate on a small part of this huge work.

The Adoration of the Lamb panel shows two opposite groups of men staring at the lamb, a representation of Christ, referred to as the Lamb

of God in the Gospel of John (1:35). Under the bleeding lamb representing Christ's blood, commemorated in every mass, is the writing *Ecce Agnus Dei qui tollit peccata mundi* (Behold the Lamb of God, who will take away the sins of the world).

On the right are the figures of the New Testament, the twelve apostles in front. They are a rough lot who have suffered through hard times, and their matted hair and scraggly beards show it. They're pure grit — all of them.

Behind are the princes of the church. The nearest pope is one profoundly unhappy man. The middle pope is perhaps a bewildered man. The farthest pope embodies squashed optimism.

The bishops behind in red robes are martyrs. St. Stephen at the front carries in his pouch the stones that killed him. Behind is Livinus holding his tongue in pincers, reflecting the details of his torture. St. Stephen looks plain sad, Livinus a squint of memory of past pain, and the bishop in the middle reminds me of a bookkeeper fussing over past jiggled books soon to be revealed. The church group, a squidgy lot, is not very inspiring.

On the left of the lamb are the Old Testament figures, Jeremiah, Ezekiel, Daniel, and Isaiah in the front row. In the back portion are all manner of figures from the Old Testament and classical antiquity. The figure in white is probably Virgil. They are a tough lot. The prophets in the front two rows are the "converted," pushing so their vision is proven true. In the back there are twenty-six clear individual face portraits. Their eyes are focused as if their life depended on it. There is no film of dreamy faith, no flagrant doubt. It is a stunning group portrait of quizzical, tough men of the world. Look at the bluest of all blue gowns of the centre figure with the red toque. What a presence!

Way off in the distance of the horizon is the new Jerusalem from the Book of Revelations. Most of the buildings are imaginary, but there is the tower of Utrecht Cathedral and the dark tower of St. Nicholas in Ghent with its needle spire. If you look at the 100-billion-pixel blow-up now available on the Internet[2] you will see it is a gothic architectural dream. Oh, to walk in those streets peering up at the towers!

There are some interesting facts about the rest of the work:

- Behind the female saints to the right of the lamb are irises and orchids. In fact, naturalists have spotted perhaps forty-two different plant varieties. The work done in 1442 reveals an iris as fresh as this morning.

- Angel musicians are on the top right — the first time angels appear without wings. The four angels standing to the right of the organ — a humming claque listening to sounds in their heads. The organ pipes as shiny as polished plate. The angel at the organ, engrossed, clothed in an ermine trimmed robe. A portrait of dazzle.

Adam and Eve are, for the first time, very natural, unidealized nudes. In the nineteenth century, church officials blushed and painted replacement panels which clothed Adam and Eve. You can apparently see them in the church.

Jan van Eyck moved to Bruges. In 1425 he was appointed painter and valet de chambre to Philip the Good, Duke of Burgundy. He was entrusted with secret missions by the duke and was a godfather to one of Van Eyck's children. Van Eyck was immensely well paid. His salary was doubled twice in his first few years and he was given bonuses. Other artists relied on individual commissions for each work actually done and sold.

Van Eyck's use of oil paint and his skill in the new medium set him apart from others. Paint was ground by the artist. It was composed of coloured plants and minerals, and then a liquid added to bind the powder into a paste. Traditionally, egg was the binding agent, known as tempera. It dried quickly and colours didn't shade off into one another. The oil paint (with linseed or walnut oil) introduced by Van Eyck allowed works with many layers and a translucency. He created the technique of covering a layer of already dried oil paint with a transparent layer of a different colour. This glazing made rich and subtle colour effects and had not been done before.

Van Eyck achieved the illusion of nature by patiently adding detail upon detail till his whole picture became a mirror of the visible world.

THE GALLERIES

Nationalmuseum, Stockholm

Holmamiralens vag 2, 111 49 Stockholm, Sweden
Telephone: +46 (0)8 519 543 52
Web: www.nationalmuseum.se

The main gallery of the Nationalmuseum in Stockholm will be closed until 2017. As of April 2013, the website indicates that from June 13, 2013, the gallery's temporary Stockholm address is at the Academy of Fine Arts (Konstakademien), Fredsgatan 12. However, it does not appear that the Rembrandts will be exhibited. The reader should, in the meantime, check the website to see where and whether the paintings are being exhibited.

In addition to the Rembrandts and the Renoir featured above, there are several other paintings worth noting in the Nationalmuseum:

Cranach was a friend and follower of Luther. Here he has painted a sympathetic picture of a man with probing intelligence, a sense of certainty, ten years after he put the resolutions on the church doors in Worms, Germany. The jaw and firm mouth will not entertain doubts — not at all.

Courbet, who suffered much embarrassment during his trial over his taking part in the demolition of the Column in Paris, was a self-promoter, but

Martin Luther
Cranach, Lucas, the Elder,
c. 1527
Photo: ©Nationalmuseum, Stockholm

The Cellist
Courbet, Gustave, 1847
Photo: ©Nationalmuseum, Stockholm

The Apostles Peter and Paul
El Greco, 1587–92
Photo: Foto Marburg / Art Resource, NY

he was indeed a fine artist. He was also remarkably handsome and sexy. Above, his self-portrait proves as much.

El Greco is full of surprises.

Crazy, fanatical Paul in volcanic red, next to Peter in a retreating yellow. The two leaders of a religion. St. Peter is down, Paul is hurt, but a blaze is there — you bet on it!

The Washerwoman
Chardin, Jean-Baptiste-Siméon, c. 1733–39
Photo: Foto Marburg / Art Resource, NY

Fatigue, humidity, and a kid who is a real handful, and yet engrossed in the fragility of the bubble.

This painting evokes steam, dreary fatigue, numbing routine, and the responsibility of caring for a child. All there to touch, the grain of the wood, the quiver of the bubble, the creased fatigue of the washerwoman's caps, the feel of a dark humidity. Welcome to the basement!

Proust adored Chardin, the artist who could reveal beauty in our everyday surroundings.

Mauritshuis, The Hague

Gemeentemuseum Den Haag, Stadhouderslaan 41, 2517 HV
The Hague, Netherlands
Telephone: +31 (0)70 3381111
Web: www.mauritshuis.nl

The Mauritshuis is one of the world's most magnificent small galleries, along with the Frick in New York, the Wallace Collection in London, and the Brera in Milan. The Mauritshuis is undergoing renovation and is closed to visitors until mid-2014. Masterpieces from the Mauritshuis are on temporary display in the Gemeentemuseum Den Haag at the above address.

In addition to the extraordinary Vermeers, Rembrandt, and other paintings featured above, there is one more worth noting:

Jan Steen owned an inn, and many of his paintings reflected merry, drunken occasions. He travelled through many towns in the Netherlands, and his scenes of domestic chaos became so well-known and popular that the phrase "a Jan Steen household" became a regular expression.

The *Young Girl Eating Oysters* is riveting, as the woman's furtive look has humour, trouble, and happy sex about it. She sprinkles salt on the oyster, next to a Delft-blue pitcher, with more oysters being prepared in the background. The

Young Girl Eating Oysters
Steen, Jan, c. 1658–60
Photo: Scala / White Images /
Art Resource, NY

seventeenth-century writer Jacob Cats, a moralist, warned against "salty oyster juice." Behind her, a bed with closed curtains!

The painting is tiny, a mere twenty-five by fifteen centimetres.

Rijksmuseum, Amsterdam

Museumstraat 1, Amsterdam, Netherlands
Telephone: +31 (0)20 662 1440
Web: www.rijksmuseum.nl

The Rijksmuseum has been renovated and reopened in April 2013. Apparently the result is dazzling. The Rijksmuseum has a number of paintings to see in addition to the ones featured:

Maternal Duty
de Hooch, Pieter, c. 1658–60
Photo: Alinari / Art Resource, NY

Pieter de Hooch is a real rival to Vermeer. Here we find an interior scene with a mother delousing a child. It is set behind a pattern of squared red floor tiles, whose pattern expands towards the edge of the picture, playing, I think, an artistic device or trick of perspective. Behind the mother, sitting in the sun and reflecting off the child's back hem of her skirt, is a hanging copper frying pan with the world's longest thin, delicate handle.

Professor Peter Brieger (FSA, FRSC) of the University of Toronto taught me to love good art. His comments in the Expo 67 Catalogue

(Montreal 1967) about Rembrandt's painting of St. Peter may tell you why he was such a special, sensitive teacher.

Jesus foretold about Peter, "Before the cock crow thou shalt deny me thrice." Professor Brieger captures the subtlety of Peter's thoughts in this candlelight scene with brutal soldiers:

Denial of St. Peter
Rembrandt Harmensz van Rijn, 1660
Photo: Foto Marburg / Art Resource, NY

> Upon Peter's face it reveals that at the moment of the last denial Peter knows that his reliance on his own strength and courage, his pride in having been chosen as the rock upon which Christ would build his church, is of no value in the face of death. While he seems to look at the eyes of the maid, he looks into himself and over his face is already spread that sadness and repentance which will make him weep bitterly as he remembers the words of the Lord.

So true. How can a painter capture this?

Avercamp, a deaf mute, does a sort of Bosch/Bruegel-style painting with *Winter Scene with Ice Skaters*. Skating, hockey, fishing, begging — it's all there. Up close, some of his figures are simple blobs of paint, but from a distance they are people in action.

Winter Scene with Ice Skaters
Avercamp, Hendrick, c. 1608
Photo: HIP / Art Resource, NY

Jan Six Museum, Amsterdam

Amstel 218, 1017 AJ, Amsterdam, Netherlands
Telephone: +31 (0)20 642 7777
Web: www.sixcollection.com
Email: info@collectiesix.nl

To see the paintings, you must email the Six Collection, indicating when you want to go and listing your name and the names of those attending with you. The Jan Six Museum is open on weekdays from 10:00 a.m. until noon, closed on weekends and public holidays. Your request is, in their terms, strictly personal, and they reserve the right to reject your request without giving reasons.

Van Gogh Museum, Amsterdam

Paulus Potterstraat 7, 1071 CX Amsterdam, Netherlands
Telephone: +31 (0)20 570 5200
Web: www.vangoghmuseum.nl

One has to have a reckoning with Van Gogh. Is he really that good? I'm not completely sure. But the two pictures featured above in this rather sterile modern box gallery in Amsterdam argue that at his best, Van Gogh (pronounced by the Dutch *Fan Hoff*) was in the top league.

In the permanent collection, there are sixteen Van Goghs in one room and sixteen in the next. Van Gogh's *Sunflowers* are here — large and lumpy. His blue is the thing — follow the blue to his irises.

Tickets are scarce, so make sure you book in advance.

Groeninge Museum, Bruges

Dijver 12, 8000 Bruges, Belgium
Telephone: +32 (0)50 44 46 46
Web: www.brugge.be/internet/en/musea/Groeningemuseum-
Arentshuis/Groeningemuseum/index.htm

The art in this museum is very good and surprisingly different. In addition to the Van Eyck featured above, there is another painting of special note:

The Judgment of Cambyses
David, Gerard, 1498
Photo: Foto Marburg / Art Resource, NY

Comparable to Rubens's *Massacre of the Innocents,* this is a vivid show-stopper that brings you to a screeching stop. And I do mean screeching. Once seen, this picture will remain in your mental lexicon.

It is a two-panel story of Sisamnes, a Persian judge who accepted bribes. The panel at the left shows him accepting a bribe under a porch of his house.

On the right is the result of King Cambyses' order of his "flaying." You may ask, "Exactly what does flaying mean?" Well, this shows you. The onlookers seem peculiarly unmoved, especially when one considers that there is no anaesthetic here and the leg is not yet entirely trimmed of skin. The butcher on the left is starting in on Sisamnes' right arm, which is tied to the table. And sure enough, there's a little puppy ready to lick the droppings.

Even more macabre is the top right portion of the painting, which shows Sisamnes' son in the future as the succeeding judge. As he dispenses justice, he is sitting on what appears to be an off-white sheet. No, it's not a sheet — it is his father's flayed skin!

Memling Museum, Bruges

Sint-Janshospitaal, Mariastraat 38, B-8000 Bruges, Belgium
Telephone: +32 (0)50 44 87 43 (Reservations)
Web: www.brugge.be/internet/en/musea/Hospitaalmuseum/
Historische_hospitalen_1/index.htm

The Memling Museum is in the chapel of Sint-Janshospitaal, one of
the oldest preserved hospital buildings in Europe, now an attractive
small museum covering history and the hospital's charitable work with
its death corners for terminal cases.

Hans Memling arrived in Bruges in 1465. He was reportedly a
student of Rogier van der Weyden, a master of sensitive portraits. He
was so popular as a painter, he became one of the wealthiest citizens
of Bruges.

Cathedral of Our Lady, Antwerp

Groenplaats 21, 2000 Antwerp, Belgium
Telephone: +32 (0)3 213 99 51
Web: www.dekathedraal.be

The inside of the Cathedral of Our Lady is huge, clean, of perfect line,
and innately boring, allowing Rubens's treasures, the triptychs *Eleva-
tion of the Cross* and *Descent from the Cross* (featured above), to surpass
the building. But it is all church, sounds of bell, filtered light through
stained glass and through gothic grisailled windows.

This is a study of furious energy as gargantuan workers heave and
labour the heavy cross and Christ up, perhaps up but so heavy it could
slip forward or even topple up and over. It is all sense of sweat, strain,

and grunt, with each shouting a loud "heave."

There is a bearded man glaring at the viewer with the beam of the cross atop his back (his back is facing us) as he heaves up, straining his upper legs and back. In the right panel, more violence. One thief treads on the face of the other under a crowding, champing horse, all brute sharp attack. The left panel has touches of erotic and mellow. The centre all splutter, groan, and a dog barking.

All this is a frame for a triumphant death. He will live — he's dying now but Rubens portrays that he'll rise again.

The Elevation of the Cross
Rubens, Peter Paul, c. 1610
Photo: Foto Marburg / Art Resource, NY

Musées Royaux des Beaux Arts, Brussels

Regentschapsstraat 3, 1000 Brussels, Belgium
Telephone: +32 (0)2 508 32 11
Web: www.fine-arts-museum.be

In addition to David's *Marat*, there is a Bruegel worth noting here:

Too fantastical to comprehend — a grotesqueness created by a blizzard of bizarre fish, frogs, lizards, clams, lobsters, and giant squid.

The Fall of the Rebel Angels
Bruegel, Pieter, the Elder, c. 1562
Photo: Scala / Art Resource, NY

St. Bavo Cathedral, Ghent

Hoofdkerkstraat 1, 9000 Ghent, Belgium
Telephone: +32 (0)9 269 20 45
Web: www.sintbaafskathedraal.be

Ghent is but a train ride from Antwerp. *The Ghent Altarpiece* by Jan van Eyck and Hubert van Eyck is in a separate part of St. Bavo Cathedral, where you pay €4 and get an informative headset. But there is glass between you and the work and often many people in front of you. Details are hard to see. You can't get close enough.

This is not one painting. It is in fact twelve separate paintings in the open altarpiece. When closed, there are fourteen more paintings.

If you go, you must study a guidebook first. There is also the most amazing website, http://closertovaneyck.kikirpa.be/, where you can focus on the details. Quite astounding.

NOTES

Chapter 1: Great Britain and Ireland

1. Paul Johnson, *Art: A New History* (London: Weidenfeld & Nicolson, 2003), p. 259.
2. *The Guardian*, September 19, 2009.
3. *British Companion to British Art* (Tate Publishing, 2001), p. 148.
4. Reproduced on the Internet — The Project Gutenberg ebook.
5. *Cézanne*, Philadelphia Museum of Art Exhibition Catalogue, Isabelle Cahn, 1996, pp. 534, 553.
6. Alan Bennett, *Untold Stories* (London: Faber and Faber Profile Books, 2005), pp. 470–71.
7. Jonathan Harr, *The Lost Painting* (New York: Random House, 2005), p. 147.

Chapter 2: France

1. Pei was born in China in 1917 and came to America in 1935.
2. Adrien Goetz, *The Big Picture Paintings in Paris* (Louvre Publisher, 2003), p. 110.
3. Emile Zola, *L'Oeuvre Folio Paris* (Paris: 1983), p. 146.
4. Excerpted from *Morning in the Burned House* by Margaret Atwood. Copyright © 1995 O.W. Toad. Reprinted by permission of McClelland & Stewart.
5. René Gimpel, *Diary of an Art Dealer* (New York: Universe Books, 1987), p. 20.
6. Ibid., p. 62.

Chapter 3: Spain

1. Robert Payne, *The World of Art* (New York: Doubleday, 1972), p. 344.
2. Russell Martin, *Picasso's War: The Destruction of Guernica, and the Masterpiece that Changed the World* (New York: Penguin, 2003), p. 121.
3. Ibid., p. 266.
4. Robert Cumming, *Art, A Field Guide* (New York: Alfred A. Knopf, Borzoi, 2001).

Chapter 5: Italy (Venice and Florence)

1. *The Grove Book of Art Writing* (New York: Grove Press, 1998), taken from Elizabeth G. Holt, *A Documentary History of Art*, Vol. 26 (New York: Doubleday, 1958), pp. 124–27.
2. Yale University, 1997.

Chapter 6: Italy (Other Regions)

1. Kenneth Clark, *Civilization* (London: British Broadcasting Corporation and John Murray, 1971), p. 170.

Chapter 7: Germany and Austria

1. Laura Cumming, *A Face to the World* (Harper Press, 2009), p. 54.
2. Jacopo Tebaldi to Alfonso d'Este, Duke of Ferrara, 1521, in *The Grove Book of Art Writing* (New York: Grove Press, 1998), p. 64.
3. *www.en.Wikipedia.org/wiki/Netherlandish_Proverbs*

Chapter 8: Eastern Europe

1. Philadelphia Museum of Art Exhibition Catalogue, 1996, p. 371.
2. Robin Blake, *Anthony Van Dyck, A Life 1599–1641* (London: Constable, 1999), p. 125.
3. Paul Johnson, *Art: A New History* (London: Weidenfeld & Nicolson, 2003), p. 203.
4. Paul Johnson, *Creators* (Harper Collins, 2006), p. 44.
5. Sister Wendy Beckett, *1,000 Masterpieces of Western Art* (Firefly Books, 1999), p. 461.
6. *Bulfinch's Mythology* (New York: Modern Library), p. 157.
7. Jean Stewart, *Selected Letters of Eugène Delacroix 1813–1863* (ArtWorks, MFA Publications, A Division of the Museum of Fine Arts), pp. 371–72.

Chapter 9: Scandinavia and the Low Countries

1. Simon Lee, *David* (Phaidon, 1999), pp. 168, 170.
2. *http://closertovaneyck.kikirpa.be/*

INDEX OF ARTISTS
AND THEIR WORKS

ANONYMOUS.
 The Wilton Diptych (1395–99), 4

AVERCAMP, Hendrick (1585–1634).
 Winter Scene with Ice Skaters,
 c. 1608, 389

BELLINI, Gentile (1429–1507).
 The Sermon of St. Mark in
 Alexandria, c. 1504–07 (with
 Giovanni Bellini), 220

BELLINI, Giovanni (1430–1516).
 The Doge Leonardo Loredan,
 1501–04, 7
 Pietà, c. 1465–70, 219
 The Sermon of St. Mark in
 Alexandria, c. 1504–07 (with
 Gentile Bellini), 220
 Woman at the Mirror, 1515, 305

BONINGTON, Richard Parkes
(1802–28).
 Stranded Ships (or Boats) near the
 Shore of Normandy, c. 1823–24,
 332

BOSCH, Hieronymus (c. 1450–1516).
 Garden of Earthly Delights, c. 1500,
 104
 The Ship of Fools, 1490–1500, 95

BOTTICELLI, Sandro (1445–1510).
 Primavera, 1482, 190
 Adoration of the Magi, 1475, 193

BOUCHER, François (1703–70).
 Reclining Girl, 1750, 276

BRONZINO, Agnolo (1503–1572).
 Lucrezia Panciatichi, 208
 Portrait of Admiral Andrea Doria as
 Neptune, 246

BRUEGEL, Pieter, the Elder (c. 1525–69).
 Conversion of St. Paul, 1567, 296
 The Fall of the Rebel Angels,
 c. 1562, 393
 The Hay Harvest, 1565, 328
 The Netherlandish Proverbs, 1559,
 298
 Parable of the Blind, c. 1568, 240
 Peasants' Dance, 1568, 306
 Return of the Hunters, 1565, 287
 Triumph of Death, c. 1562, 131

BRUEGHEL, Pieter the Younger
(1564–1636).
 The Sermon of St. John the Baptist,
 c. 1604, 331

CANALETTO, Giovanni Antonio
(1687–68).
 Portico and Court in Venice, 1765,
 175

CARAVAGGIO, Michelangelo Merisi da
(1571–1610).
 The Conversion of St. Paul,
 1600–01, 296
 The Crucifixion of St. Peter,
 1600–01, 157
 David with the Head of Goliath,
 c. 1606, 164
 Death of the Virgin, 1605–06, 61
 Deposition, 1600–04, 151
 St. Catherine of Alexandria, c. 1598,
 120
 Supper at Emmaus, c. 1606, 246
 The Taking of Christ, 1602, 44

CARPACCIO, Vittore (c. 1455–1525).
 Arrival of the Ambassadors, c. 1494,
 177
 The Pilgrims' Arrival in Cologne,
 1490, 202

CÉZANNE, Paul (1839–1906).
 Great Pine and Red Earth, c. 1895,
 314
 Lac d'Annecy, 1896, 33
 Portrait of a Peasant, 1905, 122

CHARDIN, Jean-Baptiste-Siméon
(1699–1779).
 Pipe and Drinking Cup, c. 1737, 74
 The Washerwoman, c. 1733–39, 386

CHRISTUS, Petrus (c. 1410–75/76).
 Portrait of a Young Lady, c. 1470, 297

CONSTABLE, John (1776–1837).
 The Hay Wain, 1821, 13

CORREGGIO, Antonio de
(1489–1534).
 Assumption of the Virgin, 1530, 181

COURBET, Gustave (1819–77).
 Burial at Ornans, 1849–50, 98
 The Cellist, 1847, 386
 The Water Stream (La Brême),
 1866, 125

CRANACH, Lucas, the Elder
(1472–1553).
 Henry the Pious Duke of Saxony,
 1514, 302
 Martin Luther, c. 1527, 385

DAVID, Gerard (c. 1460–1523).
 The Judgment of Cambyses, 1498,
 391

DAVID, Jacques-Louis (1748–1825).
 Jean-Paul Marat, Politician and
 Publicist, Dead in His Bathtub,
 Assassinated by Charlotte
 Corday, 1792, 379
 Madame Récamier, 1800, 65

DEGAS, Edgar (1834–1917).
 In a Café, 1875–76, 82

DE HOOCH, Pieter (1629–84).
 The Interior of the Burgomaster's
 Council Chamber in the
 Amsterdam Town Hall,
 c. 1663–65, 135
 Maternal Duty, c. 1658–60, 388

DELACROIX, Eugène (1798–1863).
 Jewish Wedding in Morocco,
 1837, 96
 Liberty Leading the People,
 July 28, 1830, 1830, 66

DÜRER, Albrecht (1471–1528).
　The Adoration of the Magi, 1504,
　　190
　Hieronymus Holzschuher, 1526, 299
　Jesus Among the Doctors, 1506, 124
　Oswald Krel, 1499, 303
　Self-Portrait in a Fur-Trimmed
　　Cloak, c. 1500, 281
　The Feast of the Rosary, c. 1506, 322

EL GRECO (1541–1614).
　Burial of Count Orgaz, 1586, 129
　The Apostles Peter and Paul,
　　1587–92, 386
　The Holy Trinity, c. 1577–79, 113

FRA ANGELICO (1387–1455).
　The Annunciation, 1425–28, 108

FRAGONARD, Jean-Honoré
(1732–1806).
　The Swing, 1767, 54

GAULLI, Giovanni Battista (Baciccio)
(1639–1709).
　Triumph of the Name of Jesus,
　　1679, 154

GENTILE da Fabriano (1370–1427).
　Adoration of the Magi, 1423, 190

GÉRICAULT, Théodore (1791–1824).
　The Raft of the Medusa, 1819, 69

GIORDANO, Luca (1634–1705).
　Perseus Turning Phineas and His
　　Followers into Stone, c. early
　　1680s, 47

GIORGIONE de Castelfranco (1477–
after 1510).
　The Sleeping Venus, 1508–10, 301
　The Tempest, c. 1507–10, 203

GIOTTO di Bondone (1266–1336).
　Devils Derobing a Man, c. 1305, 243

Hanging People on Trees, 1303, 253
St. Francis Catches the Devils of
　Arezzo, 1298, 233

GIULIO Romano (1499–1546).
　The Fall of the Giants, 1526–35, 231

GOYA (y Lucientes), Francisco de
(1746–1828).
　Sabbath, 1821–23, 111
　The Nude Maya, 1789–1805, 132
　Third of May, 1808, 1814, 109

HALS, Frans (1581/85–1666).
　Malle Babbe, c. 1633–35, 260
　The Meagre Company, 1637, 361

HOGARTH, William (1697–1764).
　O The Roast Beef of Old England
　　(The Gate of Calais), 1748, 50

HOLBEIN, Hans, the Younger
(1497–1543).
　Erasmus of Rotterdam Writing,
　　c. 1523, 95
　Jane Seymour, Queen of England,
　　1536, 305
　Portrait of Robert Cheseman,
　　c. 1533, 350

INGRES, Jean-Auguste-Dominique
(1780–1867).
　Portrait of Louis-François Bertin,
　　1832, 94

LAWRENCE, Thomas (1769–1830).
　George IV, 1822, 36

LEONARDO da Vinci (1452–1519).
　Adoration of the Magi, 1481, 191
　Lady with Ermine, c. 1490, 320

LORENZETTI, Pietro (c. 1306–45).
　Deposition of Christ from the
　　Cross, c. 1310–29, 250
　The Last Supper, c. 1310–29, 250

LOTTO, Lorenzo (1480–1556).
Portrait of a Young Man in His
Study, c. 1528, 174

MANET, Édouard (1832–83).
Bar at the Folies-Bergère, 1882, 35
Déjeuner sur l'herbe (Luncheon on
the Grass), 1863, 76
L'Amazone (Horse Woman), 1882,
123
Olympia, 1863, 79

MANTEGNA, Andrea (1431–1506).
Adoration of the Magi, c. 1464–66,
206
Dead Christ, c. 1480, 217
Family and Court of Ludovico III
Gonzaga, c. 1470–74, 228
The Meeting Scene: Grooms with
Dogs and Horse, 1465–74, 228

MARTINI, Simone (1284–1344).
St. Louis of Toulouse, c. 1317, 238
St. Martin Renounces the Roman
Army, c. 1320–23, 235

MASACCIO (Maso di San Giovanni)
(1402–142?).
The Expulsion from Paradise,
c. 1425, 198
The Tribute Money, c. 1427, 198

MATISSE, Henri (1869–1954).
Dance (1910), 312

MEMLING, Hans (1425/40–94).
St. Ursula Shrine, c. 1489, 375

MICHELANGELO Buonarroti
(1475–1564).
The Creation of Adam, c. 1510, 141
Creation of the Sun, Moon, and
Plants, c. 1511, 161
Ignudo (Creation of the Sun,
Moon, and Plants), c. 1511, 140

The Last Judgment, c. 1537–41,
143
The Last Judgment — Transporting
the Dead, c. 1537–41, 147
The Libyan Sibyl, c. 1511, 139

MILLAIS, Sir John Everett (1829–96).
Ophelia, 1852, 25

MILLET, Jean-François (1814–75).
The Angelus, 1857–59, 97

MONET, Claude (1840–1926).
Water Lilies, 1896–1923, 88

MOR, Anthonis (1519–76).
Mary I (Tudor), Queen of England,
c. 1554, 132

PARMIGIANINO (Francesco Mazzola)
(1503–40).
Antea, 1530–35, 251

PICASSO, Pablo (1881–1973)
The Absinthe Drinker, 1901, 317
Guernica, 1937, 126

PIERO della Francesca (c. 1420–92).
The Baptism of Christ, c. 1450s, 48
Battle of Heraclius and Khosrow,
c. 1450–65, 222
Constantine's Dream, c. 1450–65,
223
Portrait of Federico da Montefeltro,
c. 1465, 206

PISSARRO, Camille (1830–1903).
Boulevard Montmartre in Paris,
1897, 331

QUARTON, Enguerrand (1410–
c. 1464).
Pietà de Villeneuve-lès-Avignon,
c. 1460, 72

RAPHAEL (Raffaello Sanzio) (1483–1520).
 Baldassare Castiglione, c. 1514–15, 63
 Delivery of St. Peter in the Stanza d'Eliodoro, c. 1511–14, 149
 The Sistine Madonna, c. 1512–13, 268

REMBRANDT Harmensz van Rijn (1606–69).
 The Company of Captain Frans Banning Cocq and Willem van Ruytenburch, 1642, 367
 Denial of St. Peter, 1660, 389
 Jeremiah Lamenting the Destruction of Jerusalem, 1630, 364
 The Jewish Bride, 1667, 358
 Joseph and Potiphar's Wife, 1655, 262
 Large Self-Portrait, 1652, 295
 Moses Destroying the Tablets of the Law, 1659, 257
 The Oath of the Batavians, 1662, 340
 Portrait of Jan Six, 1654, 368
 Return of the Prodigal Son, 1668–69, 310
 Self-Portrait, 1669, 345
 Self-Portrait at the Age of 63, 1669, 11
 Self-Portrait with Two Circles, c. 1665–69, 39
 Simeon in the Temple, 1669, 343
 The Syndics of the Amsterdam Drapers' Guild, 1662, 359

REMBRANDT (School of)
 Haman Recognizes His Fate, 1665, 315

RENOIR, Auguste (1841–1919).
 Ball at the Moulin de la Galette, Montmartre, 1876, 84
 La Grenouillère, 1869, 344

RUBENS, Peter Paul (1577–1640).
 Adoration of the Magi, 1633–34, 41
 Descent from the Cross, c. 1612, 377
 The Drunken Silenus, c. 1616, 303
 The Elevation of the Cross, c. 1610, 393
 The Fall of the Damned, 1620, 274
 The Head of Medusa, c. 1618, 306
 Last Supper, 1630–32, 247

RUISDAEL, Jacob van (c. 1628–82).
 The Jewish Cemetery, 1655–60, 272
 View of Haarlem, c. 1670–75, 352

SARGENT, John Singer (1856–1925).
 Mrs. Charles Russell, 1908, 134

SIGNORELLI, Luca (1441–1523).
 The Damned in Hell, c. 1500–03, 241

SPENCER, Stanley (1891–1959).
 The Resurrection at Cookham, 1924–27, 52

STEEN, Jan (1626–79).
 Celebrating the Birth, 1664, 55
 The Merry Company, 1665, 354
 Young Girl Eating Oysters, c. 1658–60, 387

STUBBS, George (1724–1806).
 Whistlejacket, c. 1762, 19

TERBORCH, Gerard (1617–81).
 The Paternal Admonition, c. 1654–55, 298

TIEPOLO, Giambattista (1696–1770).
 Africa, 1753, 283
 America, 1753, 283
 Devotees Appearing Under a Loggia, 1745, 203

TINTORETTO, Jacopo Robusti
(1518–94).
 The Baptism of Christ, 1579–81,
 169
 Crucifixion, 1565, 166
 Crucifixion, 1568, 183
 The Finding of the Body of
 St. Mark, 1562–66, 215
 The Last Judgment, 1562–64, 185
 Pietà, c. 1560–65, 247
 Presentation of the Virgin in the
 Temple, 1552, 187
 St. Louis, St. George, and the
 Princess, 1555, 179
 Susannah Bathing, after 1560, 292
 Way to Calvary, 1565–67, 201

TITIAN, Tiziano Vecellio
(c. 1488–1576).
 Altarpiece of the Pesaro Family,
 1522–26, 204
 Assumption of the Virgin,
 1516–18, 181
 The Crowning of Thorns, c. 1570,
 279
 Danae, 1553–54, 331
 The Death of Actaeon,
 c. 1565–76, 9
 Entombment, 1566, 133
 The Flaying of Marsyas, 1570–75,
 325
 Mars, Venus, and Amor, 1560, 291
 Pietà, c. 1575, 170
 Pope Paul III Farnese (r. 1534–49),
 c. 1543, 252
 Pope Paul III with His Nephews
 Cardinal Ottavio and Alessandro
 Farnese, c. 1545, 236
 St. Jerome, c. 1555, 213
 Self-Portrait, c. 1560, 259
 Venus of Urbino, 1538, 196

TOULOUSE–LAUTREC, Henri de
(1864–1901).
 Le Lit, c. 1892, 86
 Tête-à-Tête Supper, 1899, 53

TURNER, Joseph Mallord William
(1775–1851).
 Calais Pier, with French Poissards
 Preparing for Sea: An English
 Packet Arriving, 1803, 46
 Rain, Steam, and Speed — The
 Great Western Railway, 1844, 15
 Snow Storm: Steam-Boat off a
 Harbour's Mouth Making
 Signals in Shallow Water, and
 Going by the Lead, 1842, 23
 Ulysses Deriding Polyphemus —
 Homer's Odyssey, 1829, 49

UCCELLO, Paolo (1397–1475).
 Hunters in a Wood, c. 1470, 43
 St. George and the Dragon,
 c. 1470, 21

VAN DER GOES, Hugo (c. 1420–82).
 Portinari Altarpiece, c. 1475, 207

VAN DER WEYDEN, Rogier
(c. 1399–1464).
 Deposition, c. 1436, 107
 St. John the Baptist Altar, 1455, 299
 Virgin and Child Enthroned, 1433,
 135

VAN DYCK, Anthony (1599–1641).
 Portrait of a Genoese Noblewoman,
 c. 1621–23, 263
 Portrait of Henry Danvers, Earl of
 Danby, late 1630s, 318
 Samson Made Prisoner, c. 1628–30,
 294
 Self-Portrait, 1621–22, 277

VAN EYCK, Jan (c. 1390–1441).
Altarpiece with the Madonna and
Child, St. Michael, and
St. Catherine, 1437, 272
The Ghent Altar, 1432, 382
Madonna Adored by the Canonicus
Van der Paele, 1436, 373
Portrait of Giovanni Arnolfini and
His Wife, 1434, 17

VAN GOGH, Vincent (1853–90).
Vase with Irises, 1890, 371
Wheatfield with Crows, 1890, 370

VELÁZQUEZ, Diego Rodriguez
(1599–1660).
Las Meniñas, 1656, 117
Pope Innocent X, 1650, 152
The Surrender of Breda, 1634–35,
115

VERMEER (van Delft), Jan (1632–75).
Girl Reading a Letter by an Open
Window, c. 1659, 302
Head of a Girl, 1665, 356
The Milkmaid, 1658–60, 366

The Painter, 1665–66, 289
A Street in Delft, 1658–60, 363
View of Delft, c. 1658, 348

VERONESE, Paolo (Paolo Caliari)
(1528–88).
Conversion of Saul, 1570, 313
Crucifixion, c. 1582, 202
Feast in the House of Levi, 1573, 172
The Last Supper, 1585, 212

VERROCCHIO, Andrea del (1436–88).
Baptism of Christ, 1470–75, 194

WATERHOUSE, John William
(1849–1917).
The Lady of Shalott, 1888, 27

WATTEAU, Jean-Antoine (1684–1721).
The Shop Sign for the Art Dealer
Gersaint, 1720, 265

WHISTLER, James Abbott McNeill
(1834–1903).
Nocturne in Blue and Gold: Old
Battersea Bridge, 1872–75, 29

INDEX OF PAINTINGS
BY TITLE

ABSINTHE DRINKER, THE
(Picasso, 1901), 317

ADORATION OF THE MAGI
(Botticelli, c. 1475), 193

ADORATION OF THE MAGI
(Gentile, 1423), 190

ADORATION OF THE MAGI
(Leonardo, 1481), 191

ADORATION OF THE MAGI
(Mantegna, c. 1464–66), 206

ADORATION OF THE MAGI
(Rubens, 1633–34), 41

ADORATION OF THE MAGI, THE
(Dürer, 1504), 190

AFRICA (Tiepolo, 1753), 283

ALTARPIECE OF THE PESARO
FAMILY (Titian, 1522–26), 204

ALTARPIECE WITH THE
MADONNA AND CHILD,
ST. MICHAEL, AND ST.
CATHERINE (Van Eyck, 1437), 270

AMERICA (Tiepolo, 1753), 283

ANGELUS, THE (Millet, 1857–59), 97

ANNUNCIATION, THE (Fra
Angelico, 1425–28), 108

ANTEA (Parmigianino, 1530–35), 251

APOSTLES PETER AND PAUL,
THE (El Greco, 1587–92), 386

ARRIVAL OF THE AMBASSADORS
(Carpaccio, c. 1494), 177

ASSUMPTION OF THE VIRGIN
(Correggio, 1526–30), 225

ASSUMPTION OF THE VIRGIN
(Titian, 1516–18), 181

ASSUMPTION OF THE VIRGIN,
detail of the central cupola
(Correggio, 1526–30), 225

BALDASSARE CASTIGLIONE
(Raphael, c. 1514–15), 63

BALL AT THE MOULIN DE LA
GALETTE, MONTMARTRE
(Renoir, 1876), 84

BAPTISM OF CHRIST (Verrocchio,
1470–75), 194

BAPTISM OF CHRIST, THE (Piero,
c. 1450s), 48

BAPTISM OF CHRIST, THE
(Tintoretto, 1579–81), 169

BAR AT THE FOLIES-BERGÈRE
(Manet, 1882), 35

BATTLE OF HERACLIUS AND
KHOSROW (Piero, c. 1450–65), 222

BOULEVARD MONTMARTRE IN PARIS (Pissarro, 1897), 331

BURIAL AT ORNANS (Courbet, 1849–50), 98

BURIAL OF COUNT ORGAZ (El Greco, 1586), 129

CALAIS PIER, WITH FRENCH POISSARDS PREPARING FOR SEA: AN ENGLISH PACKET ARRIVING (Turner, 1803), 46

CELEBRATING THE BIRTH (Steen, 1664), 55

CELLIST, THE (Courbet, 1847), 386

COMPANY OF CAPTAIN FRANS BANNING COCQ AND WILLEM VAN RUYTENBURCH, THE (Rembrandt, 1642), 367

CONSTANTINE'S DREAM (Piero, c. 1450–65), 223

CONVERSION OF SAUL, THE (Veronese, 1570), 313

CONVERSION OF ST. PAUL (Bruegel the Elder, 1567), 296

CONVERSION OF ST. PAUL, THE (Caravaggio, 1600–01), 157

CREATION OF ADAM, THE (Michelangelo, c. 1510), 141

CREATION OF THE SUN, MOON, AND PLANTS (Michelangelo, c. 1511), 161

CROWNING OF THORNS, THE (Titian, c. 1570), 281

CRUCIFIXION (Tintoretto, 1565), 166

CRUCIFIXION (Tintoretto, 1568), 183

CRUCIFIXION (Veronese, c. 1582), 202

CRUCIFIXION OF ST. PETER, THE (Caravaggio, 1600–01), 157

DAMNED IN HELL, THE (Signorelli, c. 1500–03), 241

DANAE (Titian, 1553–54), 331

DANCE (Matisse, 1910), 312

DAVID WITH THE HEAD OF GOLIATH (Caravaggio, c. 1606), 164

DEAD CHRIST (Mantegna, c. 1480), 217

DEATH OF ACTAEON, THE (Titian, c. 1565–76), 9

DEATH OF THE VIRGIN (Caravaggio, 1605), 61

DÉJEUNER SUR L'HERBE (Manet, 1863), 76

DELIVERY OF ST. PETER IN THE STANZA D'ELIODORO (Raphael, c. 1511–14), 149

DENIAL OF ST. PETER (Rembrandt, 1660), 389

DEPOSITION (Caravaggio, 1600–04), 151

DEPOSITION (Van der Weyden, c. 1436), 107

DEPOSITION OF CHRIST FROM THE CROSS (Lorenzetti, c. 1310–29), 250

DESCENT FROM THE CROSS (Rubens, c. 1612), 377

DEVILS DEROBING A MAN (detail from The Last Judgment) (Giotto, c. 1305), 243

DEVOTEES APPEARING UNDER A LOGGIA (Tiepolo, 1745), 203

DOGE LEONARDO LOREDAN, THE (Giovanni Bellini, 1501–04), 7

DRUNKEN SILENUS, THE (Rubens, c. 1616), 303

ELEVATION OF THE CROSS, THE (Rubens, c. 1610), 393

ENTOMBMENT (Titian, 1572), 133

ERASMUS OF ROTTERDAM WRITING (Holbein the Younger, c. 1523), 95

EXPULSION FROM PARADISE, THE (Masaccio, c. 1425), 198

FALL OF THE DAMNED, THE (Rubens, 1620), 274

FALL OF THE GIANTS, THE (Giulio, 1526–35), 231

FALL OF THE REBEL ANGELS, THE (Bruegel the Elder, c. 1562), 393

FAMILY AND COURT OF LUDOVICO III GONZAGA (Mantegna, c. 1470–74), 228

FEAST IN THE HOUSE OF LEVI (Veronese, 1573), 172

FEAST OF THE ROSARY, THE (Dürer, c. 1506), 322

FINDING OF THE BODY OF ST. MARK, THE (Tintoretto, 1562–66), 215

FLAYING OF MARSYAS, THE (Titian, 1570–75), 325

GARDEN OF EARTHLY DELIGHTS (Bosch, c. 1500), 104

GEORGE IV (Lawrence, 1822), 36

GHENT ALTAR, THE (Van Eyck, 1432), 382

GIRL READING A LETTER BY AN OPEN WINDOW (Vermeer, c. 1659), 302

GREAT PINE AND RED EARTH (Cézanne, c. 1895), 314

GUERNICA (Picasso, 1937), 126

HAMAN RECOGNIZES HIS FATE (Rembrandt [School of], 1665), 315

HANGING PEOPLE ON TREES (Last Judgment, detail of Hell) (Giotto, 1303), 253

HAY HARVEST, THE (Bruegel the Elder, 1565), 328

HAY WAIN, THE (Constable, 1821), 13

HEAD OF A GIRL (Vermeer, 1665), 356

HEAD OF MEDUSA, THE (Rubens, c. 1618), 306

HENRY THE PIOUS DUKE OF SAXONY (Cranach the Elder, 1514), 302

HIERONYMUS HOLZSCHUHER (Dürer, 1526), 299

HOLY TRINITY, THE (El Greco, c. 1577–79), 113

HUNTERS IN A WOOD (Uccello, c. 1470), 43

IGNUDO (CREATION OF THE SUN, MOON, AND PLANTS) (Michelangelo, c. 1511), 140

IN A CAFÉ (Degas, 1875–76), 82

INTERIOR OF THE BURGOMAS-TER'S COUNCIL CHAMBER IN THE AMSTERDAM TOWN HALL, THE (De Hooch, c. 1663–65), 135

JANE SEYMOUR, QUEEN OF ENGLAND (Holbein the Younger, 1536), 305

JEAN-PAUL MARAT, POLITICIAN AND PUBLICIST, DEAD IN HIS BATHTUB, ASSASSINATED BY CHARLOTTE CORDAY (David, Jacques-Louis, 1792), 379

JEREMIAH LAMENTING THE DESTRUCTION OF JERUSALEM (Rembrandt, 1630), 364

JESUS AMONG THE DOCTORS (Dürer, 1506), 124

JEWISH BRIDE, THE (Rembrandt, 1667), 358

JEWISH CEMETERY, THE (Ruisdael, 1655–60), 272

JEWISH WEDDING IN MOROCCO (Delacroix, 1837), 96

JOSEPH AND POTIPHAR'S WIFE (Rembrandt, 1655), 262

JUDGMENT OF CAMBYSES, THE
(David, Gerard, 1498), 391

L'AMAZONE (HORSE WOMAN)
(Manet, 1882), 123

LA GRENOUILLÉRE (Renoir, 1869),
344

LAC D'ANNECY (Cézanne, 1896), 33

LADY OF SHALOTT, THE
(Waterhouse, 1888), 27

LADY WITH ERMINE (Leonardo,
c. 1490), 320

LARGE SELF-PORTRAIT
(Rembrandt, 1652), 295

LAS MENIÑAS (Velàzquez, 1656), 117

LAST JUDGMENT — TRANS-
PORTING THE DEAD, THE
(Michelangelo, c. 1537–41), 147

LAST JUDGMENT, THE (detail)
(Tintoretto, 1562–64), 185

LAST JUDGMENT, THE
(Michelangelo, c. 1537–41), 143

LAST SUPPER (Rubens, 1630–32), 247

LAST SUPPER, THE (Lorenzetti,
c. 1310–29), 250

LAST SUPPER, THE (Veronese,
1585), 212

LE LIT (Toulouse-Lautrec, c. 1892), 86

LIBERTY LEADING THE PEOPLE,
JULY 28, 1830 (Delacroix, 1830), 66

LIBYAN SIBYL, THE (Michelangelo,
c. 1511), 139

LUCREZIA PANCIATICHI
(Bronzino, 1540), 208

MADAME RÉCAMIER (David,
Jacques-Louis, 1800), 65

MADONNA ADORED BY THE
CANONICUS VAN DER PAELE
(Van Eyck, 1436), 373

MALLE BABBE (Hals, c. 1633–35), 260

MARS, VENUS, AND AMOR
(Titian, 1560), 291

MARTIN LUTHER (Cranach the
Elder, c. 1527), 385

MARY I (TUDOR), QUEEN OF
ENGLAND (Mor, c. 1554), 132

MATERNAL DUTY (De Hooch,
c. 1658–60), 388

MEAGRE COMPANY, THE
(Hals, c. 1637), 361

MEETING SCENE, GROOMS
WITH DOGS AND HORSE, THE
(Mantegna, 1465–74), 228

MERRY COMPANY, THE (Steen,
1665), 354

MILKMAID, THE (Vermeer,
1658–60), 366

MOSES DESTROYING THE
TABLETS OF THE LAW
(Rembrandt, 1659), 257

MRS. CHARLES RUSSELL (Sargent,
1908), 134

NETHERLANDISH PROVERBS,
THE (Bruegel the Elder, 1559), 298

NOCTURNE IN BLUE AND GOLD:
OLD BATTERSEA BRIDGE
(Whistler, 1872–75), 29

NUDE MAYA, THE (Goya, 1789–
1805), 132

O THE ROAST BEEF OF OLD
ENGLAND (THE GATE OF
CALAIS) (Hogarth, 1748), 50

OATH OF THE BATAVIANS, THE
(Rembrandt, 1662), 340

OLYMPIA (Manet, 1863), 79

OPHELIA (Millais, 1852), 25

OSWALD KREL (Dürer, 1499), 303

PAINTER, THE (Vermeer, 1665–66),
289

PARABLE OF THE BLIND (Bruegel
the Elder, c. 1568), 240

PATERNAL ADMONITION, THE
(Terborch, c. 1654–55), 298

PEASANTS' DANCE (Bruegel the
Elder, 1568), 306

PERSEUS TURNING PHINEAS
AND HIS FOLLOWERS INTO
STONE (Giordano, c. early
1680s), 47

PIETÀ (Bellini, Giovanni, c. 1465–70),
219

PIETÀ (Tintoretto, c. 1560–65), 247

PIETÀ (Titian, 1576), 170

PIETÀ DE VILLENEUVE LÈS-
AVIGNON (Quarton, c. 1460), 72

PILGRIMS' ARRIVAL IN
COLOGNE, THE (Carpaccio,
1490), 202

PIPE AND DRINKING CUP
(Chardin, c. 1737), 74

POPE INNOCENT X (Velázquez,
1650), 152

POPE PAUL III FARNESE (R. 1534–
1549) (Titian, c. 1543), 252

POPE PAUL III WITH HIS
NEPHEWS CARDINAL
OTTAVIO AND ALESSANDRO
FARNESE (Titian, c. 1545), 236

PORTICO AND COURT IN
VENICE (Canaletto, 1765), 175

PORTINARI ALTARPIECE (Van der
Goes, c. 1475), 207

PORTRAIT OF A GENOESE
NOBLEWOMAN (Van Dyck,
c. 1621–23), 263

PORTRAIT OF A PEASANT
(Cézanne, 1905), 122

PORTRAIT OF A YOUNG LADY
(Christus, c. 1470), 297

PORTRAIT OF A YOUNG MAN IN
HIS STUDY (Lotto, c. 1528), 174

PORTRAIT OF ADMIRAL ANDREA
DORIA AS NEPTUNE (Bronzino,
c. 1530), 246

PORTRAIT OF FEDERICO DA
MONTEFELTRO (Piero, c. 1465),
206

PORTRAIT OF GIOVANNI
ARNOLFINI AND HIS WIFE
(Van Eyck, 1434), 17

PORTRAIT OF HENRY DANVERS,
EARL OF DANBY (Van Dyck, late
1630s), 318

PORTRAIT OF JAN SIX (Rembrandt,
1654), 368

PORTRAIT OF LOUIS-FRANÇOIS
BERTIN (Ingres, 1832), 94

PORTRAIT OF ROBERT
CHESEMAN (Holbein the Younger,
c. 1533), 350

PRESENTATION OF THE VIRGIN
IN THE TEMPLE (Tintoretto,
1552), 187

PRIMAVERA (Botticelli, c. 1481), 188

RAFT OF THE MEDUSA, THE
(Géricault, 1819), 69

RAIN, STEAM, SPEED — THE
GREAT WESTERN RAILWAY
(Turner, 1844), 15

RECLINING GIRL (Boucher, 1750),
276

RESURRECTION AT COOKHAM,
THE (Spencer, 1924–27), 52

RETURN OF THE HUNTERS
(Bruegel the Elder, 1565), 287

RETURN OF THE PRODIGAL
SON (Rembrandt, 1668–69), 310

SABBATH (Goya, 1821–23), 111

ST. CATHERINE OF ALEXANDRIA
(Caravaggio, 1599), 120

ST. FRANCIS CATCHES THE
DEVILS OF AREZZO (Giotto,
1298), 233

ST. GEORGE AND THE DRAGON
(Uccello, c. 1470), 21

ST. JEROME (Titian, c. 1555), 213

ST. JOHN THE BAPTIST ALTAR
(Van der Weyden, 1455), 299

ST. LOUIS OF TOULOUSE (Simone
Martini, c. 1317), 238

ST. LOUIS, ST. GEORGE AND
THE PRINCESS (Tintoretto,
1555), 179

ST. MARTIN RENOUNCES THE
ROMAN ARMY (Martini,
c. 1320–23), 235

ST. URSULA SHRINE (Memling,
c. 1489), 375

SAMSON MADE PRISONER (Van
Dyck, c. 1628–30), 294

SELF-PORTRAIT (Rembrandt,
1669), 345

SELF-PORTRAIT (Titian, c. 1560),
259

SELF-PORTRAIT (Van Dyck,
1621–22), 277

SELF-PORTRAIT AT THE AGE OF
63 (Rembrandt, 1669), 11

SELF-PORTRAIT IN A FUR-
TRIMMED COAT (Dürer,
c. 1500), 281

SELF-PORTRAIT WITH TWO
CIRCLES (Rembrandt,
c. 1665–69), 39

SERMON OF ST. JOHN THE
BAPTIST, THE (Brueghel the
Younger, c. 1604), 331

SERMON OF ST. MARK IN
ALEXANDRIA, THE (Bellini,
Gentile, and Bellini, Giovanni,
c. 1504–07), 220

SHIP OF FOOLS, THE (Bosch, 1490–
1500), 95

SHOP SIGN FOR THE ART
DEALER GERSAINT, THE
(Watteau, 1720), 265

SIMEON IN THE TEMPLE
(Rembrandt, 1669), 343

SISTINE MADONNA , THE (Raphael,
c. 1512–13), 268

SLEEPING VENUS, THE (Giorgione,
1508–10), 301

SNOW STORM: STEAM-BOAT
OFF A HARBOUR'S MOUTH
MAKING SIGNALS IN SHALLOW
WATER, AND GOING BY THE
LEAD (Turner, 1842), 23

STRANDED SHIPS (OR BOATS)
NEAR THE SHORE OF
NORMANDY (Bonington,
c. 1823–24), 332

STREET IN DELFT, A (Vermeer,
1658–60), 363

SUPPER AT EMMAUS (Caravaggio,
c. 1606), 246

SURRENDER OF BREDA, THE
(Velàzquez, 1634–35), 115

SUSANNAH BATHING (Tintoretto,
after 1560), 292

SWING, THE (Fragonard, 1767), 54

SYNDICS OF THE AMSTERDAM
DRAPERS' GUILD, THE
(Rembrandt, 1662), 359

TAKING OF CHRIST, THE
(Caravaggio, 1602), 44

TEMPEST, THE (Giorgione,
c. 1507–10), 203

TÊTE-À-TÊTE SUPPER (Toulouse-
Lautrec, 1899), 53

THIRD OF MAY, 1808 (Goya, 1814),
109

TRIBUTE MONEY, THE (Masaccio,
c. 1427), 198

TRIUMPH OF DEATH (Bruegel, the
Elder c. 1562), 131

TRIUMPH OF THE NAME OF
JESUS (Gaulli, 1679), 154

ULYSSES DERIDING POLYPHEMUS — HOMER'S ODYSSEY (Turner, 1829), 49

VASE WITH IRISES (Van Gogh, 1890), 371

VENUS OF URBINO (Titian, 1538), 196

VIEW OF DELFT (Vermeer, c. 1660–61), 348

VIEW OF HAARLEM (Ruisdael, c. 1670–75), 352

VIRGIN AND CHILD ENTHRONED, THE (Van der Weyden, 1433), 135

WASHERWOMAN, THE (Chardin, c. 1733–39), 386

WATER LILIES (Monet, 1896–1923), 88

WATER STREAM (LA BRÊME), THE (Courbet, 1866), 125

WAY TO CALVARY (Tintoretto, 1565–67), 201

WHEATFIELD WITH CROWS (Van Gogh, 1890), 370

WHISTLEJACKET (Stubbs, c. 1762), 19

WILTON DIPTYCH, THE (Anonymous, 1395–99), 4

WINTER SCENE WITH ICE SKATERS (Avercamp, c. 1608), 389

WOMAN AT THE MIRROR (Bellini, Giovanni, 1515), 305

YOUNG GIRL EATING OYSTERS (Steen, c. 1658–60), 387

INDEX OF PAINTINGS BY GALLERY

ACCADEMIA ART GALLERY,
VENICE, ITALY, 202
 Arrival of the Ambassadors (Carpaccio,
 c. 1494), 177
 Crucifixion (Veronese, c. 1582), 183
 Devotees Appearing Under a Loggia
 (Tiepolo, 1745), 203
 Feast in the House of Levi (Veronese,
 1573), 172
 Pietà (Titian, 1576), 170
 Pilgrims' Arrival in Cologne, The
 (Carpaccio, 1490), 202
 Portico and Court in Venice (Canaletto,
 1765), 175
 Portrait of a Young Man in His Study
 (Lotto, c. 1528), 174
 St. Louis, St. George and the Princess
 (Tintoretto, 1555), 179
 Tempest, The (Giorgione,
 c. 1507–10), 203

ALTE PINAKOTHEK, MUNICH,
GERMANY, 302
 Crowning of Thorns, The (Titian,
 c. 1570), 279
 Drunken Silenus, The (Rubens,
 c. 1616), 303

Fall of the Damned, The (Rubens,
 1620), 274
Oswald Krel (Dürer, 1499), 303
Reclining Girl (Boucher, 1750), 276
Self-Portrait (Van Dyck, 1621–22),
 277
Self-Portrait in a Fur-Trimmed Coat
 (Dürer, c. 1500), 281

ARCHBISHOP'S PALACE,
KROMERIZ, CZECH
REPUBLIC, 334
 Flaying of Marsyas, The (Titian,
 1570–75), 325

ASHMOLEAN MUSEUM, OXFORD,
ENGLAND, 57
 Hunters in a Wood (Uccello,
 c. 1470), 43

BASILICA OF SAN FRANCESCO
D'ASSISI, ASSISI, ITALY, 249
 Deposition of Christ from the Cross
 (Lorenzetti, c. 1310–29), 250
 Last Supper, The (Lorenzetti,
 c. 1310–29), 212
 *St. Francis Catches the Devils of
 Arezzo* (Giotto, 1298), 233

St. Martin Renounces the Roman Army (Martini, c. 1320–23), 235

BASILICA OF SAN FRANCESCO, AREZZO, ITALY, 247

Legend of the True Cross: Battle of Heraclius and Khosrow (Piero, c. 1450–65), 222

Constantine's Dream (Piero, c. 1450–65), 222–24

BASILICA OF SANTA MARIA GLORIOSA DEI FRARI, VENICE, ITALY, 204

Altarpiece of the Pesaro Family (Titian, 1522–26), 204

Assumption of the Virgin (Titian, 1516–18), 181

BORGHESE GALLERY, ROME, ITALY, 164

David with the Head of Goliath (Caravaggio, c. 1606), 164

BRERA GALLERY, MILAN, ITALY, 245

Dead Christ (Mantegna, c. 1480), 217

Finding of the Body of St. Mark, The (Tintoretto, 1562–66), 215

Last Supper (Rubens, 1630–32), 247

Last Supper, The (Veronese, 1585), 212

Pietà (Bellini, Giovanni, c. 1465–70), 219

Pietà (Tintoretto, c. 1560–65), 247

Portrait of Admiral Andrea Doria as Neptune (Bronzino, c. 1530), 246

St. Jerome (Titian, c. 1555), 213

Sermon of St. Mark in Alexandria, The (Bellini, Gentile, and Bellini, Giovanni, c. 1504–07), 220

Supper at Emmaus (Caravaggio, c. 1606), 246

CATHEDRAL OF OUR LADY, ANTWERP, BELGIUM, 392

Descent from the Cross (Rubens, c. 1612), 377

Elevation of the Cross, The (Rubens, c. 1610), 393

CHURCH OF SAN CASSIANO, VENICE, ITALY, 204

Crucifixion (Tintoretto, 1568), 183

CHURCH OF SANTA MARIA DEL POPOLO, ROME, ITALY, 164

Conversion of St. Paul, The (Caravaggio, 1600–01), 158

Crucifixion of St. Peter, The (Caravaggio, 1600–01), 157

COURTAULD GALLERY, LONDON, ENGLAND, 53

Bar at the Folies-Bergère (Manet, 1882), 35

Lac d'Annecy (Cézanne, 1896), 33

Tête-à-Tête Supper (Toulouse-Lautrec, 1899), 53

CZARTORYSKI MUSEUM, KRAKOW, POLAND, 33

Lady with Ermine (Leonardo, c. 1490), 320

DUCAL PALACE, LA CAMERA DEGLI SPOSI, MANTUA, ITALY, 248

Family and Court of Ludovico III Gonzaga (Mantegna, c. 1470–74), 228

Meeting Scene, Grooms with Dogs and Horse, The (Mantegna, 1465–74), 229

DUOMO OF PARMA, ITALY, 248

Assumption of the Virgin (Correggio, 1526–30), 225

Assumption of the Virgin, detail of the central cupola (Correggio, 1526–30), 226

DUOMO, ORVIETO, ITALY, 252
Damned in Hell, The (Signorelli, c. 1500–03), 241

GALLERIA DEGLI UFFIZI, FLORENCE, ITALY, 205
Adoration of the Magi (Botticelli, c. 1475), 193
Adoration of the Magi (Gentile, 1423), 190
Adoration of the Magi (Da Vinci, 1481), 191
Adoration of the Magi (Mantegna, c. 1464–66), 206
Adoration of the Magi, The (Dürer, 1504), 208
Baptism of Christ (Verrocchio, 1470–75), 194
Lucrezia Panciatichi (Bronzino, 1540), 208
Portinari Altarpiece (Van der Goes, c. 1475), 207
Portrait of Federico da Montefeltro (Piero, c. 1465), 206
Primavera (Botticelli, c. 1481), 188
Venus of Urbino (Titian, 1538), 196

GALLERIE DORIA PAMPHILJ, ROME, ITALY, 162
Pope Innocent X (Velázquez, 1650), 152

GEMÄLDEGALERIE ALTE MEISTER, DRESDEN, GERMANY, 300
Altarpiece with the Madonna and Child, St. Michael, and St. Catherine (Van Eyck, 1437), 270
Girl Reading a Letter by an Open Window (Vermeer, c. 1659), 302

Henry the Pious Duke of Saxony (Cranach the Elder, 1514), 302
Jewish Cemetery, The (Ruisdael, 1655–60), 272
Sistine Madonna, The (Raphael, c. 1512–13), 268
Sleeping Venus, The (Giorgione, 1508–10), 301

GEMÄLDEGALERIE STAATLICHE MUSEEN, BERLIN, GERMANY, 297
Hieronymus Holzschuher (Dürer, 1526), 299
Joseph and Potiphar's Wife (Rembrandt, 1655), 262
Malle Babbe (Hals, c. 1633–35), 260
Moses Destroying the Tablets of the Law (Rembrandt, 1659), 257
Netherlandish Proverbs, The (Bruegel the Elder, 1559), 298
Paternal Admonition, The (Terborch, c. 1654–55), 298
Portrait of a Genoese Noblewoman (Van Dyck, c. 1621–23), 263
Portrait of a Young Lady (Christus, c. 1470), 297
Self-Portrait (Titian, c. 1560), 259
St. John the Baptist Altar (Van der Weyden, 1455), 299

GROENINGE MUSEUM, BRUGES, BELGIUM, 391
Judgment of Cambyses, The (David, Gerard, 1498), 391
Madonna Adored by the Canonicus Van der Paele (Van Eyck, 1436), 373

HERMITAGE, ST. PETERSBURG, RUSSIA, 330
Absinthe Drinker, The (Picasso, 1901), 317
Boulevard Montmarte in Paris (Pissarro, 1897), 331

Conversion of Saul, The (Veronese, 1570), 313

Danae (Titian, 1553–54), 331

Dance (Matisse, 1910), 312

Great Pine and Red Earth (Cézanne, c. 1895), 314

Haman Recognizes His Fate (Rembrandt [School of], 1665), 315

Portrait of Henry Danvers, Earl of Danby (Van Dyck, late 1630s), 318

Return of the Prodigal Son (Rembrandt, 1668–69), 310

Sermon of St. John the Baptist, The (Brueghel the Younger, c. 1604), 331

Stranded Ships (or Boats) Near the Shore of Normandy (Bonington, c. 1823–24), 332

IL GESÙ, ROME, ITALY, 163

Triumph of the Name of Jesus (Gaulli, 1679), 154

JAN SIX MUSEUM, AMSTERDAM, NETHERLANDS, 390

Portrait of Jan Six (Rembrandt, 1654), 368

KENWOOD HOUSE, LONDON, ENGLAND, 56

Self-Portrait with Two Circles (Rembrandt, c. 1665–69), 39

KING'S COLLEGE, CAMBRIDGE, ENGLAND, 56

Adoration of the Magi (Rubens, 1633–34), 41

KUNSTHISTORISCHES MUSEUM, VIENNA, AUSTRIA, 305

Conversion of St. Paul (Bruegel the Elder, 1567), 296

Head of Medusa, The (Rubens, c. 1618), 306

Jane Seymour, Queen of England (Holbein the Younger, 1536), 305

Large Self-Portrait (Rembrandt, 1652), 295

Mars, Venus, and Amor (Titian, 1560), 291

Painter, The (Vermeer, 1665–66), 289

Peasants' Dance (Bruegel the Elder, 1568), 306

Return of the Hunters (Bruegel the Elder, 1565), 387

Samson Made Prisoner (Van Dyck, c. 1628–30), 294

Susannah Bathing (Tintoretto, after 1560), 292

Woman at the Mirror (Bellini, Giovanni, 1515), 305

LOBKOWICZ PALACE, PRAGUE, CZECH REPUBLIC, 334

Hay Harvest, The (Bruegel the Elder, 1565), 323

LOUVRE, PARIS, FRANCE, 91

Baldassare Castiglione (Raphael, c. 1514–15), 63

Death of the Virgin (Caravaggio, 1605), 61

Erasmus of Rotterdam Writing (Holbein the Younger, c. 1523), 95

Jewish Wedding in Morocco (Delacroix, 1837), 96

Liberty Leading the People, July 28, 1830 (Delacroix, 1830), 66

Madame Récamier (David, Jacques-Louis, 1800), 65

Pietà de Villeneuve-lès-Avignon (Quarton, c. 1460), 72

Pipe and Drinking Cup (Chardin, c. 1737), 74

Portrait of Louis-François Bertin (Ingres, 1832), 94

Raft of the Medusa, The (Géricault, 1819), 69

Ship of Fools, The (Bosch, 1490–1500), 95

MADONNA DELL'ORTO, VENICE, ITALY, 205

Last Judgment, The (detail) (Tintoretto, 1562–64), 185

Presentation of the Virgin in the Temple (Tintoretto, 1552), 187

MAURITSHUIS, THE HAGUE, NETHERLANDS, 387

Head of a Girl (Vermeer, 1665), 356

Merry Company, The (Steen, 1665), 354

Portrait of Robert Cheseman (Holbein the Younger, c. 1533), 350

Self-Portrait (Rembrandt, 1669), 345

View of Delft (Vermeer, c. 1660–61), 348

View of Haarlem (Ruisdael, c. 1670–75), 352

Young Girl Eating Oysters (Steen, c. 1658–60), 387

MEMLING MUSEUM, BRUGES, BELGIUM, 392

St. Ursula Shrine (Memling, c. 1489), 375

MUSÉE DE L'ORANGERIE, PARIS, FRANCE, 100

Water Lilies (Monet, 1896–1923), 88

MUSÉE D'ORSAY, PARIS, FRANCE, 100

Angelus, The (Millet, 1857–59), 97

Ball at the Moulin de la Galette, Montmartre (Renoir, 1876), 84

Burial at Ornans (Courbet, 1849–50), 98

Déjeuner sur l'herbe (Manet, 1863), 76

In a Café (Degas, 1875–76), 82

Le Lit (Toulouse-Lautrec, c. 1892), 86

Olympia (Manet, 1863), 79

MUSÉES ROYAUX DES BEAUX ARTS, BRUSSELS, BELGIUM, 393

Fall of the Rebel Angels, The (Bruegel the Elder, c. 1562), 393

Jean-Paul Marat, Politician and Publicist, Dead in His Bathtub, Assassinated by Charlotte Corday (David, Jacques-Louis, 1792), 379

MUSEO NACIONAL CENTRO DE ARTE REINA SOFIA, MADRID, SPAIN, 136

Guernica (Picasso, 1937), 126

MUSEO THYSSEN-BORNEMISZA, MADRID, SPAIN, 134

Interior of the Burgomaster's Council Chamber in the Amsterdam Town Hall, The (De Hooch, c. 1663–65), 135

Jesus Among the Doctors (Dürer, 1506), 124

L'Amazone (Horse Woman) (Manet, 1882), 123

Mrs. Charles Russell (Sargent, 1908), 134

Portrait of a Peasant (Cézanne, 1905), 122

St. Catherine of Alexandria (Caravaggio, 1599), 120

Virgin and Child Enthroned, The (Van der Weyden, 1433), 135

Water Stream (La Brême), The (Courbet, 1866), 125

NATIONAL GALLERY, DUBLIN, IRELAND, 57
 Taking of Christ, The (Caravaggio, 1602), 44

NATIONAL GALLERY, LONDON, ENGLAND, 46
 Baptism of Christ, The (Piero, c. 1450s), 48
 Calais Pier, with French Poissards Preparing for Sea: An English Packet Arriving (Turner, 1803), 46
 Death of Actaeon, The (Titian, c. 1565–76), 9
 Doge Leonardo Loredan, The (Giovanni Bellini, 1501–04), 7
 Hay Wain, The (Constable, 1821), 13
 Perseus Turning Phineas and His Followers into Stone (Giordano, c. early 1680s), 47
 Portrait of Giovanni Arnolfini and His Wife (Van Eyck, 1434), 17
 Rain, Steam, Speed — The Great Western Railway (Turner, 1844), 15
 St. George and the Dragon (Uccello, c. 1470), 21
 Self-Portrait at the Age of 63 (Rembrandt, 1669), 11
 Ulysses Deriding Polyphemus — Homer's Odyssey (Turner, 1829), 49
 Whistlejacket (Stubbs, c. 1762), 19
 Wilton Diptych, The (Anonymous, 1395–99), 4

NATIONAL GALLERY, PRAGUE, CZECH REPUBLIC, 333
 Feast of the Rosary, The (Dürer, c. 1506), 322

NATIONAL MUSEUM OF CAPODIMONTE, NAPLES, ITALY, 251
 Antea (Parmigianino, 1530–35), 251
 Parable of the Blind (Bruegel the Elder, c. 1568), 240
 Pope Paul III Farnese (r. 1534–49) (Titian, c. 1543), 252
 Pope Paul III with His Nephews Cardinal Ottavio and Alessandro Farnese (Titian, c. 1545), 236
 St. Louis of Toulouse (Simone Martini, c. 1317), 238

NATIONALMUSEUM, STOCKHOLM, SWEDEN, 385
 Apostles Peter and Paul, The (El Greco, 1587–92), 386
 Cellist, The (Courbet, 1847), 386
 La Grenouillére (Renoir, 1869), 344
 Martin Luther (Cranach the Elder, c. 1527), 385
 Oath of the Batavians, The (Rembrandt, 1662), 340
 Simeon in the Temple (Rembrandt, 1669), 343
 Washerwoman, The (Chardin, c. 1733–39), 386

PALAZZO TE, MANTUA, ITALY, 249
 Fall of the Giants, The (Giulio, 1526–35), 231

MUSEO DEL PRADO, MADRID, SPAIN, 131
 Annunciation, The (Fra Angelico, 1425–28), 108
 Deposition (Van der Weyden, c. 1436), 107
 Entombment (Titian, 1572), 133
 Garden of Earthly Delights (Bosch, c. 1500), 104

Holy Trinity, The (El Greco,
 c. 1577–79), 113
Las Meniñas (Velàzquez, 1656), 117
Mary I (Tudor), Queen of England
 (Mor, c. 1554), 132
Nude Maya, The (Goya, 1789–
 1805), 132
Sabbath (Goya, 1821–23), 111
Surrender of Breda, The (Velàzquez,
 1634–35), 115
Third of May, 1808 (Goya, 1814), 109
Triumph of Death (Bruegel, the
 Elder, c. 1562), 131

RIJKSMUSEUM, AMSTERDAM,
NETHERLANDS, 388
 *Company of Captain Frans Banning
 Cocq and Willem van Ruytenburch,
 The* (Rembrandt, 1642), 367
 Denial of St. Peter (Rembrandt,
 1660), 389
 *Jeremiah Lamenting the Destruction of
 Jerusalem* (Rembrandt, 1630), 364
 Jewish Bride, The (Rembrandt,
 1667), 358
 Maternal Duty (De Hooch,
 c. 1658–60), 388
 Meagre Company, The (Hals,
 c. 1637), 361
 Milkmaid, The (Vermeer, 1658–60),
 366
 Street in Delft, A (Vermeer,
 1658–60), 363
 *Syndics of the Amsterdam Draper's
 Guild, The* (Rembrandt, 1662),
 359
 Winter Scene with Ice Skaters
 (Avercamp, c. 1608), 389

ST. BAVO CATHEDRAL, GHENT,
BELGIUM, 394
 Ghent Altar, The (Van Eyck, 1432),
 382

SANTA MARIA DEL CARMINE,
BRANCACCI CHAPEL, FLORENCE,
ITALY, 209
 Expulsion from Paradise, The
 (Masaccio, c. 1425), 198
 Tribute Money, The (Masaccio,
 c. 1427), 199

SANTO TOMÉ, TOLEDO,
SPAIN, 136
 Burial of Count Orgaz (El Greco,
 1586), 129

SCHLOSS CHARLOTTENBURG
PALACE, BERLIN, GERMANY, 300
 *Shop Sign for the Art Dealer Gersaint,
 The* (Watteau, 1720), 265

SCROVEGNI CHAPEL, PADUA,
ITALY, 253
 Devils Derobing a Man (detail from
 The Last Judgment) (Giotto,
 c. 1305), 243
 Hanging People on Trees (*Last
 Judgment*, detail of Hell) (Giotto,
 1303), 253

SCUOLA GRANDE DI S. ROCCO,
VENICE, ITALY, 201
 Baptism of Christ, The (Tintoretto,
 1579–81), 169
 Crucifixion (Tintoretto, 1565), 183
 Way to Calvary (Tintoretto, 1565–
 67), 201

SISTINE CHAPEL, VATICAN
CITY, 161
 Creation of Adam, The (Michelangelo,
 c. 1510), 141
 Creation of the Sun, Moon, and Plants
 (Michelangelo, c. 1511), 161
 *Ignudo (Creation of the Sun, Moon,
 and Plants)* (Michelangelo,
 c. 1511), 140

Last Judgment, The (Michelangelo,
 c. 1537–41), 143
*Last Judgment — Transporting the
 Dead, The* (Michelangelo,
 c. 1537–41), 147
Libyan Sibyl, The (Michelangelo,
 c. 1511), 139

TATE BRITAIN, LONDON,
ENGLAND, 49
 Lady of Shalott, The (Waterhouse,
 1888), 27
 *Nocturne in Blue and Gold: Old
 Battersea Bridge* (Whistler,
 1872–75), 29
 *O The Roast Beef of Old England
 (The Gate of Calais)* (Hogarth,
 1748), 50
 Ophelia (Millais, 1852), 25
 Resurrection at Cookham, The
 (Spencer, 1924–27), 52
 *Snow Storm: Steam-Boat off a
 Harbour's Mouth Making Signals
 in Shallow Water, and Going by
 the Lead* (Turner, 1842), 23

VAN GOGH MUSEUM,
AMSTERDAM, NETHERLANDS, 390
 Vase with Irises (Van Gogh, 1890), 371
 Wheatfield with Crows (Van Gogh,
 1890), 370

VATICAN ART GALLERY,
VATICAN CITY, 162
 Deposition (Caravaggio, 1600–04), 151

VATICAN MUSEUM, VATICAN
CITY, 162
 *Delivery of St. Peter in the Stanza
 d'Eliodoro* (Raphael, c. 1511–14),
 149

WALLACE COLLECTION,
LONDON, ENGLAND, 54
 Celebrating the Birth (Steen, 1664), 55
 George IV (Lawrence, 1822), 36
 Swing, The (Fragonard, 1767), 54

WÜRZBURG RESIDENZ,
WÜRZBURG, GERMANY, 304
 Africa (Tiepolo, 1753), 285
 America (Tiepolo, 1753), 283

CHECKLIST OF THE 149 PAINTINGS

Visit the galleries of Europe and check off each painting as you see it.

NATIONAL GALLERY, LONDON, ENGLAND

- [] 1. Anonymous, *The Wilton Diptych*
- [] 2. Bellini, Giovanni, *The Doge Leonardo Loredan*
- [] 3. Titian, *The Death of Actaeon*
- [] 4. Rembrandt, *Self-Portrait at the Age of 63*
- [] 5. Constable, *The Hay Wain*
- [] 6. Turner, *Rain, Steam, and Speed — The Great Western Railway*
- [] 7. Van Eyck, *Portrait of Giovanni Arnolfini and His Wife*
- [] 8. Stubbs, *Whistlejacket*
- [] 9. Uccello, *St. George and the Dragon*

TATE BRITAIN, LONDON, ENGLAND

- [] 10. Turner, *Snow Storm: Steam-Boat off a Harbour's Mouth Making Signals in Shallow Water, and Going by the Lead*

- [] 11. Millais, *Ophelia*
- [] 12. Waterhouse, *The Lady of Shalott*
- [] 13. Whistler, *Nocturne in Blue and Gold: Old Battersea Bridge*

COURTAULD GALLERY, LONDON, ENGLAND

- [] 14. Cézanne, *Lac d'Annecy*
- [] 15. Manet, *Bar at the Folies-Bergère*

WALLACE COLLECTION, LONDON, ENGLAND

- [] 16. Lawrence, *George IV*

KENWOOD HOUSE, LONDON, ENGLAND

- [] 17. Rembrandt, *Self-Portrait with Two Circles*

KING'S COLLEGE, CAMBRIDGE, ENGLAND

- [] 18. Rubens, *Adoration of the Magi*

ASHMOLEAN MUSEUM, OXFORD, ENGLAND

☐ 19. Uccello, *Hunters in a Wood*

NATIONAL GALLERY, DUBLIN, IRELAND

☐ 20. Caravaggio, *The Taking of Christ*

MUSÉE DU LOUVRE, PARIS, FRANCE

☐ 21. Caravaggio, *Death of the Virgin*

☐ 22. Raphael, *Baldassare Castiglione*

☐ 23. David, Jacques-Louis, *Madame Récamier*

☐ 24. Delacroix, *Liberty Leading the People, July 28, 1830*

☐ 25. Géricault, *The Raft of the Medusa*

☐ 26. Quarton, *Pietà de Villeneuve-lès-Avignon*

☐ 27. Chardin, *Pipe and Drinking Cup*

MUSÉE D'ORSAY, PARIS, FRANCE

☐ 28. Manet, *Déjeuner sur l'herbe (Luncheon on the Grass)*

☐ 29. Manet, *Olympia*

☐ 30. Degas, *In a Café*

☐ 31. Renoir, *Ball at the Moulin de la Galette, Montmartre*

☐ 32. Toulouse-Lautrec, *Le Lit*

MUSÉE DE L'ORANGERIE, PARIS, FRANCE

☐ 33. Monet, *Water Lilies*

MUSEO DEL PRADO, MADRID, SPAIN

☐ 34. Bosch, *Garden of Earthly Delights*

☐ 35. Van der Weyden, *Deposition*

☐ 36. Fra Angelico, *The Annunciation*

☐ 37. Goya, *Third of May, 1808*

☐ 38. Goya, *Sabbath*

☐ 39. El Greco, *The Holy Trinity*

☐ 40. Velázquez, *The Surrender of Breda*

☐ 41. Velázquez, *Las Meninas*

MUSEO THYSSEN-BORNEMISZA, MADRID, SPAIN

☐ 42. Caravaggio, *St. Catherine of Alexandria*

☐ 43. Cézanne, *Portrait of a Peasant*

☐ 44. Manet, *L'Amazone (Horse Woman)*

☐ 45. Dürer, *Jesus Among the Doctors*

☐ 46. Courbet, *The Water Stream (La Brême)*

MUSEO NACIONAL CENTRO DE ARTE REINA SOFIA, MADRID, SPAIN

☐ 47. Picasso, *Guernica*

SANTO TOMÉ, TOLEDO, SPAIN

☐ 48. El Greco, *Burial of Count Orgaz*

SISTINE CHAPEL, VATICAN CITY

☐ 49. Michelangelo, Ceiling of the Sistine Chapel

☐ 50. Michelangelo, *The Last Judgment*

☐ 51. Michelangelo, *The Last Judgment — Transporting the Dead*

VATICAN MUSEUM, VATICAN CITY

☐ 52. Raphael, *Delivery of St. Peter in the Stanza d'Eliodoro*

VATICAN ART GALLERY
(PINACOTECA), VATICAN CITY

☐ 53. Caravaggio, *Deposition*

GALLERIA DORIA PAMPHILJ,
ROME, ITALY

☐ 54. Velázquez, *Pope Innocent X*

IL GESÙ, ROME, ITALY

☐ 55. Gaulli, *Triumph of the Name
of Jesus*

CHURCH OF SANTA MARIA DEL
POPOLO, ROME, ITALY

☐ 56. Caravaggio, *The Conversion of
St. Paul* and *The Crucifixion
of St. Peter*

SCUOLA GRANDE DI S. ROCCO,
SALLA DELL'ARBERGO, VENICE,
ITALY

☐ 57. Tintoretto, *Crucifixion*

☐ 58. Tintoretto, *The Baptism of
Christ*

ACCADEMIA ART GALLERY,
VENICE, ITALY

☐ 59. Titian, *Pietà*

☐ 60. Veronese, *Feast in the House
of Levi*

☐ 61. Lotto, *Portrait of a Young Man
in His Study*

☐ 62. Canaletto, *Portico and Court in
Venice*

☐ 63. Carpaccio, *Arrival of the
Ambassadors,* from *The Cycle of
St. Ursula*

☐ 64. Tintoretto, *St. Louis, St. George,
and the Princess*

BASILICA OF SANTA MARIA
GLORIOSA DEI FRARI, VENICE,
ITALY

☐ 65. Titian, *Assumption of the Virgin*

CHURCH OF SAN CASSIANO,
VENICE, ITALY

☐ 66. Tintoretto, *Crucifixion*

MADONNA DELL'ORTO, VENICE,
ITALY

☐ 67. Tintoretto, *The Last Judgment*

☐ 68. Tintoretto, *Presentation of the
Virgin in the Temple*

GALLERIA DEGLI UFFIZI,
FLORENCE, ITALY

☐ 69. Botticelli, *Primavera*

☐ 70. Gentile da Fabriano, *Adoration
of the Magi*

☐ 71. Leonardo da Vinci, *Adoration
of the Magi*

☐ 72. Botticelli, *Adoration of the Magi*

☐ 73. Verrocchio, *Baptism of Christ*

☐ 74. Titian, *Venus of Urbino*

BRANCACCI CHAPEL, CHURCH
OF SANTA MARIA DEL CARMINE,
FLORENCE, ITALY

☐ 75. Masaccio, *The Expulsion from
Paradise* and *The Tribute Money*

BRERA GALLERY, MILAN, ITALY

☐ 76. Veronese, *The Last Supper*

☐ 77. Titian, *St. Jerome*

☐ 78. Tintoretto, *The Finding of the
Body of St. Mark*

☐ 79. Mantegna, *Dead Christ*

☐ 80. Bellini, Giovanni, *Pietà*

☐ 81. Bellini, Gentile, and Bellini,
Giovanni, *The Sermon of
St. Mark in Alexandria*

BASILICA OF SAN FRANCESCO, AREZZO, ITALY

- [] 82. Piero della Francesca, *The Legend of the True Cross*

DUOMO OF PARMA, ITALY

- [] 83. Correggio, *Assumption of the Virgin*

DUCAL PALACE, LA CAMERA DEGLI SPOSI, MANTUA, ITALY

- [] 84. Mantegna, *Family and Court of Ludovico III Gonzaga* and *The Meeting Scene: Grooms with Dogs and Horse*

PALAZZO TE, MANTUA, ITALY

- [] 85. Giulio Romano, *The Fall of the Giants*

BASILICA OF SAN FRANCESCO D'ASSISI, ASSISI, ITALY

- [] 86. Giotto, *St. Francis Catches the Devils of Arezzo*
- [] 87. Martini, *St. Martin Renounces the Roman Army*, from *Scenes of the Life of St. Martin*

NATIONAL MUSEUM OF CAPODIMONTE, NAPLES, ITALY

- [] 88. Titian, *Pope Paul III with His Nephews Cardinal Ottavio and Alessandro Farnese*
- [] 89. Martini, *St. Louis of Toulouse*
- [] 90. Bruegel the Elder, *Parable of the Blind*

DUOMO, ORVIETO, ITALY

- [] 91. Signorelli, *The Damned in Hell* (part of *The Last Judgment*)

SCROVEGNI CHAPEL, PADUA, ITALY

- [] 92. Giotto, *Devils Derobing a Man* (detail from *The Last Judgment*)

GEMÄLDEGALERIE STAATLICHE MUSEEN, BERLIN, GERMANY

- [] 93. Rembrandt, *Moses Destroying the Tablets of the Law*
- [] 94. Titian, *Self-Portrait*
- [] 95. Hals, *Malle Babbe*
- [] 96. Rembrandt, *Joseph and Potiphar's Wife*
- [] 97. Van Dyck, *Portrait of a Genoese Noblewoman*

SCHLOSS CHARLOTTENBURG PALACE, BERLIN, GERMANY

- [] 98. Watteau, *The Shop Sign for the Art Dealer Gersaint*

GEMÄLDEGALERIE ALTE MEISTER, DRESDEN, GERMANY

- [] 99. Raphael, *The Sistine Madonna*
- [] 100. Van Eyck, *Altarpiece with the Madonna and Child, St. Michael, and St. Catherine*
- [] 101. Ruisdael, *The Jewish Cemetery*

ALTE PINAKOTHEK, MUNICH, GERMANY

- [] 102. Rubens, *The Fall of the Damned*
- [] 103. Boucher, *Reclining Girl*
- [] 104. Van Dyck, *Self-Portrait*
- [] 105. Titian, *The Crowning of Thorns*
- [] 106. Dürer, *Self-Portrait in a Fur-Trimmed Cloak*

WÜRZBURG RESIDENZ, WÜRZBURG, GERMANY

- [] 107. Tiepolo, *America* and *Africa*

KUNSTHISTORISCHES MUSEUM,
VIENNA, AUSTRIA

☐ 108. Bruegel the Elder, *Return of the Hunters*

☐ 109. Vermeer, *The Painter*

☐ 110. Titian, *Mars, Venus, and Amor*

☐ 111. Tintoretto, *Susannah Bathing*

☐ 112. Van Dyck, *Samson Made Prisoner*

☐ 113. Rembrandt, *Large Self-Portrait*

☐ 114. Bruegel the Elder, *Conversion of St. Paul*

HERMITAGE, ST. PETERSBURG,
RUSSIA

☐ 115. Rembrandt, *Return of the Prodigal Son*

☐ 116. Matisse, *Dance*

☐ 117. Veronese, *Conversion of Saul*

☐ 118. Cézanne, *Great Pine and Red Earth*

☐ 119. Rembrandt (School of), *Haman Recognizes His Fate*

☐ 120. Picasso, *The Absinthe Drinker*

☐ 121. Van Dyck, *Portrait of Henry Danvers, Earl of Danby*

CZARTORYSKI MUSEUM,
KRAKOW, POLAND

☐ 122. Leonardo da Vinci, *Lady with Ermine*

NATIONAL GALLERY, PRAGUE,
CZECH REPUBLIC

☐ 123. Dürer, *The Feast of the Rosary*

ARCHBISHOP'S PALACE,
KROMERIZ, CZECH REPUBLIC

☐ 124. Titian, *The Flaying of Marsyas*

LOBKOWICZ PALACE, PRAGUE,
CZECH REPUBLIC

☐ 125. Bruegel the Elder, *The Hay Harvest*

NATIONALMUSEUM,
STOCKHOLM, SWEDEN

☐ 126. Rembrandt, *The Oath of the Batavians*

☐ 127. Rembrandt, *Simeon in the Temple*

☐ 128. Renoir, *La Grenouillère*

MAURITSHUIS, THE HAGUE,
NETHERLANDS

☐ 129. Rembrandt, *Self-Portrait*

☐ 130. Vermeer, *View of Delft*

☐ 131. Holbein the Younger, *Portrait of Robert Cheseman*

☐ 132. Ruisdael, *View of Haarlem*

☐ 133. Steen, *The Merry Company*

☐ 134. Vermeer, *Head of a Girl*

RIJKSMUSEUM, AMSTERDAM,
NETHERLANDS

☐ 135. Rembrandt, *The Jewish Bride*

☐ 136. Rembrandt, *The Syndics of the Amsterdam Drapers' Guild*

☐ 137. Hals, *The Meagre Company*

☐ 138. Vermeer, *A Street in Delft*

☐ 139. Rembrandt, *Jeremiah Lamenting the Destruction of Jerusalem*

☐ 140. Vermeer, *The Milkmaid*

☐ 141. Rembrandt, *The Company of Captain Frans Banning Cocq and Willem van Ruytenburch*

JAN SIX MUSEUM, AMSTERDAM,
NETHERLANDS

☐ 142. Rembrandt, *Portrait of Jan Six*

VAN GOGH MUSEUM, AMSTERDAM, NETHERLANDS

- [] 143. Van Gogh, *Wheatfield with Crows*
- [] 144. Van Gogh, *Vase with Irises*

GROENINGE MUSEUM, BRUGES, BELGIUM

- [] 145. Van Eyck, *Madonna Adored by the Canonicus Van der Paele*

MEMLING MUSEUM, BRUGES, BELGIUM

- [] 146. Memling, *St. Ursula Shrine*

CATHEDRAL OF OUR LADY, ANTWERP, BELGIUM

- [] 147. Rubens, *Descent from the Cross*

MUSÉES ROYAUX DES BEAUX ARTS, BRUSSELS, BELGIUM

- [] 148. David, Jacques-Louis, *Jean-Paul Marat, Politician and Publicist, Dead in His Bathtub, Assassinated by Charlotte Corday*

ST. BAVO CATHEDRAL, GHENT, BELGIUM

- [] 149. Van Eyck, *The Ghent Altar*